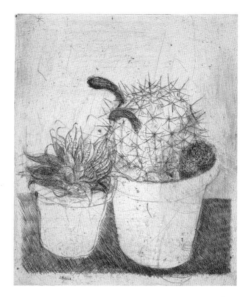

ITALIAN
PRINTS
1875–1975

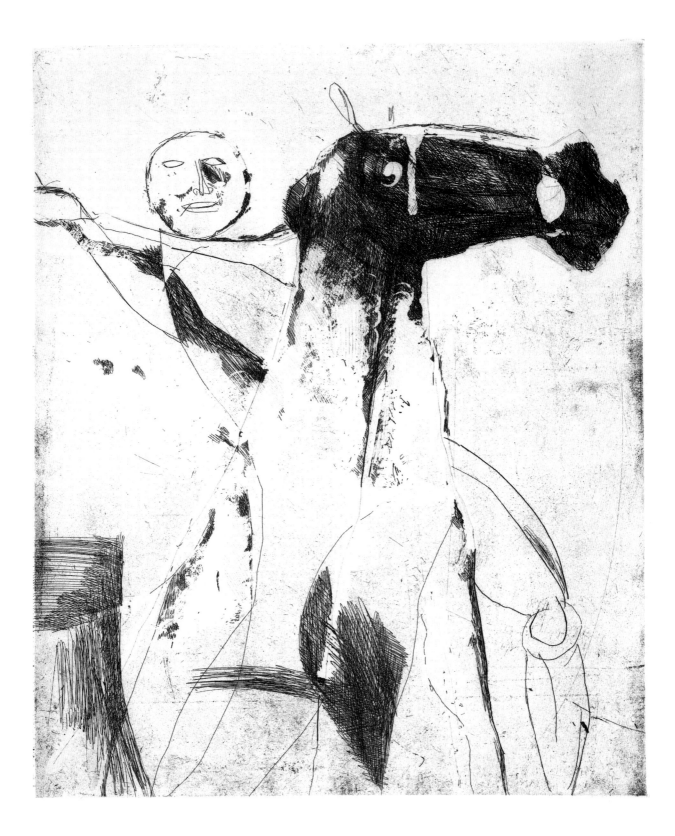

ITALIAN PRINTS 1875–1975

Martin Hopkinson

THE BRITISH MUSEUM PRESS

© 2007 The Trustees of the British Museum

First published in 2007 by The British Museum Press
A division of The British Museum Company Ltd
38 Russell Square, London WC1B 3QQ

www.britishmuseum.co.uk

A catalogue record for this book is available from the British Library

ISBN-13: 978-0-7141-2653-1
ISBN-10: 0-7141-2653-5

Designed by Andrew Shoolbred
Printed in Spain by Grafos SA, Barcelona

Contents

Preface and acknowledgements

The Department of Prints and Drawings of the British Museum has published over the past few decades a number of catalogues of exhibitions of the different schools of modern printmaking. Notable landmarks in the series are those on American prints (1980), German prints (1984), Czech prints (1986), British prints (1990), Scandinavian prints (1996) and of printmaking in Paris (1997). Our hope was to do two things at once. Firstly to use each exhibition to build up our collection of modern prints, focusing on one school at a time, and secondly to publish a catalogue that would not only serve as a guide to what could be seen in the Study Room of the Department at any time in the future, but might be more widely useful beyond our walls as an introduction to the subject. The fact that the second of these catalogues was reprinted a decade after the exhibition closed suggests that our ambitions have been largely achieved.

It was always part of our plan to continue the series to cover the major remaining schools of European printmaking. But the reduction in funds available for acquisitions made this seem impossible. The last of the series (that on printmaking in Paris) was a decade ago, and more or less coincided with the reduction of the purchase funds of the British Museum.

It therefore seemed very unlikely that our series of exhibitions could continue. That this has not been the case is due entirely to the generosity of private donors who have come to our rescue. Most notable among them is the donor (who wishes to preserve his anonymity) to whom this exhibition is due. Anyone who looks through the pages of this catalogue will notice that only nine of the items shown were in our collection before 2000, and that almost everything else has been presented anonymously since then. That anonymous donor is a single person who wished to see the printmaking of modern Italy worthily represented in our collection, and described in a catalogue that might serve to fill a huge gap in the literature on modern printmaking.

To achieve this goal, he gave the British Museum a very substantial sum from which the bulk of the prints described here have been purchased. (Many other prints also purchased from this fund have been omitted through lack of space.) When this fund was exhausted, he enabled us to complete the project by presenting further prints or giving us the funds to purchase them. This exhibition would have been inconceivable without the initial impetus he gave us, his open-handed financial support and his continuing involvement in offering much help and advice of a practical and scholarly kind. We offer him our warmest thanks. This is the first project in the Department's recent history where a donor has had such a close involvement in our activities and has achieved such a focused result, and I hope that it might

be a model for many more such collaborations with donors in the future.

Even with generous funding and support, this exhibition has proved extremely difficult to put together. Part of the problem was the lack of adequate surveys of the field, whether written in Italian or in any other language. There are many monographs on individual artists, and many specialized studies of specific groups or publishers, but very little that gives any overview. It was not at all easy to establish which of the leading Italian artists had even made prints, much less what they were. This was compounded by the fact that works by Italian printmakers of this period are rarely seen on the print markets in London, New York or Paris. Apart from Morandi, Fontana, Marini and a few others, works by these artists are available only in Italy, and are there sold privately in the trade rather than publicly by auction. This has made the process of acquisition extremely difficult, frustrating and exciting. Such great prints as those of Fattori are almost unknown outside Italy, and this exhibition might claim to be their first international exposure.

These factors have made us dependent on the help of members of the print trade in Italy, and we owe warm thanks to all of them. Most of the prints by Fattori came from Antonio Berni, of Messrs Falteri in Florence, who brought these prints with him to the Print Fair in the Royal Academy in London. Other works came from Mattia Jona in Milan, who found for us the group of prints by Conconi. But by far the greatest number came from Luigi Majno, also in Milan, who has been quite exceptionally helpful. Indeed he deserves the title of the exhibition's second patron. Not only did he put together for us a very large group of prints that we acquired in the summer of 2003; he gave constant advice as well as gifts of prints, found innumerable books that we needed and acted as middleman in seeking the support of a large number of contemporary Italian artists. We are most grateful to him; the flow of amusing letters he has sent to London by fax (and in recent months email) has been a constant pleasure.

At the end of this catalogue is a list of works presented to the British Museum by ten contemporary Italian artists. We had originally intended to include many of these in this exhibition, but the unexpected reconstruction of our exhibition gallery considerably reduced the space we had available. We therefore reluctantly decided to break off the display at 1975, with the result that they had to be omitted. This does not reduce our gratitude to the donors. All their gifts are listed here, and all these works are available to anyone to look at in the Print Room at any time when we are open. We hope that one day they will serve as the core of a future exhibition of the next period of Italian printmaking.

The final piece we needed to assemble the jigsaw of this exhibition was an author for the catalogue, and we are extremely grateful to Martin Hopkinson for taking it on. He is the former curator of the print collection in the Hunterian Museum and Art Gallery of the University of Glasgow, and one of the leading British authorities on modern printmaking. He overcame his natural hesitations at undertaking a project in an area with such inadequate published sources, and where so few were to be found in British libraries. The first part of his work was therefore to identify the necessary books (they are listed in the bibliography) and, if not available, to acquire them where possible for the library of the Department (a process in which Richard Perfitt in the Department played a significant supporting role). Two major published sources were unavailable to him. The first are the catalogues of the exhibitions in which Italian prints of the period were first exhibited. Aside from the catalogues of the Venice Biennali, very few of these are held by British libraries. Even of such important exhibitions as the Rome Quadriennale, only scattered copies are to be found. The second absence is of the vast majority of Italian journals covering visual arts of the period. This has made it impossible to consider seriously the contemporary reception of Italian prints.

The author wishes to thank for much help the staff of the British Library, the National Art Library in the Victoria and Albert Museum, the Tate Library, the Courtauld Institute Library and the Warburg Institute Library. He also owes thanks to Chris Adams of the Estorick Collection; Peter Black of the Hunterian Art Gallery; Eugenio Carmi; Stephen Coppel; Zeno Davoli of the Civici Musei di Reggio Emilia; the Fondazione Lucio Fontana; Matthew Gale of Tate Modern; Mario Graziani of the Archivio Afro; Philipp Hediger-Junod; Jane Lee; Dottssa Alessandra Klimciuk of the Fondazione Stelline, Milan; Professor Duncan Macmillan; Luigi Majno; Lino Mannocci; Professor Ronald Pickvance; Christian Rümelin of the Ashmolean Museum; Beat Stutzer of the Segantini Museum; Professor Annie-Paule Quinsac; and Dr Christopher Wilk of the Victoria and Albert Museum.

In the print trade we wish to thank Barbara Behan; Antonio Berni; Hervé Bordas; Carlo Cardazzo of Galleria Cavallino; Joseph Goddu of Hirschl & Adler; Mattia Jona; Signor Manetti of Galleria Antiquaria Gonnelli, Florence; Giuseppe Paccagnini; Signora Simona Rossi of Galleria 2RC; Gordon Samuel; Urs Ullmann of Erker-Galerie; and Allan Wolman.

In the British Museum we thank Ivor Kerslake and Lisa Baylis for taking the photographs for the catalogue. In the British Museum Company, we thank Rosemary Bradley, Teresa Francis and Laura Lappin, as well as our editor, John Banks.

A.V. Griffiths
Keeper of Prints and Drawings

Introduction

From the late fifteenth to the mid-eighteenth century Italy had a continuous and glorious history in the production of outstanding printmakers of international repute, which fully matches the achievements in the fields of painting, sculpture and architecture. Artists and connoisseurs in other European countries valued the art of Italy above all others, and flocked to the peninsula to benefit from the study of the great masters of the past and present. However, after Canaletto, Giovanni Battista Tiepolo and his son, Gian Domenico, and Piranesi, no Italian printmakers emerged to earn international fame for well over a century. It was not until the 1860s that any printmaker working in Italy achieved more than local significance. That this was so was partly due to Italy's political history.

Italy is a young nation compared with many European countries. For most of its history, until its emergence as a unified kingdom in 1870, it was the playground of squabbling forces from outside the peninsula, primarily Germany, France, Spain and Austria. Those parts of the peninsula not subject to foreign rule were divided into the relatively small units of city states, while the territorially larger area of central Italy was governed by the Pope. Previous wars had been localized, but the war initiated in 1792 by the government of revolutionary France against the old monarchies of Europe set in motion events which ultimately led to the ousting of all foreign powers from Italy. In 1796 the Corsican Napoleon, himself of Tuscan ancestry, opened a series of Italian campaigns aimed principally at defeating the Austrian Habsburgs, then the rulers of Lombardy, the capital of which, Milan, was the second city in their empire. The French general, moreover, also successfully fought the Austrians' ally, the king of Piedmont, brought an end to the ancient republic of Venice and invaded the Grand Duchy of Tuscany, which was then ruled by a junior line of the Habsburgs. He invaded the Papal States, occupied Rome and deposed the Pope. By 1799 Napoleon had defeated the forces of the Spanish Bourbon kingdom of Naples. In 1805 he even took the title King of Rome for his son and the following year he made his brother Joseph King of Naples. Napoleon's defeat by the Russians, Austrians and Prussians at the Battle of Leipzig in 1813, followed two years later by the reinstatement of the Spanish Bourbons in Naples, destroyed the French hegemony in Italy.

Nevertheless, the presence of the French together with the evidence provided by Napoleon's repeated defeats of the Austrians encouraged Italian nationalism. It was the French example of revolution, as well as nationalism, which led to the Risorgimento (Revival) and to the creation in 1870 of an independent, unified kingdom of Italy. In a series of wars of independence the Austrians were deprived of their Italian territories and the Papacy's temporal power was restricted to the limits of the Vatican City.

This late achievement of national unity meant that for very many years regions and cities retained their own traditions in the cultural sphere. No one centre in the world of visual art is dominant even today. Thus the history of art differs considerably from city to city, as will be apparent from this introductory essay.

Naples and Rome up to 1870

The unstable political and economic conditions throughout Italy during this long period were not conducive to an active market for contemporary art, nor did they encourage the flourishing of patronage or print publishing. The history of Italian printmaking during the first half of the nineteenth century is very patchy. Luigi Rossini (1790–1857) continued the Piranesian tradition of etched views of ancient Rome in a competent fashion. The Neoclassical painters Andrea Appiani (1754–1817) and Francesco Hayez (1791–1882) in Milan, and Vincenzo Camuccini (1773–1844) and Bartolomeo Pinelli (1781–1835) in Rome, all made lithographs and often etchings too. Pinelli's etchings and illustrations, in a style strongly influenced by John Flaxman, did attract some admiration abroad, particularly in France and Belgium.

However, the first intimations of a native style in printmaking came from the Neapolitan Gigante brothers of the School of Posillipo. Achille Gigante (1828–46), the youngest and shortest lived of them, was the most outstanding, and etched some fresh and lyrical landscapes *en plein air* in the vicinity of Naples and Campania. Many of these prints were issued by the Neapolitan publisher Stamperia dell'Iride, in books aimed at the tourist market. Gigante's work may be partially indebted to the German Nazarene etchers who had worked south of Rome. Achille's brother, Giacinto (1806–76), and Achille Vianelli (1803–94) continued his style in etchings and lithographs,[1] in contrast to the Palizzi brothers, Giuseppe (1812–88) and Filippo (1818–99), whose etched work was in a more romantic vein, in which the influence of the Barbizon School is evident. Giuseppe was one of the first Italian nineteenth-century printmakers to settle in Paris, in 1844.

Mariano Fortuny

Paris was also significant in the printmaking career of the finest and most influential etcher to work in Rome in the second half of the nineteenth century. This was the Spaniard Mariano Fortuny y Marsal (1838–74),[2] who came to Rome after being given a pension to study there by Barcelona's Provincial Council. Rome was to remain his principal base until 1870. Fortuny made almost all his seventy-three etchings there, the first in 1861. His success as a printmaker was sealed when the Paris dealer Adolphe Goupil gave him a contract and agreed to publish all his etchings. Through his relatives by marriage, Fortuny had access to some of the finest

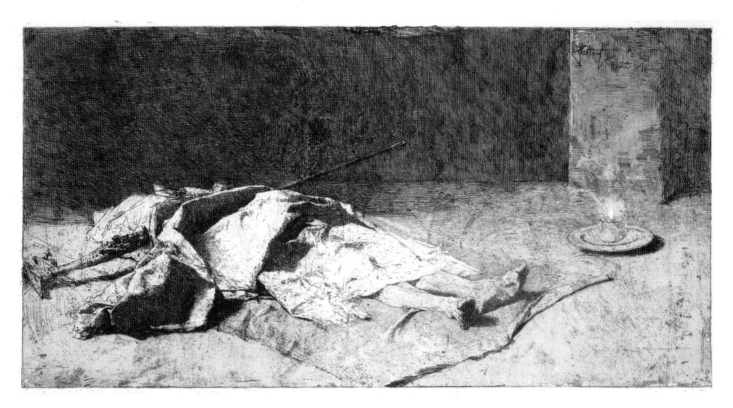

Fig. 1
Mariano Fortuny
Dead Kabylle 1867
Etching and aquatint 295 × 457 mm
1879-8-9-1012

Goya prints and drawings collections of the day and, thanks to his financial success as a painter, he was able to acquire etchings by Rembrandt, Ribera and Tiepolo. His own prints drew on Old Master traditions, but his Arab subjects (fig. 1) were derived from visits to Morocco. Fortuny was one of the leading orientalist painters of the day, but also produced paintings and etchings of costumed figures evocative of the eighteenth century. His work was fêted in a Paris that also acclaimed the paintings of Gérôme and Meissonier. Although they were published in France, Fortuny's etchings were very influential on two generations of Italian printmakers and not only on those working in Rome or southern Italy. Among them were Antonio Piccinni (1846–1920) and Francesco Michetti (1851–1929), but also Lombards, such as Mosè Bianchi (1840–1904) and Eleuterio Pagliano (1826–1903). Some artists deplored his impact, and one of the motives behind Giovanni Costa's formation in 1885 of the Arte Libertas society was to combat 'Fortunyism'.

Antonio Fontanesi

It was in North Italy that printmaking first became common among nineteenth-century artists.[3] The long-established power of Piedmont, the Kingdom of Savoy, with its capital in Turin, was the central political force in the long fight to oust the Austrians from northern Italy. The city was far more stable than other major centres, and this was an important factor encouraging artistic

development. The ruler of Piedmont, Vittorio Emanuele II of Savoy, became the first King of Italy in 1861. The key artist was Antonio Fontanesi (1818–82) from Reggio Emilia.[4] A volunteer in the Piedmontese army, who fought in 1847 alongside Garibaldi against the Austrians and was a supporter of the nationalist agitator and politician Mazzini, Fontanesi spent the years 1850 to 1865 in Geneva. There, in 1854, with the help of the dealer Victor Brachard, he found publishers for his lithographic landscapes and townscapes, which were issued in the albums *Musée Suisse*, *Villa Eynard* and *A stroll through Geneva*. Already aware of the work of Corot and Daubigny, he visited the 1855 Exposition Universelle in Paris. Fontanesi became a close friend of the Lyon landscape painter and etcher François-Auguste Ravier (1814–95), alongside whom he frequently worked at Crémieu in the Dauphiné from 1858. The Italian had begun to etch before 1857, and also made a considerable number of *clichés-verre*, a technique to which Ravier probably introduced him.[5] In these Fontanesi drew with a point on a glass plate coated with an opaque ground. He then used the plate like a photographic negative, producing positive photographic prints on sensitized paper. These eventually included a dozen atmospheric views of London, which he visited in 1866, before returning to Italy.

Despite his absence, his prints were well known in Italy. Fontanesi had presented an album of some of his earliest landscape etchings to his friend and pupil, the influential collector and amateur printmaker Ferdinando Arborio, Marchese di Breme and Duca di Sartirana (1807–69), in 1857. His work was also admired by the Macchiaioli at the first national exhibition of the United Italy in Florence in 1861. Contacts were deepened when he settled in that city as a guest of Cristiano Banti (1824–1904). Fontanesi was made professor of landscape painting at the Accademia Albertina in Turin in 1869. It was in Piedmont and Liguria that his etchings of country life, notable for their quivering light (fig. 2), had the deepest influence. It was Fontanesi who was almost single-handedly responsible for the taste among northern Italian landscape etchers for a style akin to Barbizon School printmaking.

Luigi Rocca and L'Arte in Italia
In 1845, the lawyer, journalist and writer Luigi Rocca, secretary of the Turin exhibiting Società Promotrice di Belle Arti, launched an annual series of albums of eight lithographs, which reproduced paintings chosen from those exhibited in the society's exhibitions. An etching was first introduced into these portfolios in 1860, and in the following year, for the first time, the society included an etching that was fully independent of a painted model. This was a landscape by Edoardo Perotti (1824–70), very much indebted to the French etchers Daubigny and his close associate Léon Villevieille (1826–63). Copies of the 1864 album,

devoted entirely to etching, were given to members of the society, who contributed money towards the cost of a new building to house its exhibitions.

The increase in interest in original intaglio printmaking was undoubtedly spurred by the launch, on the premises of the print publisher Alfred Cadart in Paris, of the Société des Aquafortistes.[6] Founded in 1862, the society issued its first monthly album in September that year. In Turin, artists collaborated with the printer Carlo Lovera, whose workshop printed most of the etchings produced by Piedmontese and Ligurian artists for over thirty years. As yet, however, Lovera's contribution to the North Italian etching revival has received scant scholarly attention. Aside from the etchings he printed for inclusion in journals, he also pulled plates that were published for the Esposizione Permanente in Milan. Nor has the publishing of Luigi Pomba been investigated. The activities of the Parisian society were regularly mentioned in the pages of the monthly periodical *L'Arte in Italia*, founded and edited by Luigi Rocca and the painter and etcher Carlo Felice Biscarra (1823–94), which was published and financially supported by Pomba between 1869 and 1874. From the start, this journal's interest was not parochially Piedmontese. The first three etchings to be published in its pages were by two artists from the south, Nicola Lobrandi and Filippo Palizzi, and by the outstanding Genoese landscape etcher Ernesto Rayper (1840–73). The prints that appeared within its pages were both original and reproductive. The dominant style was French-inspired. The etchings of Corot, Daubigny and Appian were the principal models, alongside those of Fontanesi. In 1870, the journal invited the Tuscan Telemaco Signorini to contribute, and he sent what may have been his very first etching, *An alley in Siena*, together with *An alley in the Mercato Vecchio, Florence*. By no means all the prints published in *L'Arte in Italia* were landscapes. The Lombards Bianchi and Pagliano provided several genre subjects. Federico Pastoris (1837–84) of Asti contributed both landscape and genre pieces. Alberto Pasini (1826–99), best known as an orientalist lithographer, sent etchings from Paris, where he had long been based.[7]

L'Acquaforte
The first Italian etching society, L'Acquaforte, Società d'Artisti Italiani, was founded in Turin in March 1869. It began publishing an annual portfolio of etchings in 1870, but the contents of its albums were much more cautious than *L'Arte in Italia*. L'Acquaforte also admitted quite a number of etchings by amateurs, and a much higher proportion of the prints were dedicated to genre, historical and religious subjects. Piedmontese and Lombard etchings also graced the pages of Cadart's *L'Illustration nouvelle* in Paris between 1868 and 1874. In Genoa, the local Società Pro-

Fig. 2
Antonio Fontanesi
Work 1873
Etching 184 × 258 mm
2003-6-30-48

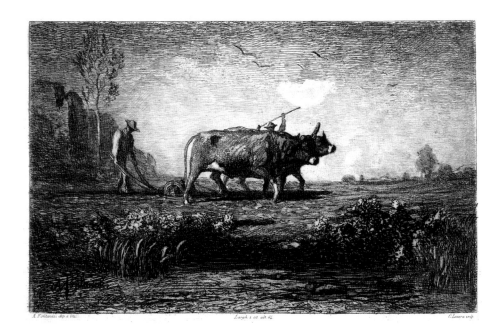

motrice delle Belle Arti followed Turin in publishing albums of etchings in 1870. The Turin society had turned to issuing portfolios of photographs after the exhibited paintings in place of etchings in 1865. This was probably the result of the loss of the assistance of the Marchese Arborio, who that year moved to Florence, the new short-term capital of Italy, to fulfil his duties at the court as Prefect of the Palace and Grand Master of Ceremonies.

The aristocracy played a major part in fostering etching in northern Italy. Arborio, who had lived in Paris between 1837 and 1848, was President both of the Turin Promotrice and of the city's Accademia Albertina. It is likely that he and other noblemen contributed financially towards the publication of etchings, as was certainly the case in contemporary Belgium.[8] Arborio retained his directorship of the Accademia Albertina, and in October 1868, not long before his death, he set up a free course in etching there, which was taught by Agostino Lauro (1806–78). Other significant figures among the promoters of L'Acquaforte were Baron Francesco Gamba (1818–87) and his brother, Enrico (1831–83). Several other supporters of this society belonged to the Piedmontese nobility. The Milanese Count Gilberto Borromeo (1815–85), who travelled to Geneva to consult Fontanesi and became a competent etcher, was an important figure in artistic circles in Genoa. There he was President of the Promotrice and of the Accademia Ligustica di Belle Arti before he became Director of the Accademia di Belle Arti in Milan in 1859. It was Borromeo who taught etching to the leading Milanese painter, Federico Faruffini (1831–69),[9] and recommended him to Maxime Lalanne, the French etcher and author of an influential treatise on printmaking.[10]

Lombardy and the Scapigliati

Lombardy had not been a significant centre for printmaking since the days of Cardinal Carlo Borromeo in the early seventeenth century. Faruffini began making etchings in a late romantic style in the mid-1860s, generally repeating the compositions, but not the finish, of his earlier paintings. The freedom and rapidity of line in his prints, which could even be considered as coarse, seems to show awareness of the work of Delacroix (fig. 3). Faruffini had visited Paris in 1865 and, with the aristocratic Arborio and Borromeo, was made a member of the Société des Aquafortistes. Faruffini committed suicide before he had time to make more than a handful of etchings. Tranquillo Cremona (1837–78), who had studied alongside Faruffini in Pavia, worked as a political cartoonist in the 1860s, producing caricatures akin to Daumier's, and received a commission to execute a lithographic portrait of King Umberto I. Cremona was a member of the Milan-centred literary and artistic movement Gli Scapigliati (The dishevelled), named after the 1862 novel *Scapigliatura* (*Dissolute life*), written by Carlo Righetti under the pseudonym Cletto Arrighi.[11] The young people in the novel were wild, restless and independent. The bohemian behaviour of the artists challenged the normalities of conventional bourgeois life. In the romantic painting associated with the term Scapigliatura, artists such as Cremona and Daniele Ranzoni (1843–89) produced vaporous works in which figures merged into the background in contrast to the prevalent Neo-classically derived academic tradition. They looked to the examples of Leonardo and of Venetian sixteenth-century painting for their chiaroscuro and colouristic effects. Much of their work was in the fields of portraiture and landscape.

Fig. 3
Federico Faruffini
*Cesare Borgia and Niccolò
dei Machiavelli* 1866
Etching 392 × 550 mm
1872-1-13-448

Acqueforti monotipate

Several of the leading figures involved with Scapigliatura made
etchings. The too little studied sculptor Giuseppe Grandi (1843–
94) made a dozen or so etchings in 1873–4, and seems to have
been the first Italian to print them with large amounts of ink left
on the plate, so that the resulting works resemble monotypes.[12]
The Italians term them *acqueforti monotipate*. The French call
this type of printmaking *l'eau-forte mobile*. The relationship
between these prints and near-contemporary experiments by
Degas's close friend Vicomte Ludovic Lepic (1839–90) in Paris is
as yet obscure.[13] The Frenchman made his first monotype in 1866
and, contemporaneously, began experimenting with *eaux-fortes
mobiles*. Lepic visited Naples in 1867–8 and in 1871. He certainly
made etchings of Lake Nemi on one of these visits, and he varied
the inking on individual impressions. However, we do not know if
he had any contact with artists in Milan on his way through Italy,

and he does not appear to have exhibited any monotypes or *eaux-fortes mobiles* until 1876. Nevertheless, there is some similarity between his 1866 *Head of a dog* and the very soft-edged prints of Grandi. In his sculpture, Grandi aimed at colouristic effects and the dissolution of forms in light. His pictorial approach anticipated the works of the much younger Medardo Rosso (1858–1928). Grandi's pupil, the sculptor Prince Paolo Troubetzkoy (1866–1938), also made a very small number of etchings.

By far the most important Scapigliatura printmaker was Luigi Conconi, whose striking etchings presage the age of Symbolism (nos. 24–9). Although he intended to publish an album of his prints, it never appeared, possibly because he realized that there was no serious market for them. Conconi also may have been deterred by the labour required in inking, wiping and printing his plates. Like Grandi, he practised *acqueforti monotipate*. Soon after Conconi took up etching in 1877, he taught the technique to his close friend the architect and architectural historian Luca Beltrami (1851–1933). Beltrami was resident in Paris from 1875 to 1877, and his largely architectural prints have some similarities with the work of some of the French etchers who specialized in this field.

Divisionism
In the last twenty years of the nineteenth century several North Italian painters, brought up on the *sfumato* tradition of the Scapigliati, developed Divisionism, a style akin to Pointillism.[14] The key figure was the Milanese art dealer Vittore Grubicij de Dragon, who was from 1881 to 1886 in Holland and Belgium, where he took up painting.[15] On his return to Italy, striving after increased luminosity, he started to juxtapose shades of different colours. There is no evidence that he saw any of the paintings of Seurat and his circle, but he had read Félix Fénéon's article on the differences between Impressionism and the work of Seurat in the Belgian journal *L'Art Moderne*, 19 September 1886, with great interest, and asked Octave Maus, that periodical's editor, for advice as to where to find a copy of Ogden Rood's theoretical work of 1879, *Modern chromatics*. It is possible, too, that Grubicij had met both the painter Théo van Rysselberghe and the poet Emile Verhaeren, Belgians who saw Seurat's *La Grande Jatte* in his studio in 1886. So, Grubicij may also have heard a verbal account of Seurat's procedure of building up compositions by applying little touches or dots of colour. As dealers, Grubicij and his brother, Alberto, initially specialized in the paintings of the Scapigliati, but in the early 1880s they took up younger Lombard artists, including Giovanni Segantini (1858–99),[16] whose work Vittore promoted strongly in the Netherlands. Vittore Grubicij encouraged him to take up the Divisionist technique. Several other painters, including Angelo Morbelli (1858–1919), Giuseppe

Pellizza da Volpedo (1868–1907) and Gaetano Previati (1852–1920), also adopted the style. The Grubicij brothers exhibited the tonal paintings of both the Scapigliati and the Divisionists in a large show of Italian art held in London in Earls Court in 1888. Segantini made a few etchings, one of which he exhibited at the Paris Salon in 1885 through the Paris firm Arnold and Tripp, with whom the Grubicij firm had dealings. Segantini's sons, Gottardo and Mario, continued their father's style and both made etchings after his paintings.[17] Of the other Lombard Divisionists, only Grubicij engaged in printmaking, making *acqueforti monotipate* that relate to the Scapigliati tradition (nos. 22–3). His subjects derived from the drawings he made in Belgium and Holland, and their mood is comparable to the prints of several Hague School artists. The Grubicij firm does not seem to have dealt much in the prints of the Lombard artists, whom they represented.

Turn-of-the-century monotypes
Two other late nineteenth-century North Italian painters, Pompeo Mariani (1857–1927) of Monza, a nephew and pupil of Mosè Bianchi, and Giorgio Belloni (1861–1944) from Codogno, devoted themselves to pure monotype.[18] Neither has received much scholarly study, but Mariani seems to have been the most prolific printmaker in northern Italy of his day. He took up etching in 1879, and exhibited prints in Berlin, Munich and Ghent, as well as in Milan and at the Venice Biennali. Mariani's monotypes in a French-influenced Belle Epoque style were made between 1897 and 1907. He exhibited thirty-seven of them at the 1905 Venice Biennale. Their subjects encompassed landscapes, marines, genre and animal pieces. Mariani also made a few woodcuts, which he exhibited in 1893. No dates are known for the monotypes of the landscape painter Belloni, but they may be from the first decade of the twentieth century. He began to etch in 1907, and he was one of the artists to be influenced by the etchings that Whistler showed at the Venice Biennali (fig. 4).

Tuscany in the second half of the nineteenth century –
the Macchiaioli
Research on Tuscan printmaking of the second half of the nineteenth century has concentrated almost entirely on the work of two major figures, Telemaco Signorini and Giovanni Fattori. There appears to have been no encouragement from patrons and exhibiting societies for original, as opposed to reproductive printmaking, comparable to that found in contemporary Lombardy. Signorini and Fattori were leading figures in the group known as I Macchiaioli, a group of young artists who painted oil sketches in the open air from the late 1850s, and exchanged ideas with their fellows and with political activists in the Caffè Michelangiolo in Florence.[19] The name of the group came from the word *macchia*,

'spot', which was used to describe the patches of paint that they used to create structure in their pictures.

Signorini met Degas when the French artist visited Florence in 1855 and 1859, and was a fellow combatant in the war of liberation with the critic and writer Diego Martelli (1839–96),[20] who became both a close friend and a patron. Martelli and the painter and sculptor Adriano Cecioni (1836–86), who served in the same artillery unit as Signorini, were the principal champions and interpreters of the Macchiaioli, and their theories were connected to contemporary scientific research into the nature of colour. From 1861, Martelli regularly invited his friends to paint on his estate at Castiglioncello, on the coast near Livorno. He founded the short-lived weekly *Il Gazzettino delle Arti del Disegno* in 1867, and six years later was the co-founder of *Il Giornale Artis-*

Fig. 4
Giorgio Belloni
Seascape c.1907–10
Drypoint 298 × 385 mm
2003-6-30-82

tico, which was also published only for a brief period. Martelli was an important link with France, a close friend and patron of Degas, and moved in Impressionist circles on his four visits to Paris. He wrote biographical articles on Signorini, Cecioni, Giuseppe Abbati (1836–68), Giovanni Costa (1826–1903) and Silvestro Lega (1826–95). Cecioni's writings in the press, which were more technical, were gathered in *Scritti e ricordi*, Florence, 1905. Signorini also wrote art criticism supporting his colleagues in the newspapers, including in Martelli's *Il Gazzettino delle Arti del Disegno*. Martelli commissioned some of Signorini's earliest etchings to illustrate his *Primi passi*, which was published in Florence, Turin and Rome by Fratelli Bocca in 1871. Another significant patron of the Macchiaioli was the distinguished geologist and political thinker Gustavo Uzzielli, for whose two editions of *Ricerche intorno a Leonardo da Vinci* (1872 and 1896) Signorini provided etchings. These instances of patronage, however, were isolated. It is not known who was the publisher of Signorini's 1886 set of etchings of Florence's Mercato Vecchio (no. 15). This may well have been a venture of the artist himself aimed at his dealers in Paris and London.

Giovanni Fattori

The greatest of Italy's nineteenth-century printmakers, Giovanni Fattori (nos. 1–14), another of Martelli's friends, was probably encouraged to take up etching by a commission in 1883 from the Florentine exhibiting Società Promotrice delle Belle Arti to make a reproductive print after his major painting *The cavalry charge at the Battle of Montebello*. This practice of societies commissioning artists to produce copies of paintings to distribute to their members was followed in other Italian cities, such as Naples, where in the early 1870s the Promotrice di Belle Arti employed the young Antonio Piccinni to make prints from pictures that had won prizes in their exhibitions. Fattori followed his 1883 commission with an attempt to diffuse knowledge of his work through a portfolio of pen lithographs, published the following year. This technique was a throwback to the early years of lithography. However, although twenty-one of Fattori's etchings were purchased by Rome's Galleria Nazionale d'Arte Moderna at the 1888 Esposizione Nationale exhibition in Bologna, he received no other significant public or private patronage for his prints. None of his numerous plates was ever published. It seems likely that during his lifetime they were little known outside his circle of friends and pupils. Both Signorini and Fattori visited Paris, and Signorini also travelled to London and Scotland. Nevertheless, their work as printmakers has little, if any, relationship with that of their contemporaries in France and Britain.

Little interest was shown in printmaking by the second generation of the Macchiaioli or their followers. Fattori's pupil Plinio

Nomellini (1866–1943) made a few etchings in the 1890s and in the first years of the new century.[21] While some of these combine his master's style with wild Symbolist skies resembling those in the lithographs of Charles-Marie Dulac, others made during his imprisonment for anarchist activities are more akin in spirit to the works of Raffaëlli and Steinlen. Nomellini also designed a number of striking posters in the international Symbolist style prevalent in the first two decades of the twentieth century. The well-to-do painter Ulvi Liegi (1858–1939), who commissioned one of Fattori's finest pictures and collected other examples of his work, etched a fine portrait of the elderly artist in his studio c.1902 (fig. 5).[22] He was also a friend of Luigi Conconi, to whom he dedicated the impression of this print which is now in the British Museum.

Italian printmakers and Paris in the 1860s and 1870s – Alfred Cadart and Adolphe Goupil

For most of the nineteenth century, Paris had considerable attraction for artists of all nations. The city offered far greater possibilities for exhibition and sales than any other. Nowhere else was there such a fully developed art market. Two dealers in particular attracted printmakers, Alfred Cadart and Adolphe Goupil, while the critic Philippe Burty enthusiastically promoted etching in the pages of the *Gazette des Beaux Arts*. In 1862 Cadart and his partner, Félix Chevalier, founded the Société des Aquafortistes, which that year began to publish a series of portfolios of etchings.[23] The enterprise was international in outlook. Cadart had correspondents in each of the Italian cities that had the most active art markets of the day. These were in Turin, where Fratelli Bocca was located, Milan (Fratelli Dumolard), Florence (Giovanni Pietro Vieusseux) and Naples (Dufrêne). The first three of these were among the most distinguished publishers of the day in Italy. Direct contacts with Italian artists began with the nobleman Gilberto Borromeo, who in April 1864 asked Maxime Lalanne, a founder member of the society, for advice over biting a plate which was intended for Cadart. This was eventually published in the society's third album in 1865, the year in which Borromeo first exhibited an etching at the Salon. Borromeo was in regular correspondence with the influential Comte de Nieuwerkerke, the French government's Surintendant des Beaux Arts, and was well acquainted with the ruling Bonaparte family. He acted as host to Princess Mathilde Bonaparte at his villa on the Isole Borromee in 1864. Borromeo also contributed etchings to another album in 1867 and, in 1869 and 1873, to *L'Illustration Nouvelle*, the monthly journal which Cadart and his then partner, Luce, launched in 1868. Borromeo and Arborio were both listed as members of the Société des Aquafortistes in 1865, as was Federico Faruffini, who had settled in Paris that November. Cadart's interest in Faruffini's work led him and his new partner,

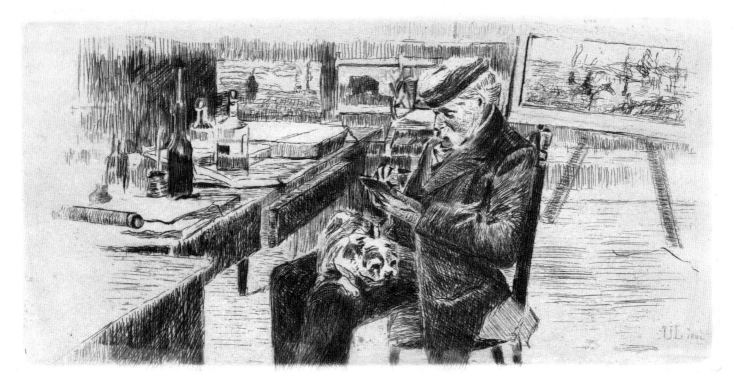

Jules Luquet, to give the Italian a one-man show of oils, water-colours and etchings in April 1866. An etching by Arborio was published in *L'Illustration Nouvelle* in 1869. Other Italians to have etchings included in Cadart's albums were Mosè Bianchi, the Piedmontese Edoardo Perotti, and Bartolomeo Ardy (1821–87), as well as the Neapolitan Saro Cucinotta (1831–71). The latter settled in Paris in 1866, and established a reputation as a reproductive printmaker for the journals *L'Art*, *Gazette des Beaux Arts* and *L'Artiste*.

Giuseppe De Nittis, Antonio Mancini and Giovanni Boldini

The finest Italian printmaker to settle in Paris at this period was Giuseppe De Nittis (nos. 16–19), who arrived in June 1868 and married a French wife. Cadart included one of his etchings in *L'Eau-forte en 1874* (no. 17), the first of a series of albums that appeared annually, which was accompanied by an introduction by the critic and collector Burty. This publication was continued until 1881, after Cadart's death in 1875, by his widow, Célonie-Sophie, and his son, Léon. De Nittis was close to Degas, Lepic and the painter-etcher Marcellin Desboutin,[24] and he experimented with monotype alongside his French friends.

Another artist from the south of Italy who came to Paris and made monotypes was the Neapolitan Antonio Mancini (1852–1930).[25] He paid two visits to the French capital in 1875 and 1877–8, and was given a contract by Goupil. Mancini knew Manet and Degas and was friendly with De Nittis, Boldini and his fellow Neapolitan the engineer turned dealer Michel Manzi, who worked for Goupil. Manzi probably played an important intermediary role between Italian artists and the French art trade. Mancini's twenty-five monotypes, largely of female nudes in ovals and circles in imitation of classical gems, probably date from his second visit. It is likely that he learnt the technique in the circle of De Nittis and Degas. Another of De Nittis's friends in Paris was the Ferrarese Giovanni Boldini, who settled there in 1870. Like Mancini, he had a contract with Goupil. He, too, was friendly with artists close to Degas. Boldini began to etch in the late 1870s (nos. 20–1), possibly after receiving instruction from Desboutin or De Nittis.

Gilli and Piccinni

A further Italian etcher who settled in Paris was Alberto Maso Gilli (1840–94). He lived in France from 1873 to 1881, winning a gold medal at the 1878 Exposition Universelle. Gilli was another artist to be published by the Cadart firm. As well as executing portrait prints and romantic subjects, he worked as a reproductive printmaker for *L'Art*, and for the dealer Adolphe Goupil. After his return to Italy, he became Director in 1884 of the Regia Calcografia in Rome. It was presumably this role that led to his election in 1887 as the only early Italian associate member of the English Society of Painter-Etchers and Engravers, founded by Seymour Haden in 1880.[26] Gilli established a workshop for photomechanical printmaking in Rome, in which Antonio Piccinni[27] played a major role. Piccinni came from Trani in southern Italy

Fig. 5
Ulvi Liegi
Giovanni Fattori in his studio c.1902–3
Etching 122 × 249 mm
2003-6-30-81

Fig. 6
Antonio Piccinni
Face of a criminal 1878
Etching and engraving over photo-etching 145 × 104 mm
1879-8-9-700

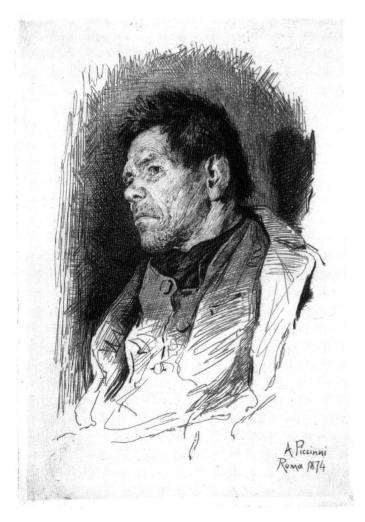

and worked in Rome, where Adolphe Goupil visited his studio, presumably on visits to Fortuny. Goupil's publication of Piccinni's etched copy of a painting by Domenico Morelli (1828–1901) was swiftly followed by the issue in 1878 by Cadart's widow of *Souvenirs de Rome*, a portfolio of genre etchings by Piccinni (fig. 6). The firm published further prints by him in *L'Illustration Nouvelle* and in *L'Eau-forte en 1880*. As early as 1874, Piccinni was using a photo-etched base for one of his etchings and engravings, and from the 1880s he was much involved with experiments with heliogravure. In his style, Piccinni may have been influenced by the Norwegian etcher Wilhelm Otto Peters (1851–1935), who was working in Rome between 1873 and 1876.

Goupil also encouraged Francesco Michetti to etch. Michetti, who was in Paris in 1871, achieved some success through Goupil and the French-based German dealer Reitlinger with his small paintings of animals and landscapes. Michetti was another to work with the Cadart firm, as did Conconi's friend Beltrami, Giuseppe Palizzi, Eleuterio Pagliano, Oreste Cortazzo (1831–1916) and the Paris-based Alberto Pasini. Quite a number of these Italian artists exhibited prints in Paris at the 1878 Exposition Universelle, as did the Piedmontese Celestino Turletti (1845–1904) and Conconi.

The Venice Biennali 1895–1914

From the middle of the nineteenth century huge international cultural exhibitions were staged regularly, principally in Paris, but also in several other European countries and in the United States. No such show was organized in Italy until the council of the city of Venice decided upon a Biennale, principally for Italian artists, but which also included a section for invited foreign artists.[28] Many leading Italian artists were invited, while others submitted works to a jury for selection. The first International Art Exhibition of the City of Venice opened in 1895 in the Palazzo dell'Esposizione, a specially designed Neo-classical building in the Giardini di Castello. Prints were included from the outset. So, for the first time Italian artists and art lovers had an opportunity to see the work of some of the best foreign printmakers in a venue in Italy. Well over 200,000 visitors came to the first exhibition. This included a special display of contemporary Dutch etching, including prints by Bauer, Josef Israels, the Maris brothers, Mauve, Mesdag, Storm van 's Gravesande, Veth, Witsen and Zilcken. The Dutch were also very much to the fore in the second Biennale in 1897. This time, two of the newcomers, Gerrit Willem Dysselhof and Willem de Zwart, were represented by forty-seven and thirty-five etchings respectively. There were also groups of lithographs by Lion Cachet and Theo van Hoytema on show. The presence of Dysselhof and Cachet prompted an Italian interest in Dutch Art Nouveau book decoration. Among the German artists

shown were Wilhelm Leibl, Max Liebermann and Otto Greiner, while Redon exhibited lithographs and D.Y. Cameron etchings. Whistler's contribution of seven etchings, mainly of Venetian subjects, was not noted in the first edition of the exhibition catalogue owing to their late arrival. Conconi was the most notable Italian printmaker on view. He exhibited twelve etchings, as did the forgotten Giuseppe Miti-Zanetti (1859–1929), whose oeuvre was almost exclusively devoted to Venice. It was at this Biennale that Italians first had a chance to see a substantial group of Japanese woodcuts, surprisingly late for a European nation. At the 1899 exhibition, Max Klinger showed his series of engravings *Dramas*, while Richard Müller and the Worpswede artist Heinrich Vogeler contributed etchings. Also on view were colour drypoints by J.F. Raffaëlli.

In the fourth Biennale in 1901, several Belgian artists were represented, most notably James Ensor with a group of etchings, some of which were touched in watercolour, Henry Meunier and Armand Rassenfosse. Anders Zorn and the Armenian Edgar Chahine both exhibited drypoints. Chahine was to become a regular favourite of the Biennale. He showed no fewer than fifty-seven prints in 1907. In 1901 Signorini exhibited four of his etchings, including three of the Vecchio Mercato in Florence (no. 15). Grubicij sent three proofs to the 1903 exhibition, in which three of Fattori's etchings were also on show. However, it was exceptional in the early years for the Italian prints that were exhibited to be as artistically significant as the works by foreign artists. The chief foreign printmakers included in 1903 were the Belgians Fernand Khnopff and Albert Baertsoen, as well as Chahine and Storm van 's Gravesande, who exhibited monotypes as well as etchings and drypoints.

At the 1905 exhibition, there was a strong representation of Dutch etchings, including twelve drypoints by Jan Toorop, which were evidently much admired by some of the younger Italian artists. The Scandinavians Anders Zorn and Fritz Thaulow also exhibited etchings, while for the first time there were lithographs by Henri Fantin-Latour, woodcuts by Félix Vallotton and colour woodcuts by Henri Rivière. The principal Italian exhibits were a large group of monotypes by Pompeo Mariani, three frames of colour zincographs by Adolfo De Carolis and two etchings by Fattori. Mariani and his fellow monotype specialist Belloni featured strongly at the seventh Biennale in 1907, where Conconi also exhibited. Félicien Rops and Rassenfosse starred among the Belgians. Others well represented were Charles Cottet, Joseph Pennell and Frank Brangwyn.[29] Brangwyn's vigorous etchings and drypoints were much admired, and he was undoubtedly the British etcher who had the most influence on Italian artists before the First World War. His high reputation led to him being given a complete room at the 1910 Rome Esposizione Internazionale di Belle Arti, in which he exhibited 100 works, including sixty etchings and seven lithographs. Ettore Cozzani's *L'Eroica* devoted a complete issue to Brangwyn in 1919, in which a number of his woodcuts and colour woodcuts were published.

A much greater range of prints was included in the 1910 Rome international exhibition, when for the first time a large number of French printmakers was shown. These were largely conservative, although they did include the young Jacques Villon. Auguste Lepère, Louis Legrand and Eugène Bejot exhibited alongside Raffaëlli and Cottet. Of the Belgians, Ensor and Baertsoen were well represented. Visitors had the chance to see prints by Corinth, Kollwitz, Kubin, Menzel, Munch, Nolde, Orlik and Pechstein for the first time, and there was a group of prints by the Finn Akseli Gallen-Kallela. Pride of place went to Pennell, who was allotted a separate room to show mezzotints and aquatints, as well as etchings and lithographs. The Italian printmakers included Giuseppe Graziosi (1879–1942), a painter and sculptor, who worked in the tradition of Millet and Segantini, and Giulio Aristide Sartorio (1860–1932). Britain's lithographic society, the Senefelder Club, was invited to exhibit in 1912, and contributed 104 works. The Senefelder Club was also allotted a section in the 1914 Secessione Romana exhibition. Their best-known artists were Brangwyn, Pennell, John Copley, Alphonse Legros and Charles Haslewood Shannon. Muirhead Bone showed his drypoints for the first time at the Biennale in 1912.

In the final exhibition before the First World War held in 1914 a room was devoted to the contemporary Italian woodcut, a display that was selected by Ettore Cozzani. For the first time, there were Polish exhibitors, among them Feliks Jasieński (spelt wrongly in the catalogue), Jan Rubczak and Léon Wyczólkowski. Once again the Belgians were well represented with prints by Jules de Bruycker, Rik Wouters and Ensor. Brangwyn, Chahine and Pennell headed the list of other foreign printmakers, while Graziosi stood out among the Italian intaglio printmakers with his aquatints. Pennell and Graziosi also featured strongly in the black and white section of the 1910 Rome International Exhibition. The most notable Italian newcomer there was Lorenzo Viani, whose work must have looked very isolated as an example of Expressionist printmaking.

This summary of foreign prints exhibited in the first twenty years of the Biennale reveals the complete absence of French Impressionist and Post-Impressionist printmakers from the exhibitions, as well as a paucity of printmakers associated with the various Austrian and German Secessions. The lack of representative works from Austria probably reflects political differences between the governments of Italy and Austro-Hungary. Of course, the many Italian artists who visited Paris had the opportunity to see advanced French printmaking. Impressionist paintings were first presented in Italy in an exhibition organized by

Ardengo Soffici, which was held in the Lyceum in Florence in 1910. This show included lithographs by Toulouse-Lautrec and Forain. From the early 1890s, a stream of North Italian artists, particularly from the Veneto and Friuli, made their way across the Alps to Vienna, and sometimes beyond it to Munich. Germanic Symbolist prints were not unknown to many Italian artists. Max Klinger had lived in Rome from 1888 to 1893, and Otto Greiner (1869–1916) moved into his studio there in 1898, remaining in the city until 1915. It was in Rome in 1889, that Klinger, at his own expense, published the first edition of his notable series of etchings *Vom Tod. Erste Teil. Opus XI*, on which he had begun work in 1882. Also important for the transmission of German ideas was the painter Arnold Böcklin, although he did not make prints. In 1894 Böcklin settled in the Villa Bellagio near Fiesole, where he lived until his death in 1901.

The Turin exhibitions of 1898 and 1902

The story in the field of poster art was very different, since the annual Turin exhibition of 1898 had examples of most of the finest French, Belgian, Dutch and German designers.[30] These posters were undoubtedly enormously influential on the subsequent development of Italian poster design over the next thirty years. Posters fall outside the scope of this exhibition and catalogue, but one cannot ignore the presence in Turin of work by such artists as Toulouse-Lautrec, Steinlen, Grasset, Bonnard, Evenepoel, Mucha, Schwabe, Toorop, Thorn Prikker, William Nicholson, Charles Rennie Mackintosh, Heine, Hohenstein and Edward Penfield. Almost equally significant for the future of Italian art was the display of the art of the book at the famous International Exhibition of Decorative Art of 1902, also held in Turin, in which the contributions of British, Belgian and Dutch artists were particularly strong.[31] This offered Italian artists the chance to see the products of William Morris's Kelmscott Press, as well as the work of Walter Crane, Lucien Pissarro and Théo van Rysselberghe. More posters were shown in this exhibition, as well as a smattering of other prints, including etched bookplates by Khnopff, colour lithographs by Rivière and linocuts and lithographs by Theo van Hoytema.

Secessione Romana

In 1912, a decade after the Turin International Exhibition, the Secessione Romana was founded.[32] It introduced the capital to the work of many leading international artists, including Cézanne, Klimt and Schiele, in a series of four exhibitions held in the Palazzo delle Esposizioni between 1913 and 1917. The Secessione's third show included woodcuts by Gauguin and Pechstein, etchings by Kollwitz and Liebermann and drypoints by Munch. Once again a group of Italian woodcuts was selected by Ettore Coz-

zani, editor of *L'Eroica*, including works by Lorenzo Viani, Emilio Mantelli (1884–1918) and Felice Casorati. Cozzani's significance as a promoter of contemporary woodcuts is discussed below.

Vittorio Pica

Very important for the appreciation of contemporary foreign art was the Neapolitan critic Vittorio Pica (1864–1930), an early champion of Symbolism.[33] Initially a writer on contemporary literature, he translated and introduced the Portuguese poet Eugenio de Castro's *Belkiss*, and was very interested in the writings of Rimbaud and Mallarmé, whose 'Mardis' he attended. From 1881 he carried on a fifteen-year correspondence with Edmond de Goncourt. Under his influence, in 1894 Pica published a book on Japanese art. He began writing on art in the Florentine journal *Marzocco* in 1897, and edited *Emporium*, in which he regularly published lengthy articles on contemporary art, which he gathered together into a four-volume book, *Attraverso gli albi e le cartelle. Sensazioni d'arte*, of 1902–21. Pica wrote the first major book in Italian on Impressionism, *Gl'impressionisti francesi*, published in Bergamo in 1908, and a monograph on Giuseppe De Nittis. He championed the work of Alberto Martini (nos. 32–5) above all Italian illustrators,[34] and also wrote on the printmakers Benvenuto Disertori (1887–1969) and Giuseppe Ugonia (1881–1944). However, it was as an advocate of foreign painting, printmaking and illustration that Pica made his greatest contribution in the journals. He particularly favoured the tradition stemming from Goya, Daumier and Gavarni. So Pica wrote with sympathy on artists such as Meryon, Redon, Rops, Steinlen, Forain, Brangwyn and Henry de Groux, as well as contributing essays on British book illustration and contemporary posters.

His wide knowledge and pre-eminence as a critic led to his appointment in 1910 as General Secretary of the Venice Biennale, which he held until 1926, when he was ousted through Fascist intrigue. Pica's period at the head of the Biennale saw a more open-minded acceptance of innovative Italian artists. Under his direction, paintings by Impressionists and Post-Impressionists were shown in 1922. Also included was a substantial group of contemporary German prints, ranging from Liebermann, Corinth and Slevogt to Barlach, Beckmann, Kollwitz, Kokoschka, Marc and the leading members of Die Brücke. Two years later, the Biennale hosted the first retrospective of Modigliani, and some African sculpture was also exhibited. At Pica's last Biennale, another selection of German printmakers was shown, including Feininger, Kolbe and Rohlfs, while Matisse exhibited twelve lithographs and Bernard a group of woodcuts. Flemish Expressionist printmaking was represented by Schelfhout's drypoints and Brusselmans's lithographs, and over thirty prints by Pica's old favourite, Rops, were on show.

The revival of the woodcut in Italy

Of course, there were many more paintings than prints exhibited in the Biennali. Many Italian artists were introduced to new foreign styles through them. In the early years of the Venice exhibitions Symbolism was the most significant of them, but the Italians were also struck by British art, in particular by the Pre-Raphaelites and their followers. Burne-Jones's work was visible in Rome, for in 1881 he had received the commission to design the mosaics for the American Episcopal church of St Paul. British art was championed by the Roman landscape painter Giovanni Costa. While painting in the Campagna in 1859, he met the young Frederick Leighton and George Heming Mason, and they became lifelong friends. Leighton introduced Costa to the Pre-Raphaelites in London, and the Italian acquired several English patrons, most notably the amateur painter George Howard, ninth Earl of Carlisle. From 1877 Costa exhibited regularly at the Grosvenor Gallery, and he became the central figure in a group of English artists, known as the Etruscan School, who painted Italian landscapes in the open air. In 1885 he founded the association In Arte Libertas, the title boldly proclaiming his background as an Italian patriot who had fought for the Piedmontese army in the war of national liberation.[35] Works by several English artists, including Burne-Jones, Dante Gabriel Rossetti and Leighton, were exhibited with this association in Rome in 1890.

Although he was not a printmaker, Costa's influence was very significant in introducing many younger Italians to British book illustration and wood engraving, in particular Adolfo De Carolis (no. 31), who became the leading figure in the Italian woodcut revival. Also important in diffusing knowledge of contemporary English art in Italy was the painter, etcher and lithographer Giulio Aristide Sartorio, who in 1893 had visited England, where he met John Everett Millais, William Holman Hunt, Burne-Jones and Arthur Hughes. Both Sartorio and De Carolis were also well aware of Austrian and German Symbolist painting and printmaking, and admired Italian and German Renaissance woodcuts.

A kick-start for modern Italian illustration was provided in 1900 by the Concorso Alinari, a competition launched by Cavalier Vittorio Alinari for the illustration of Dante's *Divine Comedy*.[36] Of the thirty-one competitors who took part, the etcher Alberto Zardo (1869–1948) was awarded first prize. Other prizes went to Armando Spadini (1883–1925), Duilio Cambellotti (1876–1960) and Ernesto Bellendi (born 1842). Other participants were De Carolis, the youthful Giovanni Costetti (no. 36) and Alberto Martini, who was to become a dozen or so years later the outstanding Italian lithographer (nos. 32–5). In 1902 the Società degli Amatori e Cultori di Roma organized an international exhibition of work in black and white.

Ettore Cozzani and Illustrated journals

The first decade of the twentieth century saw the emergence in Italy of a series of periodicals which were illustrated by original woodcuts. Among these were Luigi Romanello Sanguinetti's Chiavari-based *Ebe*, Edoardo De Fonseca's *Novissima* in Milan, the Florentine *Il Regno*, the Sicilian Giuseppe Antonio Borghese's *Hermès*, and *Leonardo*, founded in Florence by Giovanni Papini (1881–1956) and Giuseppe Prezzolini (1882–1982). *Ebe* published two large albums of woodcuts by De Carolis and Roberto Melli (1885–1958). German and Austrian art journals provided models. *Novissima* was inspired by *Pan* and *Jugend*, and *L'Eroica* by *Ver Sacrum*. The greatest Italian writer of the day, Gabriele D'Annunzio (1863–1938),[37] also took a keen interest in book illustration and commissioned work from Sartorio, De Carolis (no. 31), Cambellotti, Emilio Mantelli, Guido Marussig (1885–1972) and Lorenzo Viani.

De Carolis's and Sartorio's interest in the productions of William Morris's Kelmscott Press and of Charles Ricketts and Shannon's Vale Press was shared by Ettore Cozzani (1884–1971), who, with the architect Franco Oliva, launched the journal *L'Eroica* in La Spezia in 1911.[38] The following year, under the auspices of the periodical, he organized the first national Italian show of woodcuts, which was held in Levanto, near La Spezia. The exhibition was dominated by Adolfo De Carolis, but included prints by many promising young artists, including Emilio Mantelli, Giovanni Costetti, Guido Marussig, Gian Carlo Sensani (1888–1947) and Benvenuto Disertori. A section of Italian and German Renaissance woodcuts was shown alongside the Italians, and work by a substantial group of German, Austrian, French, Belgian and Dutch artists was also included. Of the foreign contributions, a group of twelve colour woodcuts by William Nicholson, and works by the Czechs František Kobliha and Vojtech Preissig stood out. In addition, there were small displays of publications illustrated by woodcuts, and of contemporary Italian woodcuts. A society devoted to woodcut, the Corporazione Italiana degli Xilografi, had been formed shortly before the opening of the exhibition.

A second important exhibition of black and white work followed in Pistoia in 1913, organized by a close friend and patron of Costetti, Renato Fondi (1887–1929), under the auspices of the local exhibiting society, La Famiglia Artistica, and, in 1914, by the first International Exhibition of Black and White, held in Florence by the Società delle Belle Arti.[39] Fondi also founded the journals *Athena* in 1909 and *La Tempra* in 1914. Cozzani's journal, *L'Eroica*, devoted an issue to contemporary Belgian woodcut artists, including Max Elskamp, Eduard Pellens and Edgard Tytgat in 1914. By that date, the Renaissance style of Adolfo De Carolis and his many followers had begun to look out of date, and

both Cozzani and Fondi turned to artists working in Expressionist styles. Cozzani objected to the introduction of colour into woodcut by De Carolis and followers, expressing his preference for the robustness and 'sincerity' of black and white.[40] Cozzani first promoted Sensani and Mantelli in double issues in 1913. An issue of *L'Eroica* that covered Lorenzo Viani (fig. 7)[41] in August 1914 was balanced later that year by a double issue devoted to Giulio Aristide Sartorio, but this was the last in which an artist working in the older tradition was featured. A breakaway group of artists set up the Nuova Corporazione Italiana degli Xilografi, including Sensani, Viani, Guido Marussig and Antony De Witt (1876–1967) in 1915. Cozzani's rejection of the De Carolis tradition was announced in the twenty-second issue of *L'Eroica* that year. Woodcuts by Casorati, Arturo Martini, Nicola Galante (1883–1969) and Moses Levy (1885–1968) were included in a triple number also published in 1915. The editor's taste even moved so far as to include a group of frontispieces by the young Futurist Prampolini in the twenty-fifth issue.

Associated with *L'Eroica* were the publishing houses L'Eroica Editrice and Edizioni Formiggini. The former issued a number of books illustrated by woodcuts, principally by Mantelli and Sensani. Although the firm continued its activities until 1953, most of the illustrated volumes were published between 1912 and 1929. Edizioni Formiggini published a series, *Classici del Ridere*, between 1912 and 1916, most notably volumes devoted to the individual stories in Boccaccio's *Decameron*. Once again, Mantelli and Sensani provided illustrations. Others who contributed were Gino Barbieri (1885–1917), Edoardo Del Neri (1890–1932) and Benvenuto Disertori. *L'Eroica* itself continued to 1944, but after a double issue devoted to the drawings of Adolfo Wildt in 1920, and an issue in 1924 that included woodcuts by Masereel, Henri van Straaten, Joris Minne, Robert Gibbings and Wladyslaw Skoczylas, its role as a promoter of advanced printmaking came to an end.

The production of woodcuts continued to be a significant feature in Italian art throughout the 1920s and 1930s. The Palazzo Pitti hosted an exhibition of book illustrators in 1922. Woodcut and book illustration were encouraged by the printmaker Francesco Nonni's journal *Xilografia*, founded in 1924; by the Bolognese Cesare Ratta's series of volumes *La moderna xilografia in Italia*, 1924–9, and *Gli adornatori del libro in Italia*, 1923–8; and by Luigi Servolini (1906–81), the artist and print historian, beginning with his *La xilografia* in 1929. The tireless Servolini published a large number of volumes, articles and exhibition catalogues, promoting the more traditional styles in Italian printmaking, in etching and lithography, as well as in woodcut. He also founded the Museo della Xilografia in Carpi in 1936. The same year, the Gruppo Italiano dell'Ex Libris e del Bianco e Nero

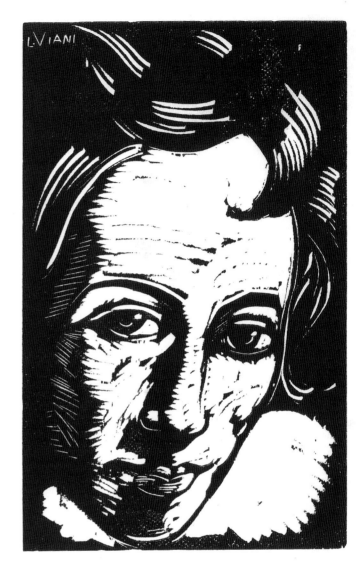

Fig. 7
Lorenzo Viani
Percy Bysshe Shelley August 1922
Woodcut 263 × 167 mm
2002-7-28-15

was established. The art of the bookplate has remained an important component in Italian printmaking ever since.

The Scuola del Libro, Urbino

Crucial, too, for the long survival of De Carolis's influence on Italian woodcut was the foundation in 1925 of the Scuola del Libro in the Istituto di Belle Arti in Urbino, which still continues to train many of Italy's leading book illustrators.[42] The Scuola began publishing illustrated books in 1927. These had much more in common with the volumes produced by the contemporary English private press movement than with French *livres d'artiste*. Their very regular publications have almost always reflected the conservative positions of the lecturers on the staff of the Scuola, such as Francesco Carnevali (1892–1987), Mario Delitala (1887–1990), Bruno da Osimo (1888–1962), Ettore di Giorgio (born 1890) and Luigi Servolini. Initially the emphasis was mainly on woodcut, but Leonardo Castellani (1896–1984), a follower of Morandi, also exercised a lasting influence on several generations of intaglio printmakers during his forty years working in Urbino.[43]

Printmaking in northern Italy in the first two decades of the twentieth century: the exhibitions of the Ca' Pesaro

Italy's first public museum of modern art, Venice's Galleria Internazionale d'Arte Moderna, opened in the Ca' Foscari in 1897. The following year, the Duchess Felicita Bevilacqua La Masa bequeathed the Ca' Pesaro to the Comune to be used for the encouragement of young Italian artists who were often excluded from major exhibitions.[44] In 1902 the city of Venice decided to move the Galleria Internazionale d'Arte Moderna into this handsome palazzo designed by Longhena, which is prominently situated on the Grand Canal. The twenty-three-year-old Nino Barbantini (1885–1952) was appointed secretary in 1907, and was to guide its policies until 1930, when he retired from the directorship. Barbantini organized the first of a series of annual exhibitions that complemented the Venice Biennali, offering opportunities to exhibit to such artists as the painters Umberto Boccioni, Felice Casorati (nos. 37–40), Pio Semeghini (1878–1964) and Gino Rossi (1884–1947), and the sculptor Arturo Martini (1889–1947). In 1910 the Ca' Pesaro housed Boccioni's first one-man exhibition, which included a group of his etchings and drypoints (nos. 41–3). Arturo Martini exhibited twenty-six prints at the 1911 show in the Palazzo, and a further group of prints in 1913. Gino Rossi was given a separate room to exhibit his work in 1911, having shown some of his prints there in 1908.[45] Barbantini offered Casorati a complete room that year, when he exhibited some of his lithographs.

Boccioni, Martini and Rossi had all been in Paris, as had three other young etchers, Gino Severini (nos. 44–6), Giovanni Costetti (no. 36) and Anselmo Bucci (1887–1955). Boccioni's etchings, all of which were made before he became a Futurist, reflect both his knowledge of Parisian printmaking and his study of works exhibited at the Venice Biennale. The styles of Severini's early prints and of the etchings of both of his friends Costetti and Bucci also derived from their periods in the French capital. Rossi was the first Italian artist to appreciate the Fauves, and he probably saw the Gauguin retrospective in Paris at the 1906 Salon d'Automne. He returned to France with his close friend Arturo Martini in 1912. Rossi's woodcuts derive from Derain and the other Fauves.

Arturo Martini

Martini,[46] who had learnt to model terracotta as an apprentice in a ceramics factory, had earlier travelled to Munich to attend the lectures of Adolf von Hildebrand. He devised his own method of using terracotta, clay and gesso matrices for his prints, which he called 'pirografie' and 'cheramografie'. After baking the clay, he covered the incised surfaces with shellac, and used the bone handle of an umbrella to print his *cheramografie*. To avoid the pressure breaking through the paper, Martini strengthened it by applying a little wax to the reverse. He made many prints throughout his career, of which, for the most part, only a few impressions were pulled. Martini also made woodcuts, linocuts and lithographs. Several of his prints were closely related to individual pieces of his sculpture. Martini drew inspiration from the poetry of Baudelaire, as well as from Fauve woodcuts. The extreme simplification of forms, caricatural drawing and broad areas of colour in his early colour lithographs derives from the French tradition of illustrated journals such as *Gil Blas*. Martini was also aware of the work of the Belgian sculptor and printmaker Minne, and of work by Austrian and German artists. Also associated with Rossi and Martini was Felice Casorati (nos. 37–40). Much of his early work showed him to be well versed in the work of the Vienna Secession. Viennese art was important, too, for the sculptor-printmaker Adolfo Wildt (no. 30), whose first major patron was German.

Etching in the second decade of the twentieth century

The Associazione Italiana Acquafortisti e Incisori, following the model of foreign etching societies, was formed early in the second decade of the century, and held its first exhibition in Milan's Palazzo della Permanente. The leading figures were Sartorio, Beltrami, Giuseppe Graziosi (1879–1942) and the Milanese Vico Viganò (1874–1967). Adolfo De Carolis was on the society's council, and D'Annunzio its enthusiastic supporter. The society's principal achievement was the wartime exhibition, in 1916, held in London under the auspices of the Royal Society of British Artists on behalf of the Red Cross. This was a show of over five hundred

works, including woodcuts, lithographs, etchings and aquatints. The only prints devoted to the war itself were a group of etchings by Anselmo Bucci. Other etchers represented were his friend Giovanni Costetti, Conconi, Grubicij and Sartorio. Giuseppe Graziosi showed lithographs and etchings, some of which were in colour, and Disertori a mixture of etchings and woodcuts. The strongest group of woodcuts came from De Carolis. A large number of lesser known artists were also included. Brangwyn selected just over a hundred prints from the London showing for a further exhibition in Cartwright Hall, Bradford's municipal art gallery. Many of the younger and more avant-garde printmakers were not involved in the Associazione Italiana Acquafortisti e Incisori.

A much smaller society, the Gruppo Romano Incisori Artisti, initially made up of just eighteen artists, was founded in October 1921 under the leadership of Professor Federico Hermanin, Soprintendente alle Gallerie e Musei di Roma, who had previously been Director of the Gabinetto Nazionale delle Stampe.[47] The members included the Germans Sigmund Lipinsky (1897–1940) and Max Roeder (born 1866), and the English architectural etcher William Walcot. The best known of the Italians were Edoardo Del Neri, Carlo Alberto Petrucci (1881–1963) and Umberto Prencipe (1879–1942). None of these could be considered an avant-garde artist. The group exhibited together between 1926 and 1928 in various shows, its final public appearance being a room of bookplates in the Mostra del Libro Moderno Italiano.

Futurism

The first major artistic movement of the twentieth century that was initiated in Italy was Futurism.[48] Its standard bearer was the writer and polemicist Filippo Marinetti, who maintained that in the modern age the museums, libraries and academies of the past had to be destroyed as impediments to progress. His Futurist manifesto was initially published in French in the Paris newspaper *Le Figaro* in 1909, but it was in his native Italy that it received acclaim from a group of young painters based in Milan, Boccioni, Luigi Russolo (no. 47) and Carlo Carrà, who were soon joined by Severini and Giacomo Balla (1871–1958). Their pamphlets *Manifesto dei pittori futuristi* and *La pittura futurista: Manifesto tecnico*, published in 1919, set out their aims to challenge traditional and realistic painting, and proposed a Symbolist-derived doctrine that colour should be used to convey sensations. As the movement developed, the artists began to dissolve forms to convey speed and the dynamism of modern life. The new style combined Divisionism and Neo-Impressionism with elements of Cubism, and was deeply influenced by contemporary photography and early Renaissance printmaking. Few prints resulted from Futurism. The artists were more interested in experimenting with typography.[49] In their efforts to surpass the Cubists 'in a caco-phony of planes, tones and colours' they played with dynamic fragmented words and lines. Among the earliest of the few Futurist prints were three by a young Florentine painter and writer, Soffici, initially a critic and later a champion of the movement. He wrote art criticism in the Florentine journals *La Voce* and *Lacerba*, both founded and edited by his close friend the writer Giovanni Papini. It was *Lacerba* that published the woodcut in this exhibition (no. 53). In most cases, Futurist prints were made specifically for contemporary journals or books. This was probably the case for Severini's linocut in this exhibition (no. 45).

Futurism was closely related to other European Post-Symbolist and modernist movements. Thus, Nicola Galante, a landscape painter associated with the Futurists, illustrated Kurt Friedel's *Torino mia* in 1912 with twelve woodcuts close to the Expressionist style, which was promoted in Herwarth Walden's *Der Sturm*. Prampolini, the most prolific Futurist printmaker, worked for French, Swiss and American, as well as Italian, journals. Some of his woodcuts appeared in the Zurich magazine *Dada*. The Bauhaus recognized Futurism by the inclusion of one of Prampolini's lithographs, and of a work based on a drawing by Boccioni, in *Neue Europäische Graphik*, its 1922 portfolio of prints by Italian and Russian artists. This album also included works by De Chirico and Carrà.

Futurism also played a significant part in contemporary Italian applied arts and design. Fortunato Depero (1892–1960) continued the Futurist tradition into the 1920s and beyond in a series of brilliant poster designs and other works made for publicity purposes, in particular for the Campari company. Among his works were the earliest screenprints made by an Italian artist.[50] The two outstanding Futurist *livres d'artiste* were published by the Rome-based Edizioni Futuriste della Poesia in the 1930s, and in both cases the prints were in hard-edged geometric abstract styles, anticipating post-war Italian works. These could also be seen as deriving from the collages of Dada. The poet, sculptor and ceramicist Tullio d'Albisola's *L'anguria lirica* of 1933–4 was accompanied by twelve colour lithographs by the young Bruno Munari, while in 1934 D'Albisola (1899–1971) provided another dozen colour lithographs for Marinetti's *Parole in libertà futuriste. Tattili – termiche olfattive.*

The First World War

Surprisingly, none of the Futurists executed prints directly related to the First World War, although they generally welcomed Italy's participation in it from the autumn of 1914.[51] Several of the leading Futurists served in the Lombard Volunteer Cyclist Battalion formed in July 1915, which fought against the Austrians in the Alps. Outside the Futurist circle, in 1914 the illustrator Alberto Martini executed *La danza macabra europea*, a biting

series of colour lithographs. Lorenzo Viani executed a series of harsh woodcuts of soldiers at the front, as did Gino Barbieri, whose prints were published in *L'Eroica*, and as illustrations to books issued by Edizioni Formiggini.[52]

Anselmo Bucci, who served alongside the Futurists in the Lombard Volunteer Cyclist Battalion, executed fifty drypoints which were published in Paris in 1917.[53] Bucci's reputation had been made in that city by two series of drypoints, *Paris qui bouge*, executed in 1908 and 1909, which were devoted to the city's street life. These were printed and published in Paris by the Galerie Devambez in 1910, and shown the following year in an exhibition of the Groupe Libre. The huge one-man exhibition of 246 works, all of which were devoted to Bucci's time at the front, held in the Palazzo San Giorgio in Genoa in March 1917, was exceptional in featuring so many of his prints. It was relatively rare in Italy in the second decade of the twentieth century for prints by a single artist to feature so prominently, although in Rome in 1913 the Circolo Artistico Internazionale had exhibited paintings and etchings by Umberto Prencipe, and in 1916 the Associazione Artistica Internazionale had shown paintings, lithographs and drawings by the Florence-based Belgian Charles Doudelet (1861–1938).

Twenty years after the outbreak of war, Queen Elena sponsored a competition in 1934 to celebrate the soldiers, sailors and airmen whose heroism had been recognized by the award of a gold medal.[54] This resulted in an exhibition in Rome of nineteen prints, along with paintings and sculpture, at the Museo Centrale del Risorgimento in the Palazzo Quirinale. Prizes were awarded to Mario Delitala (1887–1990) and Stanis Dessì (1900–86). The Decarolisian school of woodcut was strongly represented. In this competition, the royal family was following the pattern established by the many official governmental mural commissions of the period.

Pittura Metafisica

The short-lived but influential movement Pittura Metafisica was essentially the creation of Giorgio De Chirico (nos. 73–4) and his brother, the painter, writer and composer Alberto Savinio (1891–1952), who were steeped in the ideas of the German philosophers, Friedrich Nietzsche and Arthur Schopenhauer.[55] During their time in Paris between 1911 and 1915, the two men became close friends of the French poet Guillaume Apollinaire, and it was he who first described De Chirico's paintings of a dream world of mysterious abandoned city squares and claustrophobic interiors as 'metaphysical'. Typically, the urban spaces shown in steeply rising perspective were populated by classical statuary and mannequins, rather than by human beings. The interiors were packed with a mysterious assembly of balls, toys,

moulds and geometrical instruments, as well as with mannequins. The brothers were joined in 1917 by the former Futurist Carlo Carrà (nos. 49–52), when he fortuitously met them in Ferrara. Other young artists who briefly became fringe members of the group were the painters Giorgio Morandi (no. 58) and Filippo De Pisis (no. 75), while the sculptor Arturo Martini produced clay figures that combined the early Renaissance solidity displayed in Carrà's paintings with disturbing qualities derived from De Chirico. Only De Chirico and Savinio pursued the Metaphysical style. Carrà's failure to acknowledge De Chirico's primacy in the movement in his 1919 book *Pittura Metafisica* led to a major quarrel.

Valori Plastici

Pittura Metafisica was promoted by *Valori Plastici*, a journal published in Rome between 1918 and 1921, in both Italian and French, under the editorship of the painter and critic Mario Broglio (1891–1948).[56] It also published a series of monographs on the Old Masters, African, Chinese and Mexican art, and on modern art from the nineteenth century to Cubism and Expressionism. Furthermore, Italian artists associated with *Valori Plastici* exhibited under its banner in Berlin, Dresden, Hanover and Florence in 1921 and 1922. Broglio's open-minded editorial policy allowed for a wide range of contributors, and for the airing of polemical disputes. Among the notable writers living outside Italy to appear within its pages were Severini, Jean Cocteau, André Breton, Louis Aragon and Theo van Doesberg. A feature common to many of the artists and writers involved with *Valori Plastici* was an interest in Italian Renaissance painting and sculpture from Giotto to Raphael, and in art of other periods which could be seen to belong to the 'classical tradition', such as, for instance, Etruscan sculpture and the paintings of Ingres and André Derain.

Italians in Paris in the 1920s and 1930s

Paris remained a major attraction for Italian artists in the 1920s and 1930s, and was still the most important European centre for print publishing.[57] Outside the taste for fine books illustrated with woodcuts, the *livre d'artiste* remained in its infancy in Italy. The Florentine publisher Vallecchi was a rare exception, issuing Soffici's *Elegia dell'Ambra* in 1927 and Mino Maccari's *Il trastullo di Strapaese* in 1928. De Chirico's illustrations, to Cocteau's *Le Mystère* and *Mythologie*, published by Editions des Quatres Chemins, and to Apollinaire's *Calligrammes*, published by La Nouvelle Revue Française, were all issued in Paris. The illustrations for *Fleurs et masques*, Severini's greatest book, were made in Paris, and the volume was published in London (no. 46). Campigli's illustrations to Virgil's *Georgics* were commissioned

by J.-O. Fourcade. Jeanne Bucher published his first colour etching in the French capital. Both De Chirico and Severini spent long periods in Paris, as did Savinio, De Pisis, the Futurist Russolo, Campigli and Magnelli. Magnelli and Severini both executed linocuts for Gualtieri di San Lazzaro's Paris-based journal *XXe Siècle*. Di San Lazzaro dealt in the work of Modigliani, and his Editions des Chroniques du Jour published a series of significant monographs on Italian artists, starting with one on De Pisis in 1928. Among the others were volumes on De Chirico, Severini, Marini and Campigli. Waldemar George and Paul Fierens were his principal authors to write on Italian art.

Margherita Sarfatti and Il Novecento

The most prominent group of painters in the 1920s came together at the Galleria Pesaro in Milan. There they had their first exhibition, in 1923, which adhered to the 'classical' values promoted in *Valori Plastici*. Their association with the great periods of Italian art of the past was proclaimed by the title, Il Novecento Italiano, suggested by Anselmo Bucci, which was assumed by the group, echoing the terms Trecento, Quattrocento and Cinquecento.[58] The seven artists, who included Achille Funi (1890–1972), Piero Marussig (1879–1937), Ubaldo Oppi (1889–1942) and Mario Sironi (1885–1961), had a powerful spokesperson in Mussolini's mistress, the poet, novelist and art critic Margherita Sarfatti (1880–1961).[59] Sarfatti, who wrote for Mussolini's newspaper, *Il Popolo d'Italia*, came from a prominent Jewish family. From 1909 she had been the art critic of *Avanti della Domenica*, and her Milanese salon was a regular meeting place for the Futurists. She also promoted the sculptors Medardo Rosso (1858–1928) and Arturo Martini, and the poets Massimo Bontempelli and Ada Negri. The Novecento group showed together at the 1924 Venice Biennale, but by the time of its second exhibition, at Milan's Palazzo della Permanente in 1926, its membership had grown considerably. Sarfatti was keen to include the best Italian artists of the day, rather than a group tied together by particular tenets. The 1926 show included De Chirico, Campigli, Casorati, Osvaldo Licini (1894–1958), Morandi, Severini, Balla, Depero and Prampolini, as well as three of the original members, Funi, Marussig and Sironi. The exhibition even included Soffici and Rosai from the dissident Strapaese group. Under Sarfatti's direction, the Novecento artists had a number of exhibitions abroad, and many of the leading figures later received major public commissions and awards under the Fascist regime of the 1930s. Sarfatti was also appointed to official positions by the government, first in 1927 to the executive committee of the Milan Triennale, an exhibition founded in 1919 to promote modern architecture and design. The following year, she also joined the executive committee of the Venice Biennale.

Fascist intervention in the visual arts

Until 1922 Italy was a democracy, but that year, after the proclamation by the trade unions of a general strike, the former socialist Mussolini and his Fascist forces marched on Rome. King Vittorio Emanuele III then invited him to form a government to restore order. The Fascist party that Mussolini had founded in 1919 had won only thirty-five seats out of 355 in the 1921 election, but he was to head a dictatorship until 1944. The Duce, as he soon came to be called, opened the first Novecento exhibition in 1923. Dissatisfaction with the lack of achievements of the various other political parties led many to accept the end of democracy. Leading artists who had supported the nationalist politics of Gabriele D'Annunzio were among them.

For the first few years of his rule cultural matters were low on Mussolini's agenda, as he laid the institutional roots for his government. In 1925 the philosopher Giovanni Gentile, the first Fascist Minister of Public Instruction, set up the Istituto Nazionale Fascista di Cultura, an organ to disseminate culture and to attract leading scholars and intellectuals to lecture throughout the country. The following year, the Reale Accademia d'Italia, consisting of sixty leading scientists, writers and artists, was created on the model of the French Academy. Its initial members included D'Annunzio, Marinetti, the sculptor Adolfo Wildt and the painter Felice Carena (1879–1966). The first direct intervention in exhibition policy by the government came in 1926 with the replacement of Vittorio Pica as Secretary General of the Venice Biennale by the dedicated Fascist sculptor Antonio Maraini (1886–1963). That year there was a substantial exhibition of woodcuts, lithographs and monotypes by Gauguin, and a special display of advanced Czechoslovakian prints, including work by Bilek, Kobliha and Rambousek, as well as by the more conservative Svabinský and T. František Simon. Foreign governments were encouraged to build national pavilions to house the work of their contributors. The effect on the representation of international printmaking at the Biennale was deleterious, as countries tended to be conservative in their selection of artists, though some years were exceptional. For instance, there were forty-eight prints by Laboureur and twenty-five by the leading Flemish Expressionist Nicolas Eekman in the 1932 Biennale, and a substantial group of American prints, including work by John Sloan, Martin Lewis and Albert Sterner, was exhibited in 1938.

In 1928 the Federazione dei Sindacati Intellettuali (Federation of Intellectual Unions) was established as one of the units in Mussolini's Confederazione Nazionale dei Sindacati Fascisti. Two years later Mussolini replaced the Federazione dei Sindacati Intellettuali with six independent bodies, including the Confederazione dei Professionisti e degli Artisti. With the encouragement of Giuseppe Bottai, Minister of Corporations from 1929 to 1931,

who was the founding editor of the journal *Critica Fascista*, this confederation was eventually divided up into individual regional unions. These unions each began to stage regular exhibitions, the first being that of the Sindacato Fascista di Belle Arti del Lazio in 1929. Bottai was a friend of Giacomo Balla, and had been a contributor to the periodical *Roma Futurista*. Also established in 1929 was a black and white section of the Sindacato di Belle Arti. An artist needed to be a member of the Sindacato in order to qualify for teaching positions and for Sindacato exhibitions. Most artists initially welcomed the creation of a union, which offered greater prospects of employment and more exhibitions in which to show. It was in these circumstances that Morandi was appointed to teach at the Accademia di Belle Arti in Bologna, and Lamberto Vitali, the outstanding critic and print historian, became Professor of Printmaking at the Accademia di Brera in Milan.

Under the leadership of the painter Cipriano Efisio Oppo (1891–1962), a large number of regional exhibitions were launched, and some commercial galleries, such as the Galleria di Roma, under the direction of Pier Maria Bardi, were sponsored to exhibit the best in Italian contemporary art. The Galleria di Roma was a keen supporter of the Scuola Romana, artists who painted in figurative styles, including the Expressionists Mario Mafai (1902–65) and Scipione (1904–54), as well as those who adhered to a cooler tonalist manner, such as Corrado Cagli (1910–76), Capogrossi and Fausto Pirandello (1889–1975). On the national front, control of the Venice Biennale was removed from the city fathers in 1928, and transferred to a semi-state agency funded by central government. The Fascist party and government agencies created prizes, and henceforth selection for the exhibitions implied official favour. A second major exhibition, the Rome Quadriennale, open to Italian artists alone, was launched in 1931 under the direction of Oppo. This included a black and white section. The government provided a serious sum of money for purchases from the show for Rome's Galleria Nazionale d'Arte Moderna. Despite the political control, Mussolini declared that all tendencies in contemporary art should be admitted to the Quadriennale.

In 1929 Oppo had entrusted the etcher Carlo Alberto Petrucci (1881–1963) with the task of forming the black and white section of the Sindacato, which by the beginning of 1930 had 223 members.[60] Discovering that the press of the Regia Calcografia was lying neglected in the Palazzo Venezia, in 1931 Petrucci obtained permission for members to use it, and invited them to send some of their best prints to be displayed for sale. As a result, there was a new influx and several leading printmakers, including Luigi Bartolini (nos. 65–72), joined up. The Sindacato took fifteen per cent commission on sales. Fifty-two artists exhibited 105 works in the first exhibition of the section, which was well received. Carrà, Mino Maccari and Morandi were among those approached to join

the section before its second exhibition held in the Palazzo delle Esposizioni in 1932, alongside the exhibition of the Sindacato Laziale delle Belle Arti.

The following year Petrucci became Director of the Calcografia. By 1937 the membership of the section had risen to around five hundred. Sales of contemporary prints by the Calcografia gradually increased to about 150 in 1934. The Calcografia was in part responsible for the diffusion of knowledge of the etchings of Morandi (nos. 55–64), Italy's greatest etcher of the twentieth century, when it took over the printing and publication of editions of his plates, from which the artist had previously pulled only a small number of impressions himself. Italian printmakers were also promoted abroad in a series of exhibitions organized by Petrucci, the first of which, held in 1932 at the Musée des Beaux Arts, Bordeaux, was *L'Italie dans l'art du livre et de la gravure*, a show which also included French works. Italian woodcuts, book illustrations and posters were shown in Brussels in two exhibitions of 1932 and 1933. Before the outbreak of the Second World War, further exhibitions in which Italian prints were featured strongly were held in Czechoslovakia, Poland, Austria, Germany, Latvia, Lithuania and Central and South America. Petrucci continued in his post as Director of the Calcografia until 1958. He organized over a hundred print exhibitions, and published over fifty exhibition catalogues devoted to the work of contemporary printmakers between 1943 and 1960, including major retrospectives of Morandi, Bartolini and Bucci. At the same time, Petrucci managed to produce a very substantial oeuvre of his own. A retrospective of his work was held in Rome in the Accademia di San Luca in 1968.

In the late 1930s, the right wing of the Fascist party, led by the rabidly anti-Semitic Roberto Farinacci, achieved greater prominence. As early as 1929, Farinacci had attacked the Novecento group for being too modern and too influenced by international art. Sarfatti fell out of favour, and eventually fled into exile. In 1939 Farinacci set up the Premio Cremona, a prize for which competing artists had to produce work that explicitly celebrated Fascist deeds and ideals. The same year, Bottai, now the Minister of National Education, established the Premio Bergamo as a counter, for which artists of any persuasion could compete.[61] Indeed, its exhibitions were full of artists who advocated creative freedom. Among them was Renato Guttuso (1912–87), a longtime socialist, who on Mussolini's fall became an acknowledged Communist, and was awarded the prize in 1940. The fact that Bottai, who for so long was close to the Duce, could allow Guttuso and Mino Maccari to contribute to *Primato*, the journal that he founded in 1940, shows that the regime's attitude to the visual arts was far from rigid, even when Italy was a combatant ally of Hitler's Germany.

Il Selvaggio *and Strapaese*

Maccari (1898–1989), a prolific satirical draughtsman and print-maker, had taken part in Mussolini's march on Rome.[62] In 1924, he began working on *Il Selvaggio*, a journal initially published from the Tuscan hill town of Colle Val d'Elsa, which he edited from 1926 to 1943. *Il Selvaggio* argued the case for a regional nationalism, and was highly critical of Italian art that showed any signs of internationalism, in particular art that reflected Parisian ideas. Similar ideas were voiced in the Bolognese journal *L'Italiano*, edited between 1926 and 1942 by another draughtsman journalist, Leo Longanesi (1905–57). The movement which they led was known as Strapaese (Super-country), and was based in Tuscany and Emilia Romagna. It championed the traditional values of rural life against the ideas gaining ground in the cities as a result of modernization. These revisionist publications which objected to the growing centralization and elevation of the city of Rome were predominantly literary in character. Maccari and Longanesi are often crudely represented as Fascist, but they were far from uncritical of the regime, as is apparent from the many biting woodcuts and linocuts that Maccari contributed to his own journal.[63] Maccari's art, despite his nationalist position, was undoubtedly indebted to the prints of Ensor and to the drawings of George Grosz. *Il Selvaggio* published an article on the German draughtsman by Ivan Goll in 1927. It is typical of the contradictions so frequently found in Italian twentieth-century art that artists who contributed to *Il Selvaggio* included the one-time Futurists Soffici, Carrà (no. 52), Achille Lega (no. 48) and Ottone Rosai (1895–1957). Maccari and Longanesi favoured painters who were predominantly landscapists, most notably the quietist Morandi, whose art was acclaimed as 'italianissima'. De Pisis and Luigi Bartolini, Morandi's rival, as well as the young Guttuso, were others to receive their support. The acceptable form of French art for this group was the painting of Cézanne, whose landscapes could be seen as the work of a regionalist artist.

Abstraction in the 1930s

Beyond the circle of the Futurists, there was very little interesting abstract painting until the 1930s. The young Magnelli, who had encountered Cubism in Paris, had briefly experimented with it at the start of the First World War, but he returned to it only on the encouragement of Prampolini, after he had settled in Paris in 1931. Both became prominent members of Abstraction-Création,[64] the multinational group founded in the French capital that year which was in theory open to all strands of abstract art. The dominant influences, however, came from the geometric abstraction of De Stijl, as promoted by Theo van Doesberg, and from Purism, the style developed in Paris by Léger, Ozenfant and Le Corbusier. Nevertheless, there was also a strong representation

both of East European constructive art and of artists whose styles stemmed ultimately from the training of the Bauhaus. The group, which published a journal, *Abstraction-Création*, between 1932 and 1936, and held annual exhibitions in Paris from 1933, consisted of over four hundred members and friends by 1935. Undoubtedly the issues of the journal and the exhibitions played a significant part in introducing Italian artists to contemporary European abstraction. It was probably Abstraction-Création that first brought Swiss artists, such as Max Bill, to their attention. As well as Magnelli and Prampolini, Osvaldo Licini, Lucio Fontana, Atanasio Soldati, Fausto Melotti (1901–86), Luigi Veronesi, Oreste Bogliardi (1900–68), Mauro Reggiani (1897–1980) and Gino Ghiringhelli (1898–1964) all became associated with the group. Ghiringhelli's brother, the painter Virginio, ran the Galleria del Milione in Milan, which gave the Italian abstract artists their first exhibition in 1934. *Kn*, published in Milan in 1935 by the painter and critic Carlo Belli (1903–91),[65] became their theoretical gospel.

Luigi Veronesi (nos. 96–7), who had shown figurative wood-cuts in 1932 at the Libreria del Milione, was one of the first Italian artists to make and exhibit abstract prints. In 1934 he showed some of them at the Galleria del Milione in an exhibition which he shared with Joseph Albers. Albers's wood engravings had a significant influence on the young Bruno Munari. Several of Veronesi's wood engravings were reproduced in the journal *Campo Grafico*,[66] founded in Milan in 1933 by Attilio Rossi, Carlo Dadri and Luigi Minardi, which until 1939 championed avant-garde graphic design. Rossi was the organizer of an exhibition of Italian abstract artists held in 1935 at the Gallery Moody in Buenos Aires. Lucio Fontana, Fausto Melotti, Mario Radice (1898–1987), Mauro Reggiani, Atanasio Soldati and Veronesi all contributed to this show. Veronesi, Soldati and Vordemberge-Gildewart were among those who designed covers for issues of *Campo Grafico*. However, few abstract prints were made in Italy until after the Second World War. The principal exception was the group of works that Magnelli made in Grasse, where he settled with Sonia Delaunay, Jean Arp and Sophie Taeuber-Arp after the German invasion of France.

Il Corrente

Most pre-war Italian abstract art was made and shown in northern Italy. It was here, too, that a vibrant group of young figurative artists gathered around a short-lived Milanese journal, *Il Corrente*, originally titled *Vita Giovanile*, launched in 1938. Seven years before, Edoardo Persico and Lionello Venturi had urged Italian artists to go beyond the Novecento aesthetic, which they saw as parochially and provincially nationalistic, and make art that was more European. Their views were taken up by the artists of

Il Corrente, who objected to geometric abstraction as much as to what they saw as naturalistic academicism. The Ghiringhelli brothers' Galleria del Milione, however, exhibited abstract and realist art alike. *Il Corrente*'s anti-Fascist position led eventually to the authorities closing it down in 1940, not before two exhibitions had been staged in Milan. The leading artist in the movement was Renato Birolli (1905–59), while Raffaello de Grada provided critical support. Several artists who turned to abstraction after the Second World War were involved, including Vedova and Fontana. Other leading figures were Giacomo Manzù (1908–91), Aligi Sassu (1912–2000) and the Roman painter and polemicist Guttuso. *Il Corrente* artists dominated the exhibitions for the annual Premio Bergamo from its launch in 1939 as a counterbalance to the Premio Cremona, where propagandistic paintings abounded.[67]

Livres d'artiste *in the 1940s*

At first sight, it is surprising that the war years saw the flourishing of *livres d'artiste* in Italy. More than a hundred of these prestigious volumes aimed at wealthy connoisseurs were published between 1940 and 1952. The explanation may well lie in the unexpected death of Ambroise Vollard in 1938, and the collapse of the genre in Paris as a result of the German invasion of France. Vollard left behind him a series of uncompleted projects, some of which were later taken up by other publishers in Switzerland and the United States. The Italian production was led by Carlo Marzoli's Edizioni della Chimera, the much more established firm of Ulrico Hoepli in Milan and Carlo Cardazzo's Edizioni del Cavallino in Venice. Edizioni della Chimera's *L'Apocalisse* of 1941, illustrated by De Chirico (no. 73), was followed in 1942 by their *Viaggio d'Europa* by Massimo Bontempelli, for which Arturo Martini supplied twenty-two lithographs.[68] This was printed in Verona by Giovanni Mardersteig's Officina Bodoni, from whose presses issued a series of high-quality volumes.[69] Ulrico Hoepli also used Mardersteig for the text of his edition of Marco Polo's *Il Milione* in 1942, but turned to Piero Fornasetti for the printing of Campigli's accompanying thirty lithographs. The fact that the text was in French is suggestive of the expected market among bibliophiles, whose collecting had fed on the *de luxe* editions published in France between the wars. Fornasetti also published eight *livres d'artiste* of his own work, most notably *Lunario del Sole*, illustrated by thirteen of his lithographs, as well as Raffaele Carrieri's *Viaggio in Italia*, which was accompanied by lithographs by Eugène Berman. Other *livres d'artiste* published by Hoepli included *I Carmi di Catullo*, illustrated by seventeen lithographs by De Pisis in 1945, and Virgil's *Le Georgiche*, illustrated by nineteen etchings by Manzù in 1948. Also based in Milan was Edizioni della Conchiglia, the publisher, in 1943, of Petrarch's *Rerum vulgarium fragmenta*, illustrated by eleven of Carrà's lithographs,

and, in 1947, of Jacopone da Todi's *Le Laudi*, illustrated with lithographs by Mario Sironi. From Turin's Collezione del Bibliofilio came Ugo Foscolo's *Le Grazie* in 1946 with lithographs by Casorati, and in the following year the same artist also executed further lithographs for a series of new translations into Italian of the Gospels. This was for the Venice-based publisher Neri Pozza.[70] Also active in Venice were Alessandro Barnabò's Edizioni del Tridente, publishers in 1945 of De Pisis's *Alcune poesie e dieci litografie a colori*.

Pozza's second *livre d'artiste* was Mino Maccari's *Chi vuol baciar Teresa?* of 1961. Maccari also provided the plates for Aldo Palazzeschi's *Bestie del 900*, published by Vallecchi in Florence in 1951. The same publisher issued Luigi Bartolini's *La caccia al fagiano*, which was illustrated by seven of his etchings in 1954. The previous year, Bartolini's *Addio ai sogni*, accompanied by six etchings, had been published in Milan by Vanni Scheiwiller's All'Insegna del Pesce d'Oro, a firm of literary publishers founded by his father, Giovanni, in 1923. Vanni Scheiwiller, who in 1977 set up his own Libri Scheiwiller alongside his father's business, became a significant promoter of contemporary Italian printmakers.[71]

In Rome, the Contessa Pecci-Blunt's Edizioni della Cometa led the way.[72] Her Galleria della Cometa, run by Libero De Libero, had been one of the principal supporters of the Scuola Romana, the dominant group of Expressionist figurative artists in the city in the 1930s. Edizioni della Cometa was also the publisher of the art journal *Beltempo*, which was edited by Libero De Libero between 1940 and 1942, to which Savinio contributed. Also in Rome was Documento Libraio Editore, which in 1944 published Gentile Sermini's *Stratagemmi d'amore*, illustrated by four of Savinio's etchings. Edizioni d'Arte Carlo Bestetti issued two important portfolios of lithographs, De Chirico's *I Cavalli* (no. 74) in 1948 and the young Giuseppe Santomaso's *Cartelle di 6 litografie a colori* in 1948.

Carlo Cardazzo's Galleria del Cavallino in Venice was the first Italian art dealer to start publishing *livres d'artiste*, starting with Bartolini's *Poesie ad Anna Stichler*, which was illustrated with seven etchings in 1941.[73] Edizioni del Cavallino had already in 1938 published the artist's controversial book *I Modi*, which attracted political censure. Cardazzo next published an album of six lithographs by Filippo De Pisis in 1942 (no. 75). Further publications featured prints by Campigli (no. 76) and Carrà. Cardazzo also presented one-man exhibitions of Carrà's etchings and De Pisis's lithographs in 1942 and 1944 respectively, as well as a show of Italian *livres d'artiste* in 1943, which included books published by Hoepli, Editions des Quatre Chemins, Edizioni della Conchiglia and Edizioni della Chimera, in addition to his own publications. Edizioni del Cavallino took up younger artists in the

1950s, particularly Capogrossi, with whom they worked for over fifteen years. They were the publishers of Fontana's first significant portfolio of prints in 1955 (no. 99), and of one of the few prints by Tancredi (no. 111). Other dealers followed Cardazzo in issuing prints and *livres d'artiste*. Thus, the Milanese Galleria Toninelli commissioned Campigli to illustrate Raffaele Carrieri's *Il lamento del gabelliere* in 1945. Other dealer publishers in Milan included Il Sagittario, Galleria Santa Radegonda and Il Milione.

More conservative publications were regularly issued by Urbino's Istituto Statale d'Arte del Libro, the most notable of which during this period were Gogol's *La fiera di Sorocinez* of 1944, illustrated by fourteen etchings by Nunzio Gulino (born 1920), and Leonardo Castellani's *Pagine senza cornice* of 1946, which was accompanied by twenty-six of that artist's etchings. Also very active was I Cento Amici del Libro, founded in 1939 under the presidency of the critic Ojetti, by the bibliophile Tammaro De Marini and the Marchesa Serlupi Crescenzi. The Cento Amici del Libro was modelled on the French society of women bibliophiles, La Société Cent Une, started in the mid-1920s by the Russian émigrée writer Princess Zinaïda Chakhovskia and by Ardy de Carbuccia, wife of the Director of Editions de France. I Cento Amici del Libro continues today. I Cento Amici del Libro's most recent publications have been *livres d'artiste* by Arnoldo Pomodoro (born 1926) and Mimmo Paladino (born 1948). However, in the 1940s their taste was far less advanced. A typical commission was Francesco Redi's *Bacco in Toscana e Arianna*, for which Pietro Annigoni (1910–88), the future portraitist of the young Queen Elizabeth II, provided etchings in 1940.

Apart from Hoepli and Bestetti, the publishers of *de luxe* books tended to be relatively small concerns. When the big firms such as Sansoni, Garzanti and De Agostini occasionally entered this field they turned to less avant-garde artists than their smaller rivals. Occasionally, artists published their own *livres d'artiste* or albums, as when Sassu issued ten lithographs in Milan in 1942.

Publishing of Italian prints outside Italy
André Gide's *Theseus*, illustrated by twelve colour lithographs by Campigli, which was published jointly in 1949 by the Mayfair bookseller Heywood Hill in London and James Laughlin's New Directions in New York, was an early instance of the post-war phenomenon of Italian *livres d'artiste* and portfolios being published abroad. From the early 1950s Swiss publishers regularly issued Italian prints. Allianz Verlag of Zurich had included a woodcut made by Magnelli in Provence, which was printed in Berne in an Art Concret portfolio in 1942 (no. 78). Swiss publications tended to be individual prints or portfolios, rather than *livres d'artiste*. Zoran Musić was one of the earliest to work with them, particularly with Pierre Cailler's Guilde de la Gravure in

Geneva.[74] Nesto Jacometti's *L'Oeuvre Gravé* in Zurich published prints by Campigli (no. 77) and Magnelli.[75] The lithographic printers and publishers Erker Presse of Sankt Gallen worked with Afro, Magnelli, Capogrossi (no. 109) and Dorazio (no. 110). Wolfsberg Verlag, Gérard Cramer and Klipstein and Kornfeld were other Swiss dealers who published Italian prints. A number of artists based in Italy, including Dorazio, have worked with the sculptor François Lafranca, who set up a press in Locarno just north of the Italian border in 1965.[76] Emil Mathieu (no. 83) and Peter Kneubühler[77] were outstanding among the Swiss printers to work with Italian artists. In Germany, the Munich dealer and auctioneer Wolfgang Ketterer also published Italian prints, often in association with Felix Man (nos. 79 and 83).

Italian artists also made considerable use of Parisian expertise. Musić used the Atelier Lacourière and Frélaut (nos. 84–7), and later Atelier Leblanc, to print his etchings, and Desjobert to print his lithographs. Marini and Lardera also worked with Lacourière (nos. 82 and 105). Marini, Lardera, Capogrossi and Magnelli (nos. 79–80) worked regularly with the Mourlot lithographic workshop. Galerie Berggruen issued prints by Lardera and Marini, and the Crommelynck brothers printed and published etchings by Marini.

Painting and sculpture 1945–50
At the end of the Second World War, many Italian artists, both in the North and in Rome, initially focused their attention on the post-Cubist painting of Picasso. The iconic *Guernica* provided a starting point for debate, which was soon enlarged by two major exhibitions, firstly in 1946, of contemporary French painting at the Galleria Nazionale d'Arte Moderna in Rome, secondly of international Art Concret in Milan in 1947. The Marxist realist Guttuso found that many of the young artists who had grouped around his studio suddenly abandoned realism, having seen the work of Braque, Léger, Manessier, Matisse, Singier and Villon, as well as of Picasso, at the Rome exhibition. The first issue of the short-lived journal *Forma* of April 1946 published a determination that art should avoid politically committed realism and Expressionism.[78] The signatories to the manifesto included Carla Accardi (born 1924), Pietro Consagra, Piero Dorazio, Achille Perilli (born 1927) and Giulio Turcato (born 1912). They favoured combining formal experimentation derived from the geometric abstraction of Russian Constructivism, De Stijl and the Bauhaus with French interests in light and space. The new abstraction was first presented in the exhibition *Arte astratta in Italia*, in the Galleria di Roma, accompanied by a catalogue edited by the future industrial designer Ettore Sottsass Jr (born 1917), with texts by Mondrian, Le Corbusier, Bill, Gillo Dorfles, Léger and Kandinsky.

Several of the young Italians, including Accardi, Consagra, Piero Dorazio, Perilli and Turcato, visited Paris, where Magnelli and Kandinsky's widow, Nina, exercised a powerful influence on them. Dorazio, Perilli and Turcato all exhibited there at the predominantly abstract Salon des Réalités Nouvelles. The painters associated with *Forma*, and with the Roman exhibiting society the Art Club, launched in 1945, looked to the former Futurists Prampolini (no. 81) and Balla as father figures. Few prints were made by these Rome-based abstract artists at this time, apart from Consagra's 1949 album of linocuts *E trascurabile esprimere se stessi* (no. 104). Much later, in 1955, the Art Club published the album *Arte astratta italiana, 14 serigrafie*, some of the first Italian screenprints since the days of Depero (no. 81). By this time, many Roman artists had moved far from any style that had a rigid formal organization towards the Parisian Art Informel, in which indistinct shapes gesturally painted replaced all clear outlines of forms.

M.A.C. (Movimento Arte Concreta)

The artists in the contemporaneous abstract movement in Milan, Movimento Arte Concreta, looked to Switzerland and De Stijl, rather than to Paris, for their models for Art Concret.[79] The 1947 Palazzo Reale exhibition was organized by two Swiss artists, Max Bill and Max Huber, together with Lanfranco Bombelli Tiravanti, an Italian who had trained in Switzerland. The show included work by Jean Arp, his wife Sophie Taeuber-Arp, Bill, Herbin, Kandinsky, Lhose, Vantongerloo and Vordemberge-Gilderwart, as well as by North Italian artists, several of whom became involved with M.A.C. (Movimento Arte Concreta), which was founded in 1948 by Gillo Dorfles, Gianni Monnet, Bruno Munari (no. 94) and Atanasio Soldati (no. 95). This was much more tightly organized than any other contemporary Italian grouping and held together for an unprecedented eleven years. M.A.C.'s membership included architects and designers, as well as painters and sculptors, a make up reflecting the close links between fine art and design in northern Italy and Switzerland. Several artists involved, most notably Bruno Munari, established international reputations in both fields. Ettore Sottsass Jr, the future founder of the internationally famous Memphis company, contributed to the group's first album of prints. Max Huber, whose lithographs were included in the fourth album of prints, became one of Switzerland's most internationally distinguished graphic artists. His friend Lanfranco Bombelli Tiravanti, who also contributed to this album, had studied architecture in Zurich during the war. The influence of the Zurich-based Allianz group, centred on Max Bill, was strong. Texts by Bill and the architectural historian Siegfried Giedion appeared in early M.A.C. exhibition catalogues, and Camille Graeser was given an exhibition in April 1949. The principal theorist for the group was the painter Gillo Dorfles. Several other members later worked as critics or published important theoretical texts, including Augusto Garau (no. 92), Galliano Mazzon (no. 93), Gianni Monnet and Luigi Veronesi.

As well as organizing numerous exhibitions, M.A.C. was involved from the outset in print publishing with the assistance of Giuseppe Salto's Milan bookshop, Libreria A. Salto, which specialized in architecture and the decorative arts. Salto's firm had been one of the principal supporters of the Galleria del Milione before the war. Giuseppe Salto spent the war in Switzerland, where he established links with the Allianz Verlag in Zurich, the publishing arm of the Allianz group. M.A.C.'s first exhibition, held in the bookshop in December 1948, was devoted to a portfolio of lithographs by twelve of its members, which was also published by the bookshop. Among the contributors were three artists closely associated with *Forma*, Piero Dorazio, Mino Guerrini (born 1927) and Achille Perilli. Another Rome-based abstract artist, Afro, featured in the second group album of lithographs (no. 88). Eight portfolios were published in all, and a ninth projected for publication in 1957. Single albums were devoted to Enrico Bordoni (1949) (no. 91), Gianni Monnet (1949), Luigi Veronesi (1949), Nino di Salvatore (1951), Carolrama (1956) and Simonetta Vigevano Jung (1956), all published by Libreria A. Salto. Catalogues for M.A.C.'s early exhibitions were gathered together in the publications *Arte Concreta 1949–50* and *Arte Concreta 1950–51*, of which a third of the editions were distributed abroad. These volumes were succeeded by twenty-four issues of the journal *Arte Concreta*, between November 1951 and June 1954, in which prints were frequently reproduced and discussed, and occasionally published. Screenprints, linocuts and lithographs were also published in *Documenti d'Arte d'Oggi*, four issues of which appeared between 1954 and 1958. In Alberto Oggero's *Antitesi* of 1956, another publication of M.A.C., the author's poems were arranged vertically in a narrow format to face lithographs by twelve artists, including Bordoni, Capogrossi, Fontana, Reggiani, Soldati and Veronesi.

M.A.C. Espace

Further prints were published in the pages of *Sintesi delle Arti*, a journal which lasted between May 1955 and November 1956. This was after the merger of M.A.C. with the French concrete abstract Groupe Espace, which had been founded in 1951 by the architect and sculptor André Bloc.[80] Two years earlier, Bloc had founded the influential French journal *Art d'Aujourd'hui*. He and his compatriot Léon Degand, the leading critic championing abstract art in France, had both contributed texts to *Arte Concreta 1950–51*. Among the founder members of Groupe Espace were Piero Dorazio and the Paris-based Italian sculptors Silvano

Bozzolini (1911–88) and Berto Lardera, and they were soon joined by Gianni Monnet. In 1955 Bloc's *Art d'Aujourd'hui* published a portfolio of *16 serigrafie dei maestri dell'arte astratta*, which was exhibited by the Art Club di Roma at the Galleria La Cassapanca.

Although essentially a Milanese group, M.A.C. organized exhibitions of the Florentine Gruppo concretista, and of work by the Argentinian sculptor Claudio Girola, brother of Ennio Iommi, one of the most significant post-war artists in South America. It is probable that Lucio Fontana, who had been in Argentina throughout the war, was responsible for suggesting this exhibition. Both of the exhibitions that M.A.C. organized outside Italy were held in Argentina, a touring show in 1952, and another show in Buenos Aires at the Kryad Galeria de Arte in 1954. Girola was a fellow member of the Arte Concreto with Alfredo Hlito and Tomás Maldonado, central figures in the Buenos Aires-based Asociación Arte Concreto Invención. Although Fontana was not a member of any of the Argentinian abstract groups, he was teaching in Buenos Aires at the Accademia Altamira which he founded in 1946, the year of the *Manifesto blanco*, the first statement of Spazialismo, which he played a large part in drafting. The work that Fontana produced on his return to Italy bore more relation to contemporary Argentinian abstract art, particularly to the sculpture of the Slovak exile Gyula Kośice (born 1924), as well as to the painting of Max Bill, than to any Italian work.[81]

M.A.C.'s international outlook was shown also by exhibitions of prints by the Paris group Graphies of lithographs by the Swiss painter Gottfried Honegger in 1950, of intaglio prints by Léon Prébandier and Albert Yersin and of a book of etchings by Léon Zack in 1952. Other exhibitions were devoted to a group of colour prints by Guglielmo Carro (1913–2001), Vincenzo Frunzo (born 1910), Bruno Guaschino (born 1906) and Giacomo Porzano (born 1925) from the La Spezia Gruppo dei Sette, and to the books and etchings of Silvano Bozzolini, one of a group of Italian abstract painters working in Paris in the circle of Magnelli. From Rome, Prampolini contributed texts to *Arte Concreta* 11 in 1953, *Sintesi delle Arti* in May 1955 and *Documenti d'Arte d'Oggi 1955/56*, and two graphic works by Capogrossi appeared in the 1956–7 issue of the latter journal.

Spazialismo, Arte Nucleare, Art Informel

Spazialismo was formulated in the *Manifesto blanco* in Buenos Aires in 1946, a document signed by the colleagues and students of Lucio Fontana, although not by the artist himself.[82] A series of six manifestos of Spazialismo, which developed and extended the ideas in the Argentinian manifesto, was published in Italy by Fontana with various co-signatories between 1947 and 1953. Adherents included architects, writers and artists, as well as Carlo

Cardazzo, one of the most significant dealers in contemporary art of the period working through his Galleria del Cavallino in Venice and Galleria del Naviglio in Milan. Spazialismo rebelled against the flat surfaces and illusory space of the traditional canvas. Drawing on advances in science and technology, it aimed at a total and transient experience, uniting colour, sound, movement, time and space. Fontana produced constructions and environments, and made use of neon light, challenging traditional concepts of painting and sculpture. Burri was a signatory to the fifth Spatialist Manifesto. Capogrossi, Roberto Crippa (1921–72), Emilio Scanavino (1922–86) and Sottsass were among the many artists to be associated with the movement.

The Movimento Nucleare, founded in 1951, also broke with the rigidity of Art Concret and geometric constructivism.[83] One of its three founders, Gianni Bertini (born 1922), had work published in *Arte Concreta 1950–1951*, and he also contributed to *Arte Concreta* 5 and 11. His colleague Enrico Baj contributed lithographs to *Documenti d'Arte d'Oggi* in 1958. Further to this, the text of the catalogue to the 1954 Venice Arte Nucleare exhibition was published in the 1954 issue of that journal. Nevertheless, the movement rejected geometric abstraction for a figuration in which Surrealist automatism played a significant part. The artists involved opposed the misuse of the forces unleashed by nuclear physics, and openly expressed their fear of imminent environmental disaster. Bertini wrote in the Manifesto of 1951 of a desire 'to communicate . . . those facts, cosmic, stellar, scientific or mechanical, which seem to me to have the essential fulcrum of our times'. Baj and other Arte Nucleare artists found an affinity with CoBrA, and joined the Mouvement Internationale pour une Bauhaus Imaginiste, founded in 1953 by Asger Jorn, and the Italian Giuseppe Pinot-Gallizio (1902–64), in ideological opposition to the Ulm School founded by Max Bill. Arte Nucleare aimed to be a European, rather than a simply Italian movement, to counter the rigidity of the rationalism of the original Bauhaus and its derivatives.

The other main European movement originating in the early 1950s was Art Informel, strands of which were also referred to as Art Autre, Tachisme and Lyrical Abstraction. Originating in France, as an expressive and gestural alternative to Geometric Abstraction, its sources lay in the art of Kandinsky, Klee, Dubuffet, Fautrier, Miró and Masson. In Italy artists such as Vedova, Antonio Corpora (1909–2004) and Burri were its prime exponents. Burri, Capogrossi, the painter and critic Mario Ballocco (born 1913) and the sculptor Ettore Colla (1898–1968) founded the Gruppo Origine in 1951, committing themselves to an anti-decorative art aiming at simplicity of expression. The group rejected spatial illusion and descriptive colour to concentrate on the elementary qualities of painting. Burri's use of materials such

as hessian and burlap stitched together in his paintings, was paralleled in the interest in materials found in the work of the Spanish artist Tàpies. Like Fontana, Burri challenged the idea of two-dimensional pictures. The sign, rather than the mark, was central to the work of Capogrossi. That Capogrossi's art was not gestural and more ordered and pictorial goes to show how groupings of artists in Italy were far from rigid.

American art and Italy
Until 1948 advanced American art was little seen in Italy. That year the dealer and collector Peggy Guggenheim exhibited 136 works by seventy-six leading contemporary American artists at the Venice Biennale, including six paintings by Jackson Pollock and paintings by William Baziotes, Arshile Gorky, Robert Motherwell, Mark Rothko and Clyfford Still. At the same time further paintings, a substantial number of them abstract, were shown in the official United States pavilion. In 1949 Peggy Guggenheim acquired the Palazzo Venier on the Grand Canal, and set up a public gallery there. Guggenheim's collection at this date was dominated by European masters, but over the years she was to acquire and display many more American abstract paintings and sculptures.[84] In 1950 she curated a major Pollock exhibition at the Museo Correr. Her presence in Venice attracted many American artists. So, for the first time, many Italian painters and sculptors had the opportunity to meet leading American avant-garde artists. Throughout the 1950s and 1960s, the American pavilion at the Biennale staged a series of influential exhibitions featuring the best in Abstract Expressionism and the various movements that followed it in the United States. In 1970 the contribution was confined to prints, which, up to then, had had very little space allotted to them in post-war Biennali. The artists included Joseph Albers, John Cage, Sam Francis, Jasper Johns, R.B. Kitaj, Roy Lichtenstein, Robert Motherwell, Claes Oldenburg, Robert Rauschenberg (who had won the Grand Prize at the Biennale in 1964), Ed Ruscha, Frank Stella and Andy Warhol. Beyond the Biennali, the Galleria Civica d'Arte Moderna in Milan staged a major exhibition of Abstract Expressionism in 1958, *The new American painting*. It is not, therefore, surprising that American art became increasingly influential on Italian artists.

In addition, several American artists settled in Italy, most notably Cy Twombly, who established himself in Rome in 1957, and the sculptor Beverly Pepper (born 1924). Twombly contributed to *L'Esperienza Moderna*, the short-lived Rome-based journal founded in 1957 by Achille Perilli and Gastone Novelli.[85] Works by Gorky, Franz Kline, Man Ray and Enrique Zanartu were also featured in this periodical, which was primarily oriented towards European Art Informel. Allied to the journal was Edizioni de l'Esperienza Moderna, which between 1958 and 1963 published a series of *livres d'artiste*, illustrated by lithographs by Perilli, Novelli, Ugo Sterpini (1927–2000) and Luigi Boille (born 1926). The Galleria La Tartaruga, founded in Rome in 1954, exhibited the work of several New York artists including Kline, Rothko and Rauschenberg, and particularly promoted American Pop Art. Its success encouraged Marlborough to establish a gallery in the Italian capital in 1962 under the direction of Carla Panicali. The Galleria Marlborough was a major force in the Italian art market until its closure in 1977. It regularly exhibited the work of many leading Italian abstract artists, and gave one-man shows to Pollock, Motherwell, Gottlieb and Rothko, as well as to Dubuffet, Moore, Ben Nicholson, Joe Tilson, Soto and Sutherland.[86]

Beverly Pepper made many prints with the Stamperia 2RC in Rome, which were exhibited at the branch of the Galleria Marlborough there. Mark Tobey, in 1958 the first American artist to win the major painting prize at the Venice Biennale since Whistler, lived in Basel from 1960, where he was visited by leading Italian artists, particularly Dorazio. Afro, Dorazio and the sculptor Consagra were three of a number of Italian artists to cross the Atlantic to teach in the United States. A number of leading New York dealers were Italian émigrés or had Italian ancestry, most notably Leo Castelli, and later Gian Enzo Sperone. Sperone ran a gallery in Turin before emigrating to America. The Italian art trade was soon to follow up the critical success of contemporary American art at the Venice Biennali by exhibiting the work of American painters. In the north, Carlo Cardazzo led the way in his Galleria del Naviglio. In Rome, the Galleria La Tartaruga began showing American art in 1957, the same year that the Galleria dell'Obelisco gave a one-man show to Arshile Gorky, the catalogue to which had an introduction by Afro. There was an increasing level of collaboration between Italian and American commercial galleries in the 1960s.

Italian print publishing 1950–75
From the mid-1950s many more Italian publishers became active in encouraging printmaking than in the immediate post-war years. In Milan, Arturo Schwarz published Manzù's lithographic illustrations to Salvatore Quasimodo's *Il falso e vero verde* in 1954, and, six years later, Fontana's ten etchings for Alain Jouffroy's *L'Epée dans l'eau*.[87] Schwarz's publications have ranged beyond Italian artists to issuing three separate portfolios of twenty etchings entitled *L'avanguardia internazionale* in 1962. This was the year in which the lithographic printer Giorgio Upiglio opened Grafica Uno, his workshop in Milan, where he is still active today as a printer and publisher.[88] Indeed, the majority of the *livres d'artiste* that have issued from the Lombard capital have come from his workshop. Although he was trained as a

GIOVANNI FATTORI
Woman of the Gabbro

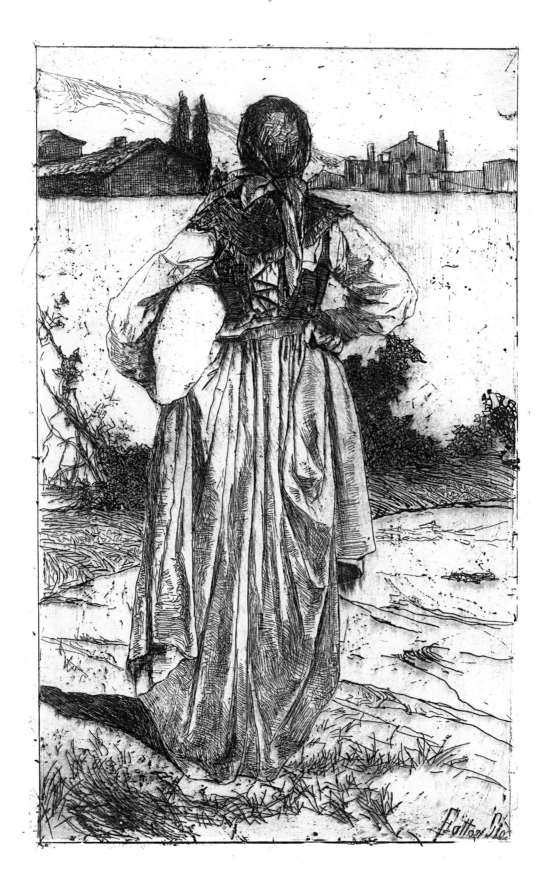

12
GIOVANNI FATTORI
Holy cow

ADOLFO DE CAROLIS
The howl of Achilles

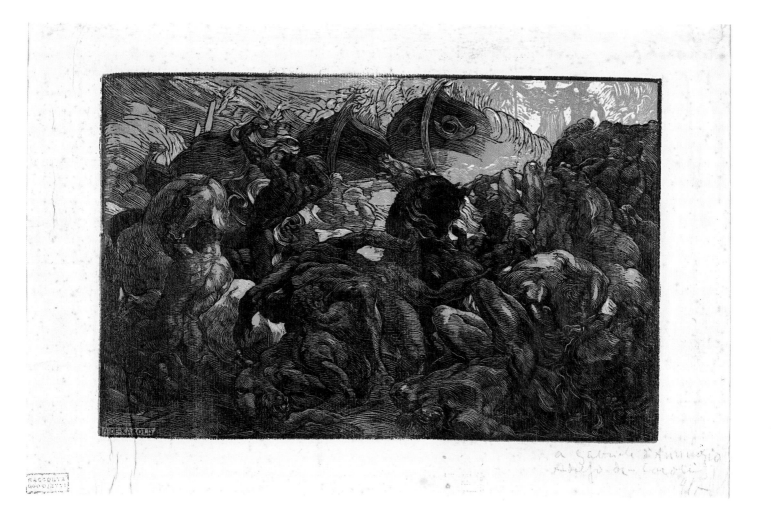

ALBERTO MARTINI
Portrait of a young woman

ALBERTO MARTINI
The beauty spot

7/10

GIOVANNI SEVERINI
Landscape and still life on a table

GIORGIO MORANDI
Large still life with paraffin lamp

GIORGIO MORANDI
Still life with thick lines

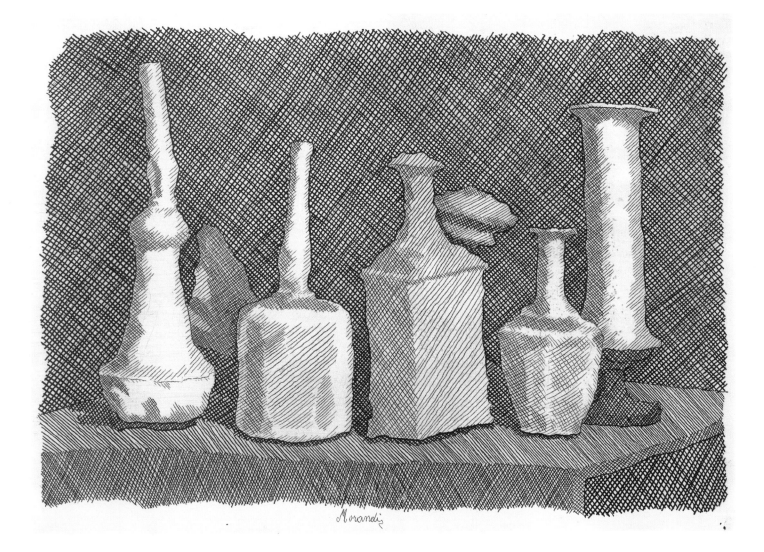

LUIGI BARTOLINI
The foals (The countryside at Monte Mario, Rome)

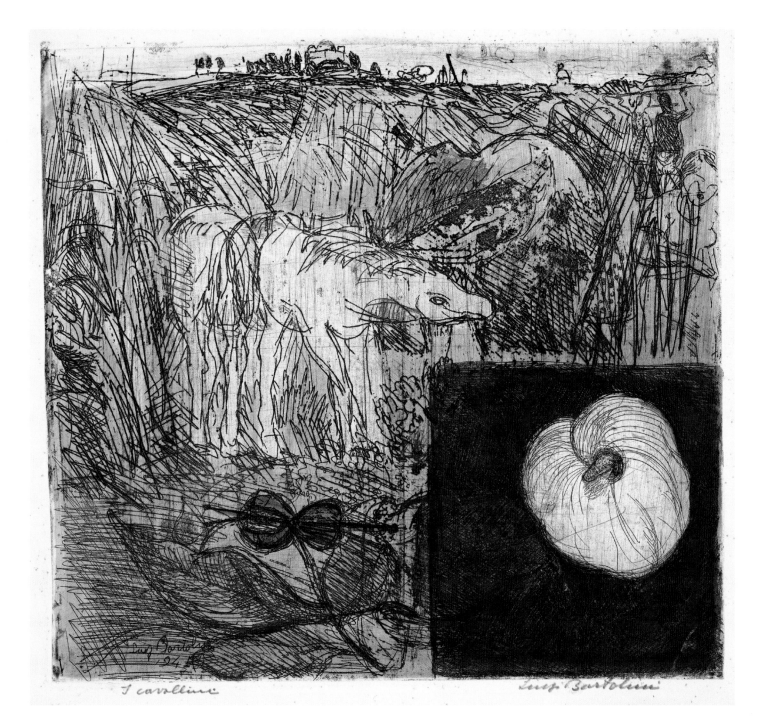

...ed ecco un gran drago...

GIORGIO DE CHIRICO
Horse at the Villa Falconieri

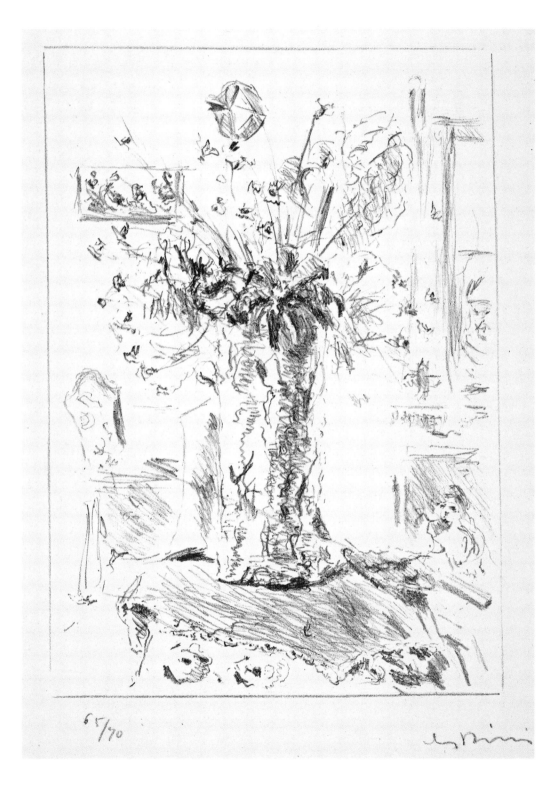

65/70

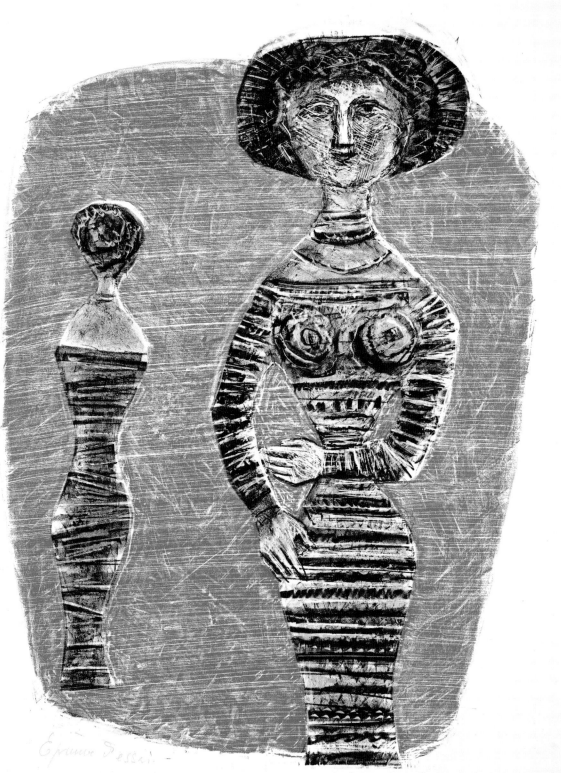

ALBERTO MAGNELLI
Untitled

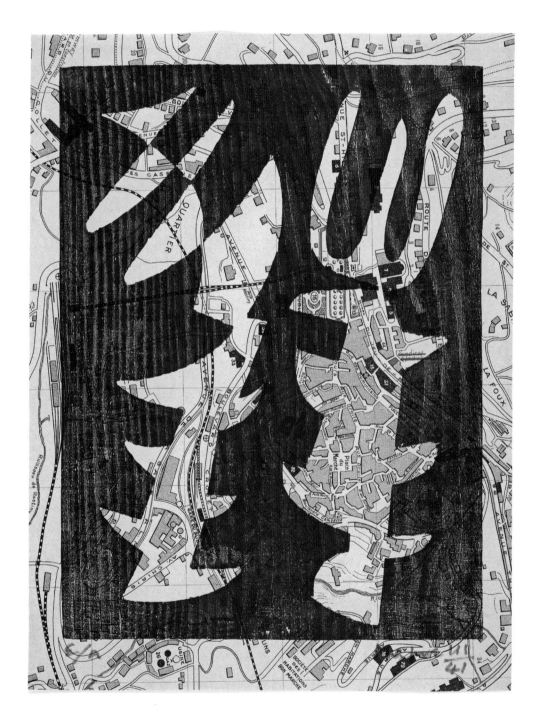

ALBERTO MAGNELLI
Composition with red

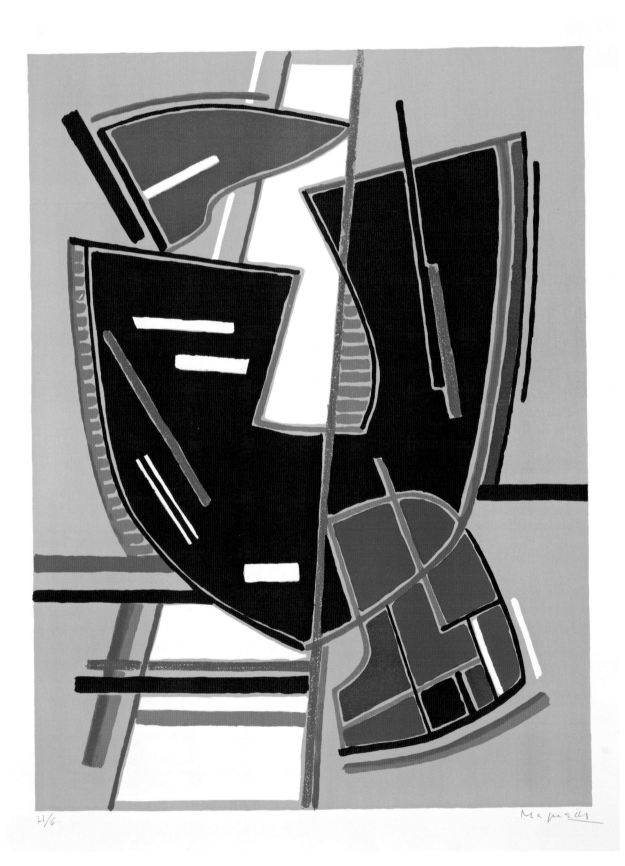

4/6.

ALBERTO MAGNELLI
Untitled

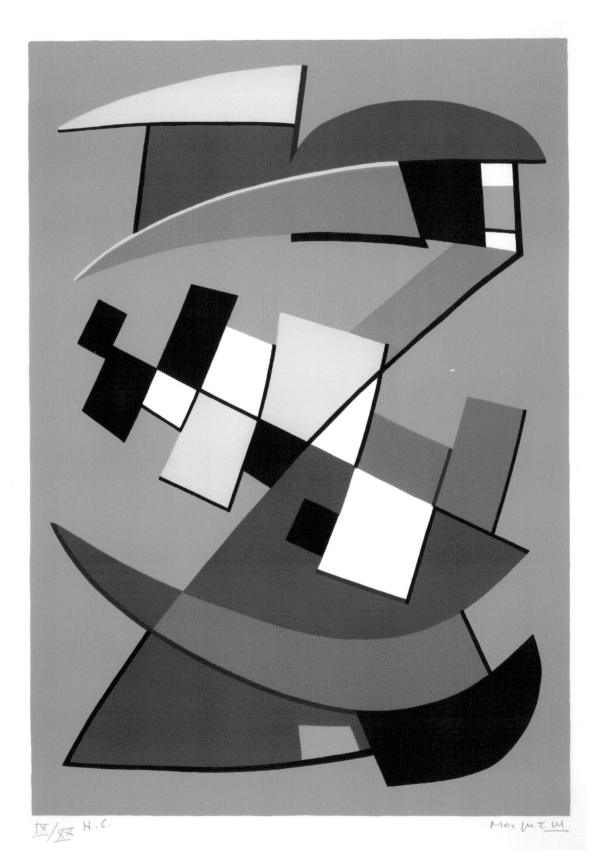

IX/XX H.C. Magnelli

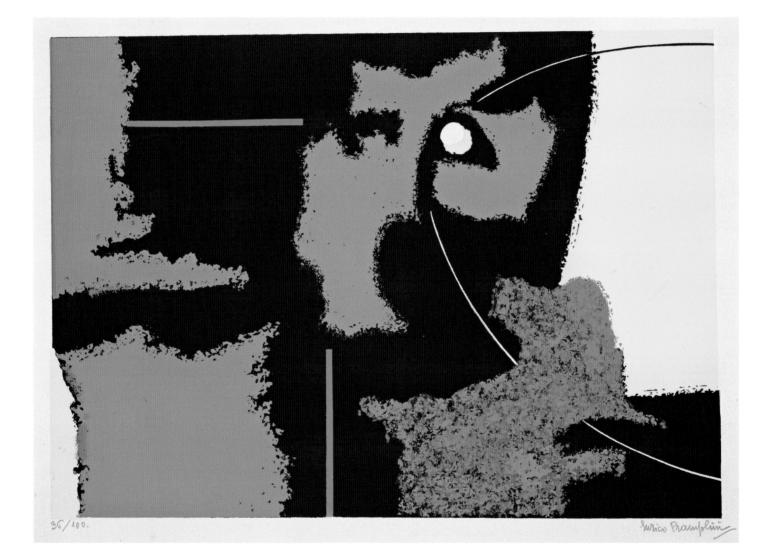

36/100. Enrico Prampolini

MARINO MARINI

The idea of the horseman

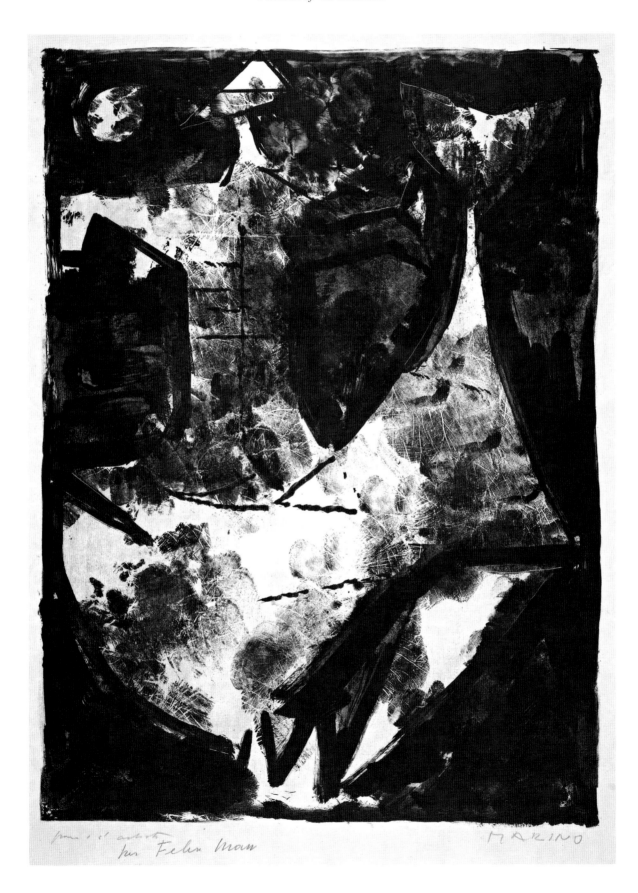

ZORAN ANTON MUSIĆ
Boats at Pellestrina

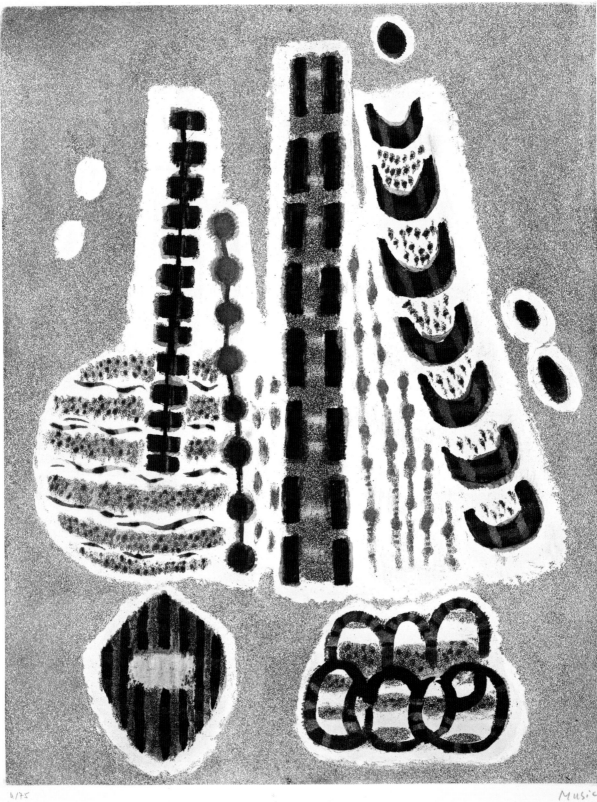

ZORAN ANTON MUSIĆ
Istrian earth

7/75 Music 59

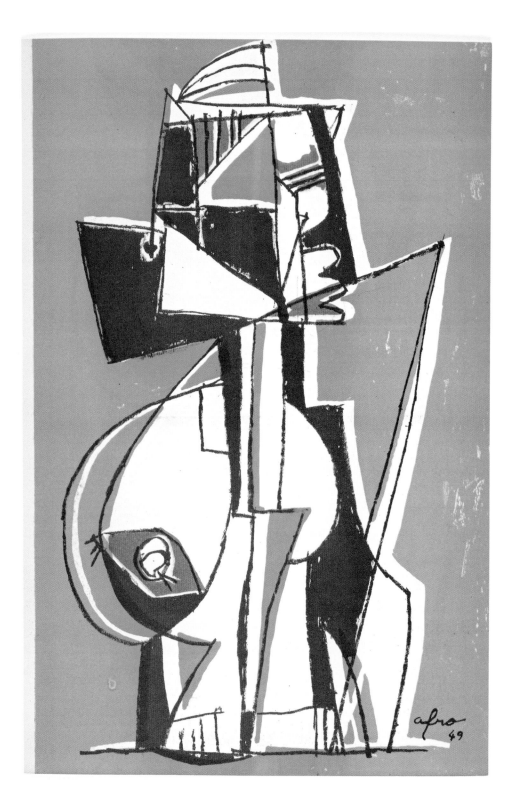

nova a Mr. Felix Man friendly afro, '66

ENRICO BORDONI
Untitled from *10 Litografie Originali*

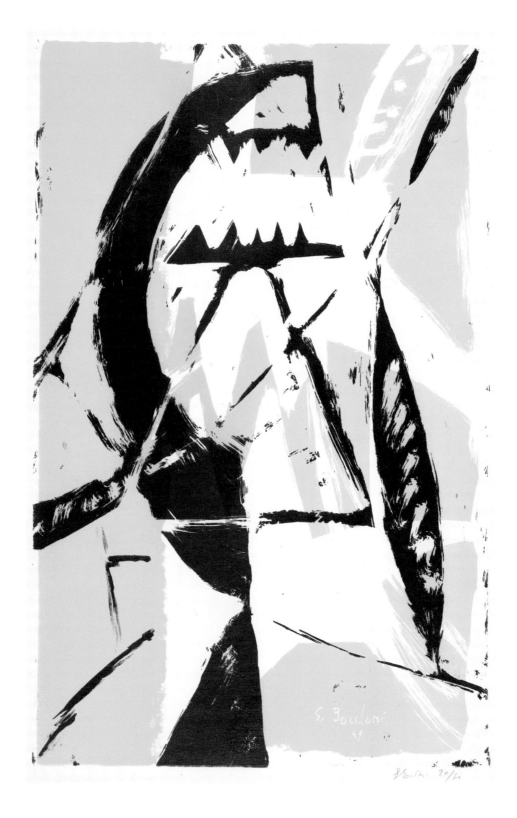

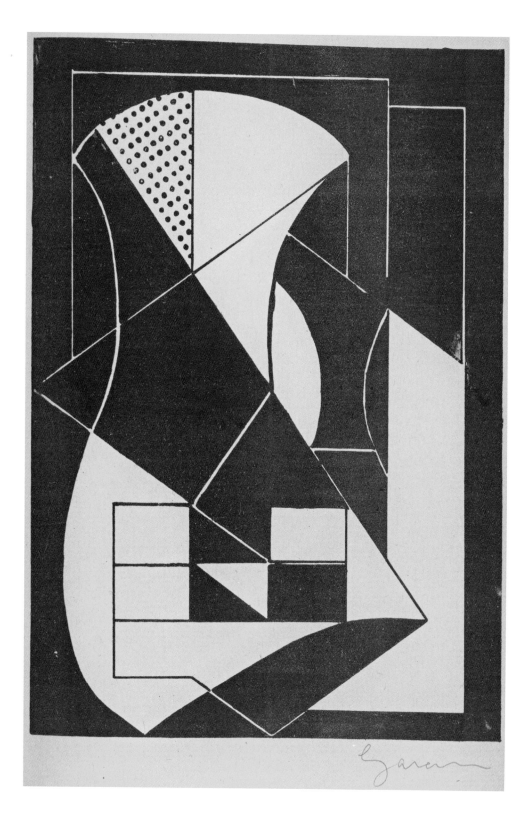

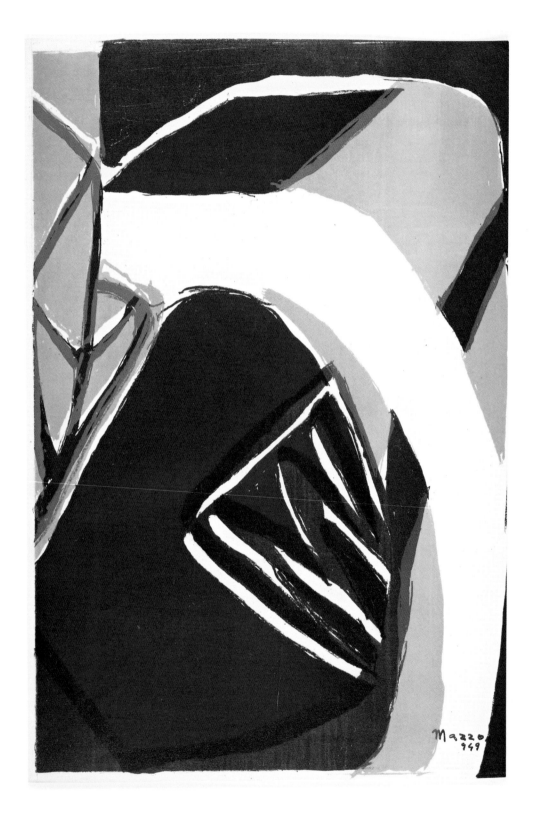

BRUNO MUNARI
Untitled

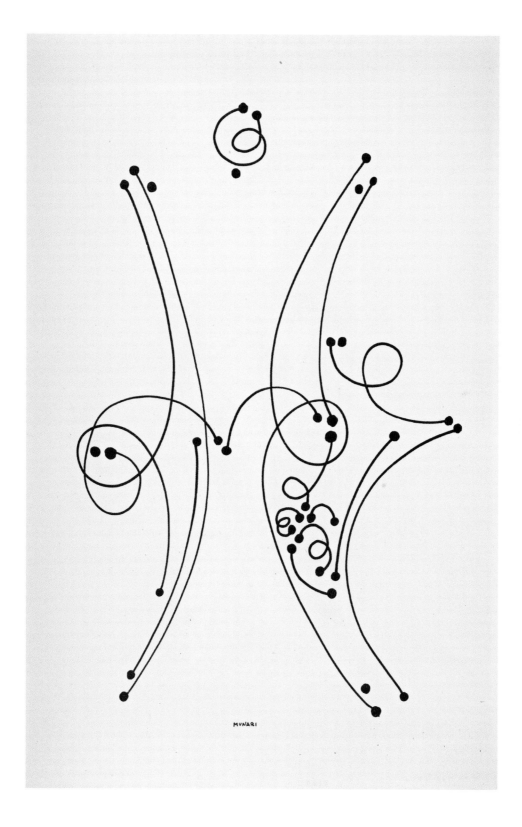

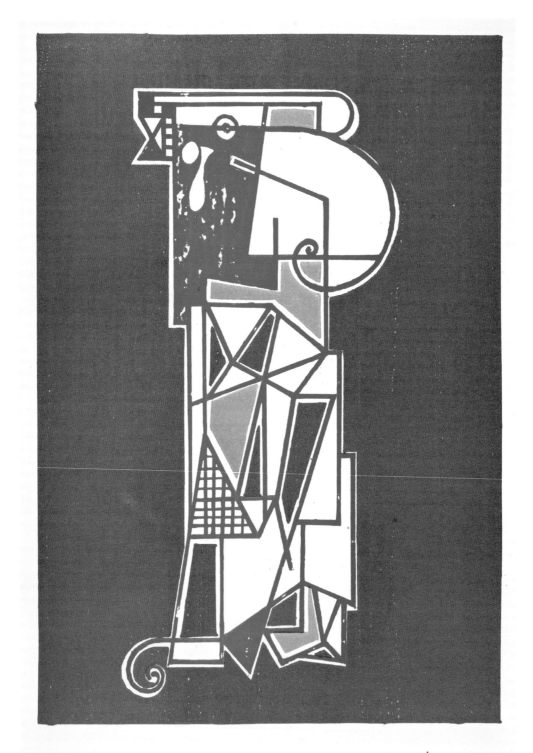

LUIGI VERONESI
Variation in red no. 4

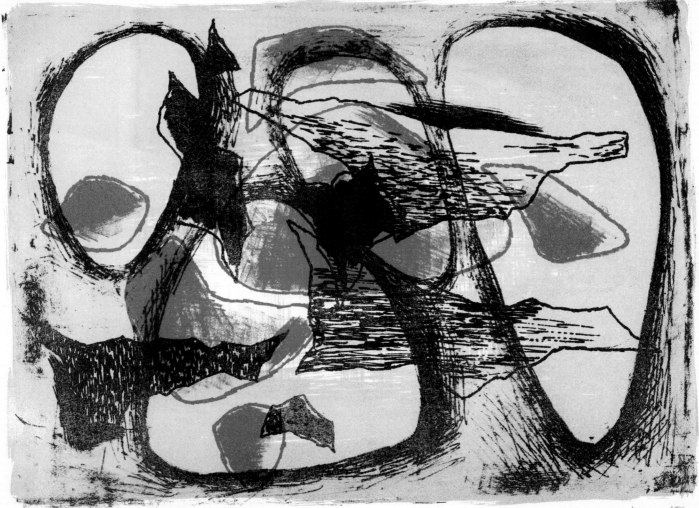

L. VERonesi '60 frammenti 4 15/15

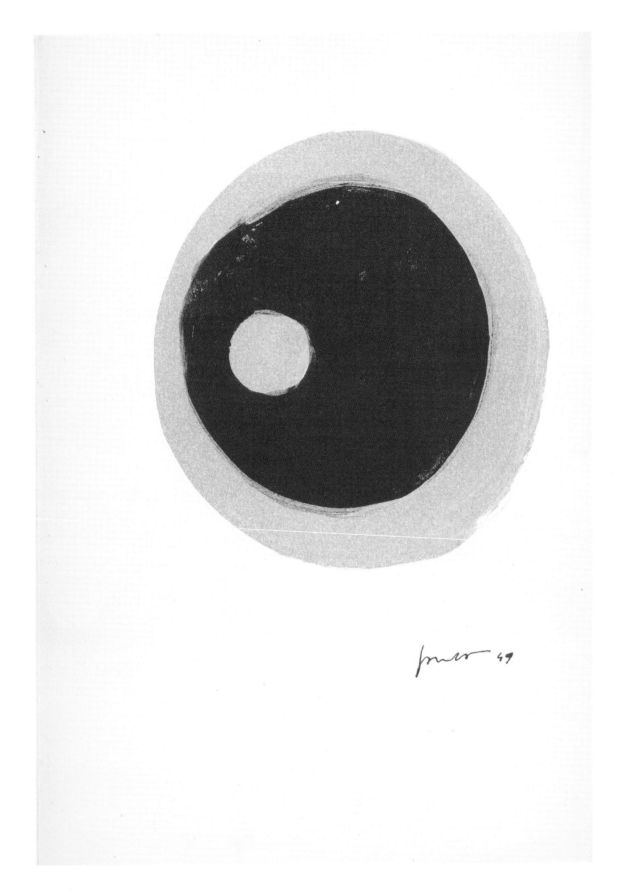

LUCIO FONTANA
Quattro litografie di Lucio Fontana

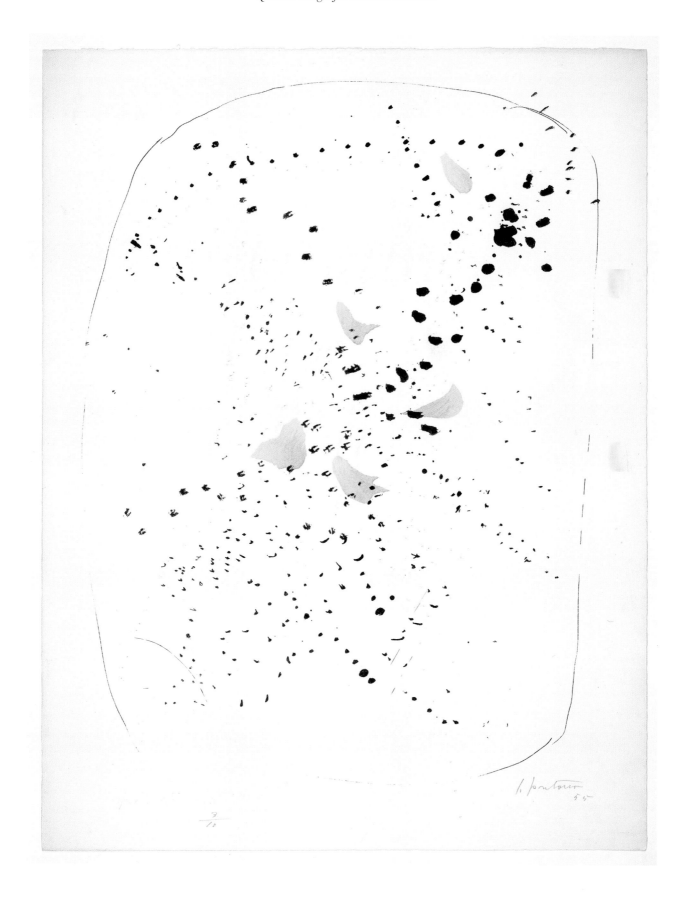

LUCIO FONTANA

Quattro litografie di Lucio Fontana

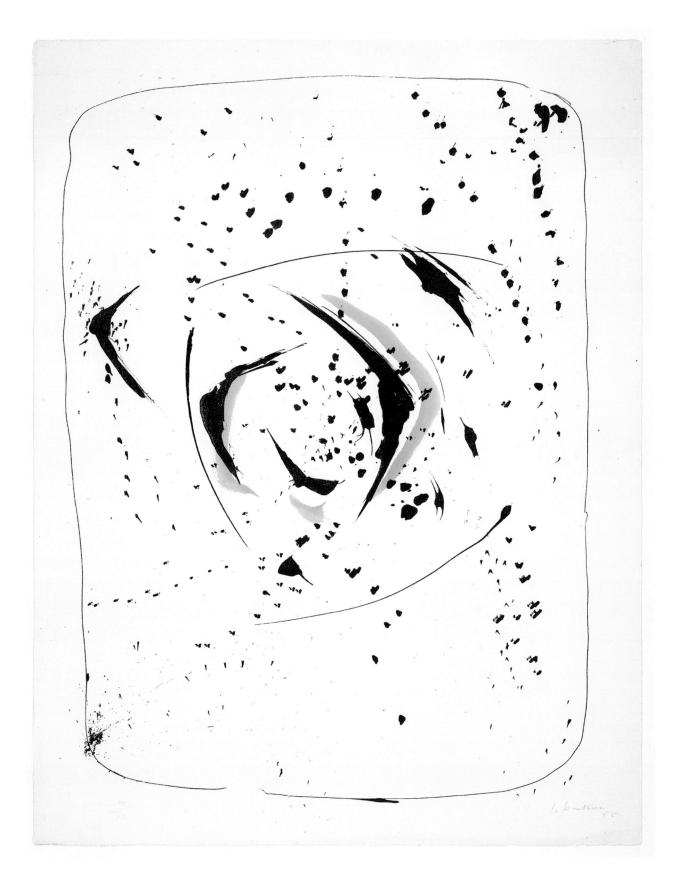

LUCIO FONTANA
Quattro litografie di Lucio Fontana

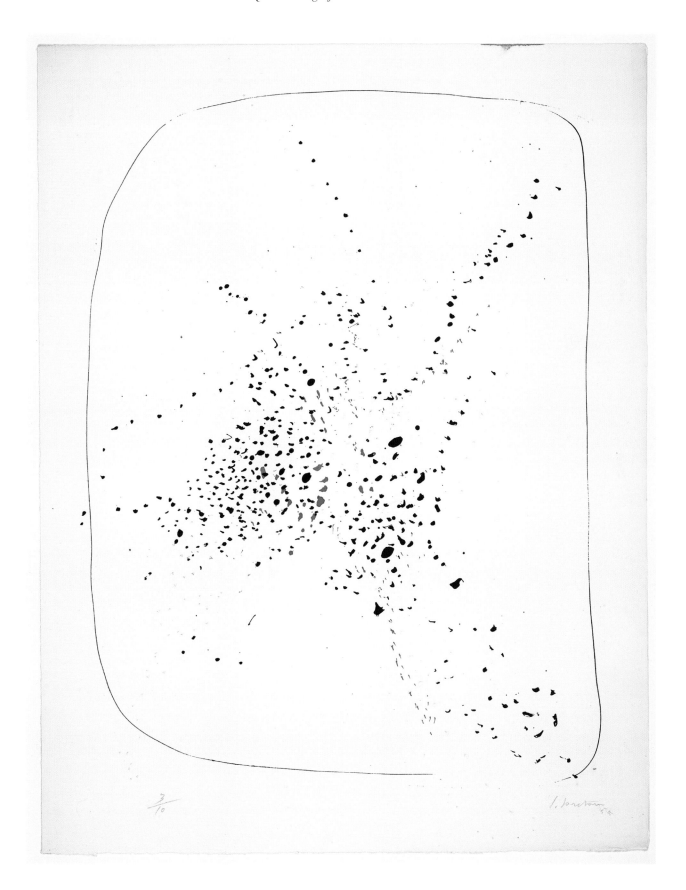

LUCIO FONTANA

Quattro litografie di Lucio Fontana

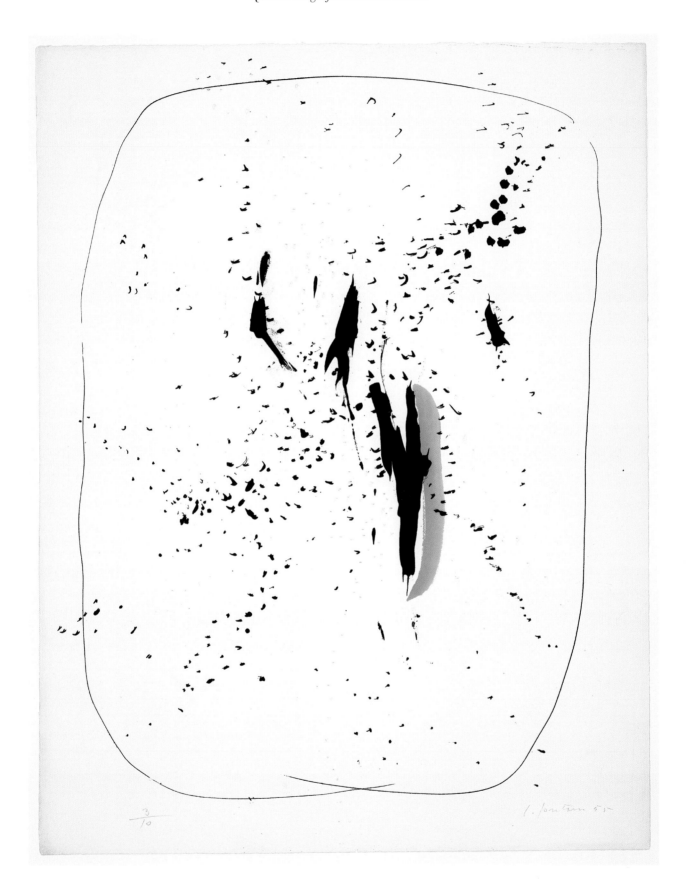

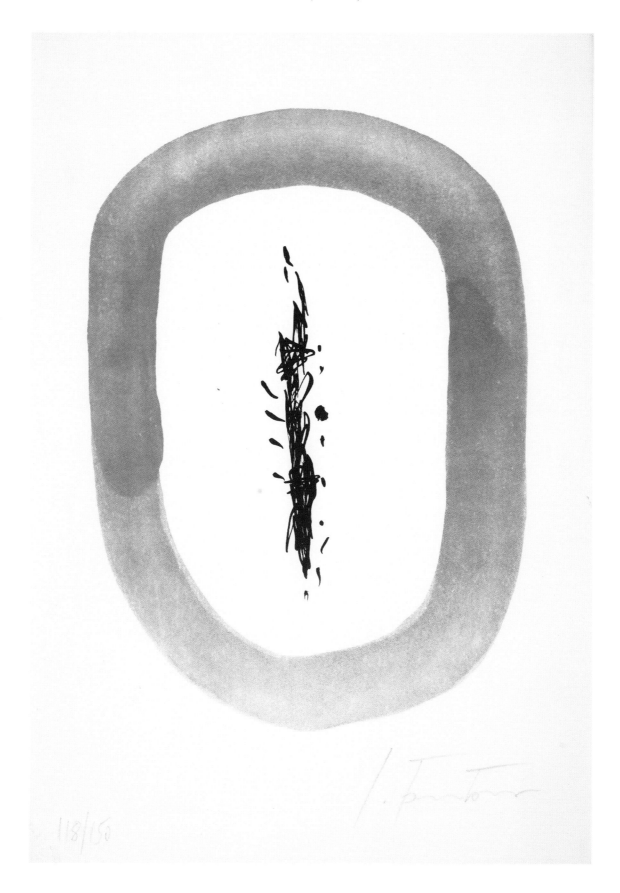

118/150

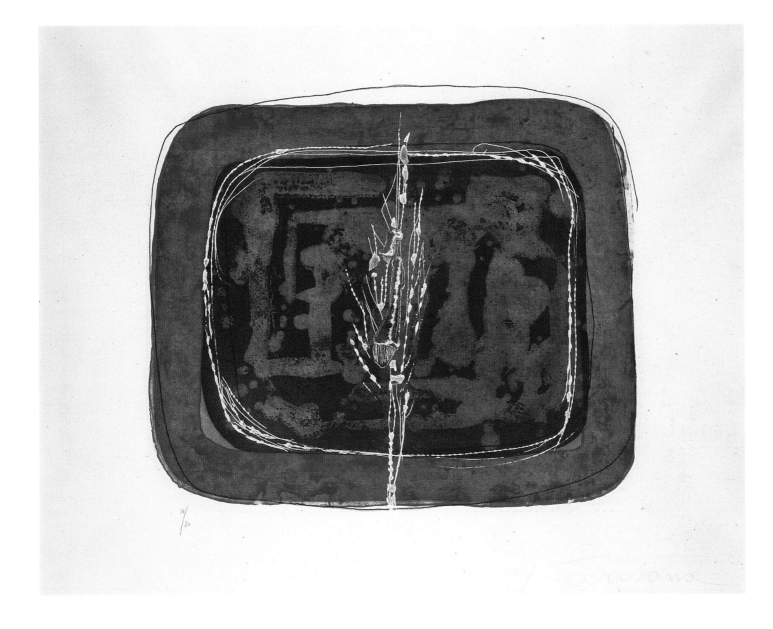

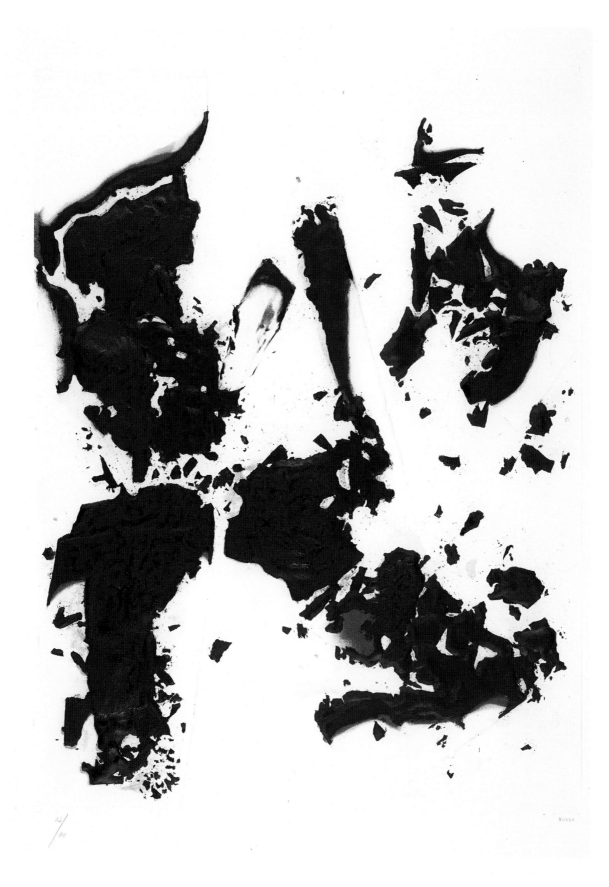

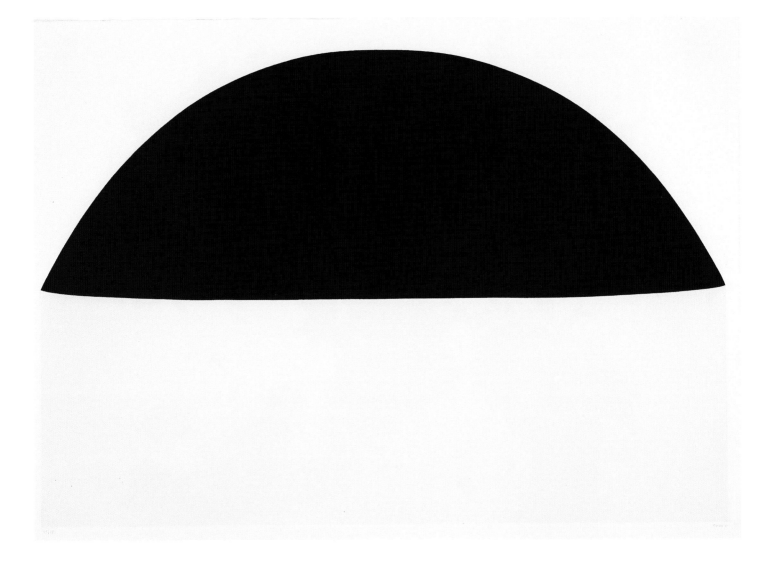

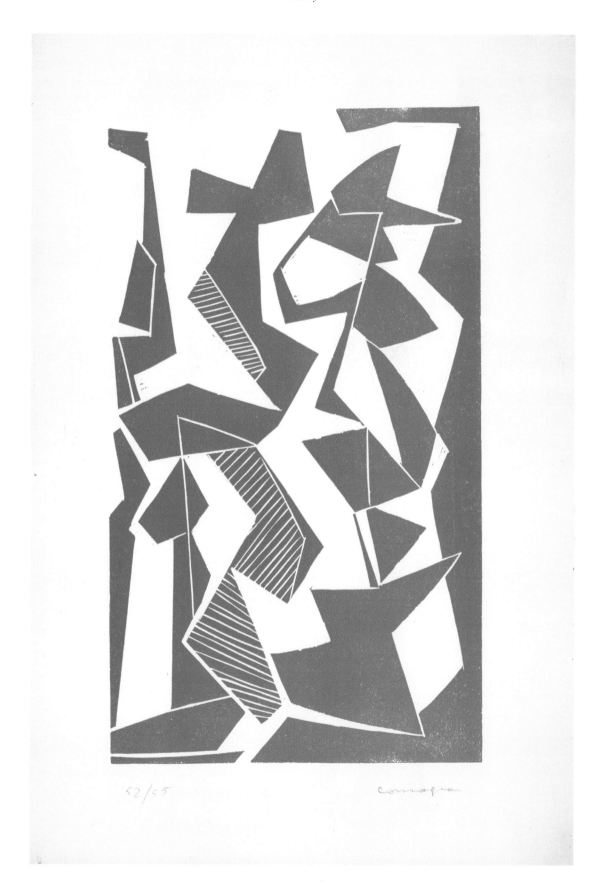

52/55 Consagra

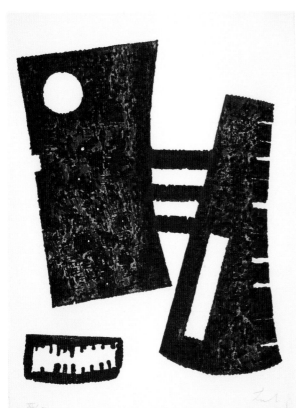

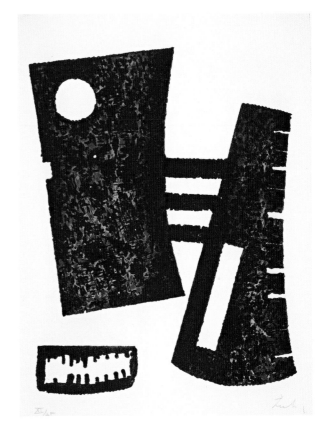

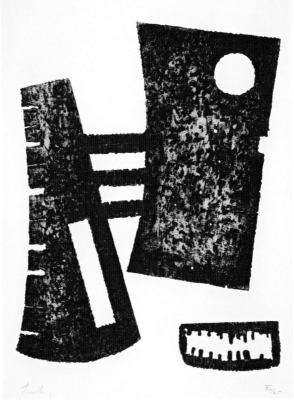

EMILIO VEDOVA
Spagna

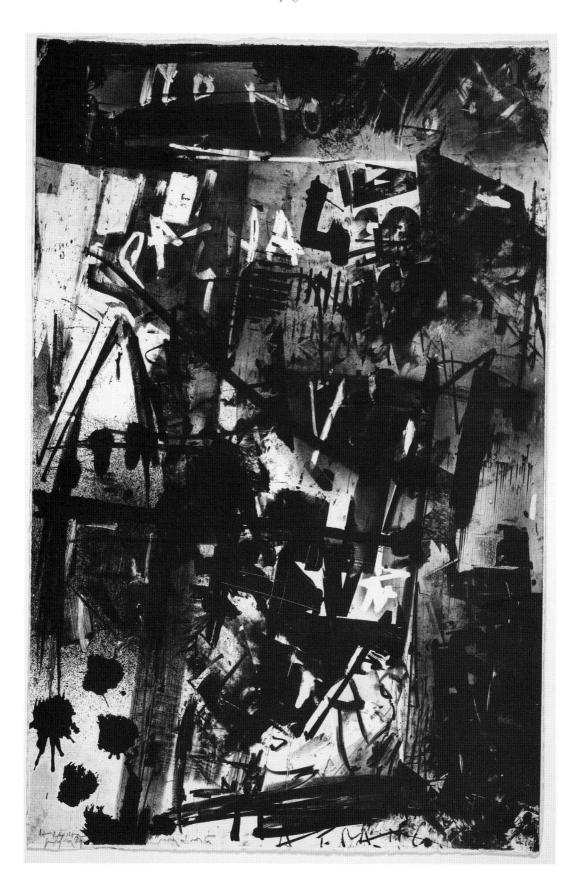

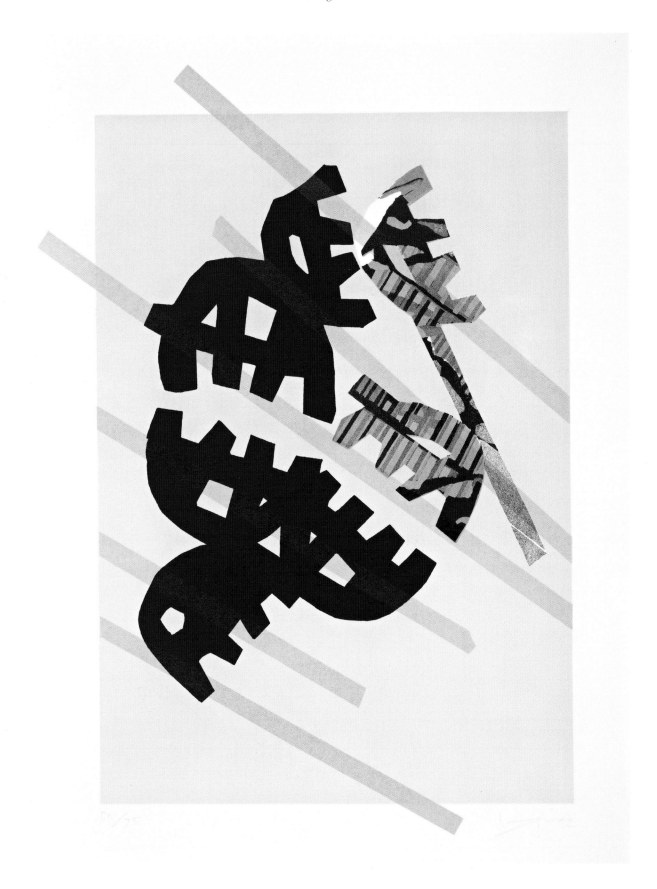

6/30

105/120

MARIO MERZ

The number increases (like): the fruits of the summer and the abundant leaves 1, 1, 2, 3, 5, 8, 13, 21, 34, 55 . . .

lithographic printer, Upiglio's workshop has also worked with woodcuts, screenprints, etchings, aquatints, engravings and mezzotints. Upiglio has collaborated with Schwarz, Studio Marconi and other galleries and publishers, as well as issuing *livres d'artiste* on his own account. Schwarz and Upiglio have been the preferred partners of Enrico Baj. Upiglio has also worked with artists as varied as Giorgio De Chirico, Luigi Veronesi, Lucio Fontana, Eugenio Carmi and the sculptor brothers Arnoldo and Giò Pomodoro (born 1930). Franco Sciardelli, who had a very fruitful partnership with the sculptor Fausto Melotti, was, from the establishment in 1966 of his Edizioni Sciardelli, for thirty years one of the leading intaglio printers in Milan.[89] Renato Volpini's Multirevol studio, just outside the city at Cornaredo, has been the outstanding printers of screenprints (no. 113).

In Rome, the principal workshops and publishers were Renzo Romero's Grafica Romero and Valter and Eleonora Rossi's Stamperia 2RC. Romero, who had previously worked as an art dealer directing the Galleria Bussola in Turin and the Galleria Pogliani in Rome, was introduced to printmaking by Roberto Bulla, whose family's commercial lithographic printing business had been established in that city in 1840.[90] After the war, Roberto Bulla began to work with contemporary artists, including De Chirico (no. 74), Maccari, Cagli, Savinio and Guttuso, as well as later with Capogrossi, Consagra, Dorazio and Perilli. Romero, who opened his workshop in 1960, with rare exceptions specialized in intaglio work. A notable exception was Emilio Vedova's 1961 portfolio of lithographs *Per la Spagna*.[91] Between 1960 and 1986 his workshop worked with abstract artists closely associated with Rome, most notably with Dorazio, Perilli, the sculptor Umberto Mastroianni (1910–98), Gastone Novelli (1925–68) and Consagra.

Stamperia 2RC, initially a print workshop founded in 1959 by Valter and Eleonora Rossi and her cousin Francesco Cioppi, later established a gallery.[92] The name 2RC derives from the two Rossis and Cioppi. International in outlook, the studio established close links with the Galleria Marlborough, a branch of the New York and London dealers Marlborough Fine Art, which used 2RC to print all the editions that it published. Many of these were co-publications. Stamperia 2RC printed lithographs and screenprints, as well as intaglio prints. Lucio Fontana (no. 101) and the sculptor Giò Pomodoro were among the earliest artists to start working there in 1963. The Rossis' most productive partnership with Alberto Burri lasted between 1962 and 1985 (nos. 102–3). 2RC also worked successfully with Giuseppe Santomaso (1907–90),[93] Capogrossi (no. 108), Dorazio, Consagra and Afro, among others. The studio also printed and published work by many American and European artists, including Sam Francis, Helen Frankenthaler, Adolph Gottlieb, Pierre Alechinsky, Eduardo Chillida, Max Bill and Victor Vasarely. Victor Pasmore, Richard

Smith and Graham Sutherland all published prints with 2RC. Stamperia 2RC and Galleria 2RC continue to flourish today.

Il Bisonte[94] was established in 1959 in Florence by Maria Luigia Guaita after a visit to the Edinburgh lithographers Harley Brothers.[95] The first premises were found by Enrico Vallecchi of the famous publishing family. Although the first artists to produce prints in the workshop included the abstract painter Emilio Scanavino (1912–86) and Giò Pomodoro, Guaita, unlike her Milanese and Roman contemporaries, with the help of Vallecchi, soon approached artists of the older generation to make prints with Il Bisonte. Soffici (no. 54) was the first and he invited Carrà to join him. Severini, Magnelli, the Futurist Primo Conti (1900–88), Maccari, Bartolini, Sassu, Afro (no. 89) and Manzù all worked in the Florentine print studio in its early years. Guaita, like the Rossis, also invited non-Italians, including Eduardo Arroyo, Alexander Calder, Lynn Chadwick, Jacques Lipchitz, Matta, Henry Moore, John Piper and Graham Sutherland to make prints. The only lithograph that Picasso made in Italy was with Il Bisonte. Although both abstract and figurative artists were welcomed, Lucio Fontana's choice to make an etching of a male nude in 1965 was in key with the overall emphasis on figuration in the products of the workshop. The workshop still operates successfully today. Central to the early years of the studio's operation were the printing skills of its technical director, the painter and etcher Rodolfo Margheri (1910–67). After his death, Raffaello Becattini continued to uphold the high standards. Intaglio and lithographic printmaking have been the strengths of the workshop, but woodcuts have also been occasionally made there. Il Bisonte's gallery has been important for the diffusion of its publications.

In Bologna, Libreria Prandi, for many years the most important dealer in Italy for prints of all periods, was also active from 1957 as a publisher of prints.[96] In 1972 the Bolognese firm published Riccardo Bacchelli's *Terra d'Emilia*, illustrated by Paolo Manaresi's etchings. Unlike most other Italian publishers, however, Prandi's policy was to commission a group of artists each to produce a single etching for an album. The Libreria also commissioned individual plates from the etcher Antonio Ligabue (1899–1965).

The presence of the Scuola del Libro in Urbino was doubtless one of the reasons for the emergence of two prolific print publishers in the Marche, Brenno Bucciarelli (1918–88) in Ancona[97] and Pier Giorgio Spallacci's Edizioni La Pergola in Pesaro.[98] Bucciarelli began publishing in 1960, and worked with Bartolini, Fontana, Veronesi and Arnaldo Ciarrocchi (1916–2004),[99] among other artists. Spallacci, who had been the printer for the Scuola del Libro, started Edizioni La Pergola in 1967. He often worked closely with Leonardo Castellani, but also with abstract artists,

such as Roberto Crippa. These two Marches publishers were joined by a third, Pio Monte Arte Studio, in Macerata in the early 1970s, who worked with Mario Merz (no. 114) and Pier Paolo Calzolari (born 1943), artists associated with Arte Povera.[100]

One of the most adventurous publishers was the painter and graphic designer Eugenio Carmi, whose Galleria del Deposito was founded in the fishing village of Boccadasse near Genoa in 1963.[101] In the half a dozen years of its existence it particularly championed Art Concret. A work by Carmi had been reproduced in the final issue of M.A.C.'s *Documenti d'Arte d'Oggi* in 1958. As the art director of a Genoese steel firm he had used screenprints to great effect in the signs that he designed. The Galleria del Deposito took up the mantle of the Movimento Arte Concreta. Gillo Dorfles and the young art historian Eugenio Battisti were the Galleria del Deposito's critical supporters. Carmi worked with the Croatian printer Brano Horvat (no. 112) in publishing screenprints, a technique that had become fashionable in the United States, France and Britain. The gallery was also a pioneer in the field of multiples. The Galleria del Deposito published screenprints by Max Bill, Sam Francis, Karl Gerstner, Richard Lohse, Jesus Raphael Soto, Joe Tilson and Victor Vasarely, alongside works by Capogrossi, Dorazio, Fontana, Munari, Arnaldo Pomodoro, Perilli and Carmi himself. The number of prints published by Carmi's gallery was very small compared with many of its contemporaries, but the uniformly high quality of its editions fully justifies its mention in this survey. Edizioni Multipli in Turin, operating from 1968, which followed on from the Galleria del Deposito in the field of multiples, also published prints, particularly by artists associated with the Arte Povera movement, a field in which their main rival became Marco Noire, also of Turin, who began publishing at the very end of the period covered by this exhibition.[102]

A single individual, the poet, philologist, translator and art critic Roberto Sanesi (1930–2002), was involved in the publication of 134 *livres d'artiste* in Italy, of which almost fifty were issued during the period covered by this exhibition.[103] A close friend of Baj, he provided the introduction for that artist's *De rerum natura* (no. 107), and participated in the Movimento Nucleare. Sanesi founded the Edizioni Triangolo in 1957. In that year he published a selection of his poems, commissioning Giò Pomodoro to illustrate them with lithographs. Subsequently he worked with a wide variety of publishers and artists. Several of the books were published by Luigi Majno's Milan-based M'Arte. Artists who have provided prints for his *livres d'artiste* have included Roberto Crippa, Marino Marini and Walter Valentini (born 1928), as well as the Japanese Masuo Ikeda and Kumi Sugai, and the Welshman Ceri Richards. Sanesi translated the work of W.B. Yeats, and the Welsh poets Dylan Thomas and Vernon Watkins, into Italian,

and spent much of the period 1958 to 1960 in South Wales. There, he became a friend of Richards, Graham Sutherland and Henry Moore. Sanesi was also the author of two books on Richards, including the catalogue raisonné of his prints, and one on Sutherland.

The choice to end this exhibition in 1975 reflects the fact that as yet the British Museum's collection of prints for the period 1975 to the present day is not as representative of the strengths of Italian printmaking of the most recent period as its holdings for the previous century. The date, however, does coincide with a peak in print publishing in Italy. The extraordinary flourishing of the contemporary art market in Italy in the late 1960s and early 1970s was marked by the annual *Catalogo Bolaffi della Grafica Italiana*, launched in 1970. These massive volumes, without parallel in any other European country, provided a photographic record of the prints by Italian artists that had been issued in the previous year. In the first volume 525 prints were recorded, including works printed by professional printers and by the artists themselves. Also included were lists of printers, print publishers and print galleries. From these one can see that the main centres for publishing were Milan, Rome and Turin, and the same cities together with Florence housed the highest number of printers. *Bolaffi* records no fewer than 712 prints as being published in 1972. In the years up to and including 1975 the number illustrated never fell below five hundred. The growth in the publishing and selling of prints was marked by the rise in the number of printers listed from 186 in 1969 to 215 in 1975, of print publishers from 228 to 240, and most dramatically in galleries selling prints from 227 to over 750. These numbers indicate that the art market for prints had developed enormously since the days of the Macchiaioli. For by the end of the century covered by this exhibition printmaking in Italy had been raised in terms of quantity of production to levels far surpassing that reached in the past. This show and catalogue aim to be an introduction to the history of the revival of printmaking in Italy that began in the years that the country achieved independence. As the recent acquisitions made by the British Museum reveal, Italian printmakers in the period 1875 to 1975 reached a quality fully worthy of comparison with their forebears. It is indisputable that Fattori, Morandi and Fontana, to select just three artists, were printmakers of international stature.

Notes

1 The prints of the Gigante have not been studied in detail, but there have been several books and exhibition catalogues devoted to their oils and watercolours, including Roberto Spadea, *Giacinto Gigante e la Scuola di Posillipo*, Sale della Loggia, Naples, 1993.

2 Rosa Vives, *Fortuny gravador. Estudi crític e catàleg raonàt*, Reus, 1991, and *Fortuny (1838–1874)*, Museu Nacional d'Art de Catalunya, Barcelona, 2003.

3 Guido Giubbini, *L'acquaforte originale in Piemonte e in Liguria 1860–1875*, Genoa, 1976.

4 Angelo Dragone, *Antonio Fontanesi: l'opera grafica*, Palazzo Chiablese, Turin, 1979.

5 Elizabeth Glassman, *Cliché-verre: hand-drawn: light printed: survey of the medium from 1839 to the present*, Detroit Institute of Arts, 1980, and *Le Cliché-verre: Corot et la gravure diaphane*, Musée d'Art et d'Histoire, Geneva, 1982.

6 Janine Bailly-Herzberg, *L'Eau-forte de peintre au dix-neuvième siècle. La Société des Aquafortistes 1862–1867*, 2 vols., Paris, 1972. For further information on Cadart and Italian artists, see pp. 16–17.

7 Giovanni Godi and Corrado Mingardi, *Alberto Pasini da Parma a Constantinopli via Parigi*, Palazzo Bossi-Bocchi, Parma, 1996.

8 Catherine Meneux, *Magie de l'encre: Félicien Rops et la Société internationale des aquafortistes (1869–1877)*, Musée provincial Félicien Rops, Namur, 2000.

9 Doriana Comerlati, ed., *Federico Faruffini pittore 1833–1869*, Castello Visconteo, Pavia, 1999.

10 Maxime Lalanne, *Traité de la gravure à l'eau-forte*, Paris, 1866.

11 Mario Chiodetti, *La Scapigliatura milanese: note, colori, versi, umori della Compagnia Brusca*, Museo d'Arte Moderna, Chiostro di Voltorre, Provincia di Varese, 2001.

12 Rosalba Dinoia, 'L'Eau-forte mobile dans l'évolution de l'estampe originale . . .', *Histoire de l'Art*, L, 2002, pp. 95–108.

13 Harvey Buchanan, 'Edgar Degas and Ludovic Lepic: an impressionist friendship', *Cleveland Studies in the History of Art*, II, 1997, pp. 32–120.

14 Gabriella Belli, *Divisionismo italiano*, Palazzo delle Albere, Trento, 1990, is one of many recent publications on Divisionism.

15 Annie-Paule Quinsac, *Vittorio Grubicy e l'Europa. Alle radici del divisionismo*, Milan, 2005.

16 Annie-Paule Quinsac, *Giovanni Segantini: luce e simbolo: 1884–1899*, Villa Menafoglio Litta Panza, Varese, 2000, is the latest of many studies of the artist.

17 The British Museum owns etchings by both brothers, 2004-5-31-30 and 2004-5-31-31.

18 Christie, Manson & Woods, London, 1 April 1989, *Monotypes by Pompeo Mariani and Giorgio Belloni*.

19 Norma Broude, *The Macchiaioli: Italian painters of the nineteenth century*, New Haven and London, 1988, and Albert Boime, *The art of the Macchia and the Risorgimento: representing culture and nationalism in nineteenth-century Italy*, Chicago and London, 1993, are two of many works on the subject.

20 Piero Dini, *Diego Martelli: storia di un uomo e un'epoca*, Turin, 1996. For Degas and Italy, see Ann Dumas, *Degas e gli italiani a Parigi*, Palazzo dei Diamanti, Ferrara, 2003, which is much fuller than the English edition of this catalogue.

21 Gianfranco Bruno, Eleonora Barbara Nomellini and Umberto Sereni, *Plinio Nomellini: la Versilia*, Florence, 1989.

22 Little has been written on Liegi. Vivian B. Mann, *Gardens and ghettos. The art of Jewish life in Italy*, New York, 1989, provides a succinct summary of his career.

23 Rosalba Dinoia, 'Les Aquafortistes italiens chez Cadart 1864–1881', *Nouvelles de l'Estampe*, CXC, 2003, pp. 6–31 and CXCIII, 2004, pp. 83–91.

24 Noël Clément-Janin, *La Curieuse Vie de Marcellin Desboutin, peintre, graveur, poète*, Paris, 1922.

25 Rosalba Dinoia, 'Antonio Mancini et la redécouverte du monotype en Italie dans la deuxième moitié du xix siècle', *Nouvelles de l'Estampe*, CXCI–CXCII, 2003–4, pp. 17–24.

26 Martin Hopkinson, *No day without a line. A history of the Royal Society of Painter Printmakers*, Oxford, 1999, p. 56.

27 Fabio Fiorani and Giovanna Scaloni, *Antonio Piccinni incisore*, Calcografia Nazionale, Rome, 2005, and Rosalba Dinoia, 'Tra invenzione e tradizione: ancora qualche riflessione su Antonio Piccinni acquafortista (1846–1920)', *Prospettiva*, CXV–CXVI, July–August 2004 (2005), pp. 184–92.

28 Lawrence Alloway, *The Venice Biennale 1895–1968: From Salon to goldfish bowl*, London, 1969, provides an overview of their history.

29 Libby Horner, ed., *Frank Brangwyn*, Leeds City Art Gallery, 2006.

30 *L'arte all'Esposizione del 1898*, Turin, 1898.

31 Rossana Bossaglia, Ezio Godoli and Mario Rosci, ed., *Torino 1902: le arti decorative internazionali del nuovo secolo*, Milan, 1994.

32 Rossana Bossaglia, Mario Quesada and Pasqualina Spadini, *Secessione Romana 1913–1916*, Palazzo Venezia, Rome, 1987.

33 Giuliana Donzello, *Arte e collezionismo: Fradaletto e Pica primi segretari alle biennali veneziane 1895–1926*, Florence, 1987.

34 Marco Lorandi, ed., *Un affettuosa stretta di mano: l'epistolario di Vittorio Pica ad Alberto Martini*, Milan, 1994.

35 Olivia Rossetti Agresti, *Giovanni Costa: his life, works and times*, London, 1904.

36 Emanuele Bardazzi in Paola Bonifacio, ed., *Alberto Martini e Dante. E caddi come l'uom che 'l sonno piglia*, Palazzo Foscolo, Oderzo, 2004, pp. 33–67.

37 Vito Salierno, *Gli illustratori di Gabriele D'Annunzio*, Chieti, 1989. See also Rossana Bossaglia and Mario Quesada, *Gabriele D'Annunzio e la promozione delle arti*, Villa Alba, Gardone Riviera, 1988, and Susanna Scotoni, *D'Annunzio e l'arte contemporanea*, Florence, 1981.

38 Guido Giubbini, *L'Eroica, una rivista italiana del Novecento*, Museo Civico di Belle Arti, Lugano, 1984.

39 Roberto Cadonici, *La grafica e la 'Tempra'*, Pistoia, 2000, and Edoardo Salvi, ed., *Il cerchio magico: omaggio a Renato Fondi, Pistoia 1887–Roma 1929*, Palazzo Comunale, Pistoia, 2002.

40 *L'Eroica*, XXVII–XXVIII, April–May 1915, p. 151, quoted by Umberto Giovannini, *Colore e libertà. La bella stagione della xilografia in Romagna*, Fondazione Cassa di Risparmio di Cesena, 2005, p. 32.

41 Rodolfo Fini, *Lorenzo Viani xilografo*, Milan, 1975, Alessandra Belluomini Pucci and Enrico Dei, *Lorenzo Viani opere grafiche e legni xilografici*, Palazzo Paolina, Viareggio, 2002, and various authors, 'Lorenzo Viani e l'Espressionismo Europeo', *Letteratura & Arte. Rivista Annuale*, II, 2004, pp. 13–145.

42 Pietro Zampetti and Silvia Cuppini Serri, *La Scuola del libro di Urbino*, Urbino, 1986.

43 Neri Pozza, *Leonardo Castellani opera grafica 1928–1973*, Vicenza, 1974, and *Ampliamenti alla grafica 1973–1984 Leonardo Castellani*, Vicenza, 1986. A substantial group of his prints is in the British Museum.

44 *Nino Barbantini a Venezia: atti del convegno organizata dalla Fondazione Bevilacqua La Masa*, Palazzo Ducale, Venice [1992], Treviso, 1995, and Maria Teresa Benedetti, 'La Fondazione Bevilacqua La Masa e le mostre di Ca' Pesaro', *Arte Documento*, VII, 1993, pp. 307–12.

45 Luigi Menegazzi, *Gino Rossi*, Museo della Casa Trevigiana, Treviso, 1974, and *Gino Rossi: catalogo generale*, Milan, 1984.

46 Although there is yet no catalogue raisonné of Martini's prints, there is a considerable recent literature on them, including Guido Perocco, 'Incisioni di Arturo Martini', *Notizie da Palazzo Albani*, Urbino, XII, nos. 1–2, 1983, pp. 323–7; *Il giovane Arturo Martini: opere dal 1905 al 1921*, Museo Civico 'Luigi Bailo', Treviso, 1989; Giuseppe Appella and Mario Quesada, *Arturo Martini: da 'Valori Plastici' agli anni estremi*, Rome, 1989; Nico Stringa, ed., *Arturo Martini: opere degli anni Quaranta*, Galleria della Fondazione Bevilacqua La

Masa, Venice, 1989; Marta Massaioli, *Arturo Martini a Faenza*, Rome, 1994, and Mirella Bentivoglio, '"Contemplazioni" di Arturo Martini: una nuova ipotesi', *Terzo Occhio*, XX, no. 4, 1994, pp. 32–3.

47 *Gruppo Romano Incisori Artisti*, Palazzo Venezia, Rome, 1988.

48 There is an enormous literature on Futurism. The fullest publication in English is Pontus Hulten, ed., *Futurism & Futurisms*, Palazzo Grassi, Venice, 1986.

49 Giovanni Lista, *'Le Livre futuriste' de la libération du mot au poème tactile*, Modena, 1984, and Mirella Bentivoglio, 'The reinvention of the book in Italy', *Print Collector's Newsletter*, XXIV, no. 3, pp. 93–6.

50 Gabriella Bella, *DeperoFuturista: Rome – Paris – New York*, Wolfsonian Foundation, Miami Beach, 1999, and, on the screenprints, Martin Hopkinson, 'Fortunato Depero', *Print Quarterly*, XXVIII, 2001, pp. 80–2.

51 Nadia Marchioni, ed., *La Grande Guerra degli artisti. Propaganda e iconografia bellica in Italia negli anni della prima guerra mondiale*, Museo Marini, Florence, 2005.

52 Umberto Giovannini, *Gino Barbieri 1885–1917. 'Sogni di Pace. Venti di Guerra'. Le xilografie*, Museo dell'Illustrazione, Ferrara, 2004.

53 Carlo Alberto Petrucci, *Le incisioni di Bucci. Mostra allestita dalla Calcografia Nazionale*, Rome, 1954, and Elena Pontiggia, *Anselmo Bucci 1887–1955. Pittore e incisore tra Parigi, Milano, e Monza*, Serrone della Villa Reale, Monza, 2005, who cites further literature.

54 Francesco Parisi and Massimiliano Vittori, *L'oro e l'inchiostro: gli incisori tra le due guerre nel 'Concorso della Regina'*, Centro Comunale di cultura 'Il Ghetto', Cagliari, 2004.

55 Renato Barilli and Franco Solmi, *La Metafisica: gli anni venti*, 2 vols., Galleria d'Arte Moderna, Bologna, 1980.

56 Paolo Fossati, Patrizia Rosazza-Ferraris and Livia Velani, *Valori Plastici*, Palazzo delle Esposizioni, Rome, 1998.

57 Maurizio Fagiolo dell'Arco and Claudia Gian Ferrari, *Les Italiens de Paris. De Chirico e gli altri in Paris nel 1930*, Palazzo Martinengo, Brescia, 1998.

58 Dino Formaggio, *Mostra del Novecento Italiano (1922–1933)*, Palazzo della Permanente, Milan, 1983.

59 Elena Pontiggia, *Da Boccioni a Sironi: il mondo di Margherita Sarfatti*, Palazzo Martinengo, Brescia, 1997, and Simona Urso, *Margherita Sarfatti dal mito del Dux al mito americano*, Venice, 2003.

60 Giulia De Marchi in Alida Moltedo Mapelli, ed., *Paesaggio Italiano. Stampe italiane della prima metà del '900 da Boccioni a Vespignani*, Calcografia, Rome, 2003, pp. 33–45.

61 Giuseppe Bottai, *La politica delle arti: scritti 1918–1943*, Rome, 1992; Francesco Rossi, *Anni del Premio Bergamo: arte in Italia intorno gli anni Trenta*, Galleria d'Arte Moderna e Contemporanea and Accademia Bergamo, 1993, and Emilio Raffaele Papa, *Bottai e l'arte: un fascismo diverso? La politica culturale di Giuseppe Bottai e il Premio Bergamo 1939–1942*, Milan, 1994, the last of which the author has not seen.

62 Luciano Troisio, *Le riviste di strapaese e stracittà: Il Selvaggio, L'Italiano, '900'*, Treviso, 1975, and Donatella Cipressi and Barbara Cinelli, *Mino Maccari: l'avventura de 'Il Selvaggio': artisti da Colle a Roma 1924–1943*, Museo di San Pietro, Colle di Val d'Elsa, 1998. For Maccari's prints, see Francesco Meloni, *Mino Maccari: catalogo ragionato delle incisioni*, 2 vols., Rome, 1979.

63 The other significant Italian printmaker to make bold attacks on Fascism was the militant Communist Tono Zancanaro: see Raffaele De Grada, ed., *Tono Zancanaro, Il Gibbo. Satira del ventennio. Disegni e incisioni 1937–1945*, Venice, 1964, and Sileno Salvagnini in *Segni del Novecento. La donazione Neri Pozza alla Fondazione Giorgio Cini. Disegni, libri illustrati, incisioni*, Galleria di Palazzo Leoni Montanari, Vicenza, 2003, pp. 141–3.

64 Norbert Nobis, ed., *Abstraction Création*, Musée d'Art Moderne de la Ville de Paris, 1978.

65 For Carlo Belli, see Giuseppe Appella, Gabriella Belli and Mercedes Garberi, ed., *Il mondo di Carlo Belli. Italia anni Trenta: la cultura artistica*, Archivio del '900, Rovereto, 1991, and Peter Gruhne, *Carlo Belli und die Utopie von der absoluten Kunst*, Frankfurt am Main, 1995. The second edition of *Kn*, Milan, 1972, can be found in several British libraries.

66 Massimo Dradi and Pablo Rossi, *Campo Grafico, la sfida della modernità*, Biblioteca Nazionale Braidense, Milan, 2003.

67 Mario De Micheli, *Corrente: il movimento d'arte e di cultura di opposizione 1930–1945*, Palazzo Reale, Milan, 1985.

68 A copy of Martini's *livre d'artiste* is owned by the Victoria and Albert Museum.

69 Hans Schmoller, ed., *Officina Bodoni. An account of the work of a hand press 1923–1977*, 2 vols., Verona, 1980, and Franco Origoni and Sergio Marinelli, *Giovanni Mardersteig: stampatore, editore, umanista*, Museo del Castevecchio, Verona, 1989.

70 Angelo Colla and Renato Zironda, *Neri Pozza Editore*, Vicenza, 1986.

71 Chiara Negri, ed., *Scheiwiller a Milano 1925–1983: immagini e documenti*, Milan, 1983.

72 Lucia Cavazzi, *Una collezionista e mecenate romana, Anna Laetitia Pecci Blunt 1886–1971*, Palazzo Braschi, Rome, 1991.

73 Antonella Fantoni, *Il Gioco del Paradiso.*
La collezione Cardazzo e gli inizi della Galleria del Cavallino, Venice, 2005.

74 Publisher of two series of monographs on contemporary French and Swiss artists, *Art-documents* and *Peintres et sculpteurs d'hier et d'aujourd'hui*, and of several major catalogues raisonnés of the oeuvres of printmakers. *Pierre Cailler, editeur d'art*, Musée de Pully, 1987.

75 Bernardo Wyder, *Lascito Nesto Jacometti*, 2 vols., Pinacoteca Comunale Casa Rusca, Locarno, 1994.

76 Heiny Widmer et al., *Bon à tirer. Ateliers Lafranca*, Aargauer Kunsthaus, Aarau, 1980.

77 Rainer Michael Mason, *Peter Kneubühler and artists of his time / Peter Kneubühler a umelecki jeho diény*, Uměleckoprůmyslove Museum, Prague, 2003.

78 *Forma 1 e i suoi artisti: Accardi, Consagra, Dorazio, Perilli, Sanfilippo, Turcato*, Galleria Comunale d'Arte Moderna e Contemporanea, Rome, 2001.

79 Luciano Caramel, ed., *M.A.C.: movimento arte concreta*, 2 vols., Galleria d'Arte Moderna, Gallarate, 1984, and Giorgio Maffei, *M.A.C. Movimento Arte Editoriale*, Milan, 2004.

80 Renée Diamant-Berger, 'De l'Union pour l'art à l'association pour une synthèse des arts plastiques et au groupe Espace', *Aujourd'hui*, LIX–LX, 1967, pp. 54–5. The complete issue was devoted to André Bloc.

81 Gabriel Pérez-Barriero, in David Elliott, ed., *Argentina 1920–1994*, Museum of Modern Art, Oxford, 1994, pp. 54–65, summarizes Argentinian Art Concret of the period.

82 Luca Massimo Barbero, ed., *Spazialismo: Arte astratta. Venezia 1950–1960*, Basilica Palladiana, Vicenza, 1996.

83 Tristan Sauvage [Arturo Schwarz], *Nuclear Art*, Stockholm, 1962.

84 Angelica Zander Rudenstine, *Peggy Guggenheim Collection, Venice*, The Solomon R. Guggenheim Foundation, New York, 1985. The most recent biography is Mary V. Dearborn, *Mistress of Modernism: the life of Peggy Guggenheim*, Boston, 2004.

85 For *L'esperienza moderna* see *L'esperienza moderna 1957–1959*, Marlborough Galleria d'Arte, Rome, 1976.

86 A list of the Galleria Marlborough's exhibitions is published in Emmanuelle Orenga de Gaffory's thesis, *La Galleria Marlborough di Roma dal 1962 al 1977 nel panorama del mercato artistico internazionale*, Università degli Studi di Roma 'La Sapienza', 2003.

87 Arturo Schwarz, ed., *1954–1964: ten years of numbered editions*, Galleria Schwarz, Milan, 1964, and Ariella Giulivi and Raffaela Trani, *Arturo Schwarz: la Galleria 1954–1975*, Milan, 1995.

88 Antonio Acampora, Kirby Ann Atterbury and Patrick Creagh, *Giorgio Upiglio stampatore in Milan. L'opera grafica*, Milan, 1975; Osvaldo

Patani, *Atelier Upiglio 1962–1985*, Turin, 1985; and Letizia Tedeschi and Marco Francioli, ed., *Incidere ad arte. Giorgio Upiglio stampatore a Milano 1958–2005. L'atelier, gli edizioni, gli artisti*, Fondazione Archivio del Moderno, Mendrisio, and Museo Cantonale d'Arte, Lugano, 2005.

89 Maurizio Giongo, Claudio Nicolodi and Mauro Cappelletti, *Fausto Melotti. La descrizione dell'invisibile. Opere realizzate nella Stamperia Sciardelli*, Palazzo Libera, Trento, 1991, and http://www.libreriamarini.it/edizionisciardelli.htm.

90 Giuseppe Appella, ed., *I Bulla: editori – stampatori d'arte tra XIX e XX secolo*, Accademia di San Luca, Rome, 2001.

91 Federica Di Castro, *La linea astratta italiana: Stamperia Romero 1960–1986*, Calcografia Nazionale, Rome, 1989.

92 As yet there has been no publication on 2RC, apart from the exhibition catalogues Ebria Feinblatt, *Big prints from Rome*, Pacific Design Center, Los Angeles, 1980, and Erich Steingraber, *Meisterwerke der Graphik 30 Jahre 2RC Edizioni d'Arte*, Galerie Ruf, Munich, n.d. [1990]. Valter Rossi's autobiography is at the moment in press.

93 Franco Calderoni, *Santomaso, opera grafica 1938–1975*, Rome, 1975.

94 The latest history of Il Bisonte is Laura Gensini, ed., *Il segno impresso. Il Bisonte. Storia di una stamperia d'arte*, Sala delle Regie Poste, Piazzale degli Uffizi, Florence, 1999. Much more information is to be found in *'Il Bisonte'. Una stamperia d'arte a Firenze (1959–1982)*, Galleria degli Uffizi, Florence, 1987.

95 Christopher Allan, *Artists at Harley's: Pioneering Printmaking in the 1950s*, Hunterian Art Gallery, University of Glasgow, 2000, and Martin Hopkinson, 'Il Bisonte', *Print Quarterly*, XIX, 2002, p. 76.

96 Fabrizio Dall'Aglio, *I Prandi: librai, editori, mercanti d'arte*, Milan, 1987.

97 Studio Bibliografico Marini http://www.libreriamarini.it/edizionibucciarelli.htm.

98 Studio Bibliografico Marini http://www.libreriamarini.it/spallacci.htm.

99 D. Cecchi, *Arnoldo Ciarrocchi acqueforti dal 1938 al 1970*, Rome, 1970.

100 Richard Flood and Frances Morris, *Zero to infinity: Arte Povera 1962–1972*, Tate Modern, London, 2000.

101 Sandra Solimano, *La Galleria del Deposito. Un'esperienza nella Genova negli anni '60*, Museo d'Arte Contemporanea, Villa Croce, Genoa, 2003.

102 Gilbert Perlein, *Arte povera: les multiples 1966–1980*, Musée d'Art Moderne et d'Art Contemporain, Nice, 1996.

103 Studio Bibliografico Marini http://www.libreriamarini.it/robertosanesi.htm.

Select bibliography

Listed here are useful publications which are not cited in the footnotes to the Introduction.

Monographic exhibition catalogues, books and articles are recorded after the biographies of each of the artists included in this exhibition.

History of Italy

Clark, Martin, *Modern Italy 1871–1995*, London, 1996

Davis, John A., ed., *Italy in the nineteenth century*, Oxford, 2000

Dizionario biografico degli Italiani, Rome, 1960–

Hearder, Harry, *Italy in the age of the Risorgimento 1790–1870*, London, 1988

Italian art

Arte e socialità in Italia dal realismo al simbolismo 1865–1915, Palazzo della Permanente, Milan, 1979

Ballo, Guido, *La linea dell'arte italiana. Dal simbolismo alle opere moltiplicate*, 2 vols., Rome, 1964

Belli, Carlo, Maria Cernuschi Ghiringhelli, Alberto Longatti and Nello Ponente, *Anni creativi al 'Milione' 1932–1939*, Palazzo Novellucci, Prato, 1980

Benzi, Fabio, *Il Liberty in Italia*, Chiostro del Bramante, Rome, 2001

Benzi, Fabio, Gianni Mercurio and Luigi Prisco, *Roma 1918–1943*, Chiostro del Bramante, Rome, 1998

Bossaglia, Renata, *Il Novecento Italiano*, Milan, 1979

Braun, Emily, ed., *Italian art in the 20th century*, Royal Academy of Arts, London, 1989

Corgnati, Martina, *Arte a Milano 1946–1959*, Galleria Gruppo Credito Valtellinese, Sondrio, 1999

Fiori, Teresa, *Archivi del Divisionismo*, 2 vols., Rome, 1968

Gambillo, Maria Drudi and Teresa Fiori, *Archivi del futurismo*, Rome, 1962

Gli annittrenta: arte e cultura in Italia, Galleria Vittorio Emanuele, Milan, 1982

Olson, Roberta J.M., ed., *Ottocento. Romanticism and revolution in 19th-century painting in Italy*,

The American Federation of Arts, New York, 1992

Pirani, Federica, *Il Futuro alle Spalle. Italia Francia – L'arte tra le due guerre*, Palazzo delle Esposizioni, Rome, 1998

Saur, K.G., *Allgemeines Künstler Lexikon. Die bildenden Künstler aller Zeiten und Völker*, Munich and Leipzig, 1992–

Thieme, Ulrich and Felix Becker, *Allgemeines Lexikon der bildenden Künstler von der Antike bis zur Gegenwart*, 37 vols., Leipzig, 1907–50

Ventimiglia, Dario. ed., *La Biennale di Venezia. Le Esposizioni Internazionali d'Arte 1895–1995. Artisti, mostre, partecipazioni nazionali, premi*, Milan, 1996

Italian printmaking

Catalogo nazionale Bolaffi della grafica 1969–

Grafica d'arte 1990–

Print Collector (Il Conoscitore delle Stampe) 1972–83. The first fourteen issues up to that of September–October 1975 were published as a single-language journal under the title *Print Collector*. From November–December 1975 it was published both in English and Italian under the dual title, the first issue in its new guise being numbered, somewhat bewilderingly, nos. 15–29.

Aeschlimann, Erardo, *Bibliografia del libro d'arte italiano 1940–1952*, Rome, 1952

Bellini, Paolo, *Arte fantastica e incisioni: incisori visionari dal XV al XX secolo*, Milan, 1991

Bellini, Paolo, *Storia dell' incisione moderna*, Bergamo, 1985

Bellini, Paolo, ed., *L'incisione in Italia nel XX secolo. 100 stampe dalla Raccolta Bertarelli*, Milan, 1992

Cecioni, Eugenio, ed., *La collezione Peruzzi. Grafica e multipli di arte italiana informale, povera, concettuale*, Villa Pacchiani, Santa Croce sull'Arno, 2004

Chapon, François, *Le Peintre et le livre. L'Age d'or du livre illustré en France 1870–1970*, Paris, 1987

Davoli, A., *L'acquaforte italiana dell'800. Rassegna storica*, Reggio Emilia, 1955

Del Guercio, Andrea B., *1900 Bianco e Nero: Ex libris, grafica minore*, Florence, 1979

Il segno nell'incisione. Inediti del '900, Castello Cinquecentesco, L'Aquila, 1981

Jentsch, Ralph, *I libri d'artista italiani del Novecento*, Turin, 1983

Liberati, Stefano, *Bibliografia dell'incisione 1803–2003*, Milan, 2004

Mapelli, Alida Moltedo, ed., *Paesaggio urbano. Stampe italiane della prima metà del '900 da Boccioni a Vespignani*, Calcografia, Rome, 2003

Marini, Giorgio, 'Il ritratto nell'incisione del Primo Novecento', in Sergio Marinelli, ed., *Il ritratto nel Veneto 1866–1945*, Verona, 2005, pp. 157–70

Micieli, Nicola, *Incidendo: ricognizione sull' incisione italiana contemporanea*, Poggibonsi, 1989

Pallottino, Paolo, *Storia dell'illustrazione italiana. Libri e periodici a figura dal XV al XX secolo*, Bologna, 1988

Segni del Novecento. La donazione Neri Pozzi alla Fondazione Giorgio Cini. Disegni, libri illustrati, incisioni, Galleria di Palazzo Leoni Montanari, Vicenza, 2003

Servolini, Luigi, *Dizionario illustrato degli incisori italiani moderni e contemporanei*, Milan, 1955

Strachan, W.J., *The artist and the book in France. The 20th century livre d'artiste*, London, 1969

Vitali, Lamberto, *L'incisione italiana moderna*, Milan, 1934

The on-line catalogue of the Biblioteca Panizzi, Reggio Emilia, records over four hundred Italian *livres d'artiste* at http://panizzi.municipio.re.it/ArtBook

Giovanni Fattori 1825–1908

The Livorno-born Fattori is now regarded as the outstanding Italian etcher of the later nineteenth century. His most significant artistic training was in Florence with Giuseppe Bezzuoli (1784–1855) and at the Accademia di Belle Arti. During Fattori's time in Florence, he frequented the Caffè Michelangiolo, where he met and became friends with a group of artists and writers with nationalist aspirations. His early pictures were landscapes and history paintings. Fattori indirectly imbibed the influence of Ingres through Enrico Pollastrini (1817–76), another painter from Livorno. He thus learnt the importance of secure draughtsmanship and of simplicity in devising compositions. In 1859, the fervent Italian nationalist Giovanni Costa (1826–1903), a close friend of Frederick Leighton and leader of the 'Etruscan School' of landscape painting in England, visited Fattori's studio, and encouraged him to enter a competition that year for a picture of a patriotic battle scene, which was organized by the Italian government, which was then based in Florence. Fattori's design for *The Italian camp during the Battle of Magenta* earned him a commission for a painting of the subject, which was completed in 1860–1 (Palazzo Pitti, Florence). Preparatory work on this led him to travel to the sites of the battlefields in northern Italy.

A series of commissions for other Risorgimento battle scenes followed over the next twenty years, but the bulk of Fattori's work was devoted to landscapes and episodes of rural life, studied directly from nature. In the early 1860s, he painted alongside Giovanni Costa in the countryside around Livorno. Fattori's preference for elongated compositions derived from the paintings of his older friend. He painted a series of landscapes on small panels, often taken from cigar-box tops. Fattori retained the simplicity of the compositions of these pictures when he came to paint larger works. In 1867 the critic Diego Martelli invited him to stay on his remote estate at Castiglioncello in the Maremma, close to the sea in south-western Tuscany. The landscape, inhabitants and animals of this low-lying wooded district were to provide Fattori with fruitful motifs for his drawings and paintings for the rest of his career. In 1882, as the guest of Prince Corsini, he visited Maremma grossetana, the southern Maremma, which provided further subjects for his art.

Fattori travelled to Rome in 1872 to make studies for his *Horse market at Terracina*, and in 1875 to Paris, where he exhibited as Costa's pupil at the Salon. He visited the Louvre, met many French artists and studied the work of painters of the Barbizon school. However, although his friend and patron Martelli was an admirer of the Impressionists, Fattori's style was unaffected by his encounter with the art of his French contemporaries. His paintings were notable for their skilfully devised compositions of contrasted areas of bold and luminous colour. Fattori found it difficult to sell his paintings, and he gave private tuition to artists to earn a living. Scholars have interpreted the work of the last thirty years of his life as showing a harsher tone of realism, and as reflecting his financial disappointments and his disillusionment with political events. In December 1888, Fattori was appointed Professor of Drawing at the Accademia in Florence and Professor of Figure Study at the School of Architecture. He supplemented his income by teaching privately when his salary was reduced. Fattori was highly respected as a teacher, and his influence on painters and printmakers extended well into the twentieth century.

Fattori made some two hundred etchings, though their dating is very uncertain, as there are few points of reference. Only two of his prints, both from the very end of his career, bear dates. We do not know who taught Fattori to etch or when he started to make prints, but it is generally assumed that he was encouraged to take up etching seriously when, in 1883, he received the commission from the council of the Promotrice Fiorentina to engrave his 1862 battle picture *The cavalry charge at the Battle of Montebello*. As commissions to produce copies after paintings exhibited in the society's exhibitions were generally given to professional printmakers, rather than to the painter himself, it has been argued that at this date Fattori must already have displayed some accomplishment as an etcher.

A portfolio of Fattori's lithographs, *20 ricordi dal vero*, was published in 1884, but he seems to have abandoned lithography after the mid-1880s. Twenty-one of his etchings were acquired by the Galleria Nazionale d'Arte Moderna in Rome, after their exhibition at the Esposizione Nazionale in Bologna in 1888. Fattori's style and subject matter remained very consistent in the latter part of his career, making the dating of his prints even more uncertain. The compositions of many of his etchings can be related to those of his paintings, sometimes to works he produced many years before, but there is also evidence that he occasionally developed pictures from his prints.

BIBLIOGRAPHY
There is a very large literature on Fattori, including two catalogues of his prints by Andrea Baboni, *Giovanni Fattori. L'opera incisa*, 2 vols., Milan, 1983, and Andrea Baboni, *Le incisioni di Giovanni Fattori nella Collezione Franconi e catalogo generale dell'opera incisa fattoriana*, Florence, 1987. Dario Durbè's *Giovanni Fattori e i suoi ricordi dal vero*, Rome, 1981, is devoted to his portfolio of lithographs. Andrea Baboni and Giorgio Cortenova, *Giovanni Fattori*, Galleria d'Arte Moderna e Contemporana, Palazzo Forti, Verona, 1998, includes many suggestive juxtapositions of illustrations of the artist's prints, paintings and drawings. For his paintings, there is also Luciano Bianciardi and Bruno Della Chiesa, *L'opera completa di Fattori*, Milan, 1970.

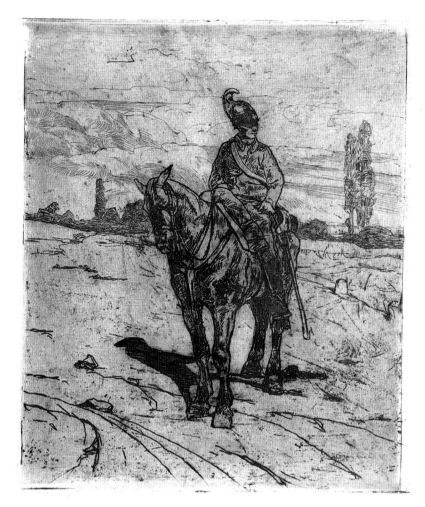

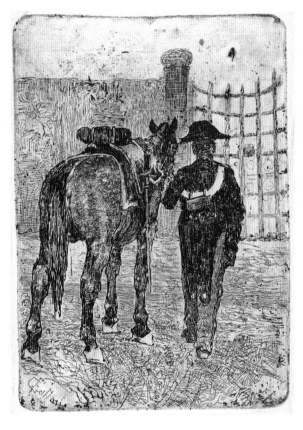

1

PATROL

c.1895–1903
Etching 202 × 176
Baboni CXLIV
2002-7-28-8
Presented anonymously, 2002

A painting of this subject probably dates
from c.1895.

2

RETURN TO BARRACKS

c.1885–8
Etching 187 × 134 signed in the plate
Baboni LXIII
2002-7-28-6
Presented anonymously, 2002

As a young man, Fattori distributed national-
ist leaflets during the period leading up to
the war of liberation in 1849, but his family
would not allow him to enrol in the army.
Thus he had no direct experience of the
brutality of the battlefields. Fattori's only
print of military action was the copy of his
painting *The cavalry charge*. Instead, he
preferred to etch scenes of manoeuvres,
reconnaissance and recuperation. Fattori
presented an unromantic view of the lengthy
periods of tedium and anticipation that
occurred before the blood and thunder of
battle. Often soldiers are represented on
guard, where there is nothing in the setting to
distract the spectator from the loneliness and
tension inherent in the situation. Much of
Fattori's military imagery derives from his
first-hand study of the Italians' allies against
the Austrians, the French troops stationed in
the grounds of the Cascine in the outskirts of
Florence in the early summer of 1859.

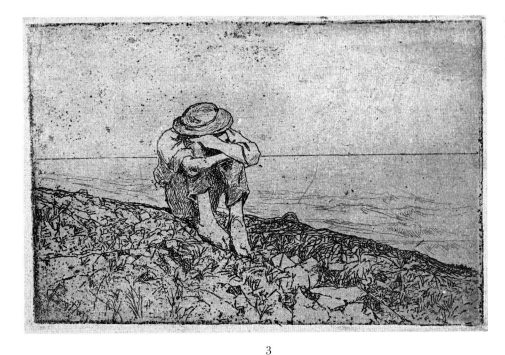

3

A BOY SEATED ON THE
SEASHORE

c.1885–8
Etching on brown paper 104 × 165 signed in
the plate
Baboni LV
2003-6-30-42
Presented anonymously, 2003

4 (see colour page 33)

WOMAN OF THE GABBRO

before 1888
Etching 338 × 213 signed in the plate
Baboni CLX
2005-5-31-9
Presented anonymously, 2005

The isolated small village of Gabbro lies close
to the Tuscan coast in the hills to the south-
east of Livorno. Many of the workers on the
Tuscan estates gathering brushwood or tend-
ing olives or vines were women. The system
of sharecropping throughout the region was
feudal. The tenant was tied to the farmstead
and obliged to supply the landlord's kitchen
and hand over fifty per cent of the crops. In
the case of olives, the division could be as
much as sixty per cent/forty per cent in the
landlord's favour. The tenant was also respon-
sible for paying the wages of harvesters and
any other outside help to work the land, as
well as for supplying his own tools. The wages
earned in the countryside were well below
those of labourers in the town. However, the
rural labour force, living in isolated buildings
on the estates, rather than close to each other
in villages, was docile, and the landlords gen-
erally did not intervene too directly in their
life. The female worker in this etching first
appears in Fattori's painting *The brush gath-
erers (outskirts of Livorno near Antignano)*
of c.1865. He kept returning to rework her
figure in various compositions over a period
of upwards of thirty years.

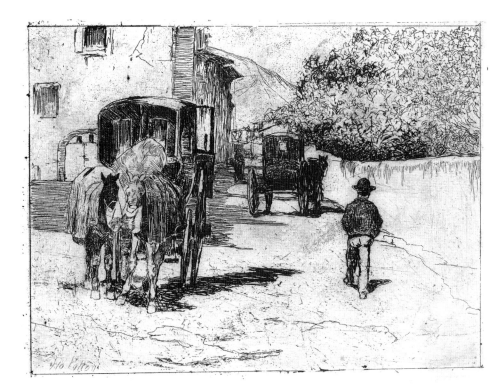

5

THE STAGE COACH

c.1883–4
Etching 173 × 233 signed in the plate
Baboni CIII
2003-5-31-8
Presented anonymously, 2003

The etching relates to the painting *The stage coach of Sesto*, which is usually dated c.1880. The small town of Sesto Fiorentino lies just north of Florence.

6

IN THE MUGELLO

before September 1888
Etching 124 × 208 signed in the plate
Baboni XC
2002-7-28-5
Presented anonymously, 2002

The Mugello is the hilly district north-west of Florence in the foothills of the Apennines. This etching was one of those acquired by the Galleria Nazionale d'Arte Moderna in Rome in 1888. The fold marks of this impression result from it being used to wrap around Fattori's plate.

7

THE PRIEST CLIMBING THE HILL

c.1903
Etching on pinkish paper 265 × 195
(trimmed within the platemark)
Baboni CXL
2001-9-30-18
Presented anonymously, 2001

An annotation on the verso indicates that this
impression was once owned by the brothers
Majno of Milan. It is probably the impression
included in the 1958 Pinacoteca di Brera
exhibition *Incisioni della Raccolta Majno*.
This etching's alternative title is
Homecoming.

8

THE LITTLE WAYSIDE SHRINE
NEAR FLORENCE

c.1888–1903
Etching 213 × 174
Baboni XCVI
2002-7-28-9
Presented anonymously, 2002

Although this etching of a wayside shrine is
probably one of the artist's later prints, the
composition is related to one of his earliest
landscape drawings which is datable to
1855–8.

9

TRACK IN THE WOOD

c.1885–8
Etching 251 × 143
Baboni XCIII
2002-7-28-7
Presented anonymously, 2002

10

HORSES AT PASTURE

c.1880–5
Etching 237 × 395 signed in the plate
Baboni CLXV
2002-7-28-13
Presented anonymously, 2002

This was one of the etchings acquired by the
Galleria Nazionale d'Arte Moderna in 1888,
and may well be one of Fattori's earliest
prints. The composition relates in reverse to
an oil painting, *Colts in the Maremma*, which
is generally dated to c.1880.

11

OXEN YOKED TOGETHER

c.1900
Etching 200 × 198
Baboni CLII
2003-6-30-44
Presented anonymously, 2003

12 (see colour page 34)

HOLY COW

after 1887
Etching 176 × 372 signed in the plate in
reverse
Baboni CXXXI
2001-5-20-87
Presented anonymously, 2001

The title is taken from part of the first line
of the Tuscan writer Giosuè Carducci's poem
Il bove, which was first published in *Strenna
Bolognese* on 22 December 1872 with the
title *Contemplazione della bellezza*, and
was reissued shortly afterwards in *Il Mare*
as *Il bue*. The definitive version appeared
in his *Rime nuove*, Bologna, 1887, p. 17.
Carducci celebrated the natural beauty of
the Maremma and the hard life of the peasant
sharecroppers, who worked for estate owners
such as Diego Martelli. Like Fattori, he
wanted to represent contemporary life unvar-
nished. Labour in the countryside is shown as
hard but rewarding. A fervent and outspoken
patriot, Carducci wrote the poem *Alla Croce
di Savoia*, which was set to music as a battle
hymn. Fattori's political and cultural views
were similar to those of the poet, who was
both anti-clerical and anti-romantic. The
landscapes, animals and hard-working
inhabitants could be seen to refer to the
noble qualities of the rural citizenry of the
new nation of Italy.

13

OXEN YOKED TO THE CART
(MAREMMA)

before September 1888
Etching 240 × 399 signed in the plate
Baboni CLXVI
2002-7-28-12
Presented anonymously, 2002

This was one of the etchings acquired in 1888
by the Galleria Nazionale d'Arte Moderna. It
was an impression of this print that in 1900
earned Fattori a gold medal when it was
exhibited in Paris at the Exposition
Universelle.

14

THE COW

c.1888–90
Etching 240 × 298 signed in the plate, and in
pencil in the margin
Baboni CXXXV
2003-6-30-43
Presented anonymously, 2003

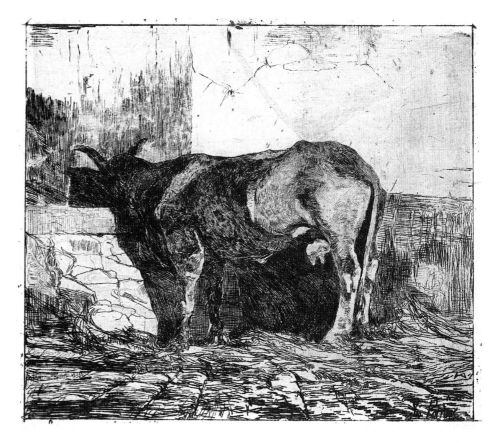

Telemaco Signorini 1835–1901

Born in Florence, the son of the topographical painter Giovanni Signorini (1808–62), who served as his teacher, Telemaco Signorini initially studied literature at the Scuola degli Scolopi in that city, before turning to painting in 1852. At first he painted historical subjects and themes taken from English romantic literature. In 1855, the painter Vito D'Ancona (1825–84) introduced him to the circle of artists and political activists who met at the Caffè Michelangiolo. It was during this period that Signorini first met Degas, who visited Florence in 1855 and 1859. The two artists became lifelong friends. Signorini painted his first open-air sketches in oil in the neighbourhood of Florence in 1858. He fought alongside the critic and writer Diego Martelli in the 1859 Lombard campaign for the liberation of Italy from Austrian rule. On Signorini's return to Florence, he began painting military subjects. In 1861, he visited Paris with his fellow Macchiaiolo Vincenzo Cabianca (1827–1902) and Cristiano Banti. There, they saw the Salon and an exhibition of Barbizon paintings. Signorini also met Troyon, Corot and Théodore Rousseau. Back in Italy, he began to publish art criticism, becoming the principal champion of the Macchiaioli in print. Among the journals for which Signorini wrote regularly was Diego Martelli's *Il Gazettino degli Artisti di Disegno*. He also developed an interest in photography in the late 1860s and began to use it as a resource for his paintings.

Signorini's interest in the radical socialism of Proudhon encouraged his move away from romanticism to realism. He began to etch in 1869, and sent one of his first prints, *Vicolo in Siena*, to the Turin journal *L'Arte in Italia* in the autumn of 1870. Among Signorini's earliest etchings are his eighteen illustrations to Diego Martelli's 1871 *Primi passi: fisime letterarie*. He was also to provide three etchings for the writer's *Fornicazioni di Fra Mazzapicchio* in 1875. Other volumes for which he provided etchings included Gustavo Uzielli's *Gita a Vinci* of 1872 (a single print) and his *Ricerche intorno a Leonardo da Vinci* of 1896 (two etchings), as well as Carlo Volterra's *Storielline* of 1876 (four etchings). In 1877, Signorini, using the anagram of Enrico Gasi

Molteni, published *Le 99 discussioni artistiche*, a series of 101 (not 99) sonnets, which he illustrated with his own woodcuts. Most of his etchings of the 1870s were of the streets of the historic towns of Tuscany. Signorini used a printer named Tedeschi for some of his plates.

Signorini revisited Paris in 1873, when the dealers Goupil and Reitlinger acquired some of his paintings. On an excursion into the countryside south-east of Paris, he painted with De Nittis and Boldini. Signorini also paid a brief visit to London. He returned to Paris and London in 1876. Francesco Netti, a contemporary critic, thought that Signorini's paintings of this period showed the influence of Japanese art. He returned to Paris in 1878 and 1880, from where he made a trip to Brittany. The following year, Signorini travelled to Bath, Edinburgh and London. His art was very well received in Britain. Arthur Lucas, Thomas McLean and other leading London dealers showed Signorini's pictures. He exhibited at both the Royal Academy and the Grosvenor Gallery. Through Nino Costa, he was introduced to Leighton in 1883. After seeing Whistler's 1884 one-man show at Dowdeswell's, Signorini visited the American painter in his studio. Some have remarked on the tonal similarities of his Elba seascapes of 1888 to the work of the American artist. That year Signorini was made Professor at both the Accademia di Belle Arti in Naples and the Accademia di Belle Arti e Liceo Artistico in Bologna. In 1889, he shared responsibility for the selection of the Italian section of the Exposition Universelle in Paris. In 1893 Signorini published *Caricaturisti e caricaturati al Caffè Michelangiolo*, his reminiscences of the 1850s and early 1860s. He also collaborated with Uzielli on a monograph of the French painter and etcher Marcellin Desboutin, whom he had known in Florence in the early 1860s, a volume which was published in 1895. Settignano, Riomaggiore and the coastal towns of Liguria provided much of the material for his later paintings.

BIBLIOGRAPHY
As yet, there is no catalogue raisonné of Signorini's prints, although Antonio Berni is working towards one. An incomplete list of seventy-nine etchings was published by Silvia Migliavacca, 'Telemaco Signorini, primi contributi per un catalogo dell'opera incisa e litografica', *Grafica d'Arte*, XXXVI, 1998, pp. 10–23, to which Duilio Pieragostini and Primo Beccaria have made corrections and an addition in *Grafica d'Arte*, XXXIX, 1999, p. 44, and XLVI, 2001, p. 47, respectively. Signorini's woodcuts have not yet been catalogued. The fullest account of his career as a whole can be found in the exhibition catalogue, *Telemaco Signorini: una retrospettiva*, Palazzo Pitti, Florence, 1997, which includes a very full bibliography. Also of interest is Dunia Grandi, *Telemaco Signorini 1835–1901. Le ricerche degli anni giovanili e la Firenze scomparsa attraverso quattro capolavori ritrovati*, Enrico Gallerie d'Arte, Milan, 2002. This writer has not seen the exhibition catalogue *Disegni inediti e acqueforti di Telemaco Signorini*, Accademia delle Arti di Disegno, Florence, 1968. Correspondence with Gustavo Uzielli relating to the printing of three of his plates has been published by Piero Dini, *Telemaco Signorini 1835–1901*, Villa Forini, Montecatini Terme, 1987.

15

Two etchings from the portfolio
The Mercato Vecchio, Florence
1886

(A) SANTA MARIA DELLA TROMBA

Etching 370 × 240 signed in pencil, and
numbered
Migliavacca 58
1933-11-6-31.3

(B) VIA DEGLI SPEZIALI
(IN WINTER)

Etching 368 × 238 signed in pencil, and
numbered
Migliavacca 60
1933-11-6-31.5

This portfolio of eleven etchings was found
in the office of the poet Laurence Binyon
(1869–1943) on his retirement in 1933.
Binyon joined the staff of the British
Museum in 1893, and served as a curator
in the Department of Prints and Drawings
from 1895 until 1913, when he established
the Department of Oriental Prints and
Drawings, of which he was the first head.

The suite can be dated from a letter that
Signorini wrote in 1892 to the President of
the Florentine Academy: 'In 1886 I worked
on some etchings of our old market, which
were derived from my paintings and my
studies.' Signorini also made a lithograph of
the Mercato Vecchio (Sala delle Stagioni di
Fernando Vallerini, Pisa, *Dipinti incisioni
disegni dell'Ottocento e contemporanei . . .*,
4 and 5 December 1964 (44)). Ten of the
etchings in the suite were among the thirty-
five plates that were reprinted in an edition
of 100 in 1967 by Aldo Gonnelli of Gonnelli
Editore, under the direction of the artist's
nephew, Enrico Signorini, and published as
*Il Mercato Vecchio di Firenze ed altre com-
posizioni*, with an introduction by Piero
Bargellini. The exception was *Mercato
Vecchio: La Colonna della Dovizia*. The
plates were presented to the Comune of
Florence and deposited in the Galleria
d'Arte Moderna.

It is not known why the cover to the
British Museum's portfolio bears the date

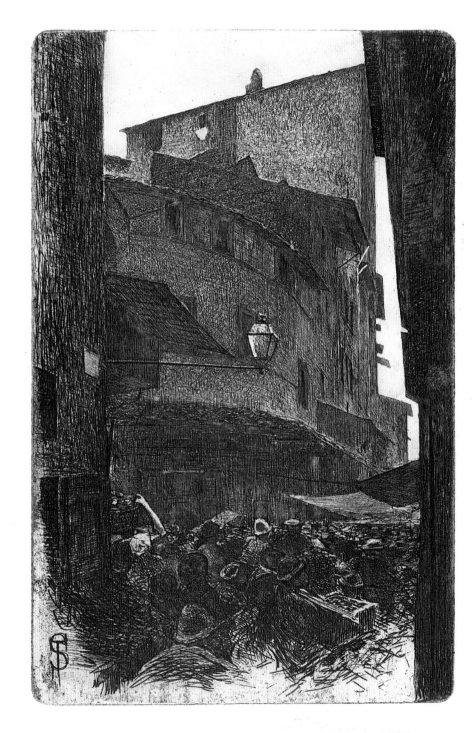

1874, the date also assigned to the suite in the Gonnelli Editore publication. However, the date probably refers to the opening of the new Mercato Centrale designed by Giuseppe Mengoni, which had resulted in the destruction of many medieval buildings. Signorini wrote a sonnet deploring the event, and in the early 1880s painted a series of paintings of further streets in the area before they were demolished in 1885, when there was further redevelopment. The etchings in this portfolio presented the same streetscapes as the pictures and their preparatory drawings, but with variations in the compositions.

The full title on the cover is in English, *Eleven views of the Mercato Vecchio and the neighbouring quarter of Florence destroyed during the recent reconstruction of the old centre of the city drawn and etched by Telemaco Signorini*, which may suggest that part of the edition was sent to England, where Signorini's work was sold by a number of London dealers. Twenty of his paintings of the Mercato Vecchio were exhibited in the Hanover Square home of Arthur Lucas (active 1867–1919), and another was exhibited at the Grosvenor Gallery in 1883.

The other plates in the portfolio are: *Mercato Vecchio: La Colonna della Dovizia (The Column of Abundance)*; *Fonte del Mercato Vecchio*; *Via degli Speziali in summer*; *Via Calimara*; *Via de' Cavalieri*; *La casa di Dante Da Castiglione*; *La via de' Pellicciai ora Pellicceria*; *Il Ghetto: Piazza della Fratellanza*; *Vico dei Lontani Morti*.

The fourteenth-century tabernacle of Santa Maria della Tromba at the corner of the Piazza del Mercato and the Via Calimala, sheltered by a sloping wooden roof at the left in Signorini's etching, was dismantled and rebuilt into the corner of the Palazzo dell' Arte della Lana. Signorini returned to the composition in his painting *Via Calimara* of 1889, in which there are some variations in the detail. The etching titled *Via Calimara* in the portfolio shows a different view of the street.

The Via degli Speziali, one of the principal medieval streets of Florence, ran east from the Mercato Vecchio to the Via del Corso. In his second print of the street, *Via degli Speziali (in summer)*, the artist looked in the opposite direction when etching the scene.

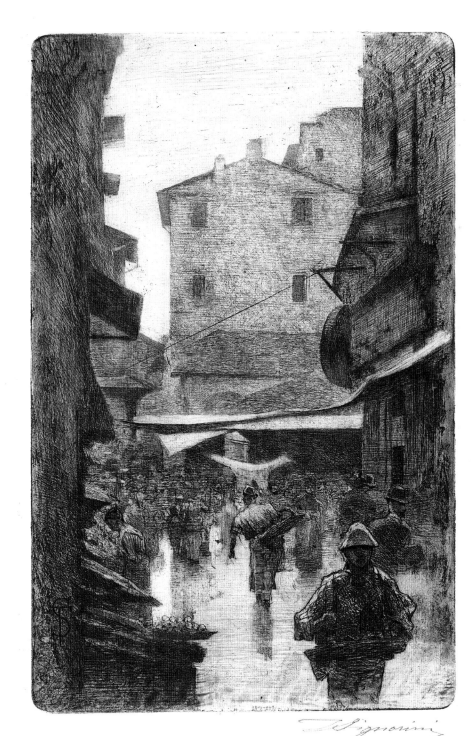

Giuseppe De Nittis 1846–84

Born in Barletta in Apulia, De Nittis received his first artistic training from Giambattista Calò, a local painter, before moving to Naples in 1861 to attend the Istituto di Belle Arti. He was expelled in 1863 for failing to conform to academic practice. At that time, De Nittis's main interest was in experimenting with *plein-air* painting. In 1864, together with Matteo De Gregorio, Federico Rossano (1835–1912) and the Florentine sculptor Adriano Cecioni, De Nittis founded the 'Scuola di Resina'. Cecioni became an important link between De Nittis and the Macchiaioli. De Nittis travelled to Paris in the summer of 1867, when he visited the studio of Ernest Meissonier, whose highly finished paintings left a deep impression on him. He also sold some small pictures to the dealer Adolphe Goupil, with whom he was to sign a contract in 1872. In the autumn of 1867 De Nittis visited Florence and met some of the Macchiaioli, establishing a close friendship with Signorini and with the French painter Marcellin Desboutin, who made some etchings after De Nittis's designs.

He settled in Paris in June 1868, marrying a French wife, Léontine Gruvelle, in April 1869. That year, De Nittis exhibited in the Paris Salon for the first time, and he continued to show there for the rest of his career. Among his Paris friends was Manet, who was to give him the painting *Au jardin*. It is possible that it was through Manet that he met Tissot, before that artist settled in London. De Nittis's first experiments in etching were made in 1871, although it is uncertain whether they were done in Paris or in Naples. It is probable that De Nittis met Degas in Naples in 1872. De Nittis returned to Paris with Telemaco Signorini in March 1873. From there, the two artists visited London with the painter, etcher and art agent Adolph Hirsch. In Paris, they moved in a circle that included their fellow Italians Boldini, Michetti and Cecioni, as well as Degas, Manet and Desboutin. A number of De Nittis's etchings of this period show that he had studied the prints of Fortuny, which were on sale in Goupil's Paris gallery. By 1873, he had begun to use drypoint, sometimes on its own, sometimes in combination with etching. Degas invited him to exhibit in the first Impressionist exhibition in 1874. De Nittis was unable to attend as he was in London, where he sold a painting to Edward Fox White, a King Street dealer, who also had dealings with Whistler that year. De Nittis had considerable success in England. The banker Kaye Knowles commissioned him to paint a series of twelve views of the city, on which he began to work in 1876. One of his etchings may be of Knowles's daughter. De Nittis also attempted to interest English dealers and collectors in the prints of his friend Desboutin, but without much success.

De Nittis became a member of Alfred Cadart's Société des Aquafortistes in 1874, the year in which the French publisher included his etching *La Danseuse Holoke-Go-Zen* (no. 17) in the portfolio *L'Eau-forte moderne*, and in 1875 he joined Degas and Count Lodovic Napoléon Lepic in experiments in etching and monotype in Cadart's print workshop. Further prints by De Nittis were included in the 1875 and 1876 albums issued by Cadart's widow. De Nittis's first pure monotype was probably made in 1876. Previously, he had experimented with different inkings of his etched plates. De Nittis's paintings were much acclaimed at the 1878 Exposition Universelle, at which he was awarded a gold medal. Shortly afterwards, he received the notable recognition of being created a Chevalier de la Légion d'Honneur. In 1880, De Nittis staged a one-man show of oil paintings, pastels, watercolours, gouaches and etchings at the L'Art gallery in Paris, which may have included examples of his monotypes. The *Gazette des Beaux Arts* published his etching *Etude dans mon jardin* in August 1881. De Nittis's final print was his only lithograph, a poster for the Circolo della Polenta, a club in Paris, where Italian artists held monthly meetings in the winter. He died of a cerebral haemorrhage in Saint-Germain-en-Laye on 21 August 1884.

BIBLIOGRAPHY
Rosalba Dinoia's exhibition catalogue and catalogue raisonné, *De Nittis incisore*, Calcografia Nazionale, Rome, 1999, records fifty etchings and monotypes, but does not include his only known lithograph. Piero Dini and Giuseppe Luigi Mariani, *De Nittis: la vita, i documenti, le opere dipinte*, 2 vols., Turin, 1990, gives the fullest account of his career.

16

WOMAN WITH A FAN

1875–6
Etching and drypoint 236 × 156
Dinoia 13
2003-5-31-7
Presented anonymously, 2003

This unrecorded proof, between the first and
second states of two with extra touches of
drypoint on the dress, was once in the collec-
tion of the writer Ugo Ojetti (1871–1946), art
critic of the newspaper *Corriere della Sera*
from 1898, and founder of the art-historical
journals *Dedalo* (1920–33) and *Pan* (1933–5).
Ojetti included a chapter on De Nittis in
the second series of his *Ritratti di artisti
italiani*, Milan, 1923. He was given the print
by De Nittis's widow. In the second state, De
Nittis used a brush to spread an ink wash on
the plate in order to achieve an evanescent
effect. Only a few impressions were printed
during the artist's lifetime. The print was
eventually published in its fourth state in
Gazette des Beaux Arts in May 1885.

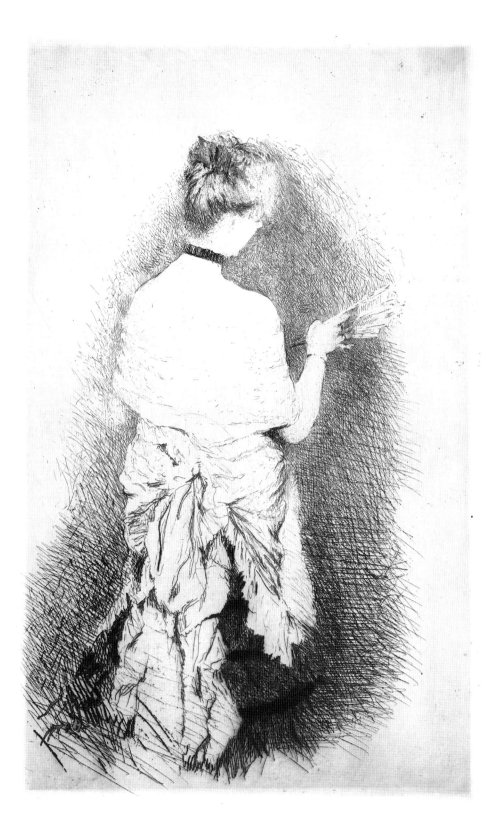

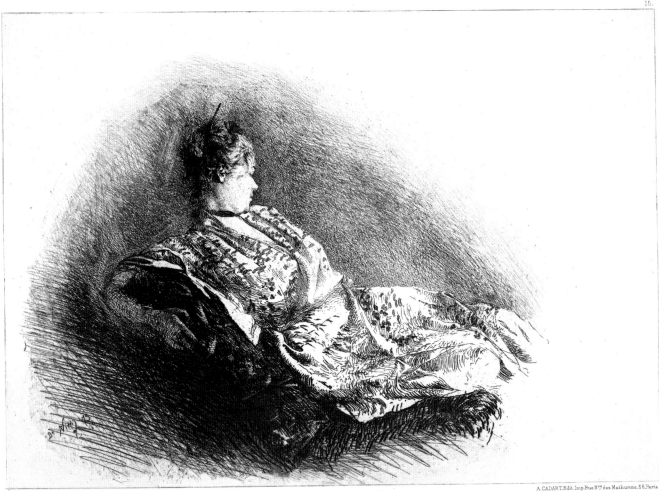

De Nittis.del.et sc. LA DANSEUSE HOLOKE-GO-ZEN. A.CADART,Edit.Imp.Rue N°.des Mathurins,58,Paris.

17

THE DANCER HOLOKE-GO-ZEN

1873
Etching 213 × 285 signed and dated *73* in the plate
Dinoia 12 fourth state of four
1882-2-11-305
Purchased, 1882

This impression of the print in its fourth and final state comes from a copy of the *Album de l'Eau-forte moderne*, published by Alfred Cadart in Paris in 1874. Like many of his artist friends, De Nittis collected Japanese prints and *objets d'art*. Edmond de Goncourt particularly admired his *foukousas*, knotted pieces of Japanese silk used to carry objects or offerings. Several of De Nittis's paintings feature kimonos or fans.

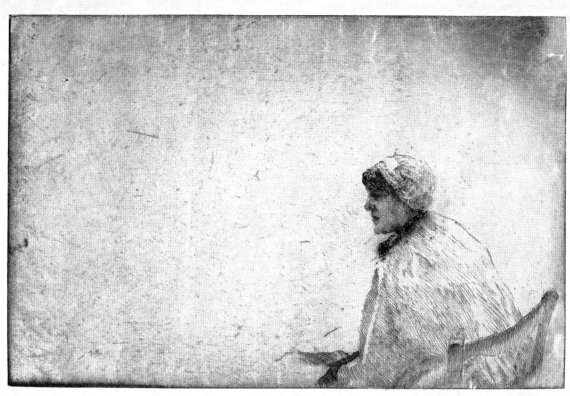

18

SEATED WOMAN

Etching 133 × 218 dedicated by De Nittis's
widow, Léontine, in ink to *la jolie petite
Mme Caputo 14 Juin 1913*
Dinoia 22 second state of three
2002-2-24-2
Presented anonymously, 2002

The sitter was the De Nittis family's maid,
of whom the artist also painted a number of
pictures. In the third and final state he added
a woman seated on her left holding a parasol.
De Nittis may have intended that the two
women should be interpreted as spectators on
a racecourse. On 14 June 1913 the artist's
widow, Léontine, gave this impression to a
Madame Caputo, possibly the wife of the
Neapolitan genre painter Ulisse Caputo
(1872–1948).

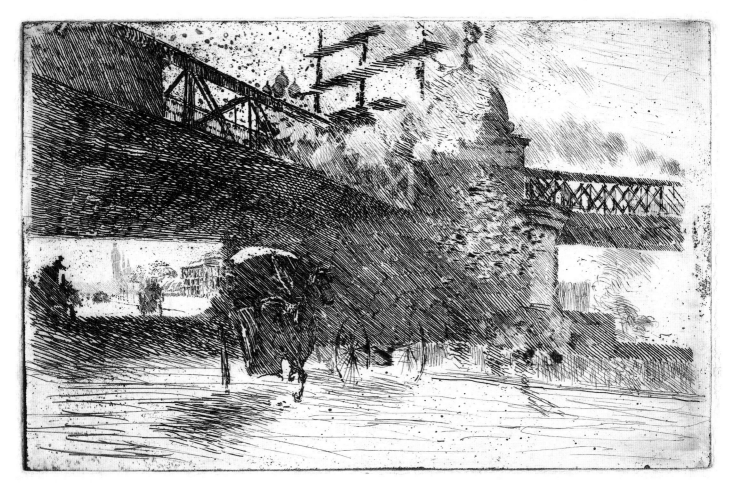

19

VIEW TAKEN IN LONDON

Etching and drypoint 156 × 236
Dinoia 38 second state of three
2003-8-31-13
Presented anonymously, 2003

De Nittis, who spent much of the period
1876 to 1880 in London, developed the
composition from his oil of the Thames
Embankment, *Under the viaduct*. Only a few
proofs were pulled during the artist's lifetime.
In its third state, the etching was published
posthumously in *Gazette des Beaux Arts* in
November 1884 to accompany the obituary of
the artist written by Ary Renan (1858–1900).
De Nittis's interest in railways as a subject
also led him to make a monotype of the Gare
de l'Ouest in Paris, and to paint *The train
passes* in 1878, and *Goods sheds of a rail-
way station* in 1879 (both in the Pinacoteca
Museo De Nittis, Barletta).

Giovanni Boldini 1842–1931

Born in Ferrara, the son of the painter Antonio Boldini (1792–1872), from whom he received his first artistic training, Giovanni Boldini studied at the Civico Ateneo di Palazzo dei Diamanti in his native city, where he had established a reputation as an accomplished portrait painter by the time he was eighteen. In 1862 he went to Florence, where he met artists in the Macchiaioli circle at the Caffè Michelangiolo, while attending the Scuola del Nudo at the Accademia di Belle Arti. Michele Gordigiani (1830–1909), the leading portrait painter in Tuscany, passed on some of his commissions to Boldini. Boldini saw and admired the paintings of Courbet and Manet at the Exposition Universelle in 1867 on a visit to Paris, where he met Degas, who became a lifelong friend. Through Signorini, Boldini met the Falconers, an expatriate English family, for whose villa near Pistoia he painted eight rural scenes and seascapes, large mural paintings in tempera. In 1867, he worked alongside Fattori and Giuseppe Abbati (1836–68), painting landscapes in the open air.

In 1870, at the invitation of a friend of the Falconers, Lord William Cornwallis-West, Boldini visited London, where he admired the paintings of Turner, Reynolds and Gainsborough, and embarked on a career as a fashionable portraitist. When he settled in Paris the following year, Adolphe Goupil gave him a contract. Boldini, like De Nittis, painted silvery views of the city, which in their tones revealed an admiration for Corot, but he also established a line in small eighteenth-century costume pieces, aiming at the same market as Meissonier and Fortuny. In 1876 he travelled to Holland, where he admired the work of Frans Hals. This was the period when he first established his reputation for portraits of beautiful high-society women, which were painted with flamboyant slashing brushstrokes. Boldini's friends included other notable portraitists, among them Whistler, Sargent and Helleu. His portrait practice extended to the intelligentsia, as well as to the aristocracy and, like Sargent, he received many commissions from various prominent members of Belle Epoque society. Boldini rarely left Paris, although in 1889 he visited Spain with Degas, where he studied the work of Velázquez, Goya and Tiepolo, and from there he went on to Morocco. In 1897 he travelled to New York for a highly successful one-man show at Boussod, Valadon and Co. Boldini developed a highly artificial style, in which the elongations and the serpentine arrangements of his sitters can be related to the work of his fellow Emilian sixteenth-century painter Parmigianino. The turbulence of his very fluid brushwork and his interest in exaggerated movement can be seen as prefiguring Futurism. From the 1880s, like Degas, Boldini used pastel for some of his full-scale portraits, and he was also a very prolific watercolourist and draughtsman.

Boldini's earliest etching, representing a working man beside the Seine, dates from c.1878–80. It is likely that he learnt the technique from Marcellin Desboutin or De Nittis. One of his earliest etchings, which may be a portrait of De Nittis, is very much in the style of Desboutin. Boldini also made several drypoints of women similar in type to the near-contemporary etchings of De Nittis. He etched two portraits of his friend Degas and a view from a box at the opera, in which the composition is very similar to the work of Degas. Few of Boldini's prints can be dated with precision. They were mostly portraits in drypoint. Boldini's sitters included the Belgian poet Georges Rodenbach, artist friends such as Cristiano Banti, Paul Helleu and John Singer Sargent, and the society figures Lord Castelreagh, the Infanta Eulalia of Spain and the Comtesse d'Orsay. He also made a few prints of figures on horseback. In all Boldini made eighty intaglio prints between the late 1870s and 1912.

BIBLIOGRAPHY
Boldini's prints were catalogued first by Dino Prandi, *Giovanni Boldini: l'opera incisa*, Reggio Emilia, 1970. They have also been recorded by Ettore Camesasca in *Boldini*, Palazzo della Permanente, Milan, 1989, pp. 258–9, by Andrea Buzzoni and Marcello Toffanello, *Museo Giovanni Boldini catalogo generale completamente illustrato*, Ferrara, 1997, and in the fourth volume of Piero Dini and Francesca Dini, *Giovanni Boldini, 1842–1931. Catalogo ragionato*, Turin and Milan, 2002, which is the most comprehensive publication on Boldini's paintings.

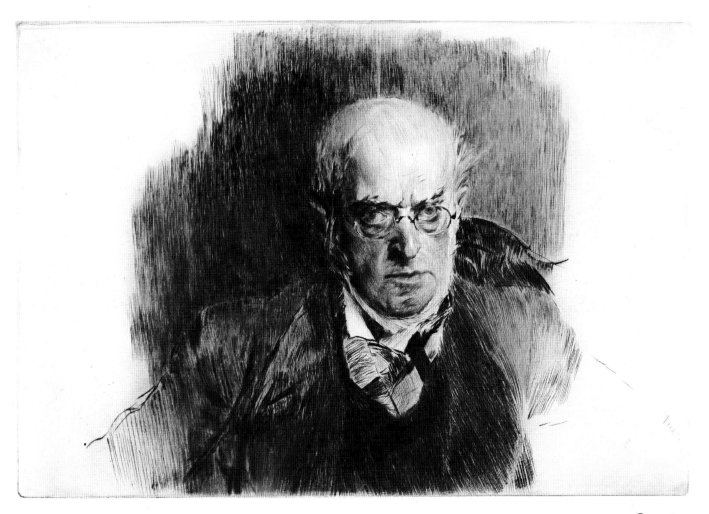

20

ADOLF MENZEL

1895
Drypoint 269 × 393 signed in ink below
the plate
Prandi 27; Dini 1346
2002-7-28-48
Presented anonymously, 2002

This portrait of the bespectacled, elderly
German realist painter, printmaker and illus-
trator (1815–1905) relates very closely to
the oil painting, now in the Nationalgalerie,
Berlin, which Boldini painted on a visit to
Berlin in 1895. The Italian artist had long
admired Menzel, whom he had met first in
Berlin in 1886. This impression is one of
only nine pulled during Boldini's lifetime.
A further nine were printed in Paris by
Eugène Delâtre in 1934 for the artist's
widow. These were numbered 10/18 to
18/18. Boldini used the other side of this
plate for a drypoint portrait of Madame
Jules Weil-Picard.

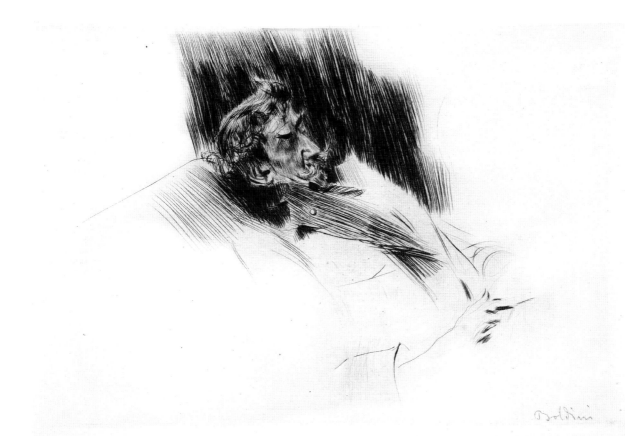

21

WHISTLER ASLEEP
1897
Drypoint 198 × 308 signed in pencil below
the plate
Prandi 24; Dini 1342
2003-1-31-1
Presented anonymously, 2003

Boldini made this portrait of James Abbott McNeill Whistler (1834–1903) in just fifteen minutes, when the American painter dozed on a couch during a break in the course of a sitting for Boldini's oil portrait of the artist, dated 1897. This painting is now in the Brooklyn Museum of Art, New York. In the picture, of which the first owner was Boldini's French rival Paul Helleu, he was represented seated. The Italian also made a quick pencil sketch of Whistler's head, which relates to the oil. Boldini first met Whistler in Paris in the early 1880s, and often visited the American's Paris home at 110 rue du Bac, to which the American had moved from London in 1892. Boldini wrote to Riccardo Selvatico, the Mayor of Venice, on 6 June 1894, recommending that he invite Whistler to exhibit in the first Venice Biennale the following year, and two years later acted as the American's intermediary when he presented a group of his etchings to the city. These are now owned by the Galleria d'Arte Moderna in Venice. Boldini was an honorary member of

the International Society of Sculptors, Painters and Gravers, founded by Whistler in 1898, but Whistler was frequently dismissive of the Italian's portraiture. Not at all happy about Boldini's drypoint being on public sale, he instructed the publisher William Heinemann in early February 1898 to 'tell Boldini . . . that I am very angry at his publishing or allowing to be reproduced the scraps of a drypoint he did from me, and that I thought he never would show as seriously at all *representing Whistler*' (Library of Congress, Washington, Whistler correspondence on line www.whistler.arts.gla.ac.uk/correspondence no. 08490). So, in 1900, the Italian asked the New York dealer E.G. Kennedy, of H. Wunderlich & Co., to return the plate and proofs that he had previously sold to him for £40. Although Boldini showed several of his paintings at the International Society of Sculptors, Painters and Gravers, he never exhibited any of his prints in one of its exhibitions.

Vittore Grubicij [Grubicy] De Dragon 1851–1920

Born in Milan, the son of a Hungarian baron and a Lombard noblewoman, who was an amateur painter, Grubicij frequented the circle of the Scapigliati in his late teens. He visited London in 1870–1 and decided to become an art dealer, from 1876 working in partnership with his brother, Alberto, for the Galleria Pedro Nessi in Milan. The brothers supported contemporary Italian painting, initially the Scapigliatura artists, in particular Tranquillo Cremona and Daniele Ranzoni. In the late 1870s, Vittore turned to younger artists, offering contracts to Giovanni Segantini and Emilio Longoni (1859–1932). Later, he took up Angelo Morbelli (1853–1919). Grubicij travelled to Paris, England and the Low Countries, becoming friends with most of the members of the Hague School, including Jozef Israels, Mesdag and Mauve, the last of whom encouraged him to paint. His correspondence reveals that, among his contemporaries, he was in touch with Théophile de Bock, George Breitner, Philip Zilcken, Willem de Zwart, William Bastiaan Tholen and, in particular, Isaac Israels. During this period in Holland of 1882–5, Grubicij made a series of drawings that he was to use much later for his etchings.

On his return to Italy, Grubicij became the art critic for the Milan newspaper *Riforma*. Inspired in 1886 by reading an article by Félix Fénéon on the difference between Seurat's painting and Impressionism, he sought out a copy of Ogden N. Rood's *Modern chromatics with applications to art and industry . . .*, London, 1879. Grubicij became the first Italian artist to adopt Divisionism, an Italian variant of Pointillism, which he promoted among other North Italian artists. In 1888, Grubicij was again in London to organize a huge exhibition of 504 contemporary Italian paintings, presented as *Alberto Grubicy's picture gallery*. During this visit, he met both Alma-Tadema and Leighton. In 1890, Grubicij gave up the management of the gallery to his brother, Alberto, in order to concentrate on writing for a new journal, *Cronaca d'Arte*. He expounded Scapigliati and Symbolist theories relating to the unity of the various arts. His paintings of the mountain valleys around

Lake Maggiore, and bordering Switzerland, were often of the transparent atmosphere at dawn or dusk, and were notable for their harmonious light effects. Grubicij aimed to create emotional symphonies by groups of pictures. His efforts to arouse feelings akin to the psychological effects of turn-of-the-century classical music led to a close friendship with the conductor Arturo Toscanini, who collected some of his best paintings.

Almost all of Grubicij's thirty-four known etchings were done over a few months in 1893–4. He often used drawings that he made during his time in Holland and Flanders. Grubicij used the press of the Famiglia Artistica in Milan to print them, and exhibited some of them in its gallery in the spring of 1894. Few impressions are known of his etchings. It is not known who taught him the technique, but his method of leaving layers of ink on the plate so that, when printed, they resembled monotypes, was used by several of his Lombard contemporaries. Grubicij referred to the etching of one of these, the sculptor Giuseppe Grandi, in the essay 'L'acquaforte nell'arte moderna', which he sent in 1895 to Antonio Fradeletto, the secretary of the Venice Biennale. It is unknown why it was not published. Grubicij mentions three other printmakers, J.F. Millet, Matthijs Maris and Philip Zilcken. After a period when he devoted himself entirely to writing and criticism, he returned to painting in 1910. Just before his death in Milan in 1920, Grubicij presented part of his collection of paintings, drawings and etchings to the newly formed Galleria d'Arte Moderna in that city. This included a significant group of works by Hague School artists. He had been one of the principal advocates of the gallery's creation.

BIBLIOGRAPHY
Patricia Foglia published a catalogue of twenty-nine of Grubicij's prints in *Grafica d'Arte*, XXVI, 1996, pp. 11–23. In addition, Rosalba Dinoia, 'L'Eau-forte "mobile" dans l'évolution de l'estampe originale à la fin du XIXe siècle. Expériences françaises et italiennes', *Histoire de l'Art*, L, 2002, pp. 95–108, discusses Grubicij's essay on etching. Sergio Rebora, *Vittore De Grubicy De Dragon: 1851–1920*, Milan, 1995, provides a catalogue of the artist's paintings and sketches, as well as of those etchings known at that date. Both these were published before the MART, Trento e Rovereto, acquired thousands of Grubicij documents, study of which is likely to amend some of the findings in previous publications on his etchings. The artist's work has been put in a wider context in the exhibition catalogue *Vittore Grubicy e l'Europa. Alle radici del divisionismo*, ed. Annie-Paule Quinsac, Skira Editore, Milan, 2005.

22

FISHPOND IN FLANDERS

1893–4

Etching and drypoint 252 × 182 dedicated
by the artist in pencil: *Omaggio all'Arch.*
Maino Vittore Grubicy
2003-6-30-79
Presented by Luigi Majno, 2003

This is an impression of the third and last
state of this print. The earlier states are
much greyer and more atmospheric. The
print is based on a study that Grubicij made
during his time in the Low Countries in the
early 1880s. As in much of his work, there is
a remarkable stillness in this landscape. The
first owner was the prominent lawyer and
socialist politician Luigi Majno (1852–1915),
who was a patron of several contemporary
Italian painters and printmakers, in particu-
lar Giuseppe Mentessi (1857–1931), the con-
tents of whose studio his family inherited.

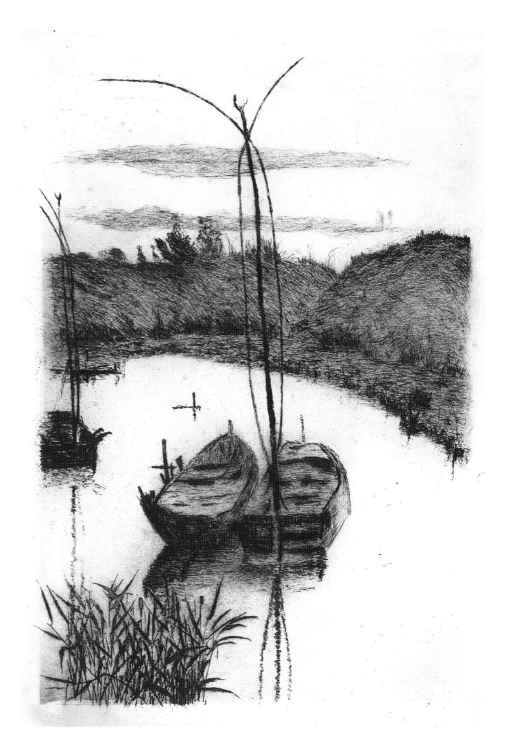

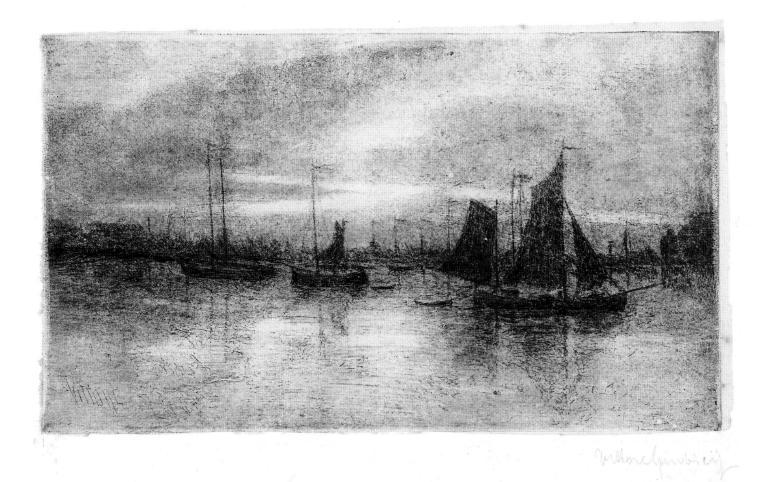

23

SEAPIECE (MARINA)

1893–4
Drypoint 113 × 198 signed in pencil
2003-6-30-80
Presented by Luigi Majno, 2003

This is one of a group of prints of the River
Scheldt, which are based on drawings and
watercolours that Grubicij had made in
Antwerp between May and December of
1885. The crepuscular effect creates a mood
akin to that found in the etchings of Matthijs
Maris. Grubicij described him as 'a very sin-
gular genius' in the essay that he sent in 1895
to Antonio Fradeletto. The composition and
inking can also be compared with the Venice
etchings of Whistler, some of which Grubicij
may have seen on his visits to London.

Luigi Conconi 1852–1917

Born in Milan, the nephew of the painter Mauro Conconi (1815–60), he studied architecture in Milan at the Accademia di Brera, and at the Regio Istituto Tecnico Superiore. His Professor of Mathematics was Luigi Cremona, brother of the painter Tranquillo Cremona. Conconi frequented the Scapigliati circle, which included Cremona, Daniele Ranzoni, Vespignano Bignami (1845–1906) and the architect Luca Beltrami. He made his first etching in 1877 in connection with his work with the architect Guido Pisani Dossi on a project for the Palazzo Marini in Milan. Conconi used his architectural training occasionally throughout his career, most notably in unsuccessful entries for a series of competitions for public monuments in the early 1880s and early 1890s. In one of these in 1891, a competition for a monument to Dante in Trento, he worked with the sculptor and printmaker Prince Paolo Troubetzkoy (1866–1938), a pupil of Giuseppe Grandi. Conconi also worked with Troubetzkoy and the furniture designer Eugenio Quarti (1867–1929) on a room for the 1906 Milan International exhibition. Three of Conconi's buildings designed between 1897 and 1900, however, were completed, the Villa Pisani Dossi on Lake Como, the tomb of the poet Felice Cavallotti, at Dagnente on Lake Maggiore, and the Segre Chapel in the Monumental Cemetery in Milan.

Conconi's early paintings were influenced by Tranquillo Cremona and Daniele Ranzoni. His critical attitude to authority and his opposition to contemporary academicism in 1881 led him to organize *L'indisposizione artistica*, a burlesque of the official National Milan exhibition. Until 1885 he shared a studio with the painter Gaetano Previati (1852–1920). Conconi soon developed an interest in visionary themes, often taking his inspiration from medieval legends and fables. He was also noted for his nocturnal subjects, and experimented with a diorama of the life of Dante. Conconi's association with the European Symbolist movement led him in 1892 to consider participating in the Salon de la Rose + Croix in Paris. However, he was often in financial straits, and after 1895 exhibited only on invitation, although he received the international recognition of prizes in Paris in 1900 and in Munich in 1913. A committed social democrat, Conconi was involved with Giuseppe Mentessi, Luigi Rossi (1853–1923) and others in the organization of courses run by the Società Humanitaria in the 1890s, and served as a radical member of the Milan city council between 1899 and 1904. Conconi also worked as an illustrator, initially for the satirical journal *Guerin Meschino*, of which he was co-founder and editor in 1882. From the early 1890s, he provided illustrations for political journals, and for books by Carlo Dossi, Alphonse Daudet, Emile Zola, Cervantes, the classical writer Longus and others.

Conconi was the leading Lombard exponent of the *acquaforte monotipata*, a technique which he learnt from the sculptor Giuseppe Grandi. Conconi's friend Beltrami compared his inking of his plates with the art of a watercolourist. On occasion, he used his fingers directly on the plate to spread the ink. The abundant plate tone created evanescent effects, which were interpreted as evocative of memory and of the past. Conconi printed all his own plates on a press lent to him by the Famiglia Artistica, the Milan exhibiting society, with which he frequently showed. Almost a fifth of Conconi's seventy-nine etchings were inspired by literature. Many of his prints were devoted to female figures. He also made seven architectural and seven portrait etchings, as well as producing landscapes, still lifes and plant studies.

BIBLIOGRAPHY
Matteo Bianchi and Giovanna Ginex, *Luigi Conconi incisore*, Castello Sforzesco, Milan, 1994, catalogues the artist's prints. The compiler has not seen the Ph.D. thesis by Emanuela Pace, *Le incisioni di Luigi Conconi*, Turin, 2000. There has been no monographic publication on the rest of his art since Polifilo (Luca Beltrami), *Luigi Conconi nelle lettere a Luca Beltrami in Parigi 1876–1880*, Milan, 1920, and Raffaello Giolli, *Luigi Conconi architetto e pittore*, Milan, 1921.

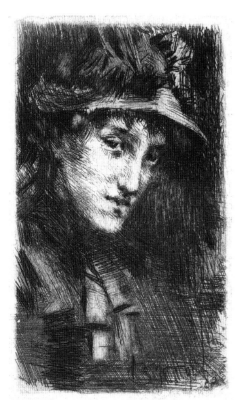

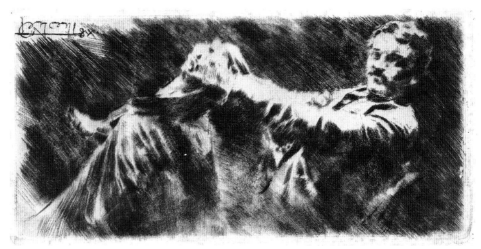

24

ADA

1880
Etching 98 × 59
Bianchi and Ginex 9
2003-6-3-39
Presented anonymously, 2003

The sitter was the sister of Conconi's friend
the painter Tranquillo Cremona.

25

PORTRAIT OF LUCA BELTRAMI

1884
Drypoint 78 × 158 signed, dated and
dedicated in plate to Luigi Majno
Bianchi and Ginex 15
2003-6-30-78
Presented anonymously, 2003

This is one of two drypoint portraits that
Conconi executed in 1884 of the distin-
guished Milanese architect and architectural
historian Luca Beltrami (1854–1933). He
was a close friend of Conconi and, under the
pseudonym Polifilo, published *Luigi Conconi
nelle lettere a Luca Beltrami in Parigi
1876–1880*, Milan, 1920, as well as writing
the introduction to Conconi's 1920 Galleria
Pesaro memorial exhibition. Conconi intro-
duced him to etching. Beltrami's best-known
print, *The cloisters of Saint Trophime, Arles*,
was published in Paris by Alfred Cadart in
L'Illustrazione Nouvelle in 1877, and was
exhibited at the Paris Salon that year.
Subsequently, he used his etchings to illus-
trate some of his scholarly publications, most
notably *La Certosa di Pavia*, Milan, 1895.
Beltrami's writings on Milanese Renaissance
architecture and art are still profitably con-
sulted by students of the period. The jurist
and philanthropist Luigi Majno (1872–1915),
Professor of Law at the University of Pavia,
and a socialist deputy for Milan from 1900,
was a major patron of Giuseppe Mentessi and
other artists associated with the Scapigliatura
movement. He shared Conconi's political
views.

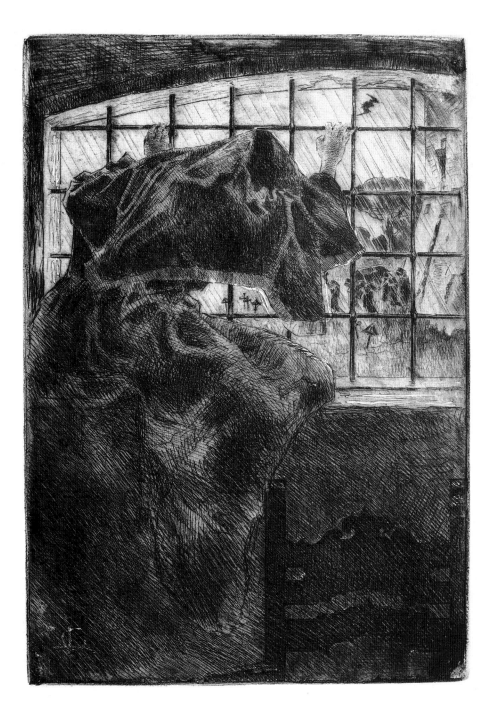

26

BLACK CAP

1889
Etching 279 × 195
Bianchi and Ginex 29
2004-5-31-37
Presented anonymously, 2004

It is likely that there is a literary or operatic source, such as Victorien Sardou's *Tosca* of 1887, for this print of a veiled woman in mourning watching a funeral procession through the barred window of a prison. Conconi took other subjects from Boccaccio, from Gounod's *Faust* and from a play by Luigi Illica. The title, *Capinera*, is the Italian for the bird the blackcap. The etching has the alternative titles *Sad moment* and, presumably ironically, *Joyful hour*.

27

MATERNAL LOVE
(AMOR MATERNO)

1893
Etching with plate tone 331 × 227 signed,
dated and dedicated *alla gentile Signora
Mentessi* in the film of ink left on the plate
in wiping
Bianchi and Ginex 43
2004-6-30-18
Presented anonymously, 2004

This etching is dedicated to the wife of
Conconi's close friend, the Ferrara painter
and etcher Giuseppe Mentessi (1857–1931).
She and her child may well be the subject of
this print. Conconi exhibited an impression
at La Permanente in 1895.

29

LA FAMIGLIA ARTISTICA

1912
Etching 201 × 238 signed in the plate, and in
ink below plate, and inscribed *Famiglia
Artistica* and *1872–1912* in the plate.
Inscribed in red ink *pv ++5* below plate
Bianchi and Ginex 53
2004-5-31-35
Presented anonymously, 2004

Conconi made this print to celebrate the
fortieth anniversary of the foundation in
Milan of the exhibiting society La Famiglia
Artistica. He had become a member of the
society in 1881.

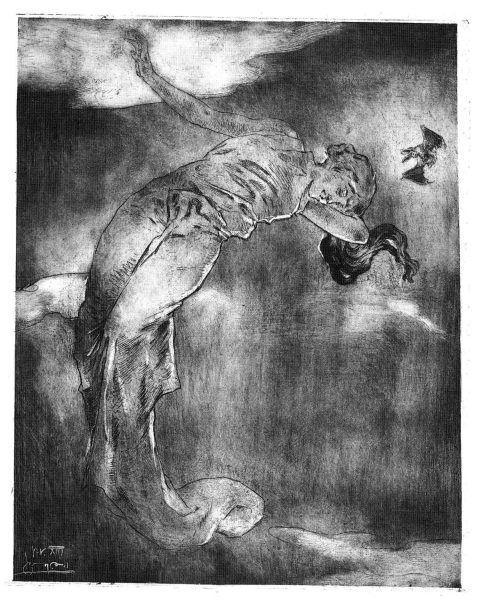

28

THE WAVE

1896
Etching with plate tone 538 × 442 signed,
and inscribed *pr. XIII*
Bianchi and Ginex 42
2004-5-31-36
Presented anonymously, 2004

Conconi intended this print to be the
frontispiece for a projected edition of his
etchings, which never came to fruition.

Adolfo Wildt 1868–1931

Born in Milan into a family of limited means, Wildt was apprenticed in 1880 as a rough carver to Giuseppe Grandi, the leading sculptor of the Scapigliatura movement. From 1882 to 1887 he learnt to work marble in the studio of Federico Villa (1837–1907), while he attended the Accademia di Belle Arti di Brera from 1885 to 1886. Wildt made studies there after the antique and Michelangelo. From 1894 his close friend the German collector Franz Rose von Doehlau (1854–1912) gave him an annual retaining fee in return for being offered first choice for each of his works. Wildt became Italy's leading Symbolist sculptor, producing highly polished marbles of remarkable translucence. His elongated, and often tortured, figures frequently approach the grotesque in their exaggerated pathos. His religious sculpture frequently combines extreme refinement and mysticism. Wildt's style, which derived in part from the study of late Gothic expressionistic sculpture, can also be related to the Vienna Secession. It also seems probable that he had looked hard at the Dutch artist J. Thorn Prikker, whose works were shown both in the 1902 Turin International exhibition and at the Venice Biennale.

From 1895, Wildt's sculpture was included in many national and international exhibitions, and he was awarded prizes in Munich, Milan and Venice. Wildt received many commissions, particularly for funerary monuments. In 1921, he published *L'arte del marmo* and, from 1921 to 1922, he ran his own art school in Milan, which was organized on the lines of a medieval workshop and specialized in marble carving. The following year, Wildt was appointed Professor of Sculpture at the Accademia di Brera, where Lucio Fontana and Fausto Melotti were among his most distinguished pupils.

Wildt made only a very few prints. Ten etchings executed c.1919 and a single lithograph of 1929 have so far been recorded. Others may yet be found, as in a letter of 16 April 1915, to the Milan publisher Giovanni Scheiwiller, Wildt writes of putting aside an unfinished etching, as he was dissatisfied with the results. A number of his etchings are based on drawings which Wildt had made a few years before. At least three of the prints are known in coloured impressions. The religious subject matter reflects Wildt's deep spirituality. The stylized elongated and boneless figures in his etchings belong to the world of Art Nouveau, and are comparable to the early etchings of Felice Casorati. It is also possible that Wildt had studied the work of the Glasgow Four, Charles Rennie Mackintosh, Margaret Macdonald Mackintosh, J. Herbert MacNair and Frances Macdonald MacNair at the famous Turin International Exhibition of Decorative Art in 1902, and at the Venice Biennali. Their work attracted the attention of the influential and much read critic Vittorio Pica. There were two editions of Wildt's etchings, pulled in the 1920s by the Milan printer Marioni, and in 1951 by the painter Aldo Galli in Como. His plates for these survive in a private collection.

BIBLIOGRAPHY

A single article has been published on Wildt's prints, M. Rotunno, 'Le incisioni di Adolfo Wildt', *Arte a stampa*, V, 1979, pp. 16–18. His sculpture and drawings were the subject of the exhibition *Adolfo Wildt 1868–1931*, Galleria d'Arte Moderna di Ca' Pesaro, Venice, 1989, the catalogue to which has a very full biography.

30

THREE MEN CARRYING THE BODY OF A WOMAN

1929
Lithograph 345 × 259 signed and numbered
54/75 in pencil
2003-6-30-77
Presented anonymously, 2003

This, the artist's only lithograph, was published in Milan by Graphica Nova. As in much of Wildt's religious sculpture, it is a work of great refinement. The exact subject of this lithograph has yet to be determined. It is possible that the starting point for the print lies in a study of Raphael's drawings of the Entombment.

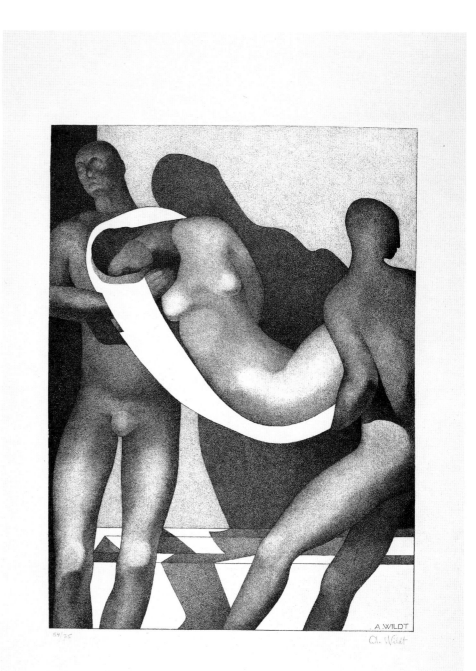

Adolfo De Carolis 1874–1928

Born at Montefiore dell'Aso, near Ascoli Piceno, De Carolis (sometimes spelt De Karolis) studied from 1888 at the Accademia di Belle Arti di Bologna, before transferring to the Museo Artistico Industriale in Rome, where he studied under Alessandro Morani (1859–1941) at the school of pictorial decoration. Between 1895 and 1897, De Carolis assisted Morani in the decoration of the Villa Blanc, Villa Manzi and Palazzo Vidoni, as well as in restoration work in the Borgia apartments in the Vatican. During this period, he met Giovanni Costa, and in 1897 became a member of In Arte Libertas, the artistic group in Rome that Costa had founded in 1885. Also in 1897, De Carolis began painting a decorative cycle in the Villa Brancadoro, San Benedetto del Tronto, which took him seven years to complete.

Shortly before his appointment in 1900 as Professor of Ornamental Design at the Accademia di Belle Arti in Florence, Adolfo De Carolis made his first known woodcut. Two of the greatest Italian writers and poets of the day, Gabriele D'Annunzio and Giovanni Pascoli, swiftly appreciated his talent, and he became their preferred illustrator. Among the D'Annunzio books for which De Carolis executed woodcuts were *Laudi di Cielo* of 1903, *La figlia di Jorio* of 1904 and *Il notturno* of 1917. De Carolis also frequently contributed illustrations to the journals *Marzocco*, *Leonardo*, *Hermès*, *Rivista Marchigiana Illustrata*, *Novissima* and *Il Regno*. His most significant individual prints were a series of four woodcuts that he devoted to the life of the sea in 1908.

A pioneer in the revival of the chiaroscuro woodcut, De Carolis studied the early sixteenth-century prints of Ugo da Carpi and his followers. His interest in Renaissance woodblock printmaking also led him to admire British illustration and book production of the late nineteenth century. De Carolis was well versed in the products of William Morris's Kelmscott Press, as well as in the Englishman's model, the *Hypnerotomachia Polifili*. From these he derived his keen interest in typography and *mise en page*, as well as in the Renaissance revival style. Rossetti, Burne-Jones and Albert Moore were among the artists whom

he admired. We do not know if De Carolis saw the chiaroscuro woodcuts of Charles Shannon, but he was certainly aware of the books of the Vale Press. Dürer, Botticelli and Michelangelo were among the other artists to influence his work. In *La xilografia*, his treatise of 1924, De Carolis refers to the early nineteenth-century Berlin printmaker Wilhelm Unger (1775–1855). It may be that the mid-century revival of the chiaroscuro woodcut by German artists, such as August Gaber (1823–94), was also known to him. De Carolis also studied antique sculpture and the Cinquecento engravings of Jacopo Caraglio, as well as prints after Rosso Fiorentino and Baccio Bandinelli.

De Carolis was the key figure in the revival of interest in woodcut in Italy in the early twentieth century, and exerted a powerful influence on the next generation of printmakers, none of whom, however, achieved the quality of his work. He was in part responsible for the organization of major exhibitions of Italian prints in London in 1916 and in Paris in 1922. De Carolis acknowledged his debt to Pierre Gusman's 1916 *La gravure sur bois et sur l'épargne sur métal du XIV au XX siècle* when writing his own treatise on the woodcut. In this enterprise, he was assisted by the printmaker and mural painter Romeo Musa (1882–1960). De Carolis also wrote articles on art for a number of journals between 1896 and 1923.

Adolfo De Carolis was a phenomenally successful mural painter. Among his most important works were his pictures of 1907–8 for the ballroom of the Palazzo della Provincia in Ascoli Piceno, and his decoration of the Salone of the Palazzo del Podestà in Bologna, the result of his success in a competition in 1908, which led him in 1910 to settle in that city. De Carolis began work on the Salone in 1911, and at his death he was still working on these murals with a team of assistants. For part of this time, De Carolis was also working on decorations for the Great Hall of the University of Pisa, a project which lasted from 1916 to 1920. Other murals that he painted were for the Sala Consiliare of the Palazzo della Provincia di Arezzo, and for chapels in the Collegiata di San Ginesio, Macerata, and San Francesco, Padua. De

Carolis also designed stained glass and mosaics for the Villa Puccini at Torre del Lago. His pre-eminence in the field of mural painting was recognized by his appointment as Professor of Decoration at the Accademia di Brera in Milan in 1915, and to the equivalent positions in Bologna and Rome in 1917 and 1922.

BIBLIOGRAPHY
Although there is an extensive literature on De Carolis, there is no catalogue raisonné of his prints. A recent contribution is Silvia Zanini, *Adolfo De Carolis e la xilografia: uno studio sulla decorazione del libro tra Otto e Novecento*, Rome, 2003, which has an extensive bibliography. A selection of his writings have been collected by Alvaro Valentini, in Luigi Dania, ed., *Adolfo De Carolis*, Cassa di Risparmio di Fermo, 1975. A useful summary of his career is provided by Adele Anna Amadio and Stefano Papetti, *Adolfo De Carolis: con gli occhi di mito*, Pinacoteca Civica, Ascoli Piceno, 2001.

31 (see colour page 35)

THE HOWL OF ACHILLES

1908
Chiaroscuro woodcut printed in two blocks in black and red-ochre 199 × 315 signed *A – DE – KAROLIS* in block, and signed and dedicated in red pencil in 1917 to Gabriele D'Annunzio
2001-5-20-91
Presented anonymously, 2001

An impression of this woodcut was first exhibited at the exhibition of black and white organized by Renato Fondi and Giovanni Costetti for the Famiglia Artistica in Pistoia in the summer of 1913. The print was particularly admired by its dedicatee, the poet and Italian nationalist Gabriele D'Annunzio (1863–1938). In a letter of 24 April 1917, he wrote, 'I cannot tell you how much the woodcut of Achilles done with heroic movement pleases me. I have put it in a frame and look at it often.' The crowded composition is filled with Michelangelesque figures, while the horses recall Leonardo's drawings for the lost *Battle of Anghiari*. In October 1921,

Alberto Martini 1876–1954

D'Annunzio gave this impression to his friend and correspondent the prolific writer and conservative art critic Ugo Ojetti (1871–1946), founder in 1925 of the art-historical journal *Dedalo*, and regular contributor to the Milan newspaper *Corriere della Sera*. The present may have been prompted by the planned publication of an article by Antonio Maraini on Adolfo De Carolis in *Dedalus*, II, 1921–2, pp. 332–51. One of Ojetti's books was *Il cavallo di Troia*, Milan, 1904.

The subject of this woodcut was taken from Homer's *Iliad* XVIII, verses 165–238. It represents the moment at which the hero Achilles emerged from his tent on learning of the death of his friend Patroclus. The devastating sound of his war cry scattered the Trojan forces, thus preventing them from setting fire to the Greek fleet. De Carolis's oil painting of the same subject, also of 1908, may have acted as a *bozzetto* for the woodcut. In that, the composition is reversed and the format is much more horizontal. De Carolis also exhibited a drawing of the subject in the first Italian exhibition devoted to the wood-cut, organized by Ettore Cozzani, editor of *L'Eroica*, and held in Levanto near La Spezia in 1912. De Carolis returned to the *Iliad* in 1924, as part of the series of works by Greek poets translated by Ettore Romagnoli, which he illustrated between 1921 and 1928 for the Bologna publisher Nicola Zanichelli.

Born in Oderzo, Alberto Martini was taught to paint by his father, the Venetian Giorgio Martini (1845–1910), who worked in a realist style and copied Old Master paintings. Alberto's abilities as an illustrator were quickly recognized, and his work was included in the 1897 Venice Biennale. Martini's visit to Munich the following year proved crucial to his development. There he was introduced to the journals *Dekorative Kunst* and *Jugend*, to which he contributed drawings, and to the art of the neo-Dürerian Bavarian illustrator and book designer Joseph Kaspar Sattler (1867–1931), and of Dürer himself. Martini imitated the latter's famous monogram. Martini's illustrations were strongly influenced by northern Renaissance printmaking and draughtsmanship, in particular by Hans Baldung Grien, but also by the mid-nineteenth-century German artist Alfred Rethel. The demonic world, already revealed in his first series of illustrations to Dante's *Divine Comedy* of 1901–2, made for a competition organized by Alinari of Florence, led later critics to regard him as one of the precursors of Surrealism. Key, too, for Martini was his meeting in 1898 with the critic Vittorio Pica, who championed his work enthusiastically for over thirty years, and used his illustrations in a series of publications, including his newly founded journal, *Emporium*. Although based in Treviso, Martini often visited Venice, where he became a friend of a younger, but equally influential, critic, Margherita Sarfatti. In 1904, he executed his first bookplates, a genre to which he made a significant contri-bution. In the same year, Martini began to illustrate the tales of Edgar Allan Poe, a pro-ject on which he worked for six years. His illustrations achieved an international reputa-tion. Martini in 1907 visited London, where he had a one-man show at the Leicester Gallery. Among his admirers were the leading Belgian critic Octave Maus and the English publisher William Heinemann, who organized a major exhibition of Martini's work at the Goupil Gallery in 1914. Two further one-man shows were held at the Leicester Gallery in 1916 and 1918. Martini's work had a major impact on the style of the English draughts-man and illustrator Austin Osman Spare, an artist close to the occultist Aleister Crowley.

Encouraged by Pica, the Italian took up pastels, executing numerous works on the theme of woman as butterfly, which he also explored in lithography. Martini's first involvement with the theatre came in 1919–20, when he designed the costumes for the ballet *Il cuore di cera*. In the early 1920s, Count Emanuele di Castelbarco's Bottega di Poesia published several volumes illustrated by Martini. The Count introduced him to aristocratic circles, in which he obtained many commissions. In 1923, Martini, inspired by the music dramas of Wagner and Strauss, and by the plays of Aeschylus and Wilde, invented a theatre on water, *Il Tetiteatro*. Upset at the lack of appreciation for his work from Italian critics, he moved to Paris and settled in Montparnasse in 1928. Martini remained there for six years, devoting himself to painting, and to illustrating French poetry and novels with drawings and watercolours. In 1932, he started to make little glass sculp-tures, and designs for textiles and wallpaper in an Art Deco style, but he was forced by financial circumstances to return two years later to Milan, where he continued his career as an illustrator, and, after 1940 in particular, as a designer of bookplates. These included lithographs, zincographs, drypoints, relief prints and various photographic processes. His paintings of the 1940s and early 1950s were in a magic realist vein.

Martini made his first etchings in 1898, but it was in the field of lithography that he made his most important prints. Between 1899 and 1900 he produced a set of nineteen chromolithographic postcards and posters for the Treviso lithographers Longo and Zoppoli, which reflected his knowledge of the Vienna Secession and of late Pre-Raphaelite art. Martini's earliest drypoints were made in 1910–11. The peak of his printmaking came in the period 1914–16, when he worked closely with the Domenico Longo lithographic workshop in Treviso. The six-print cycle *I misteri* of 1914–15 (nos. 32 and 33) was followed by the fifty-four colour lithographs *Danza macabra*, the erotic portfolio *Carezze*, and the twenty-one small lithographs *Donne, farfalle, fiori, animali*. Martini made no further lithographs, until he supplied three to Giorgio and Piero Alinari for their 1922

Florentine edition of *The Divine Comedy*. There followed another break in his engagement with lithography, which lasted until the early 1940s. Martini had returned to intaglio printmaking in the mid-1920s. He etched four plates for a second series of *Divine Comedy* illustrations, which were published by Edizioni Cenobbio in Milan in 1936. After the Second World War, he began making drypoints in a very linear style, including *Miti*, a set of twelve published in 1947.

BIBLIOGRAPHY
Francesco Meloni's catalogue raisonné, *L'opera grafica di Alberto Martini*, Milan, 1975, which records 117 lithographs, thirty-four drypoints and ten etchings, has been supplemented by Marco Lorandi, 'Una serie inedita di Alberto Martini', *Print Collector/Il Conoscitore di Stampe*, XXX, 1976, pp. 53–60, and Laura Fedeli, 'Aggiunte ai cataloghi', *Grafica d'Arte*, VII, 1991, p. 38. In recent years, there have been several exhibitions and publications devoted to his illustrations and prints, including Mario Fragonara and Laura Fedeli, *Alberto Martini. Catalogo degli ex libris*, Milan, 1993. His paintings were at the centre of the exhibition *Alberto Martini surréaliste*, Palazzo della Ragione, Bergamo, 2004. Martini's manuscript autobiography has been published by Marco Lorandi in *Disciplina e trasfigurazione*. *Alberto Martini e il teatro*, Museo del Teatro alla Scala, Milan, 1992.

32

DEATH

1914
Lithograph 535 × 425 signed, numbered *3*,
and dated in the stone
Meloni 12
2000-3-26-4
Presented by the Arcana Foundation, 2000

PORTRAIT OF A YOUNG WOMAN

1916

Colour lithograph printed in red-brown ink
on pale beige paper 339 × 242 signed and
dated in the stone, and signed in pencil
Meloni 102
2002-2-24-17
Presented anonymously, 2002

This is from an edition of ten unnumbered
impressions. A further ten impressions were
numbered 1/10 to 2/10.

THE BEAUTY SPOT

1916

Colour lithograph printed in red-brown ink
on pale beige paper 340 × 242 signed and
dated in the stone, and signed in pencil
Meloni 103
2002-2-24-18
Presented anonymously, 2002

Of the edition of thirty, ten were signed and
numbered 1/10 to 10/10, ten were signed,
but unnumbered, and ten neither signed nor
numbered. The phosphorescent lighting is
suggestive of Martini's engagement with
photographic experimentation, and seems to
prefigure Man Ray's photographs of Nusch
Eluard. Martini may have been influenced by
Allan Kardec (Hippolyte Léon Denizart
Rivail), the mid-nineteenth-century French
magnetist and theoretician of spiritualism,
whose *Che cos' è lo spiritismo* and *Il libro dei
medium* were published in Italy in 1884 and
1887 respectively.

33

MADNESS

1914
Lithograph 534 × 420 signed, numbered 6,
and dated in the stone
Meloni 10
2000-3-26-3
Presented by the Arcana Foundation, 2000

These two lithographs are from the suite of
six *Misteri*, which, although made in 1914,
were issued in an edition of fifty only in 1923
in Milan, prefaced by an introduction by the
poet Count Emanuele di Castelbarco
(1884–1964), whose Bottega di Poesia was the
publisher. The titles of the other four are
Dream, *Birth*, *Love* and *The infinite*. Martini
may have read the theosophist Rudolf
Steiner's *La direzione spirituale dell' uomo
e dell'umanità*, an Italian edition of which
was published in 1912. Similar themes appear
in Martini's cycle of drawings *Trentuna
fantasie bizarre e crudeli. Precedute dalla
diabolica imagine di Niccolò Paganini e
dall'autoritratto dell'uomo Pallido*, also
published by Bottega di Poesia in 1924.

Giovanni Costetti 1874–1949

Born in Reggio Emilia, he was baptized as Giannetto Costetti, but he soon adopted the name Giovanni. He attended the Scuola del Disegno in his native town. Both he and his elder brother, Romeo (1871–1957), decided to become artists. Romeo, attracted by the paintings of Domenico Morelli (1823–1901) and Francesco Michetti, went to Naples. He earned a reputation as a printmaker for his monotypes, which were often exhibited at the Venice Biennali. Giovanni Costetti was initially influenced by Antonio Fontanesi, Filippo Palizzi and Morelli. He knew the work of Signorini through reproductions, and of Puvis de Chavannes and Dante Gabriel Rossetti through his reading of journals. In the early 1890s Costetti visited Turin and the Accademia Albertina, and he returned to that city for part of his military service. In 1897 he went to Bern in Switzerland, where he encountered the paintings of Hodler. The Sanguinetti Bequest of the Comune of Reggio Emilia enabled him to travel and study for three years. From 1898 to 1899, Costetti was in Florence, where he met Armando Spadini, Graziosi and Soffici, and attended Fattori's Scuola del Nudo. Costetti was attracted by the symbolism of Böcklin, then living just outside Florence at Fiesole. In the winter of 1900, he followed his brother to Paris, accompanied by Soffici and Umberto Brunelleschi (1872–1949). Costetti met Rodin and Puvis de Chavannes, admired the work of Bourdelle, and studied that of Carrière. Most important for his painting was his encounter with the still lifes of Cézanne. On Costetti's return to Italy in 1901, he settled in Turin. The following year, he was involved with discussions with Soffici, which led in 1903 to the launch of the journal *Leonardo*, for which, under the *nom de plume* Perseo, he wrote an enthusiastic article on Böcklin. Costetti provided woodcuts for issue no. 7. His work attracted the attention of the English critic William Michael Rossetti, who commissioned him to paint two portraits. Costetti took part in the second Concorso Alinari, making twenty-eight illustrations to Dante's *Divine Comedy*, the composition of one of which he turned into a woodcut for *Revue du Nord* in 1905.

Most of his etchings date from 1904 to 1910. An early example is his 1904 portrait of Gabriele D'Annunzio. Between 1906 and 1908 Costetti made a series of etchings of beggars and grotesques in a seventeenth-century vein, and in the latter year he exhibited prints of mythological subjects at the Promotrice Fiorentina. Also in 1908, Costetti exhibited a group of etchings that he had made for D'Annunzio at the Esposizione Fiorentina della Società di Belle Arti. In these, muscular figures in dramatic crowded compositions are enveloped in Rembrandtesque chiaroscuro. In his subject prints, Costetti frequently quoted from sixteenth- and early seventeenth-century art. He exhibited twelve of his etchings in 1914 in a joint show with his brother Romeo at the Civico Museo, Reggio Emilia. These included a portrait of the poet and art critic Theodore Däubler, whom Costetti had met in 1908 and who had introduced him to Munch, of whose work Costetti became a devotee.

From 1916 onwards, he regularly contributed poetry and criticism to the Pistoia journal *La Tempra*, which was edited by his close friend and patron, the poet, literary and music critic and musicologist Renato Fondi. Together in 1912, they had been the prime movers in founding the exhibiting society Famiglia Artistica in that small Tuscan town, and they were responsible for the organization of a high-quality Mostra del Bianco e Nero, which was held there in the summer of 1913. In the interwar period Costetti's activity as a writer was as significant as his work as a painter. In 1921 his drama *L'idolo* was published by Vallecchi in Florence, and two years later he became editor of the *Giornale di Poesia*. Inspired by the mystic spiritualism of Pietro Zanfrognini and Guido Manacorda, he argued for a regeneration of the arts. Costetti's contributions to journals in the 1920s included much literary and theatrical criticism, as well as writings on art and mystical thought. He and Ugo Bernasconi (1872–1949) were the only artists to sign Benedetto Croce's 1925 manifesto in opposition to the Convegno per le Istituzioni Fasciste di Cultura held in Bologna. In 1926, Costetti met the poet Paul Valéry in Paris, and began to illustrate his *L'Ame et la danse*. A visit to England two years later was followed in 1929 by the publication in London by Arts & Crafts of *Vingt-six dessins de Giovanni Costetti*, which included an autobiographical note. In 1931 he published an article on Archipenko, Zadkine and Art Nègre in *Poligono*. Among the other artists on whom he wrote were Primo Conti, Arturo Martini, Giorgio De Chirico, Achille Funi (1890–1972), Arturo Tosi (1871–1956) and Mario Sironi. Costetti's art of the 1920s reveals his study of the etchings of the Swedish artists Zoir, Larsson and Zorn, which he had seen at the Venice Biennali before the First World War. His portraiture shows knowledge of such diverse artists as Zuloaga, Sargent and Van Dyck. Costetti's portraits included a series of monotypes of famous individuals made in 1926.

His staunch opposition to Fascism led him to launch a violent attack on the sculptor and arts administrator Antonio Maraini, the appointee of Mussolini's Sindacato Fascista. As a result, Costetti was excluded from the Venice Biennale of 1934, and went into voluntary exile in Norway. From there he paid regular visits to Paris, where he was at the time of the German invasion. Costetti, however, escaped to Holland, where he remained until 1948.

BIBLIOGRAPHY
There is no catalogue to Costetti's prints. The exhibition catalogue written by Giancarlo Ambrosetti, *Grafica di Giovanni Costetti (Reggio Emilia 1874 – Settignano 1949) dalle donazioni Giovanni Costetti – Wilhelmina Ferrando – Mai Costetti*, Assessorato alle Istituzioni Culturali, Ridotto del Teatro Municipale, Reggio Emilia, 1976, provides a good introduction to his work. The most recent publication on his paintings is Giuseppe Paccagnini, *Giovanni Costetti. Opere dal 1901 al 1949*, Montecatini Terme, 2004. In addition, there are two exhibition catalogues edited by Giuseppe Paccagnini, *Giovanni Costetti*, Hotel Schillerpark, Casino, Linz, 1998, and *Giovanni Costetti maestro del novecento italiano*, Galleria d'Arte Agostino Tortora, Ferrara, 1999.

36

TWO WOMEN

c.1908–9
Etching 139 × 104
Ambrosetti 83
2002-7-28-4
Presented anonymously, 2002

This is the only known lifetime impression of
one of a group of prints by Costetti which
have a Spanish flavour. He much admired the
work of Zuloaga, who had a one-man show at
the 1903 Venice Biennale, and, during his
time in Paris, he may well also have encoun-
tered the prints of Joaquin Sunyer. Giancarlo
Ambrosetti arranged for an impression to be
taken from the plate in the Civici Musei,
Reggio Emilia, in 1974. The two women may
be prostitutes, who were often the subject of
works by his friend Lorenzo Viani.

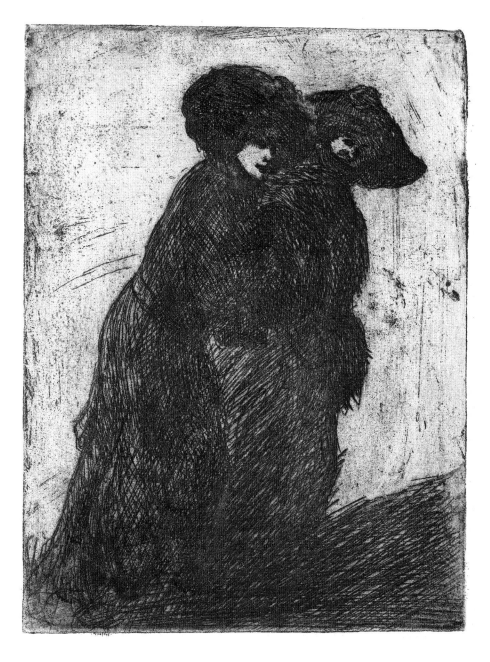

Born in Novara, Casorati spent his formative years in Padua, where he developed an interest in music and literature. He began to paint in 1902, and read law at the University of Padua, graduating in 1906, while frequenting the studio of Giovanni Vianello (1873–1926). Casorati's early paintings were in the Symbolist mode of the Vienna Secession. His adherence to this style was strengthened by seeing Klimt's installation at the 1910 Venice Biennale, where he met the Austrian painter. Casorati had spent the years 1908 to 1911 in Naples, where he particularly admired the work of Pieter Bruegel the Elder, which he saw in the Museo di Capodimonte.

Between 1911 and 1914, Casorati lived in Verona, where he was the co-founder with Pino Tedeschi and Umberto Zerbinati of the periodical *La Via Lattea*, for which he made a number of Symbolist woodcuts. Some of the etchings of this period have echoes of the drawings of Frances Macdonald MacNair, one of the four Glasgow artist designers whose work had received great acclaim in 1902 at the international exhibition in Turin, as well as of the work of Klimt, twenty-two of whose paintings were exhibited at the Venice Biennale. He was closely associated with a group of young artists, including Gino Rossi, Pio Semeghini (1878–1964) and the sculptor Arturo Martini, all of whom made prints, who showed in Venice at the Ca' Pesaro. Its director, Nino Barbantini, encouraged them in their rebellion against the tired academicism then dominant in the Veneto. Before being called up into the Italian army in 1915, Casorati made his first sculptures in varnished terracotta, a medium favoured by Martini.

Casorati settled in 1918 in Turin, where he soon became a central figure in artistic and intellectual circles. He established friendships with the pianist and composer Alfredo Casella and with the anti-Fascist agitator Piero Gobetti, whose Amici della Rivoluzione Liberale he joined in 1922. Gobetti championed Casorati's work in Antonio Gramsci's newspaper *Ordine Nuovo*. Casorati's radical associations led to his arrest for a brief period in 1923. Casorati's paintings of the 1920s were radically different from his pre-war work, which he rejected as immature. Solidly constructed figures were set securely in spaces organized on the model of Quattrocento perspectival systems, especially that of Piero della Francesca. Also important for Casorati were the dramatically foreshortened figures of Mantegna. The stillness, purity and rigidity of his compositions resemble those of the contemporary Neue Sachlichkeit movement in Germany.

In 1923 Casorati set up his own school for young artists, where he trained several of the painters, who later formed the Gruppo di Sei di Torino. He was also the co-founder of the Società Belle Arti Antonio Fontanesi, which organized exhibitions of nineteenth-century and contemporary Italian and foreign art. Much of Casorati's work in the 1920s and 1930s was in the field of decorative art, leading to his appointment in 1928 as Professor of Interior Design at the Accademia Albertina in Turin, a post which he held until his appointment to the chair of Painting at the same institution in 1941. Casorati's principal patron, the Turin industrialist Riccardo Gualino, commissioned Casorati to work with the architect Alberto Sartoris (1901–98) on the Piccolo Teatro, and on other decorative schemes. Casorati also designed costumes and sets for La Scala in Milan and for the Maggio Musicale, as well as a building for part of the Piedmontese Pavilion at the 1927 International Biennale of Decorative arts at Monza, once again working with Sartoris.

Casorati made about 150 prints, but very few of these were published in editions in his lifetime. He experimented with a wide variety of techniques, using papyrus, slate and terracotta matrices, probably under the influence of Arturo Martini, as well as more conventional methods. Casorati made his first etching in 1907. Some of his earliest etchings and woodcuts show knowledge of the early woodcuts of Kandinsky. Casorati's painfully thin elongated nudes may also reflect an interest in the work of the Belgian sculptor Georges Minne. Two landscape colour lithographs of c.1912 are almost direct interpretations of the paintings of Klimt. For a brief period in 1914 and 1915, Casorati abandoned his Secessionist style, making woodcuts in an Expressionist vein in spirit close to the Tuscan artists promoted in Cozzani's *L'Eroica*, Lorenzo Viani and Moses Levy (1885–1968).

Casorati seems to have made no further prints until 1927, by which time his style had become an Italian version of Neue Sachlichkeit. The simplified mannequin-like figures that feature in his prints of the late 1920s and 1930s remained in his etchings, lithographs and linocuts for the rest of his career. From the 1930s, several of Casorati's subjects were biblical and their compositions are often reminiscent of late fifteenth- and sixteenth-century Italian painting. The female nude, in repose or asleep, and bathers were other motifs that were popular with him. He also executed a few very striking and schematic landscapes. Casorati's *livres d'artiste*, all illustrated by lithographs, included Ugo Foscolo's *Le Grazie: Carme*, published by Edizioni della Collezione del Bibliofilo in Turin in 1946, a firm that also issued a portfolio of six of his lithographs the same year, Neri Pozza's 1947 edition of the New Testament, and an edition of Paul Valéry's *Cantique des Colonnes*, published by RAI-TV in 1959.

BIBLIOGRAPHY
There is no catalogue raisonné of Casorati's prints. Luigi Carluccio, *Felice Casorati opera grafica*, Milan, 1966, published thirty-five prints that were exhibited at the Galleria d'Arte Macchi, Pisa. They were also listed by Dino Geri, 'Opera grafica di Felice Casorati', *Gutenberg Jahrbuch*, XLII, 1967, pp. 225–7. This compiler has not seen Giorgio Trentin, *Felice Casorati opera grafica*, Cesena, 1988. The key recent publications are *Felice Casorati: incisioni, sculture e disegni, scenografie*, Aula Magna dell'Accademia Albertina, Turin, 1985, *Casorati Mostra antologica*, Palazzo Reale, Milan, 1990, in which Diego Arich de Finetti provided an essay on Casorati's early woodcuts, and *Felice Casorati dagli anni venti agli anni quaranta*, Turin, 1996.

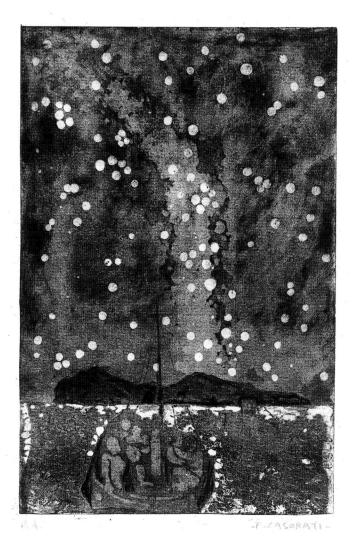

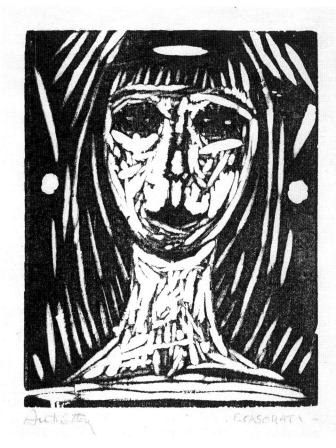

37

THE MILKY WAY AND BOATS
(VIA LATTEA E BARCHE)

1912
Etching and aquatint 217 × 145
Carluccio 3 second state of two
2005-5-30-3
Presented anonymously, 2005

Casorati made the first of his two aquatints
of this enigmatic subject in connection with
the Verona journal *Via Lattea*, of which he
was the co-founder. An edition of eight was
printed. Some impressions are printed in pale
blue or brown ink. A second posthumous
edition was published in 1966 by Luigi De
Tullio in Milan.

38

HEAD

1915
Woodcut 155 × 125
2005-5-30-2
Presented anonymously, 2005

This is one of two woodcuts in which
Casorati abandoned his previous late
Symbolist style. The directness of the cutting
can be compared with the contemporary
German printmaking of artists such as
Pechstein.

39

WOMEN AT THE WINDOW

1946
Etching 237 × 155
2005-5-30-4
Presented anonymously, 2005

This is one of a group of claustrophobic etchings of figures closely packed at the entrance to confined spaces. The crowding of bodies to the front of the composition, coupled with the uncertain depth of field, is comparable to compositions in mid-sixteenth-century Italian painting. The subject of the etching has yet to be suggested. In a related pencil drawing in a private collection Casorati set the same figures in reverse in a landscape setting.

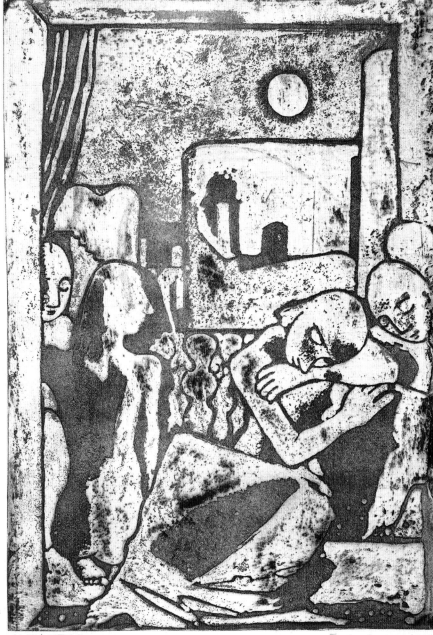

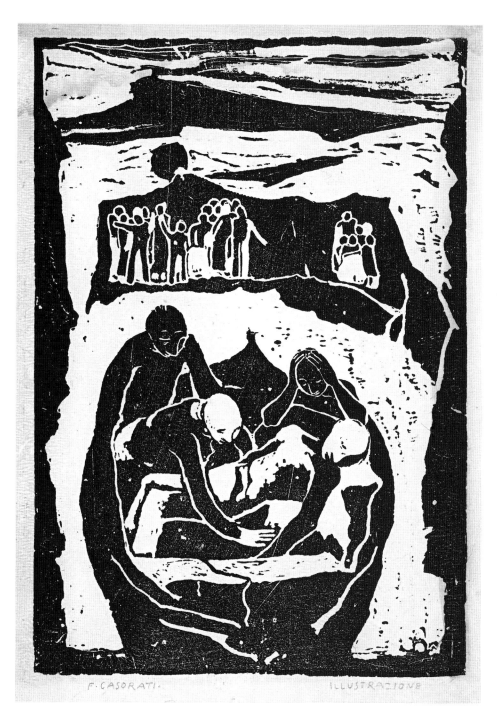

F. CASORATI. ILLUSTRAZIONE

40

THE MILL ON THE PO
(IL MULINO DEL PO)

1949
Gipsograph 335 × 235
Carluccio 19
2005-8-30-15
Presented anonymously, 2005

The Turin financier and industrialist Riccardo Gualino (1879–1964), Casorati's most significant patron, commissioned Casorati to make this print at the time of the launch of Alberto Lattauda's film *Il mulino del Po*. Based on Riccardo Baccelli's epic three-volume historical novel, originally published in 1938–40, the film was a production of Lux Italiana, the company set up by Gualino in 1934. It is likely that the few lifetime impressions of the print were given to financial supporters of the film, and to others closely involved with its production. Luigi De Tullio printed and published a posthumous edition of sixty-five in 1966. For this relief print Casorati cut into a matrix of hardened plaster.

Baccelli's novel was centred on a famous farmers' strike in the Po valley in 1876. Casorati's treatment of a dramatic episode in the third volume resembles a Renaissance Entombment. He shows the recovery from the Po of the body of the murdered blind musician 'Orbino' Luca Verginesi. Princivalle Scacerni, son of Cecilia, the central character in the book, killed Verginesi under the mistaken impression that he had been treating his sister, Berta Scacerni, as a whore.

Umberto Boccioni 1882–1916

Born in Reggio Calabria, Boccioni lived in Rome from 1899, when he began to attend the Scuola del Nudo, where he met Severini. The two young artists studied Divisionist techniques in the studio of Giacomo Balla. Early in 1906 he travelled to Paris, from where he visited Russia that summer. The following year, Boccioni was in Venice, where he was taught to etch by Zezzos, possibly the genre painter Alessandro Zezzos (1848–1914), and took up the technique with enthusiasm. He may well have been inspired by seeing the strong representation of etching at the Venice Biennale, which he visited in April shortly before making his first prints. Boccioni made six intensely worked prints in May before he moved to Milan, where he settled in August 1907.

There, he fell under the spell of the luminous Neo-Impressionist and Symbolist art of Gaetano Previati, which contrasted strongly with the more realistic work of Balla. Boccioni's etching style changed too, as he abandoned deep chiaroscuro, and relied more on line. He may well have known the prints of the German Otto Greiner, who lived in Rome between 1898 and 1915. In his diaries, Boccioni expressed an admiration for Rembrandt and Beardsley. The Dutchman was the single Old Master who mattered for his printmaking. Many of Boccioni's prints of this period were portraits, two of which bear comparison with the drypoints of the fashionable Armenian Chahine, fifty-seven of whose prints were shown at the 1907 Biennale. Two of the finest of the Italian's drypoints represent figures in action, which anticipate his later interests as a sculptor. Boccioni also turned to the desolate areas on the edge of the city of Milan as subjects for both paintings and prints. In a single etching, *The lake with swans*, he added coloured ink washes to the plate, in a manner similar to the *acqueforti monotipate* of the Milan-based Giuseppe Grandi, Luigi Conconi and Vittore Grubicij, to create an image closer in spirit to the landscapes of the Vienna Secession.

Boccioni's meeting with the poet Filippo Tommaso Marinetti, late in 1909 or early in 1910, proved decisive in turning him from realism to the challenge of capturing the sensations and dynamism of the modern city in visual form. Futurism, initially a literary movement, became closely associated with painting with the issue on 11 February 1910 of the *Manifesto dei pittori futuristi*, signed by Boccioni, Carrà, Russolo, Severini and Balla. All but one of Boccioni's last seven prints were executed during this transitional period of 1909–10, and they show no hint of Futurism, in either style or technique. In these, he returned to a heavy use of chiaroscuro. In less than three years, Boccioni had made just thirty-three etchings and drypoints. A group of his prints was exhibited in the summer of 1910 in his first one-man show at the Ca' Pesaro in Venice. Boccioni's Futurist style was diffused by a number of photographic reproductive prints derived from his drawings that were published in *Der Sturm*, and through a photolithograph published in the 1922 Bauhaus *Mappe*.

Boccioni's knowledge of Cubism, gained initially from journals such as *La Voce*, was strengthened by a visit to Paris in the autumn of 1911. The result was a fragmentation of colour, as well as of form, in his paintings, while the rich hues still belonged to the tradition of North Italian Divisionism exemplified by Gaetano Previati. The greatest difference lay in his introduction of swirling movements and lines of force that created sensations and energies not previously seen in Italian art. In 1912, Boccioni turned to sculpture, publishing the 'technical manifesto' *La scultura futurista*, and it was in this field that he created his most innovative works, *Unique forms of continuity in space* and *Development of a bottle in space*. He saw 'dynamic form' as 'a sort of fourth dimension in painting and sculpture'. Boccioni summarized his aesthetic thought in *Pittura e scultura futurista* of 1914. In the last year of his life, he returned to a figurative style in painting related to Cézanne and French Post-Impressionism, but he died from a fall from a horse when serving in the Italian field artillery.

BIBLIOGRAPHY
Maurizio Calvesi and Ester Coen, *Boccioni*, Milan, 1983, is the most substantial publication on him. Boccioni's painting and sculpture have been the subject of very considerable attention. Paolo Bellini's very thorough catalogue, *Umberto Boccioni. Catalogo ragionato delle incisioni, degli ex libris, dei manifesti e delle illustrazioni*, Galleria d'Arte Moderna Ricci Oddi, Piacenza, 2004, has superseded previous publications. Much information can be gleaned from Gabriella Di Milia, ed., *Umberto Boccioni: Diari*, Milan, 2003. Gino Agnese, *Vita di Boccioni*, Florence, 1996, has a useful bibliography.

41

MY MOTHER WORKING AT HER KNITTING

1907
Etching and drypoint 372 × 310 signed in pencil, and dated in the plate
Bellini 14
2002-7-28-2
Presented anonymously, 2002

In 1907, Boccioni made a series of pastels and etchings of his mother and of her elderly neighbour, Maria Sacchi, seated close to a window. This print repeats in reverse the subject of a pastel dated 1907. Boccioni added many more details in the print. Among these are the floral pattern visible through the glazed doors, the portrait hanging above his mother's head, the grain of the wood of the window shutter, the glass bottle and scissors on the window ledge, and the individual flagstones of the floor, two of which are broken. Nicodemi, reviewing Boccioni's posthumous exhibition at the Castello Sforzesco in 1933, suggested that he had studied the etchings of the Swede Carl Larsson, and of the Dutchman Jan Toorop. Twelve drypoints by Toorop were shown in the Dutch room in the Venice Biennale, and his work was much appreciated in Italy. Impressions of this print are found more frequently than of any other etching by Boccioni. There were at least two posthumous editions. In the first, authorized by the artist's sister, Amelia, in 1931, five impressions were pulled.

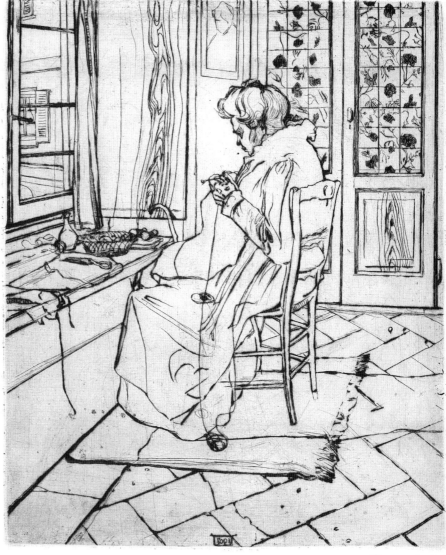

42

THE OUTSKIRTS

1908
Etching and drypoint 91 × 151
Bellini 26
2002-7-28-3
Presented anonymously, 2002

The subject of the industrial suburbs had
interested the Divisionist painter Giuseppe
Pellizza da Volpedo (1868–1907) and
Boccioni's friend Giacomo Balla (1871–1958).
On two occasions, Boccioni took etching
plates to the edge of the city of Milan and
looked back at the city. Here he drew a large
building under construction and a group of
smoking chimneys beyond it. This industrial
background contrasts strongly with the
peaceful meadows and scattered trees in the
foreground and middle ground. A similar
contrast between country and town features
in one of Boccioni's oil paintings of 1909,
Landscape with trees and factory. In the
other plate, three youths relax with their
backs to the city. Both etchings are reminis-
cent of landscape prints by contemporary
Dutch and Belgian artists, whose work
received much attention at the Venice
Biennali. Boccioni was not troubled by the
oxidization of the plate, which resulted in the
prominent irregular marks at the right and
the foreground. Two posthumous editions
issued in 1931 and in the mid-1950s, of five
and ten impressions respectively, are known.

43

HEAD OF A SMILING CHILD

1910
Etching 141 × 128 signed in pencil, and
dated in plate
Bellini 33
2003-6-30-28
Presented anonymously, 2003

This was one of Boccioni's last etchings, and
is the one in which the artist made the great-
est attempt to convey emotion. The artist was
not bothered about leaving accidental marks
and finger prints on the plate. Commentators
have rightly remarked on Boccioni's knowl-
edge of Rembrandt. A few posthumous
impressions are known.

Giovanni (Gino) Severini 1883–1966

Born in Cortona, Severini moved in 1899 to Rome, where he attended evening classes in drawing at a school known as 'Gli Incurabili'. In 1901 he met Boccioni, and together they visited the studio of Giacomo Balla, who had recently returned from Paris, and from whom they learnt the technique of Divisionism. Severini also began a prolonged study of light, eschewing chiaroscuro and tonal effects in his paintings. Disappointed by the provincial academicism that he encountered in Italy, he settled in 1906 in Paris, where he quickly met Modigliani, Picasso, Gris, Braque and the poet Max Jacob. While still studying late nineteenth-century theories on complementary colours and the work of Seurat, Severini began to break with his previous naturalistic style. Before leaving for Paris, Severini had learnt drypoint from the Florentine etcher Raul Dal Molin Ferenzona (1879–1946) and from the German Otto Greiner (1869–1916), who lived in Rome from 1898 to 1915. It is likely, too, from the outset that he was spurred on by the success in Paris of the drypoints of his friend Anselmo Bucci. Severini's first prints, a group of eight drypoints and two etchings made in 1909, were naturalistic, and not dissimilar in mood to the work of Boccioni. He was to make no further prints until 1916.

Severini was much attracted to the theatrical world, and met many actors and playwrights. He became a friend of the French Symbolist poet and critic Paul Fort, whose daughter he married in 1913. Boccioni persuaded him to sign the *Manifesto dei pittori futuristi* published in 1910. The challenge of representing the dynamism of the contemporary world led to stylized paintings, in which Seurat's colour theories and fragmented forms derived from Léger's Cubism were combined. Severini made only two prints during this decade, both linocuts in 1916, the year in which he abandoned the Futurist decomposition of forms for a more rigorously constructive Cubist style.

In 1919, Severini signed a contract with Léonce Rosenberg, a dealer associated with the Cubists. By this date, he was working simultaneously in both figurative and abstract modes. Severini's 1921 book *Du cubisme au classicisme* announced his conversion to a geometrically based figuration. His pictures of the 1920s were in part inspired by Italian Renaissance painting. In 1921 Sir George Sitwell commissioned Severini to paint frescos based on the *Commedia dell'Arte* for his Tuscan castle at Montegufoni. He produced a lithograph for the Bauhaus 1922–3 portfolio *Italienische und Russische Künstler*, and made four further lithographs, including a portrait of Paul Fort, in 1928–9. However, Severini made no other prints until after the Second World War, apart from two linocuts for the Parisian journal *XXe Siècle*, executed in 1939.

In 1923, the philosopher Jacques Maritain encouraged Severini to return to Catholicism. Over the next dozen years there followed a succession of commissions for murals and mosaics in Swiss churches. At the same time, Severini was closely associated with a group of his compatriots in Paris, led by the painter and critic Mario Tozzi (1895–1979), including Campigli, De Chirico, De Pisis and Savinio, whom he presented at the 1932 Venice Biennale. He also exhibited with the Novecento Italiano when he spent a year in Rome in 1928–9, finally leaving France to settle in 1935 in Italy, where he quickly picked up major commissions for mosaics and frescos.

After the Second World War, Severini returned in 1946 to Paris, where he worked in variations of his earlier Futurist, Cubist and figurative styles. It was during the last ten years of his life that he made most of his fifty-two prints, mainly lithographs. In addition he made a screenprint in 1955, two etchings in 1962, and a single aquatint in 1964.

BIBLIOGRAPHY
There is a very substantial literature on Severini, who wrote an autobiography, *Tutta la vita d'un pittore*, Milan, 1946, which was translated into English by Jennifer Franchina as *The life of a painter. The autobiography of Giovanni Severini*, Princeton, 1995. Severini's prints have been catalogued by Francesco Meloni, *Gino Severini, tutta l'opera grafica*, Reggio Emilia, 1982. For his paintings, there is Daniela Fonti, *Giovanni Severini: catalogo ragionato*, Milan, 1988.

44 (see colour page 38)

OLD PEASANT FROM POITOU

1909
Drypoint printed in orange brown ink
495 × 374 signed and numbered *7/10*
Meloni 8
2001-1-28-1
Presented anonymously, 2001

This is one of a group of drypoints and etchings in a realist vein, which Severini made while staying in the house of the parents of his friend Pierre Declide, in the small market town of Civray on the Charente, thirty miles from Poitiers. He paid several visits there in 1909 and 1910. One of the other prints was a portrait of Declide's father, the master tailor Camille. Severini's subject matter is akin to that found in contemporary prints by his friend Boccioni, and his style reveals his study of the drawings of Van Gogh.

45

YOUNG WOMAN IN A HAT
SEATED

1916
Linocut 107 × 82
Meloni 12
2005-3-31-7
Presented anonymously, 2005

This is one of the two prints that Severini
made in a Cubist style. The other, *The
milliner*, was published in Pierre-Albert
Birot's monthly Parisian journal *Sic*, in the
issue of August–October 1916. The maga-
zine's subtitle was *Sounds, Ideas, Colours,
Forms*. In addition to the impressions pub-
lished in the journal, Severini printed an edi-
tion of fifteen. The *Young woman in a hat
seated*, which was also printed in an edition
of fifteen, is on a very similar paper to that
of *The milliner*. It may well also have been
intended for *Sic*, which ran from January
1916 to December 1919. Both linocuts show
Severini's admiration for the work of the
Spanish Cubist Juan Gris.

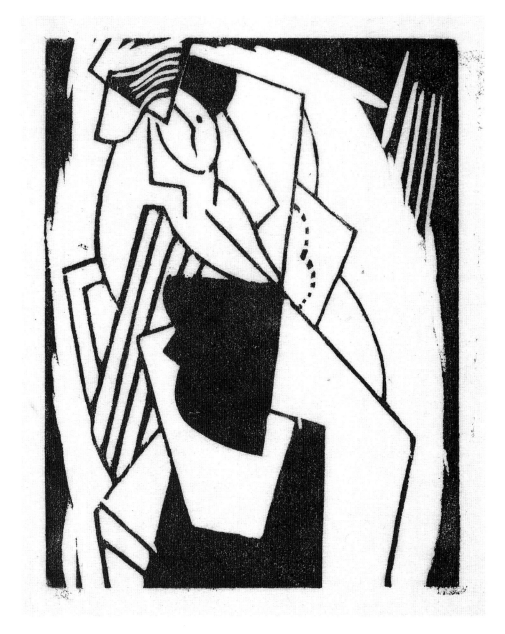

46 (see colour page 39)

LANDSCAPE AND STILL LIFE
ON A TABLE *FROM* FLEURS
ET MASQUES

1930
Sixteen pochoirs on Lafuma paper published
by Frederick Etchells & Hugh Macdonald,
Haslewood Books, 192 Church Street,
London W.8, 1930 330 × 210
Meloni 56-76
1930-11-22-3 (15)
Transferred from the British Library, 1930

The subjects of the other fifteen prints are:
*Prelude, The clown reading, The pigeon and
the grapes, The concert, Still life with a pair
of compasses, Serenade to the moon, Still
life (flowers and masks), The loves of
Harlequin, The rape of Europa, Harlequin
resting, Fruit bowl and dove, Maternity,
Still life with pigeon, The trials of
Harlequin* and *Epilogue*. The volume is
almost wordless, and its success depends
entirely on Severini's sumptuous illustrations.
Lavish use was made of gold leaf, which was
applied to the key block for each plate, before
the other colours were added by stencil. This
cost £76, as opposed to the printing work of
c. £150.

The plates were printed in the Parisian
workshop of Jean Saudé, author of *Traité
d'enluminure d'art au pochoir*, 1925, and the
finest printer of pochoirs of the day, who
was particularly well known for his work for
Georges Barbier, and for other leading Art
Deco artists and designers. The success of
this volume, which was published in an edi-
tion of 125, may well have encouraged the
young Paris dealer Jeanne Bucher to publish
*Dix reproductions 1933: Braque, Derain,
Dufy, Gris, Léger, Lurçat, Masson, Matisse,
Picasso, Rouault*.

The project is extremely well documented
by Severini's sixty letters to Haslewood
Books. Full details can be found in Peter
Tucker, *Haslewood Books. The books of
Frederick Etchells & Hugh Macdonald*,
Hanborough, 1990, pp. 44–7. Severini initial-
ly outlined his plans in detail in a letter to
Sacheverell Sitwell in November 1926. Not
surprisingly, the imagery, drawn from the
Commedia dell'Arte, develops the themes in

Severini's murals for the Sitwells' Italian
castle. Originally twenty pochoirs were
planned. Severini chose the handmade paper
at the Papeterie Navarre. Although Severini
found a Parisian printer, the book was eventu-
ally printed in London by the Pelican Press.
The publishers intended to fund the volume
from the sale of the preparatory gouaches at
£12 10s apiece. The book was announced in
both the 1927 and 1928 prospectuses of
Haslewood Books with the title *Fleurs et har-
lequinades*. The 125 copies were to be priced
at twelve guineas. Sales of the gouaches were
slower than anticipated. So the number of
plates was reduced. A further delay was
caused early in 1930 by a strike at Jean
Saudé's workshop. Severini suggested a
change of title to *20 poèmes plastiques de
Gino Severini*, before it was settled on as
Fleurs et masques. He also insisted that
copies be presented to Mussolini, and to the
Etruscan Academy at Cortona, his home
town. Gualtieri di San Lazzaro acted as
Haslewood Books' Paris agent.

Haslewood Books was founded in 1924
by the painter and architect Frederick
Etchells (1886–1973) and Hugh Macdonald
(1885–1958), a solicitor turned scholar pub-
lisher, who was a friend of Roger Fry and
Edmund Blunden. Etchells probably met
Severini in Paris, where he rented a studio
from 1911, and became a friend of
Modigliani. He was initially involved with
Roger Fry's Omega Workshops, but walked
out with Wyndham Lewis to join the
Vorticists. Etchells contributed illustrations
to the first issue of *Blast*, but after the war
turned to architecture, in which field he is
best known for his 1930 building in Holborn
for the advertising agency Crawford, which
was one of the earliest buildings of the mod-
ern movement to be built in London. He also
translated two of Le Corbusier's most impor-
tant books, *Towards a new architecture*,
1927, and *The city of tomorrow and its
planning*, 1929.

The majority of the thirty-two books
issued by Haslewood Books between 1924 and
1931 were reprints of Elizabethan and other
early literary texts, but the firm also pub-
lished *Sailing-ships and barges of the West
Mediterranean and Adriatic Seas*, 1926,

illustrated by copper engravings by Edward
Wadsworth, a friend of Etchells since the
days of Vorticism. The colour was applied to
these plates by pochoir. Other publications
included John Nash's *Poisonous plants,
deadly, dangerous and suspect*, 1927, accom-
panied by his own wood engravings, and
Robinson Crusoe, 1929, illustrated by
pochoirs after designs by the London-based
American E. McKnight Kauffer. In addition,
the wood engraver Hester Sainsbury, who was
to marry Etchells in 1932, contributed prints
to four of their works, and Wadsworth, work-
ing with Wyndham Lewis's friend Richard
Wyndham, provided a series of drypoints for
his own *A book of towers and other build-
ings of southern Europe*, 1928. Haslewood
Books deserve to be considered as worthy
rivals of their contemporaries The Golden
Cockerel Press and the Nonesuch Press.

Luigi Russolo 1885–1947

Born in Portogruaro in the Veneto, Russolo was trained as a musician, first as a pianist, then as a violinist. In 1901, he moved to Milan, where he began to attend the free courses organized by the Accademia di Brera, copying plaster casts of antique sculpture, while working as an apprentice to a restorer. His first pictures were landscapes in the Divisionist style then dominant among the more avant-garde painters in the city. These paintings were in a dreamlike key. Russolo's work was closest to that of Gaetano Previati among contemporary Lombard artists. All his forty-one prints date between 1907 and 1911. These were principally aquatints and etchings, which he occasionally combined with drypoint. Russolo also made a couple of mezzotints. Until 1909, his prints were Symbolist in style and subject matter. Russolo's early aquatint of masks is reminiscent of Ensor. He wrapped Nietzsche's head with Art Nouveau-like strands of hair. Other prints have been compared with the visionary symbolism of Alfred Kubin. *Carezza-morte* of 1907–8 updated Legros. In December 1909, Russolo showed a group of Symbolist etchings and aquatints at the Famiglia Artistica's black and white exhibition in Milan, where he met and became friends with Boccioni. The subject matter in both his paintings and his prints of 1909–10 is similar to that of Boccioni: melancholic views of the industrial suburbs and building works. Like Boccioni, Russolo seems to have admired the work of Jan Toorop, as can be seen from their etchings of women in profile in interiors.

In February 1910, Russolo was one of the signatories with Carrà, Balla and Severini both of the *First manifesto of Futurist painters* and of *The technical manifesto of Futurist painting*. He made one notable Futurist etching on the theme of the dynamism of the body, *Movimenti simultanei di una donna*. Russolo participated in all the Futurist exhibitions up to the First World War. However, it was in music, rather than painting or printmaking, that he made his most profound contribution to Futurism. Famously in 1913, at the Teatro Costanzi on the occasion of a Futurist evening concert, dedicated to the musician Francesco Balilla Pratella, Russolo delivered his letter-manifesto, *L'arte dei rumori*, followed by a performance using the 'intonarumori' instrument invented by Ugo Piatti. From this date, he abandoned his pictorial career to concentrate on music, on which he wrote in the journal *Lacerba*. This theoretical phase reached its acme in the April 1914 Futurist concert staged in Milan's Teatro dal Verme, which met with such violent public disapproval at the weird instruments employed, *gorgoliatori* (gurgling machines), *crepitatori* (crackling machines) and *ululatori* (howling machines) that the police had to close it down. The scandal of twelve Futurist concerts in London attracted the attention of Stravinsky. Russolo's *L'arte dei rumori* was published in Milan by Edizioni Futuriste di Poesia in 1916.

Russolo was wounded in the First World War and decorated for valour. He rejoined his colleagues for the Esposizione Nazionale Futurista, held at the Palazzo Cova in Milan in 1919, where once again he gave a performance with his *intonarumori*. In 1921 Russolo had a concert performance at the Théâtre des Champs Elysées in Paris, which was reviewed at length by Mondrian. Russolo also moved and collaborated in cinematographic circles. He eventually settled in the French capital in 1927. Russolo's art was included in the Venice Biennali of 1926 and 1930, the Turin Quadriennale of 1927 and the large *Novecento Italiano* exhibition in 1926.

In 1934, he moved back to Italy to settle at Cerro di Laveno on Lake Maggiore, where he supervised an edition of his prints pulled by Mario Costantini. Costantini was also responsible for another edition on the occasion of the posthumous exhibition organized by the Comune of Portogruaro. One finds inauthentic signatures added to some of these impressions. Late in his life, in 1942, Russolo began to paint again in a style which he described as 'classic-modern', but he made no further prints before his death in 1947.

BIBLIOGRAPHY
G.F. Maffina, *Luigi Russolo e l'arte dei rumori: con tutti gli scritti musicali*, Turin, 1978, records forty-one prints by the artist. This writer has not seen Gian Franco Maffina, *L'opera grafica di Luigi Russolo*, Castano Primo, Ceal, 1977, or E. Piselli, *Luigi Russolo incisore e pittore. 1907–1913*, Bornato in Franciacorta, 1990.

47

ON THE BALCONY

1910
Soft-ground etching and aquatint 256 × 125
Maffina 17
2001-5-20-59
Presented anonymously, 2001

The subject of Russolo's etching of blocks of
flats and factories, seen through a window,
shows similar interests to those of Boccioni.
However, the Rembrandtesque chiaroscuro
totally obscures the features of the seated
woman, and the buildings are treated in
summary fashion, so that the effect is very
different from that of the etchings of his
friend. Russolo also executed *The city asleep*,
a nocturnal view of factory chimneys and
street lighting topped by a stormy sky.

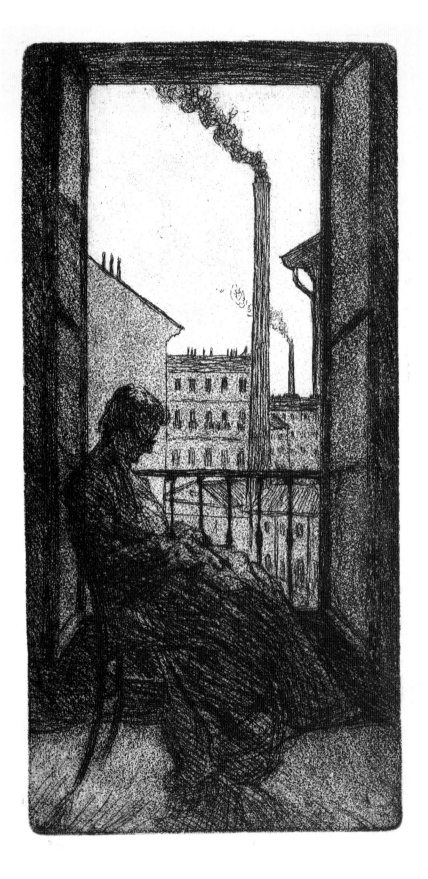

Achille Lega 1899–1934

Born at Brisighella in the province of Ravenna, Lega moved with his family to Florence, where he received his first artistic training from the landscape painter Ludovico Tommasi (1866–1941), who taught him to etch. Lega also attended the Accademia di Belle Arti and the Scuola Libera d'Incisione, where the influence of Fattori was still strong. There, he encountered Celestino Celestini (1882–1961), who was to be his more significant second master. Lega learnt woodcut in his mother's home town of Pistoia, probably from Alberto Calignani, and it was there, in 1915, that he exhibited two woodcuts. The following year, he published a woodcut in the Pistoian journal *La Tempra*, on which Giovanni Costetti, Arturo Checchi (1886–1971) and Giovanni Michelucci (1891–1990) also collaborated. Lega had met Ottone Rosai in Florence at the Scuola Libera, and his early prints are similar in style to the work of Rosai. Like many of his Italian contemporaries, he was much interested in the work of Cézanne. Lega's woodcuts have a hint of the more Expressionist work of Lorenzo Viani. Miniature matchstick-like figures populate his soft-ground etchings of Tuscan townscapes, in which the buildings totter, as if to convey their antiquity. The possibility of Lega's interest in the early etchings of Casorati is raised by his *I Renaioli* of 1916.

In Florence, he frequented the Caffè delle Giubbe Rosse, and became a close friend of Primo Conti (1900–88). Lega went through a brief period of attachment to Futurism between 1917 and 1919. He was one of the forty artists who exhibited in the 1919 exhibition organized by Marinetti at the Galleria Nazionale d'Arte di Palazzo Cova in Milan. However, Lega soon returned to his previous style. In the early 1920s, he took up art criticism, writing reviews of the work of such artists as Soffici, Carrà, De Chirico and Giovanni Costetti in *La Rivista della Domenica*, *Il Nuovo Paese* and *Il Corriere di Firenze*. He was one of the earliest critics to support Morandi. Lega also contributed prints, drawings and criticism to Mino Maccari's *Il Selvaggio*, and exhibited with the Gruppo del Selvaggio. He took up drypoint in 1925, and made two lithographs in 1930, but the majority of his intaglio prints were in pure etching. Lega's later etchings of Tuscan farm buildings and hilly landscapes were devoid of figures. He was a friend of Carrà, whose style he approached in his 1927 *Castiglioncello e Fornace*. Lega also made a few portrait etchings. After his unexpected early death from a fever in Florence, a retrospective was mounted there at the Galleria dell'Accademia, in the catalogue for which another close friend, Soffici, wrote the introductory essay.

BIBLIOGRAPHY
A catalogue raisonné of Lega's prints has been published by Sigfrido Bartolini, *Achille Lega l'opera incisa e iconografia*, Reggio Emilia, 1980. For his paintings there is Raffaele De Grada, *Achille Lega 1899–1934*, Faenza, 1977.

48

SYNTHESIS OF A SEATED FIGURE

1917
Soft-ground etching 185 × 140 signed, titled
and dated in pencil
Bartolini XXXV
2003-5-31-10
Presented anonymously, 2003

Lega's two variant etchings of the same seated
female figure were his only Futurist prints.
He pulled very few impressions from each
plate. The dissolution of the figure into inter-
secting planes is deeply indebted to Cubism.

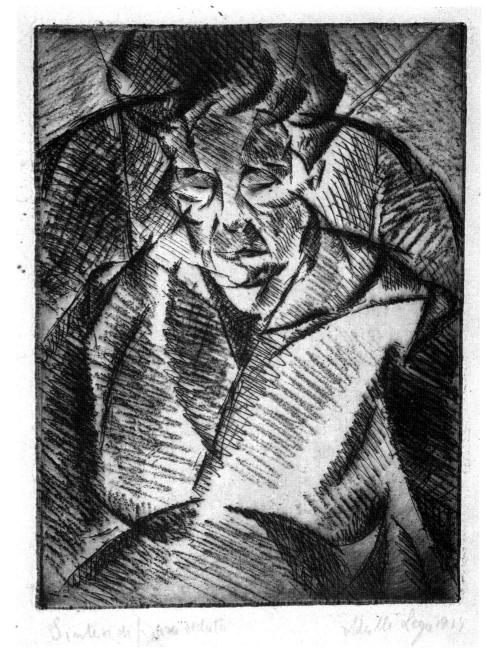

Carlo Carrà 1881–1966

Born in Piedmont at Quargnento, north of Alessandria, Carrà was apprenticed to a team of decorators whose work took him to Milan, London, Switzerland and to the 1900 Paris Exposition Universelle. In London, he was introduced to the writings of Marx and Bakunin by a group of exiled Italian anarchists. Carrà had visited many European museums before he enrolled first in 1904 at the Scuola Serale d'Arte Applicata in Milan, and two years later at the Accademia di Belle Arti di Brera. His paintings initially were Divisionist in style. In the course of organizing exhibitions for La Famiglia Artistica in Milan, Carrà became friends in 1908 with Boccioni and Russolo. The three artists met Marinetti in 1910, and together published the *Manifesto dei pittori futuristi*. The following year, a trip to Paris led to Carrà's discovery of Cubism, and to his establishment of contacts with Apollinaire, Modigliani and Picasso. This visit encouraged Carrà to radically rework his Divisionist *Funeral of the anarchist Galli* in a Futurist style. Two further visits in 1912 and 1914 strengthened his relationship with French artists. Carrà was deeply involved with Giovanni Papini and Ardengo Soffici's Florentine periodical *Lacerba*, for which he both wrote and provided drawings. Following the example of the Cubists, he also experimented with collage.

During the war, Carrà studied Florentine early Renaissance painting, in particular the works of Giotto and Uccello, on both of whom he published. Their aesthetic and other 'primitive' art, such as the paintings of Henri Rousseau and African sculpture, were to be fundamental for the post-war development of his paintings. When Carrà was called up into the Italian army in 1917, he met De Chirico, Savinio and De Pisis in Ferrara. With De Chirico he developed Pittura Metafisica. However, although Carrà painted mannequins akin to De Chirico's, his colours were more restrained, his constructions more akin to Cubist sculpture, and his interior perspectives related to the art of the Trecento. He experienced a psychological crisis between 1918 and 1920, and largely abandoned painting, although he continued to draw and write, in particular for the journal *Valori Plastici*, as well as publishing a book, *Pittura*

Metafisica. Carrà was one of the most significant art critics of the 1920s and 1930s, particularly in the pages of the Milan newspaper *L'Ambrosiano*, for which he wrote for seventeen years.

Carrà took up etching with enthusiasm in 1922, having received instruction from the ceramicist Giuseppe Guidi (1861–1931), who had just opened a print workshop in Milan. He made forty-five etchings in the three years 1922 to 1924. Carrà made his first lithograph for the Bauhaus portfolio of prints by Italian and Russian artists in 1922, and a further five lithographs and an aquatint in 1927 and 1928. He returned to printmaking only in 1944, when twenty-two lithographs were published in the portfolio *Segreti*, published by Edizioni della Colomba. The same year, Carrà made a further twelve lithographs as illustrations to Rimbaud's *Versi e prose*, for another Milan publisher, Edizioni della Conchiglia. *Segreti* included Carrà's only Cubist print. Three years later, Carrà illustrated Mallarmé's *Monologue d'un faune* for the Milanese publisher Il Balcone, with five more lithographs. His later prints all drew on his earlier styles. Eight of his lithographs in the 1949 portfolio *Carrà 1912–1921* were based on drawings from the years of Pittura Metafisica, the other two being Futurist designs. Carrà used colour in prints for the first time in 1952, and fifteen of his last eighteen prints were colour lithographs. Most of these, as well as his two final etchings of 1964, recapitulate works of the 1920s.

From that period onwards, his landscapes and seascapes owed much to the example of Cézanne. In 1933, Carrà was a signatory with Sironi, Campigli and Achille Funi to the *Manifesto della pittura murale*. His frescos for the Milan Triennale that year, and for the Palazzo di Giustizia in Milan in 1938, demonstrated his capacity for monumental work. Carrà became Professor of Painting at the Accademia di Belle Arti di Brera in 1941. In the post-war period he continued to paint the themes of the 1920s, tranquil Ligurian coastal subjects and landscapes, to which repertoire he added views of Venice, in all of which the human figure was absent.

BIBLIOGRAPHY
The most reliable catalogue of Carrà's 111 prints is Elena Pontiggia, *Carlo Carrà. I miei ricordi. L'opera grafica 1922–1964*, Fondazione Stelline, Milan, 2004. His writings have been collected by Massimo Carrà, *Carlo Carrà. Tutti gli scritti*, Milan, 1978. Carrà's paintings have been catalogued by Massimo Carrà, *Carlo Carrà: tutto l'opera pittorica*, 3 vols., Milan, 1967–8.

49

CHILD'S HEAD

1922
Etching 217 × 147 signed in the plate, and
signed, dated and inscribed in pencil 18/25
Pontiggia 6
2003-6-30-32
Presented anonymously, 2003

An edition of twenty-five and two or three
artist's proofs was printed in 1924. The date
on the plate is of its publication, not of its
creation. A further edition of thirteen was
made in 1951.

18/25 carlo Carrà 924

50

THE HOUSE OF LOVE II
(THE HOUSEWIFE)

1924
Etching 300 × 217 signed in the plate, and
signed, dated and inscribed *24/25* in pencil
Pontiggia 45
2003-6-30-34
Presented anonymously, 2003

Three further editions of twenty-five, ten and
seventy impressions were pulled from this
plate in 1924, 1951 and 1971. The enigmatic
subject of *The house of love* was treated by
Carrà in several paintings and drawings in the
early and mid-1920s. He made at least two
preparatory drawings for this print. The pose
of the faithful dog closely resembles that of a
statue of the Egyptian cat goddess Bastet in
the Egyptian museum in Milan. This deity
was the protector of the home and of preg-
nant women. A more realistically depicted
dog with a cocked air had appeared in a simi-
lar interior in Carrà's first lithograph, *The
acrobats*, published in the Bauhaus portfolio
Europäische Graphik in 1922. The housewife
gazes at a painting on the wall of a phallic
tree, and the building with a small round
window, hinting at an erotic content. It is
conceivable that Carrà intended her heavily
wrapped statuesque figure to indicate that
she was with child. Both housewife and her
attendant wait for the arrival of a male visitor
through the door which is half ajar. In *The
house of love I (Expectation)*, an etching of
1920, an almost nude, pubescent Aphrodite
stands with Eros outside the door of a house.
It is tempting to read the two prints as *Before*
and *After*.

24/25 Carlo Carrà 924

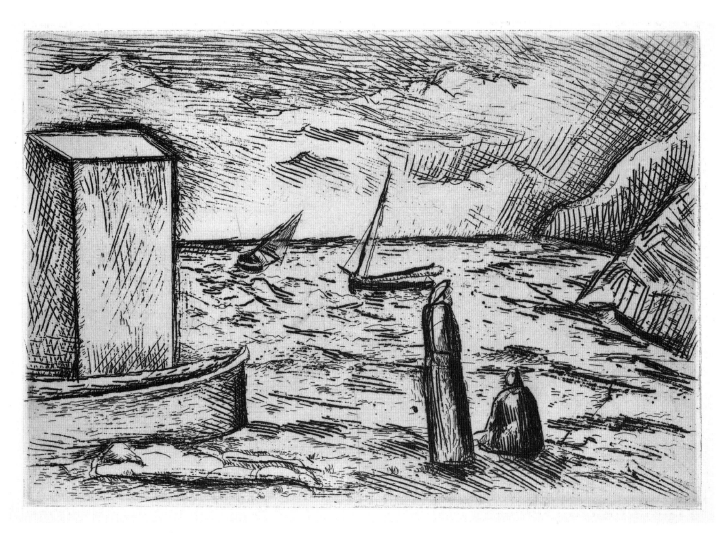

51

ON THE BEACH
(THE BEACH AT MONEGLIA)

1924
Etching 148 × 217 signed, dated and
inscribed *24/25* in pencil
Pontiggia 14
2003-6-30-33
Presented anonymously, 2003

There were two editions of this etching, of
twenty-five in 1924 and of ten in 1951. In
addition, Carrà pulled two or three proofs
in 1924. The composition is a more heavily
worked and deeply bitten version in reverse
of the artist's 1923 etching *The shoal at
Moneglia*. Moneglia lies halfway between
Sestri Levante and Levanto, on the Ligurian
coast south-east of Genoa. Carrà spent the

summer of 1923 at the fishing village of
Camogli, north of Sestri Levante, between
Genoa and the peninsula of Portofino. He
may have made this print back in his studio.
Sixteen of Carrà's etchings of the 1920s
were devoted to the beaches and villages of
this coast.

52

THE WAYFARER

1924
Etching 307 × 168 signed in the plate.
Signed, dated *924* and numbered *24/25*
in pencil
Pontiggia 40
2003-6-30-35
Presented anonymously, 2003

In this etching, the artist took up the compo-
sition of two drawings of 1921, both entitled
The beggar. The tall gaunt figure, and
Carrà's method of hatching, are reminiscent
of certain early Michelangelo pen drawings.
An edition of twenty-five and three artist's
proofs were pulled in 1924. Two further
editions were made, of ten in 1951 and
of seventy in 1971 after Carrà's death. *The
wayfarer* was published in *Il Selvaggio* on
30 April 1931.

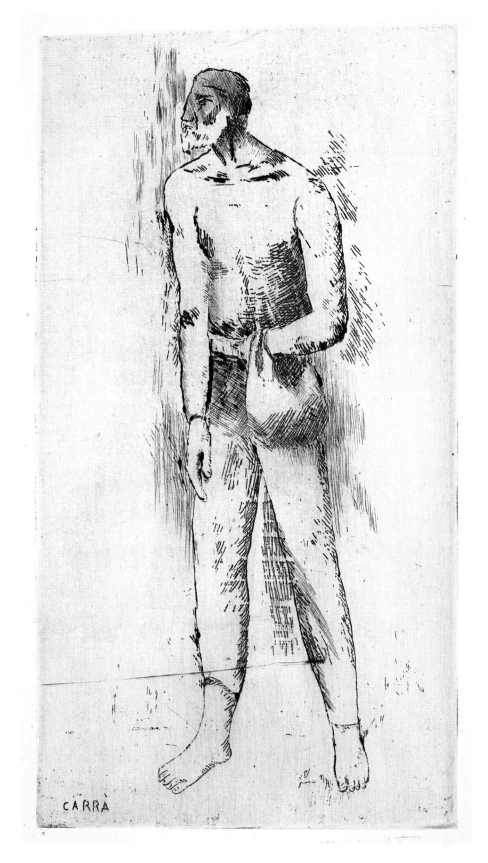

Ardengo Soffici 1879–1964

Born near Florence at Rignano sull'Arno, Soffici showed a precocious interest in drawing and literature. He attended the Accademia di Belle Arti in Florence, where he met Fattori and Signorini. Soffici admired paintings by Bonnard, Puvis de Chavannes and Giovanni Segantini at the 1897 *Arte e fiori* exhibition in Florence. His interest in French painting induced him to travel to Paris with Giovanni Costetti and Umberto Brunelleschi (1879–1949) in 1900 to see the Exposition Universelle. To make a living, he worked for several satirical magazines, including *La Plume* and *L'Assiette au Beurre*, supplying them respectively with etchings and woodcuts. For some of this period he stayed in La Ruche, the famous Montparnasse studios. Soffici's friends included the poets Karl Boës and Jean Moréas, and later Max Jacob and Apollinaire. Soffici exhibited regularly at the Salon des Indépendants from 1902 and established close friendships with Picasso, Braque and Gris. He also knew the philosopher Henri Bergson and the novelist André Gide. From Paris Soffici sent regular contributions to the Italian journals *Riviera Ligure* and *La Voce*, becoming well known for his polemical art criticism in support of the international avant-garde. He supplied woodcuts to the Florentine journal *Leonardo*, and wrote stimulating articles on Medardo Rosso, Henri Rousseau and Cubism. In 1910, Soffici organized an important exhibition of Impressionist paintings in Florence. Together with his friend the journalist, poet, critic and novelist Giorgio Papini, the founder editor of *Leonardo* and *La Voce*, he fostered many cultural initiatives in Tuscany.

Cézanne, on whose art he wrote an article in *La Voce*, and Picasso soon replaced Symbolism as influences on his painting. Initially, Soffici's severe criticisms of the Futurists and their manifestos led to angry reactions from Boccioni, Carrà and Marinetti, but he modified his views and took part in the 1912 and 1913 Futurist exhibitions, which toured to Paris, Brussels, London, Berlin and Florence. Unlike many of his Futurist colleagues, he explored the possibilities of the style for still life. Soffici also used it in experiments in typography in his 1915 book *BIF§ZF+18 simultaneità e chimismi lirici*.

Soffici served as a volunteer in the First World War, and in 1918 founded *La Ghirba*, a journal for the soldiers of the Fifth Army, to which De Chirico and Savinio also contributed. He distanced himself from the bombasticism of Futurism, and became close to Carrà. In 1919, he settled outside Florence at Poggio a Caiano, devoting much of his time to writing, founding the journal *La Vraie Italie* with Papini, and the following year *Rete Mediterranea*. Soffici also published a series of monographs on other artists, including *Carlo Carrà*, Milan, 1928, and *Medardo Rosso*, Florence, 1929. During the 1930s, he worked for a number of journals that supported the Fascists. In his painting in the early 1920s he established a neo-traditionalist style, producing sensitive and poetic interpretations of the Tuscan countryside. In their timelessness they owed much to the example of Cézanne. Soffici's pictorial language remained unchanged for the rest of his career.

His earliest prints were woodcuts, which he made between 1902 and 1927. Soffici made his first monotype in 1913, and continued to use the technique until 1928. Between 1926 and 1957 he largely devoted himself to drypoint. Soffici took up lithography only in 1960, when he was invited to produce an album of prints by Il Bisonte, the newly founded Florentine workshop.

BIBLIOGRAPHY
The literature on Soffici is extensive. He published four volumes of autobiography, *Salti nel tempo*, Florence, 1929, *L'uva e la croce*, Florence, 1950, *Il salto vitale*, Florence, 1954, and *Fine di un mondo*, Florence, 1955. Several studies have been published in recent years by the Associazione Culturale Ardengo Soffici, Poggio a Caiano. Two exhibition catalogues that survey his career are Luigi Cavallo, *Ardengo Soffici. Un percorso d'arte*, Villa Mediceo, Poggio a Caiano, 1994, and Ornella Casazza and Luigi Cavallo, *Soffici: arte e storia*, Villa di Petriolo, Rignano sull'Arno, 1994. Sigfrido Bartolini, *Ardengo Soffici. L'opera incisa*, Reggio Emilia, 1972, catalogued his prints, recording thirteen monotypes, forty-three woodcuts, twenty-one drypoints and seventeen lithographs.

53

PLANES AND LINES OF A LADY COMBING HER HAIR (TAKEN FROM LIFE)

1912
Woodcut 280 × 222
Bartolini pl. XXXV
Lent by the Estorick Collection

This rare woodcut, which was published in *Lacerba*, 1 November 1913, p. 242, is one of only three prints made by Soffici during his Futurist period. He pulled a few proofs in addition to the impressions published in that journal. The artist made a preparatory drawing in charcoal for this woodcut (private collection). Soffici's domestic subject matter is comparable to that in the pre-Futurist intaglio prints of his friend Boccioni. However, not only the Cubist-derived style but also the programmatic title signalled Soffici's complete break with the recent past.

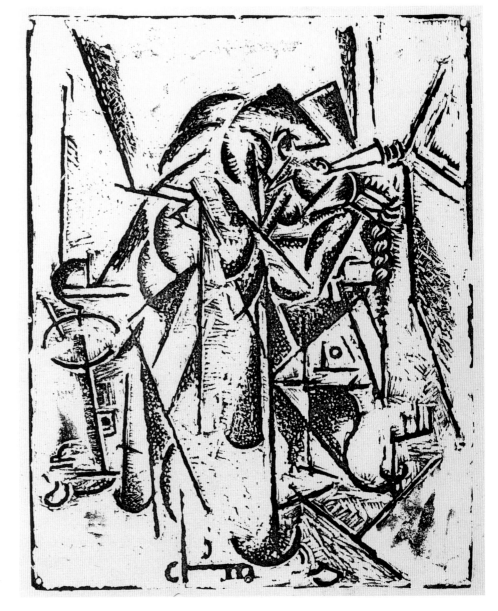

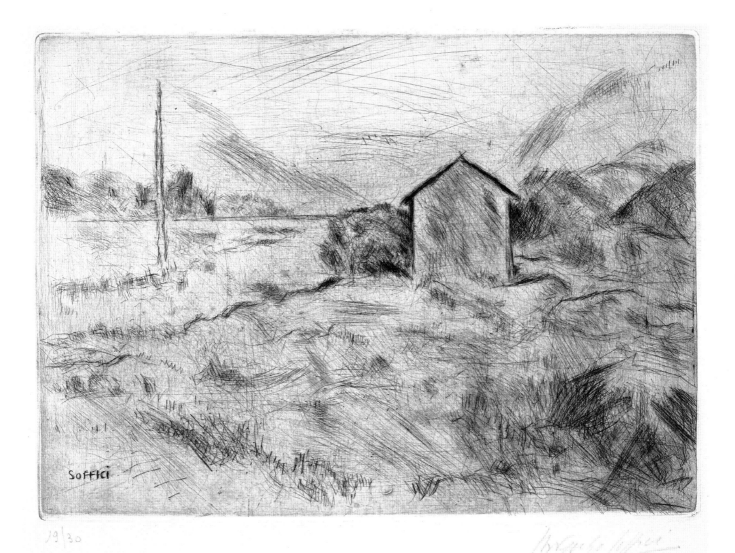

19/30

54

CINQUALE

1926–7
Drypoint 224 × 312 signed and numbered
19/30 in pencil
Bartolini pl. XLVII
2003-5-31-13
Presented anonymously, 2003

Cinquale is a bathing resort between Forte dei Marmi and Marina di Massa on the Versilian coast of the Tyrrhenian Sea. The fact that this print was published by the Florentine print workshop Il Bisonte only in 1963 in its third state in an edition of thirty has often led to it being dated to that year. However, both *Cinquale* and two other

Versilian drypoints published by Il Bisonte, *Seascape at Forte dei Marmi* and *Huts at Forte dei Marmi*, were executed in 1926–7. In all Soffici made twelve drypoints of this coast. The spareness of his treatment of the windswept beach cabins recalls the coastal prints of Fattori, an artist whom Soffici admired greatly.

Giorgio Morandi 1890–1964

The outstanding Italian printmaker of the twentieth century, Morandi was born in Bologna, where he studied at the Accademia di Belle Arti from 1907. He discovered contemporary French art through his reading of articles by Ardengo Soffici in *La Voce*, as, unlike most of his contemporaries, he did not leave Italy to see the French avant-garde at first hand. Morandi saw some Impressionist paintings at an exhibition organized by Soffici in 1910 in Florence, where he had gone to study the work of Giotto, Masaccio and Uccello. He also travelled to Rome in 1911 in order to see an international exhibition, which included paintings by Renoir, Monet and Matisse. Morandi's friend the Futurist composer Francesco Balilla Pratella introduced him to Boccioni and Marinetti in 1913 in Florence, where he saw the Futurist exhibition organized by *Lacerba* at the Libreria Gonnelli. The following year, Pratella invited him to show in Rome with the Futurists at the Galleria Sprovieri. To support himself as a painter, Morandi taught drawing at a succession of elementary schools until 1926. The dominant influence on Morandi's still lifes and landscapes was that of Cézanne. From an early stage, he restricted himself to a very limited range of subjects, which he explored in depth in an infinite number of subtle variations. Morandi destroyed a number of his Cubist-Futurist paintings, but, from the few that survive, it is evident that he had studied a Picasso drawing of 1909, which was illustrated in *La Voce*, and that he was almost certainly aware of the work of Derain.

Morandi's brief period in the Italian army took him to Parma, where he had the opportunity in 1915 to study the twelfth-century sculpture of Antelami, before he suffered a nervous breakdown. His still lifes can be seen as low-relief sculptures transformed into paintings. Morandi became a friend of the young Bolognese writer Giuseppe Raimondi (1898–1985), who founded *La Raccolta*, which in April 1918 became the first journal to publish the artist's work, including a Futurist etching of 1915. In 1916, even before Morandi met De Chirico and Carrà, he had begun to paint in a style akin to Pittura Metafisica, and from 1918 he introduced tailor's dummies and objects suspended in boxes into his work, bringing his pictures closer to theirs. Filippo De Pisis, joint editor with Raimondi of the Dadaist *Avanscoperta*, tried to persuade Tristan Tzara to publish Morandi's paintings. De Chirico arranged for him to have an exhibition in 1919 at the Galleria Giosi in Rome, prompting Mario Broglio to visit Morandi's studio in Bologna. Broglio purchased twenty paintings and watercolours, gave him a contract, and published an article by Raffaello Franchi on Morandi's work in *Valori Plastici*. Morandi's strong representation in the exhibition of *Valori Plastici* artists, which Broglio organized in Berlin and Hanover in 1921, established his international reputation, while a lavish catalogue, published by Broglio's journal for a much larger exhibition in Florence in 1922, ensured that Morandi was acclaimed by Italian critics. Despite this, it was some time before he received any official recognition. Morandi acknowledged that in the 1920s he developed a great interest in the paintings of Chardin, Vermeer and Corot. These artists, Cézanne, the early Cubists, and the masters of the Italian Renaissance, Giotto, Uccello, Masaccio and Piero della Francesca, were to form the small canon of artists whose qualities he strove to emulate for the rest of his career.

In the second half of the 1920s, Morandi became close friends with the artist writers Mino Maccari and Leo Longanesi, editors of *Il Selvaggio* and *L'Italiano* respectively. Between 1926 and 1932, these journals published some of the first serious articles on his work, and illustrated thirty-four of his drawings and etchings. Morandi was a member of the regionalist and anti-internationalist Strapaese group, and his work was collected by several leading figures in the Fascist regime. However, Morandi was not active politically. Indeed his association with the art historian Carlo Ragghianti and friendship with other anti-Fascists led to his arrest by the secret police in 1943. In 1930 Morandi was appointed Professor of Etching at the Accademia di Belle Arti in Bologna. Further official support came from Carlo Alberto Petrucci, the Director of the Calcografia Nazionale, who recognized that he was the finest Italian printmaker of the day. The Calcografia exhibited and marketed Morandi's etchings, and eventually took over printing them. Petrucci organized the major retrospective of his prints in 1948. Also important for diffusion of his work were the brothers Ghiringhelli of the Galleria del Milione in Milan, who became his principal dealers in 1941. For the rest of his life, Morandi continued to paint timeless still lifes using the pots, bottles and boxes in his studio, which, although intimate, have a remarkable monumentality. It was only on his retirement in 1956 from the Accademia di Belle Arti in Bologna that he first travelled outside Italy, when he visited Lugano to see the Thyssen collection. Morandi then went on to Winterthur to see a retrospective of his own work, and to Zurich for a Cézanne exhibition.

Morandi made his first etching in 1912, having taught himself the technique by reading a treatise of 1660 by his fellow townsman Odoardo Fialetti. He executed very few prints until the 1920s, and only 138 in all. Eighty of his prints were made in the short period between 1927 and 1933, and he made only a small number of etchings after the Second World War. Although Morandi is primarily thought of as a still-life specialist, almost a third of his etchings were landscapes. In addition, he etched eighteen flower pieces and four portraits. Morandi made his only woodcut in 1928. Before the Calcografia Nazionale in Rome began to print and publish editions of his etchings, Morandi had pulled small numbers of proofs himself on a small press in the bedroom which was also his studio. He generally worked directly from his subjects, and drew everything on the plate at one time. So there are few states for his prints. Morandi particularly admired Rembrandt and Goya among his predecessors in intaglio printmaking. Morandi's use of hatching and avoidance of contours parallel those found in the prints of his contemporary Jacques Villon, but his web of lines was softer and less systematic than that of the Frenchman. He used a special tool which he called a 'cat's tongue' to make a twisting swelling line, as well as several different etching needles of varying thickness, and an *échoppe* (an etching needle with a sharp but rounded end). Morandi used

a burin only when he needed to make an additional line that was missing after the biting. He preferred handmade papers, the ivory, chamois and grey colours of which enhanced the images. Occasionally, he employed *chine collé* (in which a very fine and fragile piece of paper is laminated to a heavier support). While he avoided leaving thick layers of ink on the plate, Morandi sometimes left it incompletely wiped, so that he could print impressions filled with atmosphere and delicate chiaroscuro.

BIBLIOGRAPHY
Lamberto Vitali's catalogue *L'opera grafica di Giorgio Morandi* (fourth edition), Turin, 1989, has been updated by Volker Feierabend, Heinz Spielmann and Lamberto Vitali, *Giorgio Morandi 1890–1964. Gemälde, Zeichnungen, Das druckgraphische Werk. Werkverzeichnis der Druckgraphik*, Schleswig-Hollsteinisches Landesmuseum, Schloss Gottorf, 1998, which contains a concordance with Vitali, and with another catalogue raisonné, Michele Cordaro, ed., *Morandi l'opera grafica: rispondenze e variazioni*, Istituto Nazionale per la Grafica, Calcografia, Rome, 1990 (also published as Michele Cordaro, ed., *Morandi incisioni catalogo generale*, Milan, 1992). For his paintings, there is Lamberto Vitali, *Morandi: Catalogo generale*, 2 vols., Milan, 1983. A useful biography has been published by Janet Abramowicz, *Giorgio Morandi. The art of silence*, New Haven and London, 2005.

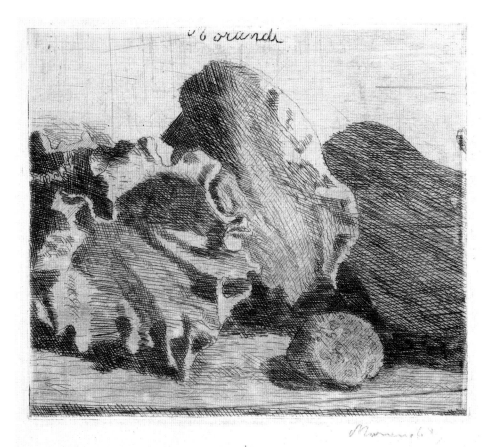

55

STILL LIFE WITH VASE, SHELLS AND QUINCE

1921
Etching 101 × 117 signed in the plate, and in pencil
Vitali 7 second state of three
2004-6-2-119
Bequeathed by Alexander Walker, 2004

This is one of a small number of proof impressions taken before the artist added the letter *v* at the upper left. The plate was then deposited with the Calcografia Nazionale in Rome. Like his contemporary Bartolini, Morandi frequently introduced shells into his prints. He particularly admired Rembrandt's etching of a single shell of 1650, to which he paid tribute in his *Shell* (Vitali 10), also of 1921.

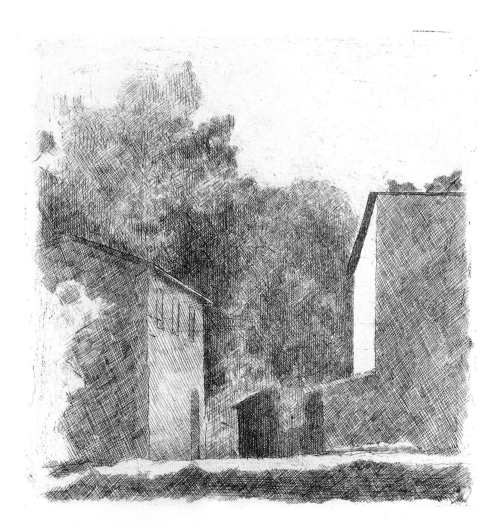

56

LANDSCAPE, CHIESANUOVA

1924
Etching 160 × 155 dated in pencil
Vitali 24 second state of three
Lent by the Estorick Collection

The composition is a mirror image of the artist's painting of houses in a suburb in south-east Bologna. Morandi had first drawn the motif for the frontispiece of his friend Giuseppe Raimondi's *Stagioni seguite da Orfeo all'Inferno e altre favole*, Convegno Editoriale, Milan, 1922.

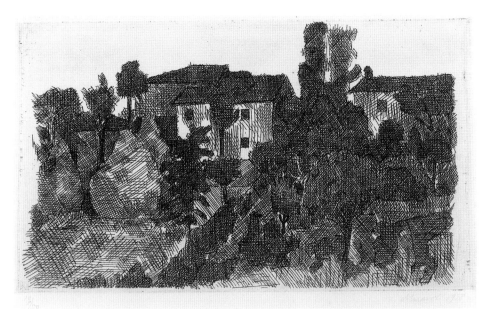

57

THE HILLSIDE IN THE EVENING

1928
Etching 140 × 240 signed, dated and inscribed in pencil 17/52
Vitali 42
Lent by the Estorick Collection

Morandi had earlier etched *The hillside in the morning*, which he printed on a white paper that shone out strongly conveying the bright light. Here, a warmer-toned paper, combined with the chiaroscuro created by heavy crosshatching, produces a much softer effect appropriate for the fading of the day.

58

STILL LIFE WITH CONDIMENT
DISH, LONG AND FLUTED
BOTTLES

1928
Etching 230 × 180 signed and dated 1917
in the plate
Vitali 50 first state of two
Lent by the Estorick Collection

The date 1917 is a mistake for 1916. For it
refers to Morandi's painting of that year in
the Giani collection, the composition of
which in this etching he repeated in reverse.
Only very rarely did Morandi execute etch-
ings after his paintings. In two other cases
like this one he made prints from pictures
from his Metaphysical period.

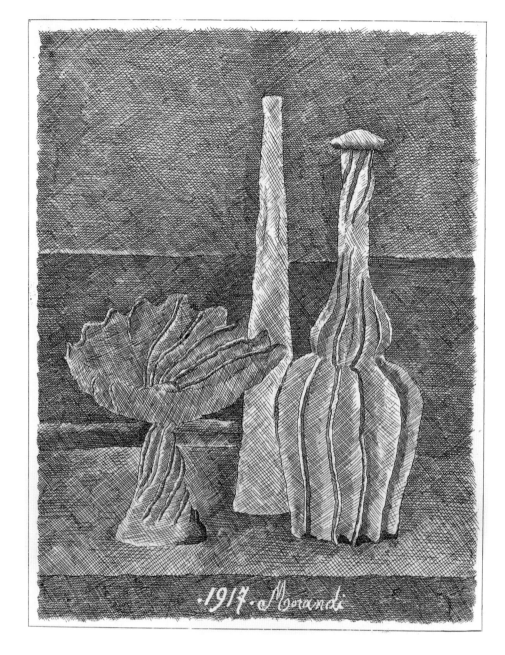

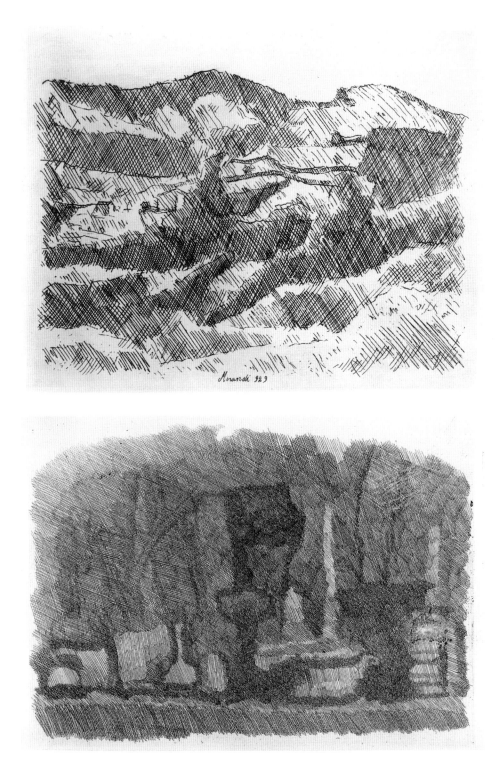

59

THE MOUNTAINS OF GRIZZANA

1929
Etching 135 × 165 signed and dated 929 in
the plate
Vitali 58 first state of two
Lent by the Estorick Collection

The village of Grizzana, where Morandi had
his country studio, lies in the rolling hills
above the Reno valley, twenty miles south-
west of Bologna. Morandi first visited it in
1913, and returned to it sporadically in the
years 1927 to 1939. During the Second World
War, in 1943, he painted many of his most
famous landscapes there. This etching was
published in an edition of fifty.

60

STILL LIFE

1929
Etching 145 × 195
Vitali 67 first state of two
Lent by the Estorick Collection

Morandi had used the reverse of this plate for
another *Still life* (Vitali 66), the composition
of which he traced and transferred to the
other side. In this second version, the group
of vases and flasks are swathed in a misty
atmosphere. This etching was published in an
edition of sixty-two.

61 (see colour page 40)

LARGE STILL LIFE WITH PARAFFIN LAMP

1930
Etching 302 × 361
Vitali 75 fifth state of six
2003-6-30-19
Presented anonymously, 2003

From the edition of forty.

62 (see colour page 41)

STILL LIFE WITH THICK LINES

1931
Etching 247 × 342 signed in the plate, signed, dated and numbered *43/50* in pencil
Vitali 83 second state of three
2001-11-25-29
Presented anonymously, 2001

This impression comes from the edition of fifty. Morandi repeated this composition, slightly cut at the left, in *Still life with white objects on a dark background* (Vitali 82), and in his unfinished etching *Still life with vases on a table* (Vitali 84).

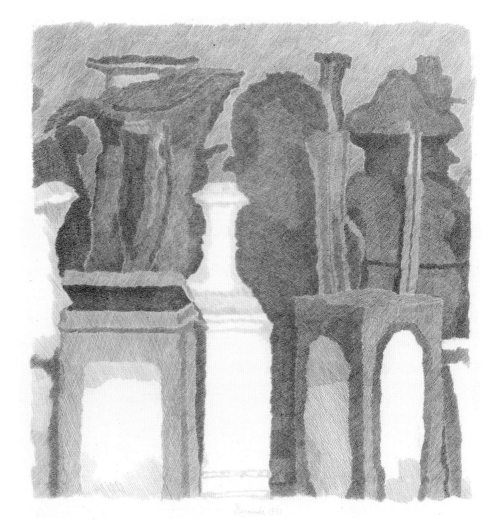

63

STILL LIFE WITH VERY FINE HATCHING

1933
Etching 248 × 238 signed and dated in plate *Morandi 1933*
Vitali 105 first state of two
Lent by Tate Modern

Exceptionally, Morandi cropped his composition of tins, bottles and jugs to exclude any sight of the table on which they were set. Only in an oval *Still life* of c.1942 did he go further, when he omitted to show the tops of some of the bottles and containers.

64

LARGE CIRCULAR STILL LIFE
WITH A BOTTLE AND THREE
OBJECTS

1946
Etching 252 × 324 signed and dated in
plate *Morandi 1946*
Vitali 113 first state of two
Lent by the Victoria and Albert Museum

This etching is one of a group of four still
lives set in *tondos*, which Morandi began in
1942. This composition is the reverse of that
of a near-contemporary painting. Morandi
reused a plate on the back of which he had
begun a first version of his 1933 etching
White road (Vitali 104).

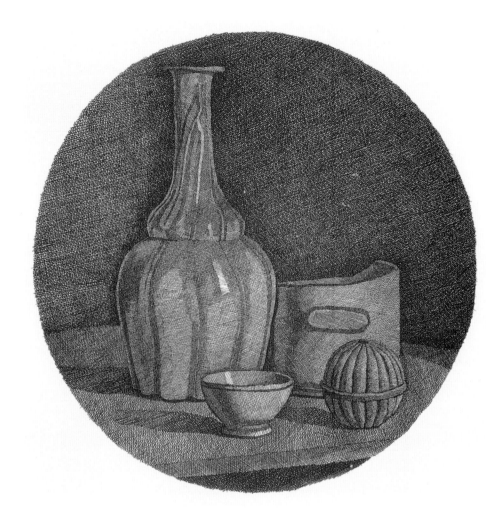

Luigi Bartolini 1892–1963

Born in Cupramontana, near Ancona, Luigi Bartolini was the twentieth-century Italian etcher who came closest to the stature of his great rival, Morandi. As a teenager, he saw the collection of etchings, including work by Callot, owned by the Corradi family in Iesi. From 1907 to 1910 Bartolini studied at the Istituto di Belle Arti in Siena, and started to etch c.1909. He moved in 1910 to Rome, where until 1912 he frequented the Accademia di Belle Arti, while also attending lectures on literature and the history of art, and courses on anatomy at the University in Rome. Bartolini studied the etchings of Goya and took lessons on drawing at the Accademia di Spagna. From there, he went in 1913 to Florence, where he attended the Scuola del Nudo. Bartolini continued his anatomical research, as well as studying architecture, making himself the most assiduous student of all Italian twentieth-century printmakers. He also visited the Uffizi and Florentine print dealers to look at the etchings of Rembrandt and Fattori. Bartolini painted his first oils just before the outbreak of the First World War. Although he painted pictures throughout the rest of his career, and was awarded the Premio Marzotto for them in 1956, they have been far eclipsed in fame by his etchings and writings. During the First World War, Bartolini published his first collection of poetry. A very prolific and accomplished writer, in this field he is best known today as the author of the novel *Ladri di biciclette* (*Bicycle thieves*) of 1946, which was quickly turned into a celebrated film by Vittorio De Sica and Cesare Zavattini.

After the First World War, Bartolini held a series of minor teaching posts in Macerata, Sassari, Avezzano, Pola and Caltagirone, while he continued to etch, and started a long career as a polemical journalist and critic of art and architecture. From 1923 to 1929, he wrote for the Naples periodical *Cimento*, but he also contributed to *Il Selvaggio*, *Quadrivio*, *Italia Letteraria* and *L'Ambrosiana*. Bartolini's 1924 exhibition of etchings at the Casa d'Arte Bragaglia in Rome was a great success, and later that year he showed seventy etched landscapes of the Marches at the Casa Palazzo di Roma. The following year he visited Paris, where he paid particular attention to the paintings of Van Gogh. Bartolini's political convictions led to him being assaulted by Fascists and hospitalized in 1928. Two years later, he won a prize at the Venice Biennale, where he had exhibited a portfolio of etchings. In 1930, the Turin publisher Buratti began to issue a series of portfolios of etchings by contemporary Italian artists under the editorship of Cipriano Oppi, selecting Bartolini for the first album. The following year, Buratti published *Le carte parlanti*, a portfolio of ten of Bartolini's etchings, which was published in an edition of twenty. In 1932, Bartolini shared the first prize at the *Prima Mostra dell'Incisione Moderna* at the Uffizi with Morandi and Boccioni. His close friend the leading anti-Fascist art historian Lionello Venturi acted as his agent, selling his etchings in Paris. Bartolini's correspondence with his compatriots in exile led to his imprisonment, from which he was released on Mussolini's personal intervention. He was then placed under political surveillance. From 1933 to 1938, Bartolini taught in Merano, where he painted and etched in the open air, finding subjects on the banks of the fast-flowing Adige. Despite being under political suspicion, he was given a one-man show of fifty etchings at the second Rome Quadriennale in 1935, when he was awarded the first prize for printmaking. Bartolini still encountered political difficulties, and his *Modi*, published by Edizioni del Cavallino in 1938, was censured by Alfieri, a government minister. Nevertheless, it was another minister, Bottai, who opened his one-man show at the Galleria di San Marco in Rome in 1943. The 1930s and 1940s were Bartolini's most prolific period as an etcher. He made as many as ninety-nine in 1936 and eighty-one in 1943.

Bartolini frequently illustrated his own writings. In 1943, *Sante e cavalle*, a set of twelve etchings, was printed under his direction at the Calcografia Nazionale, and published by Edizioni Documenta in Rome, while Tumminelli, another Roman publisher, issued his *Vita di Anna Stickler*, which was illustrated by twenty etchings. These were followed in 1946 by Bartolini's illustrations to Rimbaud's *Les Illuminations* and *Une saison en enfer*, which were published by De Luigi, also in Rome. In 1953, his *Addio ai sogni: 6 poesie et 6 acqueforti* was published in Milan by Giovanni Scheiwiller's All'Insegna del Pesce d'Oro, while the following year, in Florence, Vallecchi published his *La caccia al fagiano*, which was illustrated by seven of his etchings. Bartolini's final *livres d'artiste*, illustrations to Leopardi's *Canti* and to his own *L'eremo dei Frati bianchi* and *Testamento per Luciana*, were published in 1962 and 1963 by Renzo Bucciarelli in Ancona.

Bartolini also made a small number of lithographs. In 1948, he was one of the artists who illustrated the memorial volume *Elegia in morte di Ines Fila*. The Florentine workshop Il Bisonte published two portfolios in 1962, one consisting of six of his lithographs, the other of six of his etchings.

BIBLIOGRAPHY

The *Catalogo aggiornato dell'opera grafica di Luigi Bartolini (1892–1963)*, Galleria Marino, Rome, 1972, not seen by this cataloguer, records 1,368 prints, supplementing the listings in Carlo Alberto Petrucci, *Le incisioni di Luigi Bartolini*, Calcografia Nationale, Rome, 1951. Three significant recent exhibition catalogues are Luigi Ficacci, *Luigi Bartolini alla Calcografia*, Istituto Nazionale per la Grafica, Rome, 1997, Alessandro Tosi, *Le incisioni della Collezione Timpanaro*, Gabinetto Disegni e Stampe degli Uffizi, Florence, 1998, and Nicola Micieli, *Mino Rosi e Luigi Bartolini: un sodalizio intelletuale: Le incisioni di Luigi Bartolini nella collezione Rosi nella collezione Fondazione Cassa di risparmio di Volterra*, Volterra, 1998. A wider perspective is provided by *Luigi Bartolini 1892–1965: L'uomo, l'artista, lo scrittore*, Palazzo Ricci, Macerata, 1989. For his paintings, there is Franco Solmi, *Luigi Bartolini: la pittura*, Bologna, 1983. Bartolini's writings on art have been edited by Vanni Scheiwiller, *Scritti d'arte*, Milan, 1989.

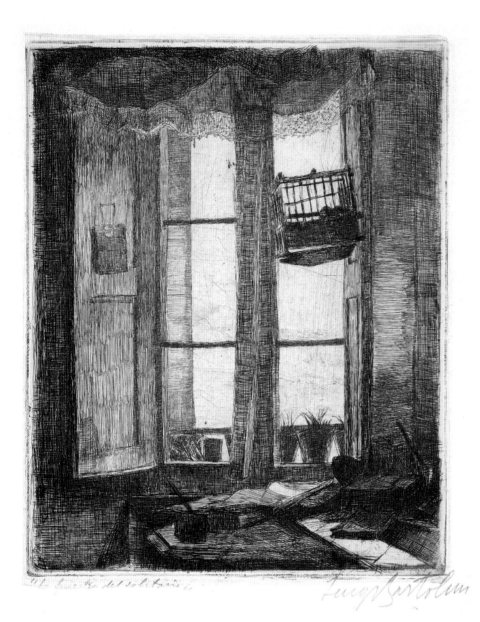

65

THE WINDOW OF THE SOLITARY PERSON

1925
Etching 200 × 160 signed and titled in pencil,
and with the artist's blind stamp
Petrucci 190 first state of two
2003-6-30-20
Presented anonymously, 2003

This is the third of the four versions that
Bartolini made of this subject, the first of
which dates from 1924. In the second state
Bartolini added more shading and his
signature.

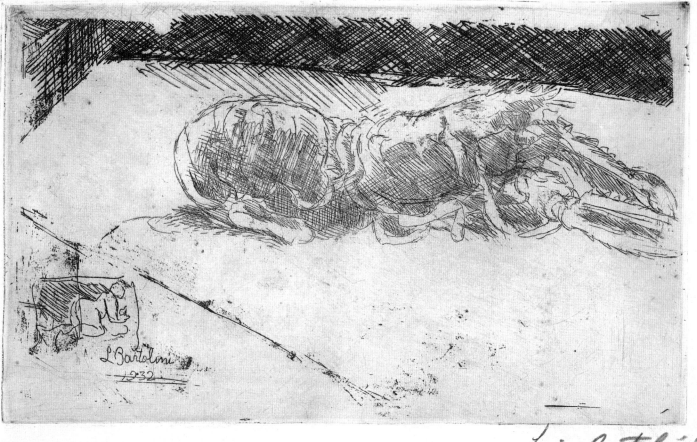

66

LOBSTER

1932
Etching 166 × 280 signed and dated in the
plate, and signed in pencil
2003-6-30-25
Presented anonymously, 2003

Bartolini etched five plates of lobsters in the
1930s, of which this is the earliest.

67

TWO FLOWER POTS WITH
CACTUS PLANTS

1934
Etching on chine appliqué 275 × 235 signed
in the plate, and annotated in pencil
'Primo stato'
2003-6-30-24
Presented anonymously, 2003

In this state Bartolini added the pot and plant
on the left. He also made another etching in
1934 of two pots containing cactus plants,
this time seen from a rather different angle
and set against a hatched background.
Bartolini made at least eleven etchings of
pot plants, most of them in the period 1934
to 1937.

68

THE FRAGILE SHELL

1936
Etching 208 × 246
2003-6-30-27
Presented anonymously, 2003

This etching's alternative title, *Sweet image
of death*, reveals that this print of a large
clam belongs to the same tradition as the
memento mori of seventeenth-century still-
life painting. There was an edition of fifty.
Shells were a favourite subject of the artist.
Bartolini made the first of many etchings of
the motif in 1914.

69

THE MEAL
(CHILDREN EATING BESIDE
THE PASSIRIO)

1936
Etching 228 × 289
Petrucci 621
2002-7-28-1
Presented anonymously, 2002

The River Passirio, which rises in the
Dolomites, close to the frontier with Austria
in the Alto Adige, flows south into the Adige
at Merano, where Bartolini probably etched
this subject.

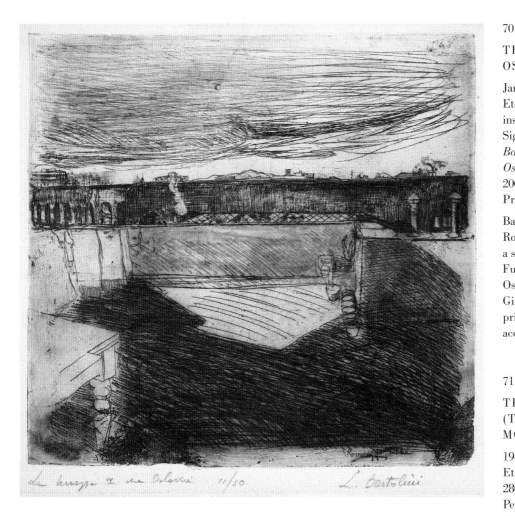

70

THE TERRACE OF VIA OSLAVIA 37

January 1939
Etching and aquatint 302 × 327 signed and inscribed in the plate *Roma 1 gennaio 1939*. Signed and inscribed in pencil *11/30 Luigi Bartolini ha il suo studio in Roma in via Oslavia n. 37 scala A interno 17*.
2003-5-31-11
Presented anonymously, 2003

Bartolini's studio was in the Prati district of Rome between the Tiber and Monte Mario, a suburb in the north-west of the city. The Futurist Giacomo Balla also lived in the Via Oslavia, which runs south into the Piazza Giuseppe Mazzini. Bartolini included this print in his article 'Presentazione delle mie acqueforti', *Emporium*, December 1940.

71 (see colour page 42)

THE FOALS (THE COUNTRYSIDE AT MONTE MARIO, ROME)

1941
Etching and aquatint touched in watercolour
280 × 303
Petrucci 842
2001-5-20-92
Presented anonymously, 2001

Monte Mario lies north of the Vatican City on the west bank of the Tiber within walking distance of Bartolini's studio. Bartolini only occasionally applied colour to his prints, the first being *The sunset* in 1914. Another example in the British Museum's collection is his 1936 *The freshwater fisherman*.

72

THE RIVERS OF THE MARCHES.
THE POTENZA

1941
Etching 332 × 380
2003-6-30-22
Presented anonymously, 2003

The etching is also known by the alternative titles *Apologia of the rivers of the Marches* and *Bridge on the Chienti*. The Potenza and Chienti are the two rivers that run north-east to the Adriatic, between which lies the ridge topped by the hill city of Macerata. The figure writing may be a self-portrait. Bartolini returned several times to the motif of a mooring platform on the Chienti. His first two etchings of it date from 1921 and he took up the subject again in 1936. Bartolini's final version dates from 1962.

Giorgio De Chirico 1888–1978

Born in Volos in central Greece, halfway between Athens and Salonica, Giorgio De Chirico was the son of a railway engineer. His family's regular travel to the capital provided a stimulus for some of the themes in his art, in which the ancient and modern worlds are combined. He and his younger brother, the composer, writer and painter Andrea (1891–1952), who took the pseudonym Alberto Savinio, received a thorough grounding in classical history, languages and mythology. De Chirico studied painting at the Athens Polytechnic from 1903 to 1905, before moving on the death of his father to Florence, where he attended the Accademia delle Belle Arti. However, it was his period from 1906 to 1910 at the Akademie der Bildende Künste in Munich which proved his most significant artistic training. De Chirico was influenced by Max Klinger, Hans Thoma and, in particular, Arnold Böcklin. In 1910, he returned to Italy, and devoted himself to the study of Schopenhauer and Nietzsche, before following his brother to Paris the following year. For the rest of his career, his art could be seen to be based on the second half of Nietzsche's *The birth of tragedy and the spirit of music*. De Chirico began painting a succession of haunting arcaded city squares, captured when the sun cast its deepest shadows, and often populated only by mysterious statues, a theme that was to recur throughout his career. His style owed more to German art, including the Nazarenes, than to any French artist. He became a friend of the Polish-born poet Guillaume Apollinaire, who applied the term 'metaphysical' to his pictures. The two men shared a German-Italian education. Inspired by one of his brother's poems, De Chirico introduced the mannequin into his work.

De Chirico was called up in 1915 to serve in the Italian army, and was posted with his brother to Ferrara. There, he met Carlo Carrà, who became his close associate in the development of Metaphysical Painting, in which canvas stretchers, toys and various geometrical objects were depicted in claustrophobic spaces. After the war, De Chirico became preoccupied with mythological subject matter and classical sculpture. He made his first lithograph, *Orestes and Pilades*, in 1921, which was published, by the Bauhaus in Weimar, only in 1925 in the portfolio *Neue Europäische Graphik*. De Chirico made five etchings in 1927, and made the occasional intaglio print later in the 1920s and 1930s. Most of De Chirico's prints were in fact lithographs. An exception was a single linocut made for the journal *XXe Siècle* in 1938. He began to make etchings in a significant number only in 1969, towards the end of his career. Of De Chirico's 385 recorded prints, 165 lithographs and forty-four intaglio prints were made between 1969 and 1977. The vast majority of De Chirico's prints were published in portfolios, or *livres d'artiste*, beginning with the sixty-six prints for Apollinaire's *Calligrammes*, which were printed by Desjobert and published in 1930 by Gallimard in Paris. He had returned to Paris in 1924, settling there the following year, and he spent much of the next decade there. De Chirico's art was greatly admired by the poet André Breton and by the Surrealists, and, in 1929, he published a novel, *Hebdomeros*, one of the finest pieces of Surrealist literature. He received a major mural commission for the 1933 Milan Triennale, and designed the sets and costumes for Bellini's *I Puritani*. In 1935, the success of a series of New York exhibitions attracted him to the United States, where he spent three years. De Chirico's later work frequently recapitulated his early masterpieces. He paid tribute both in his paintings and writings to Courbet and Derain, and his late work is often seen as parallel to the late pictures of Picabia.

BIBLIOGRAPHY
Antonio Vastano and Edoardo Brandi, *Giorgio De Chirico: catalogo dell'opera grafica 1921–1977*, 2 vols., Bologna, 1996, has superseded Alfonso Ciranna, *Giorgio De Chirico catalogo delle opere grafiche (incisioni e litografie)*, Milan and Rome, 1969, and Edoardo Brandi, *Giorgio De Chirico. Catalogo dell'opera grafica 1969–1977*, Bologna, 1990. For his paintings there is the seven-volume *Catalogo generale Giorgio De Chirico* by Claudia Bruni Sakraischik and Isabella Far, Milan, 1971–83.

73 (see colour page 43)

AND I SAW A BEAST RISE UP FROM THE SEA *FROM* THE APOCALYPSE

1941
Lithograph touched in pastel 305×220
signed in pencil
2003-6-30-47 (13)
Presented anonymously, 2003

This portfolio of twenty lithographs illustrating the poet and art critic Raffaele Carrieri's translation of the Bible, *L'Apocalisse*, was published in an edition of 160 by Edizioni della Chimera in Milan. Each plate is lettered with a title in facsimile handwriting, and signed in pencil. The lithograph on display is the one of those to which pastel was added under De Chirico's direction. St John the Divine's vision of the seven-headed beast is described in chapter 13 verse 1 of the Book of Revelation.

This copy of the portfolio was printed for the anti-Fascist Milan lawyer and collector Edoardo Majno, whose print collection was exhibited in 1958 at the Pinacoteca di Brera. Majno also wrote a monograph in 1932 on the painter and etcher Giuseppe Mentessi. Carrieri published a monographic study on De Chirico in 1942. In these small lithographs the artist paid tribute to Dürer's famous woodcut *Apocalypse* of c.1498. Several of the compositions are directly based on those of his forerunner.

74 (see colour page 44)

HORSE AT THE VILLA FALCONIERI

1954
Colour lithograph in black, red and green
340 × 435 signed in pencil, and inscribed
fc (fuori commercio)
Ciranna 125 Vastano 140
2003-6-30-45
Presented anonymously, 2003

This proof is the third of six lithographs in the portfolio *Cavalli e ville*, which was printed by Igino Alessandrini, and published by Carlo Bestetti in Rome in an edition of 125. For five select collectors, an additional impression of each lithograph was printed on white silk. Carlo Bestetti, who opened his business in 1947, had already published *Cavalli*, a suite of ten lithographs, also printed by Alessandrini in 1948. The last portfolio of De Chirico's prints to be issued by Bestetti was *Sei litografie* of 1966, for which Alessandrini was assisted by Roberto Bulla in their printing. The Villa Falconieri in Frascati, in the Alban hills south of Rome, was largely rebuilt to the design of Francesco Borromini in the late 1660s, and is surrounded by a large and beautiful park.

Born in Ferrara into the nobility as Luigi Filippo Tibertelli, Filippo De Pisis identified himself with his medieval ancestor, the fifteenth-century condottiere Filippo Tibertelli da Pisa, a variant of whose name he adopted in 1912. He maintained a romantic and antiquarian attitude throughout his life. From childhood, De Pisis was a keen student of literature, and collected butterflies, wild flowers and all kinds of objects, putting together a herbarium which he eventually gave to the University of Padua. From an early age he was also a keen draughtsman. From 1914, he studied literature and philosophy at the University of Bologna. De Pisis became friends with the brothers De Chirico and Savinio, when they were stationed in Ferrara in 1916, and he also met Carrà, Soffici and Morandi. The De Chiricos helped him to make contact with the Parisian avant-garde, and he corresponded with Apollinaire and Tristan Tzara. De Pisis's first collection of poems, *I canti de la Croara*, dedicated to the poet Giovanni Pascoli, was published in 1916. His first important artistic work was a 'museum' in his studio, incorporating collages among his botanical and antiquarian collection, a sort of sculptural equivalent of Pittura Metafisica. In this De Pisis anticipated Eduardo Paolozzi's intervention in London's Museum of Mankind.

Between 1920 and 1924, De Pisis was in Rome, where the Casa d'Arte Bragaglia gave him his first one-man show, which was devoted to drawings and watercolours. During this period, he worked as a schoolmaster, while frequenting the *Valori Plastici* circle, writing in support of Pittura Metafisica, and painting still lifes, which included unexpected juxtapositions of objects. De Pisis was closest to Giovanni Comisso among contemporary writers. In 1925 he moved to Paris, where he was influenced by Manet, Sisley, Pissarro and Dunoyer de Segonzac, and showed interest in the contemporary colour of Matisse. De Pisis's private life led him to explore the representation of the hermaphrodite. Much later, a prize was withheld from him at the 1948 Venice Biennale because of his homosexuality. De Pisis was a central figure in the loose association of artists Gli Italiani di Parigi.

De Pisis returned in 1931 to Italy, where he established a high reputation for his still lifes, male nudes and cityscapes, notable for his use of light and space, and for his delicacy of touch. He visited London in 1933, 1935 and 1938, and there is some similarity between his paintings and the late work of Sickert. De Pisis was held in some suspicion by the governing regime for his sexuality and as an opponent of Fascism. During the war, he settled in Milan until his house was destroyed by bombing in 1943, when he moved to Venice. There, he was inspired as much by the paintings of Guardi as by the light and atmospheric conditions of the lagoon. In 1948 De Pisis was admitted to a neurological clinic, and he spent almost all the rest of his career in a hospital near Milan, where he still continued to paint.

All fifty-six of De Pisis's prints were lithographs, and his printmaking activity was limited to five brief years. On the occasion of his exhibition in February 1932 at the Galerie Jeune France, the subscription bulletin for a projected monograph on De Pisis by Antoine Aniante (Antonio Rapisanda), which Editions Le Triangle intended to publish, announced that it would be accompanied by a colour lithograph by the artist. However, neither the book nor the lithograph ever appeared. Ten years later, the colophon to Ugo Nebbia's monograph on De Pisis, published by Il Chiantore in Turin, stated that there would be a signed lithograph in each of fifty numbered copies. Once again no print was ever made. De Pisis may have had a problem over delivery, since on at least three occasions prints that had been promised were never executed, including a set of lithographs to illustrate his poems, *Gli angeli*, for Enrico Damiani, the publisher and scholar of Slav literature. He eventually made his first lithograph in Milan in 1943, bringing the stone with him to Venice, where it was printed by Carlo Cardazzo of the Galleria del Cavallino. The same year, two further lithographs, which were probably intended as illustrations for a book that was never published, were printed in Verona by Giovanni Mardersteig's Officina Bodoni. The Milan publisher Ulrico Hoepli paid 2,000 lire for each of the lithographs that De Pisis made in 1944–5 for *I carmi di Catullo*. In 1944, Alessandro Barnabò's Il

Tridente offered to publish a volume of his poetry, which was illustrated by ten colour lithographs. These were printed in Venice by Carlo Ferrari, and published the following year as *Alcune poesie* De Pisis made his last lithograph in 1947, *Concilium lithographicum*, which was dedicated to the poet Velso Mucci, and published in Rome by Dora Broussard Mucci. It was sometimes De Pisis's practice to add watercolour to his prints, despite his stated preference that 'a good lithograph *ought* to say everything in black and white'. It seems that connoisseurs may have demanded the added touch of delicate colour. In the one case in which he made colour lithographs, *Alcune poesie*, De Pisis added watercolour to up to eight separate black and white proofs from which the printer worked under his careful supervision.

BIBLIOGRAPHY
Two catalogues were published in 1969, Manlio Malabotta, *L'opera grafica di Filippo de Pisis*, Milan, 1969, and Giuseppe Marchiori and Manlio Malabotta, *De Pisis. Le litografie*, Verona, 1969. The most recent publications on his work are Luca Massimo Barbero, *Filippo De Pisis. Opera grafica dalla collezione Malabotta*, Casa del Mantegna, Mantua, 1996, and Sandro Zanotto, *Filippo De Pisis. Ogni Giorno*, Vicenza, 1998. Several exhibitions were held to commemorate the fiftieth anniversary of his death, including *De Pisis a Ferrara*, Museo d'Arte Moderna e Contemporanea 'Filippo De Pisis', Ferrara, 2006, the catalogue for which includes all 117 impressions of the artist's lithographs in its possession.

75 (see colour page 45)

FLOWERS

1944
Lithograph, touched in watercolour 392 × 284
signed in charcoal and inscribed *65/70*
Barbero 15
2003-6-30-40
Presented anonymously, 2003

This is from the portfolio *Sei litografie*, which was printed by Carlo Cardazzo's Stamperia del Cavallino and published by Edizioni del Cavallino in Venice in 1944, accompanied by an introduction from Rodolfo Pallucchini. There was an edition of seventy. A further ten impressions were reserved for the publisher. De Pisis made watercolour additions to a number of black and white impressions, including one of the two impressions in the Museo d'Arte Moderna e Contemporanea 'Filippo De Pisis' in Ferrara. He had met Carlo Cardazzo in Milan in the late 1930s, and it was to him that he entrusted the printing and publication of his first lithographs in 1943, the first of which was also devoted to flowers.

Massimo Campigli 1895–1971

He was born as Max Ihlenfeld in Berlin, but his mother took him to Florence when he was two, before moving to Milan. In the 1920s, he changed his name to Massimo Campigli. At the age of nineteen, he published a poem in the Florentine Futurist journal *Lacerba*. After the First World War, in which he was captured and imprisoned in Hungary, before escaping to Russia, Campigli became a journalist with the Milan newspaper *Corriere della Sera*. The newspaper sent him in 1919 to Paris, where he worked for it for nine years, until he married a wealthy Romanian painter. There, Campigli initially began to paint in a style indebted to Picasso and Léger. In 1923, the Galleria Bragaglia in Rome gave him his first one-man show. By the mid-1920s, Campigli had started to paint doll-like figures in close to symmetrical compositions, which paralleled the work of the Purist art, which was promoted in the journal *Esprit Nouveau*. Memories of the rigidity found in Russian icons may also have played a part in his development.

Campigli was a regular visitor to the Egyptian galleries in the Louvre, and, on a visit to Rome, he studied the Etruscan collections in the Villa Giulia, which offered him possibilities to explore compositions which were not symmetrical. He also became interested in Roman wall painting. The works that Campigli exhibited in 1929 in his show at the Galerie Jeanne Bucher included wasp-waisted women akin to archaic statuettes. The isolated schematic figures, plaster-like colours and contrasts between heavily worked areas and lightly sketched backgrounds stressed his connections with the art of the antique world.

In 1930 the Parisian literary publisher J.-O. Fourcade commissioned Campigli to illustrate Virgil's *Georgics*. Although this project never came to fruition, five prints resulted. The following year, Jeanne Bucher published Campigli's first colour etching. He made two further etchings in 1932, and two drypoints in 1938. In the 1930s his work received considerable acclaim. Campigli had four exhibitions in New York, and he showed with the Novecento group in Italy. When he

left Paris for Italy in 1933, he was a signatory to the *Manifesto della pittura murale*, and entered a highly successful period as a muralist. Campigli's most notable public commissions were for Milan's Palazzo di Giustizia, and for the University of Padua. His style and subject matter, women calmly going about their daily activities, remained remarkably consistent for the rest of his life.

Campigli's career as a printmaker blossomed in the Second World War with the publication in 1942 by Editrice Hoepli of *Il milione di Marco Polo*, for which he made thirty lithographs, which were printed for him by Piero Fornasetti. Two years later, twelve more lithographs illustrated *Liriche di Saffo*, a *livre d'artiste* printed in Milan by Stamperia del Cavallino, and published in Venice by the closely associated Edizioni del Cavallino. Almost contemporaneous was the publication in Milan by G.P. Giani of Verlaine's *Poèsie (Poèmes saturniens – Sagesse)* illustrated with ten lithographs by Campigli printed in Milan by Fornasetti. Fornasetti was also the printer of the artist's eleven lithographs for Raffaele Carrieri's *Il lamento del Gabelliere*, which was published in 1945 by Edizioni Tonelli in Milan. Like Daumier, Campigli provided models in watercolour for colour to be added by hand under his direction. His last major collaboration with Fornasetti was in 1948, when he executed lithographs for André Gide's *Theseus*. The book was published by Giovanni Mardersteig's Officina Bodoni the following year. In 1951, Campigli began working with the Zurich-based print publisher Nesto Jacometti, for whom he made over thirty lithographs. He produced two further significant *livres d'artiste*. The lithographs for Jean Paulhan's *Campigli La Ruche* were printed in Venice by Edizioni del Cavallino, and published in Paris in 1952 by N.R.F. (Nouvelle Revue Française). Thirteen years later in 1965, Campigli made eleven etchings and aquatints for Italo Calvino's *Le memorie di Casanova*. The publication of this portfolio was delayed. Salamon e Tonini editori in Rome issued it only in 1981, a decade after Campigli's death.

BIBLIOGRAPHY
Francesco Meloni and Luigi Tavola, *Campigli. Catalogo ragionato dell'opera grafica (litografie e incisioni) 1930–1969*, Livorno, 1995, catalogues 218 prints, of which 201 are lithographs. There is a considerable literature on his paintings, including Flaminio Gualdoni, ed., *Massimo Campigli 1895–1971: 'Essere altrove, essere altrimenti'*, Museo della Permanente, Milan, 2001, and Klaus Wolbert, ed., *Massimo Campigli. Mediterraneità und die Moderne*, Institut Mathildenhöhe, Darmstadt, 2003.

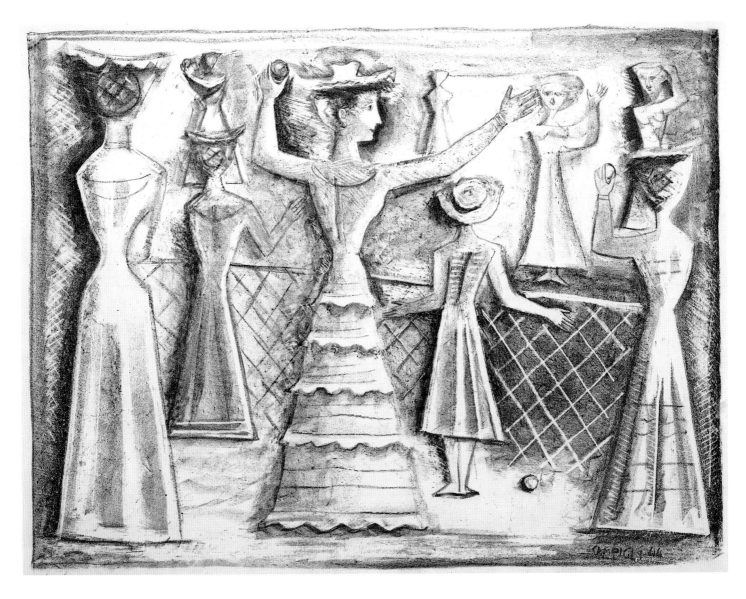

76

THE GAME OF PALLA

1944
Lithograph 290 × 383 (sheet) signed and
dated in pencil, and numbered *58/60*
Meloni & Tavola 88
2002-7-28-44
Presented anonymously, 2002

This lithograph was printed and published by
Edizioni del Cavallino in Venice in an edition
of sixty. The traditional Tuscan handball
game of palla is particularly popular in the
area between Siena and Grosseto. Of medi-
eval origin, it is similar to real tennis. The
game is played in the street by teams facing
each other, who strike the ball with bare or
gloved hands. The courts are marked out with
painted lines. The players can make use of
rebounds off the adjacent buildings and,
sometimes, spectators. A second bounce can
result in a 'chase', rather than a point, which
is marked in chalk when the ball stops rolling.

77 (see colour page 46)

THE WOMEN TAKING A STROLL

1957

Colour lithograph (green, yellow, red and black) 465 × 350 signed and dated in pencil, and inscribed *Epreuve d'essai*

Meloni & Tavola 167

2002-7-28-60

Presented anonymously, 2002

This lithograph was printed in Paris by Desjobert, and published in an edition of 200, in Zurich and in Paris, by Nesto Jacometti's L'Oeuvre Gravée. Campigli made over thirty lithographs with Jacometti from 1951 on, including another on the same subject, *La passeggiata*, which was published in Paris in the Guilde Internationale de la Gravure series in 1952. In the warm evenings and on Sunday mornings in Italy it is customary for whole families to go out in their finery for a stroll, known as a *passeggiata*, through the main streets of their town or village. The slow pace of the walk makes it an ideal occasion to converse with friends, and in some ways the practice fulfils the role played in Britain by the local pub. Campigli's subject may have been inspired by the Futurist Aldo Palazzeschi's early collage-poem *La passeggiata*.

Born in Florence, he came from a family of wealthy textile traders. Magnelli taught himself to paint, studying from pictures in museums and from fifteenth-century frescos in Tuscan churches. In 1911, he came into contact with Futurism through Giovanni Papini and Soffici, and with Cubism through the illustrations in Apollinaire's *Les Peintres cubists: Méditations esthétiques*, before he travelled in 1914 to Paris. There, Magnelli purchased paintings by Picasso, Gris and Carrà, and sculpture by Archipenko for his uncle's collection. His highly organized paintings were informed by study of Piero della Francesca and Paolo Uccello, as well as by Cubism, while he also adopted the unmodulated colours and dark outlines of Matisse.

At the outbreak of the First World War, Magnelli was in Italy, where for two years he painted entirely abstract works, before returning to figuration after an interruption due to military service and illness. After the war, he painted pictures of quiet Tuscan landscapes, and figure studies in a style akin to that promoted in *Valori Plastici*, which owed something to Pittura Metafisica. The colour was more subdued than in his previous work. From 1925, Magnelli began to use brighter tones again, and simplified both his modelling and his perspective. A crisis in confidence and uncertainty as to his artistic direction led him briefly to abandon painting at the end of the 1920s. However, a visit to the marble quarries in Carrara in 1931, and Magnelli's decision to leave provincial Tuscany for Paris, gave his art a fresh start. His paintings of *Pierres*, heavily outlined large floating rocks set in an indeterminate space, bore a resemblance to the work both of Magritte and of other Surrealists, as well as to his friend Léger's contemporary depiction of isolated objects. Prampolini encouraged Magnelli to return to abstraction, and both artists were prominent in the Abstraction-Création group.

Magnelli spent the Second World War in Grasse in Provence, where he worked with the Arps and with Sonia Delaunay. Together, they produced a collaborative album of ten lithographs. However, this was not published until 1950. For the Gestapo arrested his intended printer, and the few proofs that he had pulled

were destroyed. During this period, owing to a scarcity of painting materials, Magnelli made collages and painted in gouache on gridded slate slabs. Magnelli returned in 1944 to Paris, where his work provided the inspiration for many younger French and Italian abstract artists. For the rest of his career, his paintings were notable for clearly delineated hard-edged forms set against large matt areas of colour. Magnelli's example was particularly important for the development of abstraction in Rome in the 1950s among the artists of the Art Club.

Magnelli made his first two etchings at Forte dei Marmi in the summer of 1934, when he was working on his *Pierres*. His earliest relief prints, one of which was commissioned by Gualtieri di San Lazzaro for *XXe Siècle*, were made from masonite matrices in 1938. These were followed in 1941 by four woodcuts, the first of which was for the catalogue of his one-man show at the Galerie Drouin in Paris. After his collaborative lithographs of 1941–3 with the Arps and Sonia Delaunay, Magnelli made no more prints until 1949, when an aquatint printed in Paris by Lacourière was published by Iliazd in *Poèsie de Mots Inconnus*. He began making lithographs with Edmond and Jacques Desjobert in Paris in 1950. Magnelli contributed to *Maîtres de l'art abstrait*, one of the first major albums of screenprints to be produced in France, which was printed by Wifredo Arcay (born 1925) in Meudon, and published in 1953 by Architecture d'Aujourd'hui in Boulogne-sur-Seine. He made his first linocut in 1965, which was printed in Vallauris by Hidalgo Arnéra, who became his regular printer for linocuts, including the two for Aldo Palazzeschi's *La passeggiata*, published in 1970 by M'Arte in Milan. Magnelli had accompanied the Futurist poet to Paris in 1914. In his last major print project, Magnelli made ten lithographs in 1969–70 for *I collages di Magnelli*, which were printed by Francesco Cioppi, and published in 1971 by Il Collezionista d'Arte Contemporanea in Rome. The vast majority of Magnelli's 100 prints were made in the last twenty-two years of his life. Among the other publishers with whom he worked were L'Oeuvre Gravé in

Zurich, Il Bisonte in Florence and Erker Presse in Sankt Gallen.

BIBLIOGRAPHY

Anne Maisonnier, *Alberto Magnelli l'œuvre gravé*, Bibliothèque Nationale, Paris, 1980, catalogued those prints which the artist's widow had presented to the Bibliothèque Nationale. All 100 of Magnelli's prints were included in the exhibition organized by the Istituto Svizzero di Milano, *Magnelli opera grafica*, Galleria Gruppo Credito Valtellinese, Milan, and Galleria Gruppo Credito Valtellinese, Sondrio, 2001, the catalogue for which, written by Luciano Caramel and Dominique Stella, has not been seen by this compiler. Anne Maisonnier-Lochard is also the author of *Alberto Magnelli. L'Oeuvre peint: catalogue raisonné*, Paris, 1975, *Alberto Magnelli: les ardoises peintes: catalogue raisonné*, Saint-Gall, 1981, and *Magnelli: collages: catalogue raisonné*, Paris, 1990.

78 (see colour page 47)

UNTITLED

1941

Woodcut in black and reddish purple signed and dated in pink ink 254 × 195 (woodcut) 291 × 233 (map) signed, dated and numbered in red ink
Maisonnier 5
1994-6-19-5
Purchased, 1994

This is one of about ten or twelve proofs printed on a map of Grasse in southern France, where Magnelli and his wife spent the Second World War with Sonia Delaunay and the Arps. Magnelli probably printed it there himself. He made additions to a few impressions in red ink. This example shows wartime conditions in the town, notably the cancellation of the Syndicat d'Initiative (the local tourist board). A standard ordinary edition of this woodcut was printed by Benteli in Bern, and published in 1942 by Allianz Verlag in Zurich in the portfolio *10 Origin*, which was accompanied by texts by Jean Arp, Max Bill and Magnelli. The other plates were contributed by Arp, Bill, Sonia Delaunay, Cesar Domela, Wassily Kandinsky, Leo Leuppi, Richard Lohse, Sophie Taeuber-Arp and Georges Vantongerloo, a formidable array of the leading artists associated with Art Concret. There was an edition of 100, and an exceptionally large number of thirty-five artist's proofs.

79 (see colour page 48)

COMPOSITION WITH RED

1966

Colour lithograph 555 × 425 signed in pencil, and inscribed *46/65*
Maisonnier 42
1997-1-19-17
Purchased, 1997

This proof is one of six that were printed in Paris by Fernand Mourlot, in addition to the edition of 100, which was published in the portfolio *Europäischer Graphik VIII (Italienische Künstler)* by Galerie Wolfgang Ketterer in Munich and Felix H. Man in London. This impression was owned by one of its co-publishers, the photo-journalist and lithographic historian Felix Hans Man (1893–1985) (Hans Baumann). The other two etchings and four lithographs in the portfolio were contributed by Baj, Dorazio, Renato Guttuso, Marini, Achille Perilli and Toti Scialoja (1914–88). In 1965 Magnelli had contributed a lithograph to the portfolio *Europäische Graphik III (Italienische Künstler)*, which was issued by the same publishers in 1966 (see no. 90). Magnelli made at least two preparatory drawings for *Composition with red*, the first in pencil with an indication of the intended colours, the second in colour. Mourlot printed many of Magnelli's later lithographs.

80 (see colour page 49)

UNTITLED

1969

Colour lithograph 582 × 417 signed in pencil, and inscribed *IX/XX H.C.*
2003-6-30-57
Presented anonymously, 2003

This proof is one of twenty pulled in addition to the fifty that were printed by Mourlot for *Album de la Ferrage*, a portfolio of ten plates published by *XXe Siècle* in Paris, and by Léon Amiel in New York. These consisted of four lithographs, four linocuts printed by Hidalgo Arnéra in Vallauris, and two colour etchings printed by J. David in Paris. The plates were accompanied by Magnelli's poem *Premier juillet*, and by a photograph of the artist by A. Villiers.

In 1938, Magnelli began to spend his summer holidays high in the hills near Grasse, at the farm of La Ferrage, owned by the family of Susi Gerson, whom he married in 1940. Together, they spent the war years of 1939 to 1943 there, and they regularly returned in the summer months from 1947 to Magnelli's death. Magnelli also made a suite of six colour linocuts, *La magnanerie de la Ferrage*, in 1972, which were printed in Vallauris by Arnéra and published by the Société Internationale d'Art XXe Siècle in Paris.

Enrico Prampolini 1894–1956

Born in Modena, Prampolini studied from 1912 at the Accademia di Belle Arti in Rome with the sculptor and illustrator Duilio Cambellotti (1876–1960). He had already encountered the paintings of Klimt in the International Exhibition held in Rome the previous year, and his early work as an illustrator was in a Secessionist style. However, Prampolini soon joined the Futurist circle, publishing a manifesto, *L'atmosferastruttura – basi per un'architettura futurista*, and exhibiting at the Galleria Sprovieri's Esposizione Libera Futurista in 1914. The following year, he wrote *Costruzioni assolute di motorumore*, and later he published articles on Futurist scenography and choreography. Theatre design would be an almost constant component of Prampolini's art throughout the rest of his career. In 1916, he met Tristan Tzara and Hans Arp, and became involved with the Zurich-based Dada movement, which he promoted in the pages of *Noi*, the journal that he founded with Benedetto Sanminiatelli. Two years later, Prampolini organized an exhibition at the Galleria dell'Epoca', which included the work of the Metaphysical painters De Chirico and Savinio. With the help of Mario Recchi, he also founded the Casa d'Arte Italiana in Rome to promote the international avant-garde through exhibitions and cultural events.

In 1922 Prampolini met the artists in the *Der Sturm* circle in Germany, and attended an International Congress of Progressive Artists in Düsseldorf with El Lissitzky and Theo Van Doesberg. The following year, he became the Italian delegate to Archipenko's Berlin and New York-based International Society of Modern Art. Prampolini spent the years 1925 to 1927 in Paris, where he organized the Futurist section of the Exposition Internationale des Arts Décoratifs et Industriels Modernes, and presented his Magnetic Theatre, which used light effects instead of actors. Through the pages of *Noi* and *Documents de l'Esprit Nouveau*, the journal which he founded with the Belgian artist and art critic Michel Seuphor, he supported Léger and Purism.

In the 1930s, Prampolini was the outstanding figure to be involved with *aeropittura*, the painting of subjects inspired by the cosmic revelations of aviation. Contemporaneously, biomorphic and non-objective forms replaced bio-mechanically derived abstractions in his paintings. Prampolini was the leading Italian artist to be associated with the Parisian Abstraction-Création group between 1931 and 1935. Towards the end of the war, he returned to a figurative style in a series of paintings of anguished women strongly influenced by the near-contemporary work of Picasso. This was a short-lived interlude before Prampolini developed a brightly coloured abstraction akin to Art Informel. In 1945, he was one of the founders of the Art Club in Rome. Prampolini was very much the father figure for the younger abstract painters in the city. He also joined the Milan-based M.A.C. (Movimento Arte Concreta). Prampolini's lifelong engagement with stage design was acknowledged by his appointment in 1955 as Professor at the Accademia di Belle Arti di Brera.

Prampolini's first known print was an etched portrait of a man dated 1911, made for the Turin journal *L'Artista Moderno. Rivista Illustrata di Arte Applicata.* However, most of his prints were woodcuts, starting with thirteen frontispieces for the special issue of *L'Eroica* in 1915, which was devoted to Armenia. These were illustrations to Alessandro Rosso's translation of Constant Zarian's poems *Canti mistici*. Prampolini's early prints were in a late Symbolist Secessionist mode, and show knowledge of the work of Kupka. Some of his woodcuts were included in the *L'Eroica* exhibition held in Sarzana in 1916. Several of Prampolini's prints were made in connection with the stage, such as his frontispiece to the April 1917 number of *I Novissimi*, which was devoted to the Ballets Russes. A linocut of the Ukrainian dancer Zais Galitzky was published in Anton Giulio Bragaglia's Roman journal *Cronache d'Attualità* on 30 July 1916. Two years later, Prampolini provided twelve photo-engravings and woodcuts to illustrate Bragaglia's *Territori Tedeschi in Roma*. His two woodcuts in the Parisian journal *Sic* of 1917 related to his scenery and costume designs for its editor Pierre Albert Birot's *Matoum et Tévibar*, which was performed at the Teatro dei Piccoli in Rome in 1919. A woodcut by Prampolini was published in Zurich in *Dada No 2* in December 1917, and he provided two further woodcuts as covers for the November and December issues of the New York journal *Broom, an International Magazine of the Arts*. Four woodcuts were made between 1917 and 1920 for *Noi*. A further three prints intended for *La Brigata* were never published. Other prints appeared in *Avanscoperta*, *Le Pagine*, the French periodical *Les Lettres Parisiennes*, and *Atys*, an Anglo-Italian journal founded by the English writer Edward Storer (1882–1944) and the American artists Myron Nutting (1890–1972) and A. Wallace. A small group of individual woodcuts of architectural subjects by Prampolini is also known. Apart from a single lithograph made for *Neue Europäische Graphik*, the 1922 Bauhaus portfolio of prints by Italian and Russian artists, Prampolini appears to have abandoned printmaking until May 1950, when he made a lithograph for *Forma 2*, no. 1, which was printed by Roberto Bulla in Rome and published by Edizioni Age d'Or, This publication also included lithographs by Capogrossi and Mino Guerrini (born 1927). Prampolini executed at least one screenprint (no. 81).

BIBLIOGRAPHY
Very little has been published on Prampolini's prints. The fullest overall account of his career is provided by the exhibition catalogue *Prampolini dal Futurismo all'Informale*, Palazzo delle Esposizioni, Rome, 1992.

Marino Marini 1901–80

81 (see colour page 50)

UNTITLED

1955

Screenprint 253 × 361 signed in pencil,
and inscribed *36/100*

2003-6-30-68

Presented anonymously, 2003

This may have been Prampolini's last print
and his only screenprint. Stylistically it
derives from his cosmic abstraction of the
mid-1930s. It was published in Rome in an
edition of 100 by Edizioni dell'Art Club in a
portfolio of screenprints, *Arte astratta ital-
iana, 14 serigrafie*, with an introduction by
Michelangelo Conte and Filiberto Menna.
The other artists represented were Afro,
Giacomo Balla, Michelangelo Conte
(1913–96), Dorazio, Józef Jarema (born
1900), Magnelli, Luigi Moretti (1907–73),
Munari, Gualtieri Nativi (1921–99), Achille
Perilli, Mario Radice (1900–87), Severini and
Soldati. A second portfolio, *16 serigrafie dei
maestri dell'arte astratta*, published by the
journal *Art d'Aujourd'hui*, was exhibited as
the ninetieth exhibition of the Art Club di
Roma at the Galleria La Cassapanca in Rome
from 3 to 9 January 1955.

Born in Pistoia, Marini began studying paint-
ing with Galileo Chini (1873–1956) at the
Accademia di Belle Arti in Florence in 1917.
He made his first intaglio prints c.1920, after
receiving instruction from Celestino Celestini
(1882–1961). Many of his earliest plates are
now lost. Marini studied sculpture in 1923
with Domenico Trentacoste (1859–1933), but
for the next twenty years painting was at least
as significant for him as sculpture. He found
inspiration in Roman and Etruscan statuary,
in the work of Arturo Martini, and in Tuscan
Quattrocento sculpture. Marini often visited
Paris in the 1920s, where he met Picasso,
Laurens, Braque, Lipchitz and Maillol. In
1929 Arturo Martini was responsible for his
appointment as his successor at the Scuola
d'Arte di Villa Reale in Monza, a post which
he held until 1940, when he became Professor
of Sculpture at the Accademia di Brera in
Milan. Marini's work was notable for its refer-
ences to the antique, whether in his series of
sculptures devoted to the horse and rider, in
his nudes or in his portraits. His figures
were always serene and static.

At the outbreak of war, Marini moved
to Locarno in Switzerland, where he
became friends with the sculptors Alberto
Giacometti, Felix Wotruba and Hermann
Haller (1880–1950), and met Germain
Richier. The events of the war profoundly
affected him, and as early as 1943 a note of
harshness and anguish entered his work. For
the rest of his career, there is a tragic feeling
in his riders, who appear to be wounded or
stricken with terror. Marini's sculpture
acquired an angularity, which has been
attributed to the influence of Cubism. He
certainly studied Picasso's *Guernica* with
great attention.

Marini made his first lithographs, a group
of forty, between 1943 and 1945, a period
when he made just three etchings. He worked
with the Stamperia Salvioni in Bellinzona in
1943, and with J.C. Muller in Zurich from
1944 to 1945. Marini's main subject in these
prints was the female nude. Between 1946
and 1950, he made no further lithographs,
but he returned to etching. Prints such as
The hanged man made explicit references to
the horrors of war. In 1951 Marini began
working with the Parisian lithographic print-

er Mourlot, and the Curt Valentin Gallery in
New York started to publish his prints. The
previous year, he had visited New York for an
exhibition at that gallery, where his sculpture
was extremely well received. He also worked
with a series of Swiss dealers and publishers,
Gérald Cramer, Nesto Jacometti and
Klipstein and Kornfeld, as well as Wolfgang
Ketterer in Munich, Berggruen in Paris and
Toninelli Arte Moderna in Milan. Marini used
the Zurich-based Kratz and Emil Mathieu as
alternative printers to Mourlot. Selections of
his etchings were published by Crommelynck
Frères in Paris, Propyläen Verlag in Berlin
and Graphis Arte in Livorno. In all Marini
made 236 etchings and aquatints, 163 litho-
graphs and three screenprints.

BIBLIOGRAPHY
The fullest catalogue of Marini's prints is Giorgio
Guastalla and Guido Guastalla, *Marino Marini cata-
logo ragionato dell'opera grafica (incisioni e
litografie)*, Livorno, 1990, of which an English-
language edition was published in New York in
1993. His sculpture has been catalogued by Giovanni
Carandente, *Marino Marini: catalogo ragionato
della scultura*, Milan, 1998, while his paintings have
been published by Lorenzo Papi, *Marino Marini:
paintings*, Johannesburg, 1989.

82

THE ANNUNCIATION

1958
Etching 354 × 297 signed and numbered
H.C. V/XV in pencil
Guastalla and Guastalla A57
2003-6-30-17
Presented anonymously, 2003

This etching was printed in Paris by Atelier
Lacourière, and published by Gualtieri di San
Lazzaro's *XXe Siècle* in Paris, and Léon
Amiel in New York, as plate IX of twelve in
Album no. 1. The prints were of various
dates. Di San Lazzaro provided the accompa-
nying text. The same two publishers issued
ten of Marini's etchings, *Tout près de
Marino*, in 1971, and three other portfolios
of his lithographs, *From color to form*,
Chevaux et cavaliers and *Personnages du
Sacré du Printemps*. Amiel (died 1988) often
worked with Parisian printers and publishers,
and is particularly known for his collabora-
tions with Chagall, Dalí, Ernst, Miró and
Man Ray.

83 (see colour page 51)

THE IDEA OF THE HORSEMAN

1968
Colour lithograph on heavy Japanese paper
650 × 500
Guastalla and Guastalla L90
1997-1-19-12
Purchased, 1997

This lithograph was printed in Zurich by
Emil Mathieu, and published in spring 1969
in the portfolio *Europäische Graphik* by
Galerie Wolfgang Ketterer in Munich, and by
Felix H. Man in London in an edition of
sixty-five.

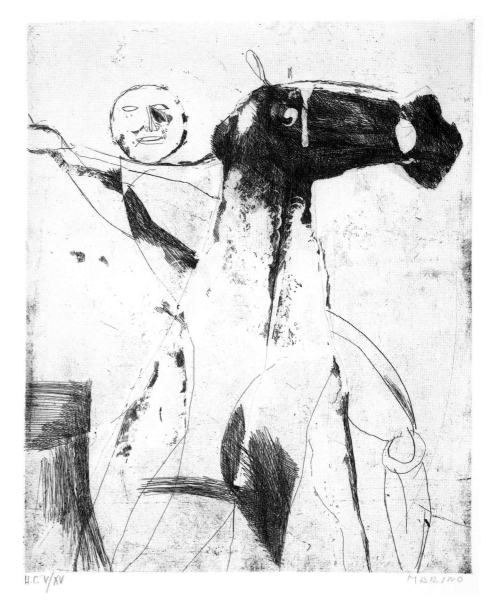

Zoran Anton Musić 1909–2005

Born in Gorizia, then part of the Austro-Hungarian empire, Musić made several short visits in the 1920s to Vienna, where he saw paintings by artists associated with the Secession. He also encountered work by the French Impressionists in Prague. Musić studied at the Zagreb Academy of Arts from 1930 to 1935 with a pupil of Franz von Stuck and with Ljubo Babić, who encouraged him to visit Spain. His stay there in 1935 introduced him to the works of El Greco and Goya. Musić also studied Pieter Bruegel's famous painting *The triumph of death*, in which the landscape is studded with armies of skeletons. On his return, Musić began painting the bare low hills of the Karst (Carso) plateau, close to the Dalmatian coast in present-day Slovenia. The arid wind-worn landscape was to provide motifs for his art throughout the rest of his career. After Italy occupied Dalmatia and Slovenia during the war, Musić in 1943 visited Venice, where he met the painter Guido Cadorin (1892–1976) whose daughter, also a painter, Ida Barbarigo (born 1925), he was to marry in 1947. When the Germans invaded Italy in 1944, the Gestapo accused him of collaboration with anti-Nazi groups and arrested him, interning him in Dachau. Musić made a series of drawings there, recording concentration-camp life, and his experiences of 1944–5 later led to a horrifying series of paintings, prints and drawings, *We are not the last*, on which he worked between 1970 and 1976.

After liberation, Musić settled in Venice, where he painted self-portraits and horses in oils, and gouaches and watercolours of the city, all recurrent subjects in his art. Throughout his maturity he worked in series. In 1948 he discovered the rounded hills around Siena, which provided motifs akin to the landscape of the Karst. Musić's earliest prints were all drypoints, of which he made twenty-two between 1947 and 1949, which he printed on his own press. He was particularly attracted to the technique by its kinship with drawing, and by its directness and purity. 'One cannot cheat', Musić wrote. That year he made his first etching and his first lithograph. Musić made twenty-two lithographs between 1949 and 1953. For these, he worked for the Swiss publishers Arta Stiftung der

Kunstfreunde and Johann Edwin Wolfensberger's Wolfsberg Verlag, both in Zurich, and Pierre Cailler's Guilde de la Gravure in Geneva. Wolfensberger and Emil Mathieu were his printers. He frequently stayed in Zurich and Basel with Piero Cadorin, his brother-in-law. The award to Musić in 1951 of the Prix Paris, organized by the Centre Culturel Italien de Paris, enabled him to go to the French capital, where he had his first major one-man show, organized by Gildo Caputo and Myriam Prevôt, at the Galerie de France in 1952. That gallery offered Musić a contract, and he began to divide his time between Paris and Venice. His paintings became more abstract in response to the predominant style of the Ecole de Paris, although they always retained a basis in nature. In 1955, Musić started to make etchings with the Atelier Lacourière. The subjects of his paintings and prints were drawn from the Dalmatian landscape. Among his publishers were Nesto Jacometti and Klippenstein. In 1961 Musić started to spend his summers regularly at Cortina in the Dolomites. Twenty-five years after his release from Dachau, he was finally able to his unleash his memories of that terrifying experience in *We are not the last*. A first set of sixteen etchings was printed by Lacourière et Frélaut in 1970. In 1974 Cerastico in Milan published *Cadastre de cadavres*, seven lithographs, which had been printed in Paris by Desjobert. A further seven drypoints, *Coffret. Nous ne sommes pas les derniers*, made in 1975, were printed by Lacourière et Frélaut, and published only in 1991, with a text written by Musić himself in 1948, which he had amended in 1980. In addition, eight separate drypoints were printed in 1975 by Atelier Leblanc in Paris. In the last thirty years of his life, Musić returned to calmer themes, rocky landscapes, views of Venice, the dark interiors of churches, and self-portraits and double portraits of himself and his wife. He also turned to the subject of the nude in lithography. Hervé Bordas estimates that Musić made over four hundred prints in all.

BIBLIOGRAPHY
Rolf Schmücking's incomplete catalogue, *Zoran Music, das graphische Werk 1947–1981*, Galerie

Schmücking, Basel, 1986, records 241 prints by the artist made up to 1981. Some of his more recent prints of Venice were published in Margaret MacDonald and Joan Ramon Escriva, *James Whistler. Zoran Musić. Venecia*, IVAM, Valencià, 2005. Other works unrecorded by Schmücking are published in *8. Zoran Musić*, Galerie Bordas, Venice, 2004. The prints made in response to his wartime experiences have been the subject of the exhibition *Nous ne sommes pas les derniers. Cycle gravé de 1970 à 1975 par Zoran Music. Eaux-fortes, lithographies, pointes sèches*, Musée Goupil, Bordeaux, 1995, and his paintings were shown in *Zoran Music*, Galerie Nationale du Grand Palais, Paris, 1995.

84 (see colour page 52)

BOATS AT PELLESTRINA

1957
Colour etching and aquatint in caramel brown and black ink 526 × 416 signed and numbered *4/75*
Schmücking 66
2001-1-28-15
Presented anonymously, 2001

This aquatint was printed and published in Paris by Atelier Lacourière in an edition of seventy-five. The island of Pellestrina is one of the spits of land, just south of the Lido, between the Adriatic and the Venetian lagoon. Musić repeated the composition in another aquatint of 1958 (Schmücking 72).

85 (see colour page 53)

ISTRIAN EARTH

1959
Colour etching and aquatint in red-brown and black ink 409 × 565 signed, dated and numbered *7/75*
Schmücking 77 (a)
2001-1-28-16
Presented anonymously, 2001

This aquatint was printed and published in Paris by Atelier Lacourière in an edition of seventy-five. Sovereignty of the Istrian peninsula is divided between Italy and Slovenia.

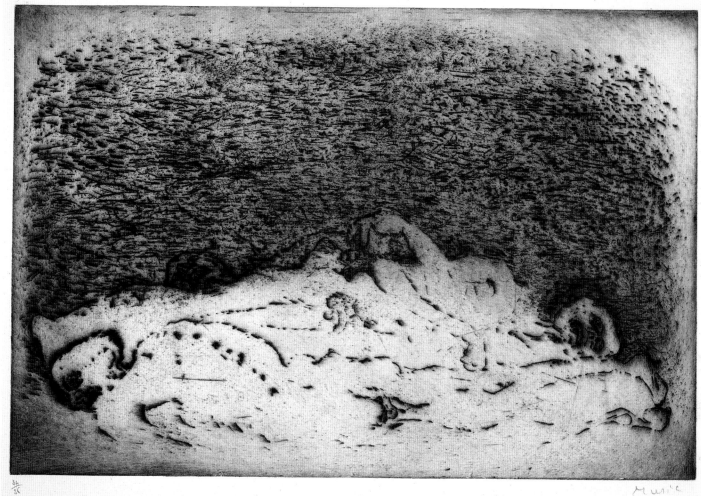

86

WE ARE NOT THE LAST

1973
Etching 348 × 525 signed and numbered
34/36 in pencil, and inscribed *R.J.* (?)
Not in Schmücking
2001-1-28-19
Presented anonymously, 2001

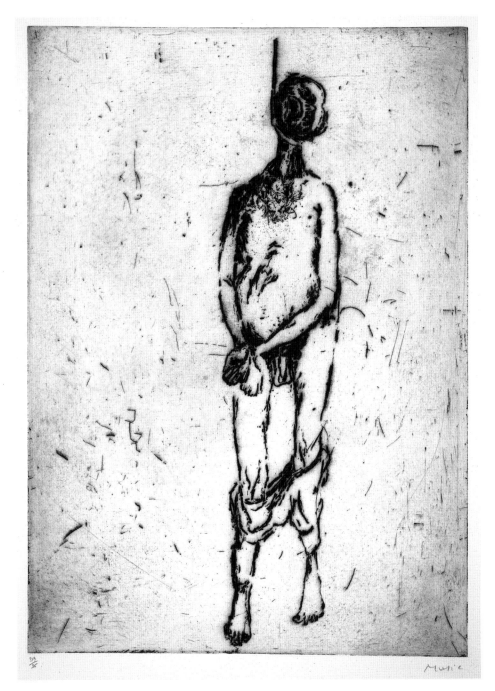

87

WE ARE NOT THE LAST

1973
Etching 563 × 408 signed and numbered
29/36 in pencil, and inscribed *R.P.*
Schmücking 201
2001-1-28-18
Presented anonymously, 2001

Both etchings were printed at Atelier
Lacourière in Paris. Musić's extraordinarily
moving descriptions of the horrors of
Dachau, based on the drawings that he
made in the camp in 1944 and 1945, can
be compared with the prints of Goya.

Afro 1912–76

Born in Udine, he was the youngest of three brothers in the Basaldella family, all of whom became artists. Both he and the second of his brothers, the sculptor Mirko (1910–1969), dropped their surnames to avoid confusion with their elder brother, Dino (1909–1969), another sculptor. From 1926 to 1931, Afro studied at the Liceo Artistico in Florence, as well as with his brother Dino. He met Scipione and Mario Mafai in Rome in 1929, and, when he returned there in 1933 after his first one-man show at Milan's Galleria del Milione, his figure paintings and still lifes were in the vigorous style practised by the Scuola Romana. Afro had become friends in Milan with Renato Birolli and Ennio Morlotti (1910–92), two of the leaders of the rebellion against the prevalent classicism of the Novecento group. Corrado Cagli was the most significant influence on his paintings of the 1930s. It was during this period that Afro made his first prints, a group of traced monotypes dating between 1938 and 1943. He may have learnt the technique made famous by Klee on a visit to Paris in 1938, where he particularly studied the colour effects achieved by the Impressionists. The subjects were still lifes, portraits and studies of models.

In 1941 he was appointed Professor of Mosaic at the Accademia di Belle Arti in Venice. His designs for the mosaics of the Palazzo dell'EUR show a growing interest in Cubism. By the end of the 1940s, Afro's work had become fully abstract, in a style derived from Braque and Klee. He contributed two lithographs to *24 litografie originali*, the fourth album of prints published by M.A.C. in 1949. Afro, however, made no other contribution to this group. In 1949 he made the first of many visits to the United States, where the following year he had a one-man show at Catherine Viviano's New York gallery. Viviano went on to give Afro an exhibition every two years until 1969. Afro also taught at Mills College, Oakland, California, in 1954. Among Italian painters, he was one of the closest to the Abstract Expressionists. The work of Franz Kline, Willem de Kooning and Arshile Gorky, in particular, attracted his interest. In 1957, Afro wrote the introduction to Gorky's one-man show at the Galleria

dell'Obelisco in Rome, the American's first exhibition in the city.

Afro returned to lithography for the frontispiece to the catalogue for his own exhibition at that gallery in April 1953. There followed a sporadic engagement with the medium. All his prints of this period were printed in Rome by Enrico Castelli, and most were published by him. These lithographs were exhibited in the show *Afro Opera grafica* at the Galleria Schneider in Rome in 1961. In 1964, Afro began working with the Swiss lithographic printers and publishers Erker Presse in Sankt Gallen. He made his first etching in 1964, and, two years later, began to work with Renzo Romero's Grafica Romero in Rome. Afro turned to aquatint in 1968–9, and the vast majority of his later prints were etchings or aquatints. Thirty-three of his prints date between 1970 and 1975. In 1970, Afro began working with Valter Rossi at the Stamperia 2RC in Rome, initially making lithographs, but he soon reverted to aquatint, making twenty-seven of them there. A major exhibition, *Afro Opere grafiche 1970–1974*, was held in 1974 at the Galleria San Luca in Bologna and the Galleria 2RC in Rome, which was accompanied by a catalogue written by Nello Ponente. During the 1970s, Afro's style moved away from Abstract Expressionism. The areas of flat colour in his later aquatints paralleled the near contemporary screenprints of Alberto Burri.

BIBLIOGRAPHY
Enrico Crispolti, *Afro Catalogo ragionato delle incisioni e litografie*, Milan, 1986, records eighty-two prints made by Afro between 1954 and 1976. However, he includes neither the artist's monotypes nor his earliest lithographs. For Afro's paintings, there is *Afro. Catalogo generale ragionato*, Rome, 1997. The exhibition *Nel segno di Afro Basaldella. Il giovane Afro. Ricerche, confronti e affinità*, Galleria d'Arte Moderna, Udine, 2006, included a selection of his monotypes.

88 (see colour page 54)

UNTITLED

1949
Lithograph 320 × 220
1989-7-22-3 (2)
Purchased, 1989

This is one of the two prints that Afro published in the portfolio *24 litografie originali*, which was published in an edition of 250 by Salto Editore in Milan in October 1949, the fourth album of prints to be issued by M.A.C. (Movimento Arte Concreta). The portfolio consisted of two lithographs apiece by twelve artists, and was accompanied by a text in Italian and in French written by Giulio Carlo Argan. The other contributing artists were Lanfranco Bombelli Tiravanti (p. 175), Enrico Bordoni (p. 176), Gillo Dorfles (p. 177), Lucio Fontana (no. 98), Augusto Garau (no. 92), Max Huber (p. 178), Galliano Mazzon (no. 93), Gianni Monnet (p. 180), Bruno Munari (no. 94), Atanasio Soldati (no. 95) and Luigi Veronesi (p. 183). This copy of the portfolio is no. 178. The other prints from this portfolio which are included in this exhibition are recorded after the biographies of the individual artists, which are arranged in alphabetical order below (pp. 173–86). Afro's two prints may have been his earliest lithographs. Stylistically they are indebted to post-war Parisian cubism, and reveal an interest in the abstracted figurative sculpture produced by several young artists in France in the late 1940s. He soon abandoned work in this style.

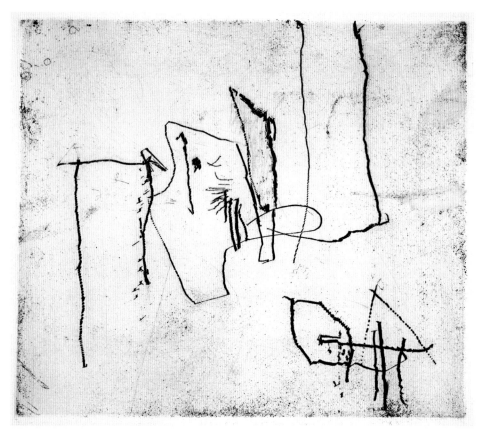

89

UNTITLED 4

1964
Etching 200 × 240
Crispolti 25
2005-6-29-5
Presented anonymously, 2005

Afro's first etching was commissioned as a
fundraising exercise by the Associazione
Nazionale per l'Assistenza agli Spastici.
It was printed by Il Bisonte in Florence, and
published by Galleria Grafica Contemporanea
in an edition of 102. Afro may well have
known the work of the American Abstract
Expressionist painter Cy Twombly, who
settled in Rome in 1957.

90 (see colour page 55)

FOR MAN

1966
Colour lithograph 382 × 537
Crispolti 33
1997-1-19-10
Purchased, 1997

Printed in Rome by Caprini, with whom Afro
worked on several lithographs until 1969, this
lithograph was published by Galerie Wolfgang
Ketterer in Munich and Felix H. Man in
London in the album *Europäische Graphik
III* in an edition of 125. There were also
twenty-five artist's proofs and five printer's
proofs. Afro made an aquatint variant of this
composition, also titled *For Man*, which was
printed by Grafica Romero in Rome, and
published by Renzo Romero in an edition of
seventy.

Lanfranco Bombelli Tiravanti born 1921

Usually known as Bombelli, Bombelli Tiravanti was born in Milan, the son of a lithographic printer and a Swiss mother. As a young man, he frequented the Galleria del Milione. With a few friends, he founded the journal *Il Balcone*, and published monographic studies on the architects Antonio Sant'Elia, Richard Neutra, Frank Lloyd Wright and Ludwig Mies van der Rohe. Bombelli began to study architecture at the Politecnico in Milan in 1940, but in 1942 he enrolled as a marine cadet in the Accademia at Livorno. On the German invasion of Italy in 1944, he fled to Switzerland, where he resumed his architectural studies at the Federal Polytechnic in Zurich. Bombelli quickly became closely associated with the Allianz group of artists, designers and architects, which had been founded in 1937. He owed his introduction to the Swiss artist Max Huber, who before the war had been studying graphic design in the studio of Boggeri in Milan. Crucial for Bombelli's development was his meeting with Max Bill, whose work was already familiar to him through the international journals on contemporary art which he had consulted in the Castello Sforzesco. They became lifelong friends, and they collaborated on designing a building. Other leading artists in the Allianz group who practised Concrete Abstraction included Camille Graeser, Leo Leuppi, Verena Loewensberg and Richard Lohse. The formative sources of their art lay in the Bauhaus and De Stijl, as could be seen in *Konkrete Kunst*, the important exhibition organized by Bill in Basel in 1944, which included work by Klee, Kandinsky, Vantongerloo, the Arps and Mondrian. During his time in Switzerland, Bombelli was also in touch with the Geneva-based architect Ernesto Nathan Rogers, and M.S.A. (Movimento Studi per l'Architettura), a group of Milanese architects who played a significant role in the reconstruction of Italy after the war.

On his return to Italy, with the help of Huber and Max Bill, Bombelli was the principal organizer of the major international exhibition *Arte astratta e concreta*, at the Palazzo Reale in Milan in 1947. A founder member of M.A.C. (Movimento Arte Concreta), he contributed two lithographs to *24 litografie orig-*

inali, the fourth of its portfolios of lithographs. These prints were strongly influenced by Bill. Bombelli shared an exhibition of tempera paintings with Max Huber, which was organized by M.A.C. at the Libreria A. Salto in 1950, and contributed a drawing to its journal, *Arte Concreta 1950–1951*. He also exhibited at the Salon des Réalités Nouvelles in Paris between 1948 and 1950. In 1949, Bombelli's father published a portfolio of lithographs, which included his son's work alongside that of Munari, Huber and Veronesi.

In 1950, however, his direct involvement in Italian art came to a halt when he formed a partnership with the American architect Peter Harnden. Their practice, based initially in Paris, lasted twenty-two years. They were principally employed in designing buildings for the American government, which were funded by the Marshall Plan. In 1962, Bombelli established a studio in Barcelona and bought a house there. In 1973, two years after the death of Harnden, he founded the galería cadaqués, which quickly became one of Spain's liveliest print publishers. The works of Swiss and Italian abstract artists were regularly exhibited and published by Bombelli, alongside Spanish artists. The gallery's very first album of screenprints, issued in Harnden's memory, included work by Huber, Lohse and Munari, as well as one of Bombelli's own prints. Two years later, he published a portfolio of eleven screenprints by Munari. Bombelli also published prints by Antonio Calderara (1903–78) and Giuseppe Santomaso. Other Italian artists he exhibited were Domenico Gnoli (1933–69), Elsa Peretti (born 1940), Vittorio Stoppa and Francesco Volsi. The Englishman Richard Hamilton was shown more often than any other artist, and Bombelli published several of his prints and multiples. His interests extended to exhibiting work by Tàpies, Frank Stella, Mel Ramos, Joseph Beuys, R.B. Kitaj, Claude Viallat and John Cage. The last publication of the galería cadaqués, issued in 1997, the year of its closure, was a tribute to Max Bill, a portfolio that included screenprints by Bill's son, Jakob, and Bombelli himself, together with a lithograph by François Morellet, and prints by two other artists.

BIBLIOGRAPHY
There is no monograph on Bombelli Tiravanti. Giorgio Maffei, *M.A.C. Movimento Arte Concreta*, Milan, 2004, discusses his early career. His activity as a print publisher was the subject of the exhibition *galería cadaqués (1973–1997)*, Museo National Centro de Arte Reina Sofía, Madrid, 2004.

Enrico Bordoni 1904–69

Born in Altare near Savona in Liguria, Bordoni studied engineering in Genoa for two years, before turning to painting. In 1931, he moved to Florence, where he worked in the theatre with Max Reinhart, Jacques Copeau and Giulio Salvini. On his return to his home town in 1935, he staged a series of open-air theatre performances. Bordoni also worked in the field of decorative arts. A set of glasses designed for Sandro Bormioli won him a prize at the sixth Milan Triennale in 1936. The subjects of his pre-war paintings were Florence, the Tuscan landscape and still lifes. Bordoni spent the war in Monferrato, and in 1945 began teaching at the Accademia di Belle Arti in Milan, where he was to remain for eighteen years.

His transition to abstraction has yet to be charted, but it is likely that a visit to Paris was significant for him. His paintings of 1949–50 have strong black outlines that recall the contemporary work of Atlan. Bordoni was a founder member in 1948 of M.A.C. (Movimento Arte Concreta), of which he served as President from 1957 to 1958. His paintings were often close-toned and were filled with chiaroscuro in a style that can be compared both with CoBrA and with the constructivist tradition. In the 1950s, Bordoni's pictures became more sculptural and filled with overlapping cut-out shapes painted in single colours. His zoomorphic *figure dentate* can be seen as brutalized Arps.

On the closure of M.A.C. in 1958, Bordoni became one of the first Italian artists to produce monochrome paintings, in black or white, or bichrome black and white. These he called *Arkè*. Bordoni moved closer to Art Informel, before, in 1961, he began to combine upright bands of raised or incised patterned decoration with areas of a single matt acid or candied colour. This use of relief has been compared with the work of the Stuttgart painter Werner Schreib (1925–69). The elements of the decoration, circles, squares and oblongs, appear to derive from Jugendstil, in particular from the paintings of Klimt. Among his contemporaries, Bordoni can be compared with the Austrian Hundertwasser, and for his increasing interest in raw material with Burri. In 1963 he became a Professor at the Accademia di Belle Arti in Florence. There, his major work was inspired by the flood that inundated the city in 1966.

As a printmaker, Bordoni made etchings, lithographs, woodcuts and screenprints. It is likely that he had made some prints before he produced a set of ten lithographs for the second album published for M.A.C. in 1949 (no. 91). Later the same year, Bordoni also contributed two lithographs to M.A.C.'s fourth album *24 litografie originali*. In 1950 one of his lithographs was published in France in an album, which also included work by Estève, Birolli, Gischia, Lapicque, Bruno Cassinari (1912–92) and Morlotti. Bordoni designed a plate for the double issue of the M.A.C. journal *Arte Concreta* 16 and 17 of October–November 1952, and three more for *Sintesi delle Arti*, the joint publication of M.A.C., and the French group Espace. Four of his lithographs and six screenprints appeared in the 1955–6 and 1956–7 issues of another M.A.C. periodical, *Documenti d'Arte d'Oggi*, respectively. A further lithograph was included in Alberto Oggero, *Antitesi*, Libreria A. Salto, Milan, in 1956, which was another M.A.C. venture. Salto Editore also published a further portfolio of five Bordoni lithographs with an introduction by Gillo Dorfles, which was not a M.A.C. project. His boldest prints were a set of six colour woodcuts published by Galleria del Grattacielo in Milan c.1958. At least one of these shares the same composition as a contemporary painting. The Galleria del Grattacielo gave Bordoni one-man shows in 1959, 1962, 1967 and 1969.

BIBLIOGRAPHY
There has been no publication on Bordoni's prints. For his career as a whole there is Giulio Carlo Argan and Gillo Dorfles, *Enrico Bordoni*, Palazzo Strozzi, Florence, 1973. Further information can be found in N. Corradini s.v. Bordoni in K.G. Saur, *Künstlerlexikon*, XIII, Leipzig, 1996. This complier has not seen Raffaello Franchi, *Enrico Bordoni pittore*, Florence, 1942.

91 (see colour page 56)

UNTITLED
FROM 10 LITOGRAFIE ORIGINALI

1949
Colour lithograph 350 × 230 signed
1989-7-22-2 (5)
Purchased, 1989

This, the second portfolio of prints to be published in Milan by Salto Editore for M.A.C., was the first to be devoted to a single artist. It was published in an edition of fifty and was accompanied by a text by Gillo Dorfles. The lithograph exhibited is the fifth in the portfolio. Bordoni also contributed two lithographs to the *24 litografie originali*, the fourth album of prints to be published by Salto Editore for M.A.C.

Gillo Dorfles born 1910

Augusto Garau born 1923

Born in Trieste, Dorfles studied medicine in Milan and Rome, specializing in psychiatry, before turning to art. After attending a Rudolf Steiner conference at the Goetheaneum, Dornach, in 1934, he began painting canvases influenced by anthroposophic thought. Dorfles had seen work by Klee and Kandinsky in Berlin and Dresden. His pictures of 1935–40 featured grotesque ghostlike figures and masks, alongside slithering snakelike forms, often painted in acidic yellows, browns and purples. Dorfles probably knew the work of Ensor. Throughout his career, Dorfles's art has been akin to what was later labelled 'outsider art'. Automatism and other Surrealist elements entered his work in the 1940s. Dorfles was also interested in the work of Kupka and Delaunay. He had been writing criticism since the early 1930s, and among the artists on whom he wrote sympathetically were Wols, Michaux and Matthieu. Dorfles also explored the connections between Zen Buddhism and Western calligraphy.

In 1949, Dorfles was a founder member with Monnet, Munari and Soldati of M.A.C. (Movimento Arte Concreta), and its chief theorist. He had one-man shows in Milan at the Libreria Salto in 1949 and 1950, and contributed works to many M.A.C. group shows. In 1949 Dorfles wrote the introductions to the portfolios of lithographs by Enrico Bordoni and Luigi Veronesi which were published by Libreria Salto for M.A.C. He regularly published prefaces in M.A.C.'s *Arte Concreta* for the exhibitions of Mazzon, Munari, Monnet, and for many other one-man shows held by the group, as well as for the group's exhibitions at the Galleria Bompini in 1951 and in Argentina in 1952 and 1954. In the latter year, Dorfles became part of the Italian section of the Groupe Espace together with Munari, Alvaro Monnini (1922–98), Mauro Reggiani and Veronesi. His work in the early 1950s was in a lyrical abstract style influenced by Kandinsky.

Dorfles has also been very active as an art critic for well over seventy years, and it is in this field that he has achieved his highest reputation. Among the large number of journals to which he has contributed are *Rassegna d'Arte*, *Le Arti Plastiche*, *La Fiera*

Letteraria, *Il Mondo*, *Aut Aut*, *The Studio* and *The Journal of Aesthetics*. Dorfles was particularly associated with *Domus*, of which he was Vice Director. He taught aesthetics at the Universities of Milan, Trieste and Cagliari. From the late 1950s, Dorfles largely abandoned painting for criticism. He has written on aesthetics, art, sociology, design and costume history, as well as on contemporary art and architecture. When he returned to painting in the 1980s, his pictures included amoeba-like forms. Dorfles is still painting today.

Dorfles contributed a print to M.A.C.'s first album, *12 stampe a mano*, published by Salto Editore in 1948, and two lithographs to *24 litografie originali*, its fourth portfolio published in 1949. Two of his linocuts appeared in M.A.C.'s journal *Documenti d'Arte d'Oggi* in October 1954. It was projected that he would provide two further linocuts with Monnet and Veronesi for M.A.C.'s ninth portfolio of prints. However, it appears that this album was never published. Dorfles began making monotypes in 1951, at first using acrylic, before turning first to oils in 1954, and then, from 1955, employing a mixed technique. A group of them were exhibited at the Gallery Wittenborn in New York in 1955. This exhibition was followed by shows of monotypes and 'bitypes' at the Libreria San Babila, Milan, in 1957, and of monotypes alone at the Galleria Spaziotemporaneo, Milan, in 1989. Monotype has remained his preferred method of printmaking.

BIBLIOGRAPHY
There is no publication on Dorfles's prints. One of his most recent exhibitions was *Gillo Dorfles: il pittore clandestino*, Padiglione d'Arte Contemporanea, Milan, 2001. His *Itinerario estetico*, Pordenone, 1987, includes a bibliography of his writings between 1930 and 1986. The author has not seen Gillo Dorfles and Flavio Puppo, *Dorfles e dintorni*, Milan, 2005.

Born in Bolzano, Garau was trained at the Accademia di Brera in Milan, where he studied with Francesco Messina and Achille Funi. He was the youngest member of M.A.C. and a very close friend of Atanasio Soldati. Garau's work was included in the important exhibition *Arte astratta in Italia*, organized by the Art Club in the Galleria di Roma in 1948. The Galleria Salto, which was closely associated with M.A.C., gave him his first one-man show in 1949. His works were then abstract. The Milanese Galleria Bergamini, the Galleria Bianchi in Gallarate and the Negozio Lagomarsino in Pavia all gave Garau one-man exhibitions in 1952. Gianni Monnet wrote the introduction to the catalogue for this last show, *Opere concrete di Garau*, as well as to that for an exhibition of his ceramics at the Studio b24 in Milan the following year. Eventually, Garau turned to figurative painting. His one London exhibition, at the St Martin's Gallery in 1964, was of expressionist nudes. Garau taught colour theory and psychology at the Politecnico di Disegno in Milan, and published *Le armonie del colore* in Milan in 1984 (translated into English by Nicola Bruno as *Colour harmonies*, Chicago and London, 1993), and *Dinamiche del colore e della forma*, 1997.

BIBLIOGRAPHY
Very little has been published on Garau. He had a one-man show at the Civica Galleria d'Arte Moderna, Gallarate, in 1983. The best source for his prints is Giorgio Maffei, *M.A.C. Movimento Arte Concreta Opera Editoriale*, Milan, 2004.

92 (see colour page 57)

UNTITLED

1949

Colour lithograph 326 × 230

1989-7-22-3 (11)

Purchased, 1989

This is one of the two lithographs that Garau contributed to the album *24 litografie originali*, published by Salto Editore, Milan, in an edition of 250, in October 1949, for M.A.C. (Movimento Arte Concreta). A lithograph by Garau was also included in the first of M.A.C.'s portfolios published by Libreria A. Salto Editore in an edition of thirty on 15 December 1948. Garau contributed a drawing to M.A.C.'s journal *Arte Concreta* published on 20 January 1952.

Born in Baar, Switzerland, Huber made his first prints and watercolours at the local school at the age of fourteen. He studied with Alfred Williman at the Zurich Kunstgewerbeschule, before joining the printing and publishing firm Conzett and Huber, best known as the publishers of the magazine *Du*. Huber had met both Max Bill and Hans Neuburg. So he was well versed in Bauhaus-inspired design by the time he moved to Milan in 1940. There, he worked as a graphic artist in the Studio Boggeri, while attending courses at the Accademia di Brera in the evening. He returned to Switzerland, when Italy entered the war. In 1942 he became a member of Allianz, the Zurich-based group of abstract artists and designers. It was there that he became a close friend of Lanfranco Bombelli Tiravanti. Huber went back in 1945 to Milan, where the publisher Giulio Einaudi placed him in charge of graphic design. With Bombelli Tiravanti, he was one of the key figures in the organization of the *Arte astratta concreta* exhibition in 1947 at the Palazzo Reale in Milan, for which he designed the cover to the catalogue and the poster. He contributed two lithographs to the 1949 M.A.C. portfolio, *24 litografie originali*. Huber's work was included in the exhibition *Opere concrete di 7 artisti milanesi*, shown in Turin and Lugano in 1950, as well as in two exhibitions of artists associated with M.A.C. at the Galleria Bompiani in Milan in 1951. For the rest of his career, he was one of Switzerland's most significant graphic designers, producing many notable posters and winning acclaim for his innovative typography. Huber's work is a major influence on the American painter Peter Halley. It is not known how many prints he made. Huber contributed a screenprint to *cadaqués portfolio one (In memoriam Peter Harnden)*, the first print publication issued by his friend Bombelli Tiravanti's galería cadaqués in Catalonia, which also gave him a two-person show with his wife, Aoi Huber Kono, in 1986. The Max Museo, opened in Chiasso in 2002, and the Fondazione Huber are devoted to his work.

BIBLIOGRAPHY

There is no publication devoted to Huber's prints, although Sigi Overmatt, 'Max Huber', *Baseline*, XLVI, 2004, pp. 13–20, discusses one of his most significant posters, and his work as a designer of book jackets and as an exhibition organizer. The compiler has not seen Max Huber, *Progetti grafici 1936–1981*, Milan, 1982, the articles 'Max Huber', *Creation (Japan)*, XVII, 1993, pp. 70–87 and 167, and Sergio Polano, 'Thinking through images: Max Huber', *Affiche*, IX, April 1994, pp. 46–51, or the monograph by Stanislaus von Moos, Maria Campana and Giampiero Bosoni, *Max Huber*, Oxford, 2006.

Galliano Mazzon 1896–1978

Born at Camisano Vicentino, Mazzon emigrated to Brazil with his family when he was a child. On his return to Italy, he served in the Italian army, and lost his right hand in the battle of Monte Santo in 1917. Mazzon attended the Accademia di Brera from 1920 to 1926. He founded his own school of painting for the young, the Scuola Mazzon, in 1929, an establishment which achieved fame beyond the borders of Italy. Mazzon challenged accepted academic methods, banning his students from copying from nature, and encouraging spontaneous expression of the emotions, fantasy, the imagination and dreams. He became friends with the dealer Gino Ghiringhelli and the critic Edoardo Persico, and frequented the Galleria del Milione in Milan from 1930. Mazzon painted his first abstract pictures in 1932–3. At this period, he was influenced by Surrealism. In 1934, he retired to a lonely Alpine hut in the Dolomites, where he spent five years studying Taoism in the aphorisms of the Chinese writer Lao Tze. In 1940, his interest in the Orient led him to publish an article on the influence of Japanese culture on the world for the Tokyo publisher Kokusai Bunka Chukka. Much later, in 1969, he published two volumes of philosophical reflections, *Quindici validi spirituali* and *Oltre la soglia*, which were followed in 1971 by *Canto del risveglio mistico omaggio alla memoria di Sissa Pagan*, which he illustrated with twelve of his drawings. Like many contemporaries in the 1930s, Mazzon developed an interest in *arcana*, which can be seen in his poetry, *Un mazzo di fiori per chi ama il loro segreto*, Milan, 1938, and *Come le stelle*, Milan, 1969.

During the Second World War, he suffered a deep depression and spent some time in an asylum in Varese. Mazzon taught at the Scuola Media Alfredo Panzani from 1945, when he began producing a series of drawings in ink and pastel, foreshadowing Art Informel. Mazzon was one of a group of Italian abstract artists to exhibit at the Salon des Réalités Nouvelles in Paris in 1947, and again from 1950 to 1952. In 1948, he was one of the founders of M.A.C. (Movimento Arte Concreta), and his prints were represented in the first and fourth albums of lithographs of the group published by Libreria A. Salto Editrice in 1948 and 1949. A show of his paintings at the Libreria in 1949 was accompanied by a preface written by Gillo Dorfles. A second exhibition, *Spontanee fantasie astratte infantili. Mostra di disegni*, was held there in 1950, followed by a related exhibition of work by his pupils at the Galleria Bompiani in Milan. In that year, he also published *Considerazioni dell'arte d'oggi*, Milan. In 1953, Mazzon abandoned abstraction for a lyrical and magical figurative style. He contributed two lithographs to the 1956–7 issue of *Documenti d'Arte d'Oggi*, a journal in which he also published some of his poetry. Mazzon's deep fear of the outbreak of a third world war led to a series of paintings of desolate and Expressionist visions begun in 1962. Two years later, he suffered a further breakdown and spent a spell in a clinic. On his recovery, Mazzon turned to lyrical abstraction. In 1968, a portfolio of six screenprints, accompanied by a text by Francesco Vincitorio, editor of *N.A.C.* (*Notiziario Arte Contemporanea*), was printed by Officina d'Arte Grafica A. Lucini e C. in Milan. *L'essenza dell'essere ovvero fuga di Galliano Mazzon verso gli altipiani*, his twelve-part *livre d'artiste* of 1972, is a sort of autobiographical expression of his philosophy of life. As editor of the first eighteen issues of the bulletin *Arte Concreta* between 1951 and 1953, Mazzon's wife, Giulia Sala, was also closely involved with M.A.C.

BIBLIOGRAPHY
Nothing has been published on Mazzon's prints. For his paintings, there is a monograph by Luigi Lambertini, *Galliano Mazzon*, Milan, 1977. Giorgio Maffei, *M.A.C. Movimento Arte Concreta Opera Editoriale*, Milan, 2004, provides very useful information on Mazzon's involvement in M.A.C.

93 (see colour page 58)

UNTITLED

1949
Lithograph 326 × 230
1989-7-22-3 (15)
Purchased, 1989

This was one of the two prints which Mazzon contributed to *24 litografie originali*, the album of prints published in an edition of 250 by Salto Editore, Milan, for M.A.C. Another lithograph by Mazzon was also included in the first of M.A.C.'s portfolios, which was published by Libreria A. Salto Editrice in an edition of thirty on 15 December 1948.

Gianni Monnet 1912–58

Born in Turin in 1912, Monnet studied architecture there. He began painting as a very young man, paying particular attention to the work of Bonnard and Matisse. In 1944, Monnet had his first exhibition, a survey show, at the Circolo Ticinese di Cultura in Lugano, of figurative and abstract paintings dating from 1929 to 1944. He settled in 1946 in Milan, where he taught at the Istituto Tecnico per Geometri, while maintaining close contacts with Switzerland, writing articles on contemporary art and architecture for the newspaper *Corriere del Ticino* and for the *Rivista Tecnica della Svizzera Italiana*. In 1948, Monnet was the principal figure in the foundation of M.A.C., and the organizer of the publication of its first portfolio of prints. The same year, he was included in *Arte astratta in Italia*, the exhibition organized by the Art Club at the Galleria di Roma. Gillo Dorfles wrote the preface to *Pitture concrete di Gianni Monnet*, his April 1949 one-man show at the Liberia A. Salto, which later that year presented some of his tempera paintings, together with the five lithographs from the album *Litografie originali di Monnet*, the third of M.A.C.'s portfolios of prints.

In 1951, Monnet became an early member of the French-based international group Espace. He exhibited in Paris at the Salon des Réalités Nouvelles from 1950 to 1952, and contributed to André Bloc's journal *L'Art d'Aujourd'hui*. He was one of the signatories of the *Manifesto dell'arte totale* at the Galleria Annunciata in Milan in 1952. Monnet shared a show of paintings with Galliano Mazzon at the Libreria Salto in October 1950, and his work was included in further M.A.C. group exhibitions at various venues virtually every year until 1958. It was a show of his pastels at the Libreria A. Salto in May 1958 that closed the exhibiting activity of M.A.C. Monnet also showed at the Galleria del Naviglio in Milan. He was a regular contributor of texts, drawings and collages to the periodical *Arte Concreta*, and wrote an article on the work of Albano Galvano and Filippo Scroppo in M.A.C.'s annual *Arte Concreta* of 1950–1. Among the artists Monnet wrote about were Mazzon, Munari, Garau and Soldati. He also wrote for that journal's successors, *Sintesi delle Arti* and *Documenti d'Arte d'Oggi*, for which he made two lithographs for the 1955–6 issue, and two linocuts for the 1956–7 issue. Alongside Dorfles, Veronesi and Munari, Monnet was one of the contributors to the journal *A. Arte d'Oggi*, originally called *AZ. Mensile d'Arte*, which ran from 1949 to 1952. He also wrote for several other journals, including *Epoca*, *Prospettive* and the Zurich-based *Graphis*. Among the subjects of Monnet's articles were Kandinsky, the birth of abstract art, Picasso and Chagall. One of his most important works was his design of *Enten Eller*, a publication of poems by Antonino Tullier, issued by M.A.C. in 1954. The following year, Monnet's *L'arte moderna dall'A alla Z*, illustrated by lithographs to his design, and with a cover that he designed jointly with Gillo Dorfles and Bruno Munari, was published by Libreria A. Salto for M.A.C. as part of the collection *Sintesi delle arti*. These three artists also designed the cover for the other volume in the collection, Alberto Oggero's *Antitesi* of 1956, which included twenty-four lithographs by Capogrossi, Fontana, Soldati, Veronesi and others. The ninth and last portfolio of prints listed as published by M.A.C. in 1957 was to include six linocuts by Gillo Dorfles, Luigi Veronesi and Monnet. However, no copy of this album has yet been found, which suggests that the project was never completed. The two lithographs that Monnet printed for Veronesi in 1957 and 1958 might be related to this project. Monnet also provided the cover of issue no. 6 of the Milan-based periodical *Serigrafia* in September 1957. His screenprint was defined as 'serigrafia a vellutazione'. Monnet's death in 1958 led to the dissolution of M.A.C.

BIBLIOGRAPHY
Very little has been written about Monnet. The best source of information is Giorgio Maffei, *M.A.C. Movimento Arte Concreta Opera Editoriale*, Milan, 2004.

Bruno Munari 1907–98

Born in Milan, Munari began work as a graphic artist in 1925. The following year he met Marinetti and became associated with the Futurist movement. Munari soon became deeply involved with book design, and it was in this field that he made some of his greatest contributions to art and design. He took up the mantle of Fortunato Depero. In 1934, he designed the cover and contributed eleven lithographs to Tullio D'Albisola's outstanding Futurist book *L'anguria lirica (Lungo poema passionale)*, published in Rome and Savona by Edizioni Futuriste di Poesia-Litolatta. As a sculptor, Munari was influenced by constructivism in his *macchine aeree* of 1930, which were followed in 1933 by his kinetic *macchine inutili*. This title probably reflects a temporary interest in Surrealism. Munari knew the mobiles of Calder, while Prampolini introduced him to the work of Vantongerloo and De Stijl. He also made animated cartoons. In 1935, Munari was inspired by Man Ray and Moholy-Nagy to experiment with photograms. These led eventually in the late 1940s and 1950s to his *negativi positivi*. Munari made ceramics with Tullio d'Albisola, and designed toy theatres for the 1936 Milan Triennale. The work of Herbert Bayer and the *Bauhausbücher* were important for his interest in radical innovations in typography and graphics.

After the war, Munari was very active as an industrial designer involved with mass production. His 1945 alarm clock, *X ora*, in which rotating half-disks replaced conventional hands, has been claimed as the earliest multiple, although it was not actually put into production until 1963. Also in 1945, his *Bruno Gigi cerca il suo berretto*, published by Arnoldo Mondadori, was illustrated by bold colour lithographs, each of which had a moveable flap that revealed another image beneath. This was a children's book, a field in which Munari made an outstanding contribution over the next forty years. At the same time, he produced *libri illegibili*, book objects that had no text. Their content consisted of geometric figures, transparent sheets, tracing paper, perforated, pierced and torn pages and rigid sheets of black or single bright colours. Munari also experimented with projecting light through plastic, and, in 1963, made a coloured-light film, *I colori della luce*, accompanied by electronic music. His post-war sculpture had affinities with the works of Arp and Gabo, while in its use of motors it prefigured Tinguely.

With Dorfles, Garau and Monnet, Munari was included in the 1948 exhibition *Arte astratta e concreta*, at the Galleria di Roma, and he was also a participant in *Arte astratta italiana e francese*, arranged by the Art Club at the Galleria d'Arte Moderna in 1953. He exhibited with Salon des Réalités Nouvelles in Paris in 1951. Munari had no fewer than four exhibitions under the aegis of M.A.C. between 1949 and 1955. It was in the pages of the group's journal, *Arte Concreta* 10, 1952, that he published his *Manifesto del macchinismo*, *Manifesto dell'arte totale*, *Manifesto del desintegrismo* and *Manifesto dell'arte organica*. Munari contributed a screenprint to M.A.C.'s journal *Documenti d'Arte d'Oggi* in October 1954, and a linocut to the 1956–7 issue of the same periodical.

Munari's most inventive printmaking was in the field of xerography, with which he started to experiment in 1964, working with Rank Xerox. He obtained his prints by moving the image during the five-second period that it took for the light to cross the screen. Munari's xerographs included abstract geometric shapes, lettering, textured and moiré effects and Futurist-like motorcyclists. He held the first of several exhibitions of these prints at Rank Xerox in 1965, and published a book, *Xerografie originali*, with the firm in 1972. In addition N. Zanichelli published a set of Munari's xerographs in Bologna in 1977. By the 1970s, he was making them in colour. He continued to make xerographs into the 1980s. Eugenio Carmi's Galleria del Deposito in Boccadasse published a screenprint by Munari in 1969, and Lanfranco Bombelli Tiravanti's galería cadaqués issued a portfolio of eleven of his screenprints in 1975. He called these pictographs *scrittura illeggibile di popolo sconosciuto*. Munari turned five of his designs of the 1930s into screenprints, and included them in the portfolio *Bruno Munari 10 opere grafiche originali 1930–1970*, which was published in Como in 1979 by Direzione Artistica Paolo Minoli, Edizione R.S. He continued to make screenprints in the 1980s and 1990s, including at least one on an aluminium sheet in the manner of Michelangelo Pistoletto (born 1933) in 1994.

BIBLIOGRAPHY
There is no publication on Munari's prints, although there is a very large literature on his work as an artist and designer, including Aldo Tanchis, *Bruno Munari: design as art*, Cambridge, Massachusetts, 1987. For his books there is Giorgio Maffei, *Munari: I libri*, Milan, 2000.

94 (see colour page 59)
UNTITLED
1949
Lithograph 326 × 230
1989-7-22-3 (20)
Purchased, 1989

This is one of two prints that Munari contributed to M.A.C.'s fourth album, *24 litografie originali*, published in Milan by Salto Editore in an edition of 250. He had also contributed to the first M.A.C. album published by Salto Editore in 1948.

Atanasio Soldati 1896–1953

Born in Parma, Soldati studied architecture at the Accademia di Belle Arte in his native city until 1920. He practised as an architect, while teaching drawing at the Scuola Professionale at Langhirano from 1923 to 1925, and began to paint. Soldati moved to Milan in 1925. His simplified compositions of urban subjects have something in common with Pittura Metafisica. Carlo Carrà was the most significant influence on his art of this period. Soldati had his first one-man show in 1931 at the Galleria del Milione in Milan, where he had the opportunity to see the abstract work of Mauro Reggiani and Gino Ghiringhelli. In the early 1930s, he studied both Cubism and Purism. A visit to Paris in 1933 brought Soldati into direct contact with the work of Kandinsky, Klee and Picasso. The critic and theoretician of abstract art Carlo Belli wrote the introduction to the catalogue of his second exhibition at the Galleria del Milione in 1933. By the time of his third show, Soldati's paintings had become fully abstract. His work was in the linear abstraction vein of Mondrian and Vortemberge-Gildewart. In 1936, Soldati made the logical decision to join the Paris-based international group Abstraction-Création. He paid a second visit to Paris in 1938.

During the war, his Milan studio was completely destroyed, and he moved to Losana near Pavia. Soldati was a member of the Italian Resistance movement. After the war, back in Milan he was one of the founders of M.A.C. (Movimento Arte Concreta) in 1948, and he began to teach at the Accademia di Brera. Soldati was included in *Arte astratta in Italia*, the major exhibition organized by the Art Club in the Galleria di Roma in 1948. Aggressive jagged forms in his art suggest an interest in Futurism. The overlapping planes can be compared with some of the works of Magnelli and Prampolini. Soldati was allotted a room to himself at the 1952 Venice Biennale. Despite recurrent illness, he produced high-quality work to the end of his career.

BIBLIOGRAPHY
There are no publications on Soldati's prints. There are several exhibition catalogues devoted to his paintings, including M. Meneguzzo, *Atanasio Soldati*, Lorenzelli Arte, Milan, 1983. His part in M.A.C. is charted in Giorgio Maffei, *M.A.C. Movimento Arte Concreta*, Milan, 2004.

95 (see colour page 60)

UNTITLED

1949
Lithograph 326 × 230
1989-7-22-3 (21)
Purchased, 1989

This print was one of two by the artist which were included in *24 litografie originali*, the fourth of the albums published in an edition of 250 by Salto Editore, Milan, on behalf of M.A.C. (Movimento Arte Concreta). These two lithographs are among the most sculptural of his works, and demonstrate his interest in Cubist collage. A lithograph by Soldati was included in the first of M.A.C.'s albums, which was published by Libreria A. Salto Editrice on 15 December 1948 in an edition of thirty. Soldati also contributed a lithograph to another M.A.C. publication, Alberto Oggero's *Antitesi*, published in 1956 in an edition of fifty, which was illustrated by eleven other artists. He provided drawings for the M.A.C. journal *Arte Concreta* 4, published on 20 February 1952, and *Arte Concreta 8*, published on 15 October 1952. Screenprints by Soldati were published in the 1954 and 1958 issues of M.A.C.'s *Documenti d'Arte d'Oggi*, and one of his drawings was reproduced in the 1956–7 issue. M.A.C. also organized an exhibition of Soldati's drawings and tempera paintings at the Libreria A. Salto in December 1949.

Luigi Veronesi 1908–98

Born in Milan, Veronesi studied with the painter Carmelo Violante and the critic Raffaello Giolli (1889–1945). In 1927, Veronesi made his first prints, five linocuts, four of which were of skiers in a sub-Futurist style. After a gap of three years, by which time he had moved to Paris, he turned to woodcuts, mainly of deserted urban scenes and of figures from the world of dance halls, cafés and the boxing ring. Some of Veronesi's prints recall the work of Pascin and Gromaire. He frequented Léger's studio and became a member of Abstraction-Création, as Veronesi's art gradually became abstract through 1932–3. His work of this period reveals his study of Gris, Gleizes and Arp. He showed his first abstract paintings at the Galleria del Milione in Milan in 1932. In the mid-1930s, Veronesi became interested in the products of the Bauhaus. Particularly important for him were Vantongerloo and Moholy-Nagy. Veronesi followed Moholy-Nagy into photography, an interest that he was to maintain throughout his career. He also worked on experimental films, and undertook research into colour theory. Veronesi was one of the leading figures in Italian avant-garde photography, using photograms, solarization and photomontage, as well as more traditional and conventional forms. Like many of his colleagues among Italian abstract painters, he also turned his hand to graphics and publicity design. The various aspects of Veronesi's art were closely interrelated. A lasting interest in the interpenetration and transparency of forms can be seen throughout his mature work. Veronesi published the results of his scientific research in such volumes as *I numeri*, Milan, 1944, *I colori*, Milan, 1945, *La grafica nella coerenza del gusto*, Milan, 195–, *Appunti sulla sezione aurea*, Milan, 1985, and *Proposta per una ricerca sui rapporti fra suono e colore*, Milan, 1985.

From the very start of Veronesi's printmaking he used Japanese papers. He pulled very few impressions from the blocks, even for his two pre-war portfolios, an album of six woodcuts of 1935 and an album of ten woodcuts of 1937, *Composizioni H*, which was strongly influenced by Moholy-Nagy. After the war, according to his fellow artist Enrico Bordoni, Veronesi made a screenprint in

1948, which may have been the first made in Italy since Fortunato Depero's prints of the late 1920s and early 1930s. This was five years before Wifredo Arcay opened his famous screenprint studio in Meudon. Veronesi made ten colour linocuts for the portfolio *10 forme 1949*, published by M.A.C. that year with an introduction by Gillo Dorfles. He also contributed prints to both of the group portfolios of M.A.C. in 1948 and 1949. It was intended, too, that M.A.C.'s ninth portfolio should include two of Veronesi's lithographs, alongside two each by Gillo Dorfles and by Gianni Monnet. A linocut and five further lithographs were published in the four issues of M.A.C.'s journal *Documenti d'Arte d'Oggi*, between 1954 and 1958. Veronesi also contributed the cover to its *Arte Concreta* 22 in 1954, and a lithograph to Alberto Oggero's *Antitesi* of 1956, another M.A.C. publication. In 1952 he began a long association with the Milanese printer and publisher Bertieri, to whom he entrusted many of his woodcuts and linocuts for thirty years. These included the five woodcut illustrations to Arthur Rimbaud's *Voyelles* of 1959. In 1963 Veronesi began to collaborate with the Milanese poet Osvaldo Patani (born 1923), illustrating his *Le stelle sono i fiori della notte* with three woodcuts, which was another Bertieri publication. This was followed the next year by *Aspettando il Gran Vento*, this time illustrated by two woodcuts. A second edition in 1976 of *Le stelle sono i fiori della notte*, illustrated by two etchings printed by Giorgio Upiglio, was published by Maestri Editore in Milan.

In 1964, Veronesi's return to geometric constructivism, in a style akin to the work of Moholy-Nagy and Kandinsky in the 1930s, is apparent in the portfolio of six lithographs, *Composizioni in rosso*, which he printed and published himself. Throughout his career, Veronesi printed many of his own prints. He also worked with Il Torchio Editore, Edizioni Ferrania, Edizioni O and Galleria Marconi editore in Milan, La Nuova Grafica and Galleria Martano in Turin and Galleria Plusart Editore in Mestre. Veronesi made his first etchings in 1976, initially working with Upiglio, but in 1979, for an album of six prints published by Galleria Spatia in

Bolzano, he turned to Franco Sciardelli, who became his preferred printer for intaglio works.

BIBLIOGRAPHY
Osvaldo Patani, *Luigi Veronesi. Catalogo generale dell'opera grafica 1927–1983*, Turin, 1983, catalogued 280 prints by Veronesi. However, he did not include the prints Veronesi made for M.A.C. (Movimento Arte Concreta), or the screenprint of 1948 mentioned by Bordoni. Patani also failed to record at least one *livre d'artiste* to which he contributed. It is probable that Veronesi made well over three hundred prints in all. For his career as a whole, there are the exhibition catalogues *Luigi Veronesi*, Pinacoteca Comunale di Ravenna, 1983, and *Luigi Veronesi: razionalismo lirico 1927–1997*, Galleria del Design e dell'Arredamento, Cantù, 1997.

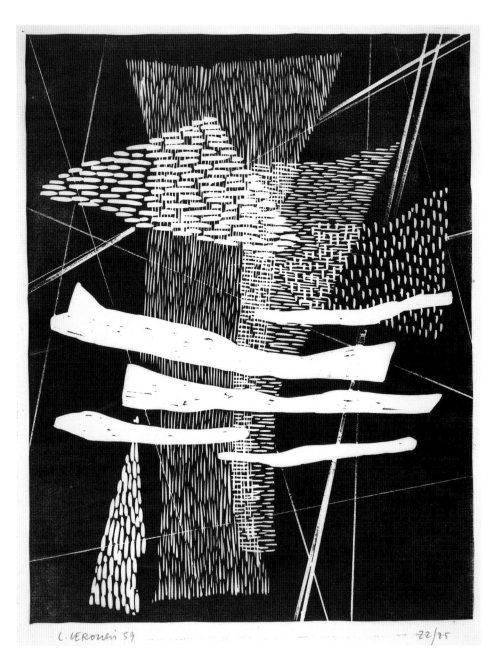

L. VERONESI 59 22/25

96

COMPOSIZIONE

1959
Linocut on Minomitre paper 463 × 360
signed, dated and numbered *22/25* in pencil
Patani 97
2004-6-30-15
Presented anonymously, 2004

Veronesi himself printed an edition of twenty-
five on Minomitre paper, which he had first
used in 1934. He used the same Japanese
paper for five other linocuts in 1959, and he
continued to employ it for linocuts and wood-
cuts until 1972. This print is one of the best
examples of Veronesi's interest in the 1950s
in the interaction between the surface and
pre-existent space.

97 (see colour page 61)

VARIATION IN RED NO. 4

1960
Colour lithograph in pale green, red and
black on Umbria paper 260 × 370 signed,
dated and numbered *15/15*, and inscribed
frammenti 4 in pencil
Patani 111
2004-6-30-16
Presented anonymously, 2004

This print comes from a portfolio of ten
three-colour lithographs, which were printed
by the artist himself and published in an edi-
tion of fifteen. The artist's pencil inscription
'Frammenti 4' is an alternative title. From
1955 until 1971, Veronesi often used this
central Italian paper for his lithographs.

Lucio Fontana 1889–1968

Born in Argentina at Rosario di Santa Fè, the son of a Milanese sculptor, Fontana, the most significant artist to work in Italy in the post-war period, studied as a surveyor in Milan, and served in the Italian army in the First World War, before returning to his native country. He established his own sculpture studio in Buenos Aires in 1924, travelling back to Milan to study with Adolfo Wildt at the Accademia di Brera between 1928 and 1930. In the 1930s, Fontana worked in both figurative and abstract modes. Initially influenced by Arturo Martini and by late Symbolist Secessionist sculpture, he soon found inspiration in the expressive touch of Medardo Rosso, and abandoned the traditional plinth. Fontana's use of biomorphic forms and freely worked surfaces showed some kinship with Surrealist automatism, but also with the expressive dynamism of Boccioni's sculpture. He became one of the Italian members of Abstraction-Création in 1934. Much of his sculpture was in terracotta, cement, gesso and ceramics. From 1936 to 1939, Fontana worked in the Ligurian studio of the ceramicist Tullio D'Albisola, and in 1937 at the Sèvres factory near Paris. In the late 1930s, he exhibited with the left-wing Il Corrente group in Milan.

Fontana returned to Argentina in 1940, where he initially worked in a figurative vein. He founded the Academia Altamira in Buenos Aires in 1946, by which time he had taken up abstraction. That year, although not actually a signatory, Fontana was the major figure behind the *Manifesto blanco*, the first text that launched Spazialismo. Five further manifestos were issued in Italy between 1947 and 1952 after his return to Milan. Figuration and illusionistic space were rejected in favour of metaphysical investigations of colour, sound, movement, time and space. The future for Fontana lay in three or four dimensions. Planar surfaces were to be replaced by environments, of which his 1949 *Spatial environment*, a darkened room filled with suspended forms lit by neon light, anticipated developments in international art in the 1960s. Fontana collaborated with the architect Luciano Baldessari on several avant-garde exhibitions in the early 1950s. In 1949, he made his first *Holes*, punctuated canvases.

These attacks on the traditional flat canvas were followed in the 1950s by *Slashes*, sharp linear cuts dramatically breaking the surface at an angle from the vertical. Although apparently haphazard, careful consideration was taken of the resulting compositions. In other canvases, irregularly shaped pieces of glass were attached to interrupt the smooth surfaces. Fontana made parallel experiments in his terracotta and metal sculpture, using wax, chalk, paint and glass, and retaining the organic qualities in which he had delighted in his sculpture of the 1930s. Among his last sculptural works were the *Teatrini*, little theatres in which irregular spheres and silhouettes were set against enclosed backdrops.

Fontana's first prints were figurative woodcuts made to illustrate the February 1925 issue of the monthly *Italia*, published in his home town of Rosario in Argentina by the Società Dante Alighieri. These were in the neo-sixteenth-century style popularized by Adolfo De Carolis. Fontana made no more prints until he contributed three lithographs in 1949 to early albums of M.A.C. (Movimento Arte Concreta). His first significant portfolio of lithographs was published by Edizioni del Cavallino in 1955 (no. 99). The exhibition of the Spazialismo group at the Galleria del Naviglio, Milan, the following year led to Fontana's participation in the Fourth Biennial of Lithography in 1956, but it was only in the early 1960s that he became a prolific printmaker. In 1962, the Milan publisher Arturo Schwarz issued Alain Jouffroy's '*Dix-eaux fortes*' *l'épée dans l'eau: en hommage à Lucio Fontana* in an edition of seventy-five. These small colour etchings may have been made some years previously, as at least one of them is similar in style to Fontana's work of the late 1940s. Two years later, the Kestner Gesellschaft, Hanover, published a portfolio of six monochrome relief etchings. Fontana employed mechanical methods for the first time to make holes in his prints in the screenprints that he made for the Galleria del Deposito, Boccadasse, in 1965. The same year, he used screenprint for works in his *Teatrini* series for a portfolio of multiples on perforated aluminium foil, *Quattro oggetti di Lucio Fontana e due poesie di Salvatore Quasimodo*, printed in Milan by Arturo Tosi.

The holes in this case were die-cut. In 1966 Lanfranco Bombelli Tiravanti's galería cadaqués in Catalonia published a portfolio of his etchings, *Lucio Fontana: serie rosa aguafertes*. Not all his prints were abstract. Il Bisonte published an etching of a kneeling male nude in the portfolio *Cinquanta incisori italiani* of 1964. This again may have been made some years previously. For in spirit it has a kinship with his ceramic sculpture of the 1930s. Fontana also produced an etched self-portrait in 1966, and made an aquatint of a leaf at an unknown date in the 1960s.

Fontana exhibited at the Premio Biella per l'Incisione in 1963 and 1965, and at the fourth and sixth Biennale dell'Incisione at Opera Bevilacqua La Masa in 1961 and 1965.

Fontana was one of the first artists to work with the Ancona printer Brenno Bucciarelli's Edizioni Bucciarelli in 1962, when he illustrated Leonardo Sinisgalli's *Ode a Lucio Fontana* with two small etchings. Another etching was published posthumously in Leonardo Sinisgalli, *Diario*, in 1972. One of Fontana's later *livres d'artiste*, issued by the same publisher, was Giuseppe Ungaretti's *Apocallissi e sedici traduzioni*, for which he provided two *concetti spaziali* in 1965. A further two lithographs were published posthumously in 1980 with prints by seven other artists in Marcello Pirro, *Presenze*, another Bucciarelli publication. In one of his last prints, *Concetto spaziale B* of 1968, Fontana combined aquatint with carborundum etching.

BIBLIOGRAPHY
Considering the vast literature on the rest of his work, Fontana's prints have received surprisingly little scholarly attention, apart from an article on his early woodcuts by Rossana Bossaglia, 'Fontana senza tagli', *Arte*, XVI, June 1986, pp. 76–9. A substantial group of prints was included in the exhibition *Lucio Fontana: opera grafiche*, Istituto Italo-Latino Americano, Rome, 1972, but without any discussion of them in the catalogue. His 1964 portfolio of etchings is discussed by Hannelose Kersting-Bleyl, *Farbe und Raum. Graphischen Mappewerke von El Lissitzky, Moholy-Nagy, Schwitters, Kandinsky, Albers, Palermo und Fontana*, Städtische Galerie im Städelschen Kunstinstitut, Frankfurt am Main, 1980. Enrico Crispolti, *Fontana: Catalogo generale*, 2 vols., Milan, 1986, provides a catalogue raisonné for his sculpture and ceramics.

98 (see colour page 62)

UNTITLED

1949
Colour lithograph 326 × 230
1989-7-22-3 (9)
Purchased, 1989

This is one of the two lithographs that Fontana contributed to the album *24 litografie originali*, which was published by Salto Editore, Milan, in an edition of 250 in October 1949 for M.A.C. (Movimento Arte Concreta). He had earlier contributed a lithograph to M.A.C.'s first portfolio, published by Libreria A. Salto Editore on 15 December 1948, and the Libreria had hosted his April 1949 exhibition of *Concetti spaziali* for M.A.C. The style in these prints is the closest that Fontana approached to Max Bill. He was among the artists who provided a lithograph for Alberto Oggero's *Antitesi* in the collection *Sintesi delle Arti*, published by Libreria A. Salto for M.A.C. in 1956. Another lithograph was published in M.A.C.'s *Documenti d'Arte d'Oggi 1958* by Libreria A. Salto. In the issues of 1955–6 and 1956–7, two perforated plates and a drawing accompanying a poem by Antonino Tullier were included.

99 (see colour pages 63–66)

QUATTRO LITOGRAFIE DI LUCIO FONTANA

1955
Portfolio of four colour lithographs, each with punched holes 497 × 388 each.
Each print signed, dated *55* and inscribed *3/10*; the cloth cover to the portfolio signed in brush with yellow paint
2005-10-30-2 (1–4)
Purchased with the aid of a grant from the National Art Collections Fund, 2005

These lithographs were printed in Milan by Piero Fornasetti, and published by Carlo Cardazzo's Edizioni del Cavallino in Venice. It is probable that these were the first prints that Fontana made with pierced holes. The compiler has not seen a copy of Beniamino Joppolo and Milena Milani, *Un racconto spaziale: uomo e donna con dieci tavole di Lucio Fontana*, Edizioni d'Arte Moneta, Milan, 1951. It is possible that the *tavole* were *pochoirs*. The small size of the edition of the Edizioni del Cavallino portfolio suggests that there was as yet little market for Fontana prints, although he had made a lithograph, *Concetto spaziale*, published by Edizioni d'Arte Moneta in 1951, in a style akin to his prints for M.A.C. The British Museum's portfolio was acquired directly by its first owner from the artist through the Martha Jackson Gallery in New York. It is very rare. The Fondazione Lucio Fontana's copy is the only other so far traced in public hands.

The printer of the portfolio was Gio Ponti's partner, the famous designer Piero Fornasetti (1913–88), well-known for his collages of earlier engravings printed onto furniture, textiles and ceramics. Fornasetti and Fontana had both worked on decorations for the interior of Milan's Cinema Arlecchino in 1948. Around 1950 Fontana had designed the gilt bronze handles for a mahogany cabinet by Osvaldo Borsani, which was decorated with a fabric by Fornasetti. Fornasetti had earlier printed lithographs for Sassù, Campigli, De Chirico, Manzù and other leading Italian artists.

100 (see colour page 67)

UNTITLED (PINK CUT)

1963
Colour lithograph 356 × 255 signed in pencil and inscribed *118/150*
2003-6-29-1
Presented anonymously, 2003

This lithograph was published in Milan by Stamperia d'Arte Il Torchio in an edition of 150. Fontana was well aware of the possible erotic readings of his works. One of his etchings of 1968, hand-coloured in watercolour, was assigned the title *Fanny Hill*.

101 (see colour page 68)

UNTITLED

1968
Colour lithograph and etching on thick cream paper 295 × 372 signed in pencil, and inscribed *16/80*
2004-6-30-14
Presented anonymously, 2004

One of a set of six prints made and signed by Fontana at the Stamperia 2RC in the last year of his life, this was published posthumously in 1970 by Edizioni 2RC jointly with Galleria Marlborough in Rome. The delay in publication was the result of a dispute over the artist's estate. In addition to the edition of eighty there were fifteen proofs numbered I–XV/XV.

Alberto Burri 1915–95

Born in Città di Castello, Burri trained initially as a doctor, taking up painting while a prisoner of war in Texas. On repatriation, he settled in Rome, where he painted Expressionist landscapes and still lifes. In 1948, inspired by Miró, Klee, Arp and Prampolini, he began to make highly coloured abstract works. In style, Burri was aligned with Art Informel. He used industrial paint and unorthodox materials, as well as oils. These included tar, pumice, sand and enamel. Burri delighted in contrasts between smooth and textured surfaces. In 1950, he began to use torn and patched sacking and burlap on a scale that distanced his work from its precedent, the *Merz-bilder* of Kurt Schwitters. With Ettore Colla, Mario Ballocco and Giuseppe Capogrossi, Burri founded the Gruppo Origine in 1951. He abhorred the decorative and eschewed any hint of spatial illusion. For the rest of his career, Burri worked in series, employing a limited number of colours. Monochrome works appeared first in his pitch-black *Tars* in 1951. These were succeeded in the later 1950s by the burnt surfaces of his *Combustioni*. The effects of fire were also found in the melted folds and membranes of Burri's *Plastics* in the 1960s. More austere were his stacked *Wood pieces* and his *Iron pieces*.

In the early 1970s, Burri again reduced his colours, in a series of monochrome, mainly black, *Clays*, in which the surfaces was broken up into fissures, which contrasted strongly with his contemporaneous *Black and whites*, in which the simplicity of the arcing curves have similarity to the work of Ellsworth Kelly. He had been the best-known Italian artist in America from the 1950s. Rauschenberg's early work became indebted to Burri after he visited the Italian's studio in 1953. An affinity with American abstract painting can also be found in his *Cellotex* series, begun in the mid-1970s, in which he used industrial fibreboard, which he divided into broad areas of single matt colours. For the rest of his career, Burri oscillated between works of this kind, monochromes and highly coloured paintings that revisited his pictures of the late 1940s.

Burri's earliest known print, a lithograph of a dancing figure against an Art Informel background dating from 1950, is tinged with Surrealism. He returned to printmaking in 1957 with two prints combining etching and lithography, which were published by Edizioni Castelli in Rome. Two years later, the same publisher issued the first of his *Combustioni*. However, it was only in 1962 that Burri began to make prints regularly, when he executed three aquatints for Emilio Villa's poems *Variazioni*, which were published in Rome by Edizione Origine. One of these was in relief, and in the others he incorporated collaged gold leaf. These were the first fruits of Burri's long partnership with Valter and Eleonora Rossi's Stamperia 2RC. There followed a set of *Combustioni* in 1965 (no. 102), and his first set of six *Bianchi e neri* in 1967–8. The latter prints combined engraving, lithography and collage. Burri made his first screenprints in 1969. From then on this was his preferred technique. Of his 150 prints, seventy-five were screenprints. Among Burri's finest prints were a set of eight etchings and aquatints, *Cretti*, made in 1971, in which he created a tarlike effect of crevasses by applying a mixture of glue and gesso to the matrices. The process of making these prints was so complicated that each took several weeks to complete. The majority of his later works were vividly coloured screenprints, which relate stylistically to his small tempera paintings of the late 1940s. In 1973, Burri began to make ten lithographs to illustrate Villa's translation of the poems of Sappho, a project which involved the use of 200 stones and which was completed only in 1982. In 1986, he turned back to the blacks of the late 1960s in a set of screenprints made with the Stamperia Fausto Baldessarini in Fano. Between 1988 and 1990, Burri also worked on ten mixografias at Luis and Lea Remba's Mixografia Workshop in Los Angeles. In these three-dimensional prints the ink is absorbed into the paper, creating a fresco-like quality.

BIBLIOGRAPHY
Chiara Sarteanesi, *Burri Grafica opera completa*, Fondazione Palazzo Albizzini Collezione Burri, Città di Castello, 2003, is a catalogue of Burri's prints. For the rest of his work, there is G.P. Zamboni and others, *Alberto Burri: Contributi al catalogo sistematico*, Città di Castello, 1990.

102 (see colour page 69)

COMBUSTIONE 1

1965
Carborundum etching, drypoint and aquatint
380 × 305
Sarteanesi, p. 30
2005-7-30-9
Presented anonymously, 2005

This is one of a series of six aquatints printed by Stamperia 2RC in Rome, which were published jointly by Stamperia 2RC and Galleria Marlborough in an edition of eighty plus eleven proofs. Burri used grains of sand stuck together with glue in the aquatint. Valter Rossi and Burri created a special heavy-duty press, which they nicknamed Alessandro il Magno, to print the *Combustioni*.

103 (see colour page 70)

BIANCO E NERO 1971

1971
Lithograph, intaglio and acetate collage on hand-made Japanese paper 400 × 600
Sarteanesi, p. 64
2005-8-30-16
Presented anonymously, 2005

Burri's print was part of a portfolio of eleven prints printed in Rome at the Stamperia 2RC, which was published by the International Association of Art (IAA/AIAP, UNESCO) in an edition of seventy-five plus twenty-five artist's proofs. The Japanese artist-members of the association provided the handmade paper as a gift. It was Burri who proposed the idea of the portfolio in 1969, as well as selecting the other contributing artists, Max Bill, Alexander Calder, Sonia Delaunay, Robert Matta, Joan Miró, Louise Nevelson, Victor Pasmore, Kumi Sugai, Victor Vasarely and Felix Wotruba. The IAA/AIAP's purpose is to foster international co-operation between artists of all countries, to improve their social and economic conditions, to defend their material and moral rights, and to foster international exchanges. Currently it has national committees and territories. This portfolio was the first publication of original prints by the IAA/AIAP.

Pietro Consagra 1920–2005

Born in Mazara del Vallo on the south-west coast of Sicily, Consagra trained in the Accademia in Palermo from 1941 to 1944, before moving to Rome, where Renato Guttuso lent him his studio. Consagra saw the ateliers of Brancusi, Picasso and Giacometti on a visit to Paris. He also found inspiration in the wrought-iron sculptures of Julio González and in the work of Anton Pevsner. Consagra became friends with the young Dorazio, Perilli, Giulio Turcato and Carla Accardi, and, in 1947, he was a founder member of the Forma 1 group, which championed abstraction in the face of the Marxist realism promoted by Guttuso. He was also involved in the organization of the first exhibition of abstract art staged by the Art Club that year. Though abstract, Consagra's sculptures retained hints of standing human figures seen in silhouette, as is also hinted at by the titles of a series of sculptures from 1954 to 1962, *Colloqui* (*Dialogues*). These were built up of slender overlapping metal sheets, which had little apparent depth and which Consagra intended should be seen frontally. He made many preparatory drawings, which were translated by cutting, rather than modelling the forms. In 1952, Consagra published *Necessità della scultura*, a polemical defence of sculpture to counter the claim made in the advent of abstraction by Arturo Martini in his 1947 *La scultura lingua morta* that the medium was dead.

The importance of his work as Italy's leading abstract sculptor was recognized by one-man shows at the Venice Biennali in 1956, 1960 and 1972. In 1961, Consagra was one of the founders of the Continuità group, which continued the tradition of Forma 1. From the early 1960s onwards, he received a series of major public commissions, including large environmental projects. Consagra worked in steel, aluminium, iron, bronze, marble and wood. Transparency became a significant part of his work, whether achieved through cutting holes in the metal or by using materials through which one could see. In several of Consagra's later sculptures he experimented with colour. Poetry was an important component in his art, and he published *Ci pensi amo* in 1985. With Senator Ludovico Corrao, Consagra created an open-air museum in Gibellina Nuova, after an earthquake had destroyed the old Sicilian town in 1968. Its collection included works by Arnoldo Pomodoro, Burri, Schifano and other leading contemporary sculptors.

Consagra's earliest prints were portraits in drypoint, printed in the workshop at the Accademia di Belle Arti in Palermo in 1942. Two years later, he made his first etchings, a market scene, a print of frogs and a seapiece influenced by Ensor. Consagra's next prints were fully abstract, a set of linocuts, *E trascurabile esprimere se stessi* of 1949 (no. 104). In 1958–9, Stamperia Ca' Giustinian in Venice printed some of his etchings, and, in 1961, the journal *XXe Siècle* published a woodcut. The same year, Consagra began working with the Stamperia Romero in Rome, with whom he made both etchings and aquatints. In 1967 the Galleria Marlborough in Rome published *MGA*, a portfolio of six lithographs printed by Edizioni 2RC. This was followed by an album of screenprints, printed and published in 1967–8 by the Minneapolis Institute of Art, where he was teaching for a year. Consagra made his first relief etchings in 1970 with Stamperia 2RC. One of his etchings was made in collaboration with Dorazio. Consagra produced two other portfolios in the early 1970s, a set of ten etchings, *1° poema frontale 'Euforia'*, with Stamperia 2RC in 1973, and four prints combining lithography and intaglio illustrating Luciano Erba's *Senza titolo* in 1974, which were published in Udine by Edizioni Stamperia La Zebra. He paid tribute to his fellow Sicilian late seventeenth-century sculptor Giacomo Serpotta, in *Omaggio a Serpotta: una poesia, una nota, dodici disegni e tre litografie*, L'Arco, Rome, 1981. Consagra worked with a wide variety of publishers in Florence, Turin, Palermo, Pollenza, Todi and Treviglio, as well as in Milan and Turin. His preferred printer was Stamperia 2RC, but he also used workshops in Milan, Carrara and Verona.

BIBLIOGRAPHY
The 114 prints that Consagra made up to 1977 have been catalogued by Giuseppe Appella, *Consagra. Opera grafica 1942–1977*, Milan, 1977. He wrote an autobiography, *Vita Mia*, Milan, 1980, and his theoretical writings have been collected in *Consagra che scrive: scritti teorici e polemici 1947–1989*, Milan, 1997. There have been numerous exhibition catalogues devoted to his sculpture including *Pietro Consagra: la città frontale*, Institut Mathildenhöhe, Darmstadt, 1997.

104 (see colour page 71)

STUDY

1949
Linocut 390 × 227 signed and inscribed *52/55*
Appella 14
2005-4-29-23
Presented anonymously, 2005

This is one of ten linocuts from a portfolio enigmatically titled *E trascurabile esprimere se stessi* (*It is negligible to express oneself*), which was printed in Rome by Stamperia Zampini and published by Edizioni Nicoli, Rome, in an edition of fifty-five. These were Consagra's earliest abstract prints. The very sculptural shapes can be compared to the work of Magnelli, as well as to his own 1948 sculpture *Homage to Christian Zervos*.

The British Museum also owns a *de luxe* copy of Consagra's *L'agguato c'è* (*The snare exists*), a volume with text in Italian, French and English, which was published in an edition of sixty on 31 December 1960 by Edizioni della Tartaruga, Rome, for which he made and printed two screenprints and the linocut cover. The ordinary edition without any prints consisted of 440 copies.

Born in La Spezia, the son of an engineer who worked in the naval shipyards, Lardera studied at the University of Florence. He first went in 1929 to Paris, where he met Brancusi, Maillol and Laurens. Lardera paid a second visit in 1934–5. It was only in 1939 that he established a workshop in Florence, and cast his first bronze. Later that year, Lardera travelled to the south of France, where he studied drawing. His early sculptural work was in the fields of portraits and bas-reliefs. These can be compared with the sculpture of Arturo Martini and of the young Manzù, as well as with Rodin's *Gates of hell*. One of his etchings, made decades later, was a *Hommage à Rodin*. Lardera spent three years during the Second World War as an active participant in the Italian Resistance, during which time he began to make two-dimensional abstract sculpture. From 1945 to 1947, he wrote regular articles on contemporary art in the newspaper of the Socialist Comitato di Liberazione in Florence. The biomorphic forms of some of Lardera's sculpture of this period are reminiscent of Arp, while his use of metallic strings can be compared with the work of Pevsner and Domela. Some of his drawings of this period make direct reference to Picasso.

Crucial for the rest of Lardera's career was his permanent move to Paris in 1947. He exhibited that year at the Salon des Réalités Nouvelles. Following his first Parisian one-man show at the Galerie Denise René in 1948, Lardera became a regular exhibitor at the Salon de Mai and at the Salon de la Jeune Sculpture. He was associated with the Milan-based M.A.C., and was a leading member of the abstract group Espace, founded by the architect André Bloc. Dissatisfied with his treatment at the hands of the artistic authorities at the Venice Biennale, he rarely showed in Italy after 1954. Lardera was a professor at the Hamburg School of Fine Arts from 1958 to 1960. Throughout the rest of his career, he received a series of major commissions for large-scale sculpture in France, Germany, the United States, Canada, Israel and Gabon, but his only Italian commissions were private ones.

It is not yet known when Lardera made his first prints. The Galerie Berggruen published some lithographs that he made in the workshop of Fernand Mourlot in 1954, and

gave him an exhibition which included them that year. Ten of his prints were exhibited at the Kunstkring, Rotterdam, later that year. Lithographs were included also in Lardera's first New York exhibition at the Wittenborn One Wall Gallery in 1955. He worked with Mourlot, too, for the lithographs published by the Parisian gallery M. Warren in 1956, the Munich collector and dealer Otto Stängl in 1958 and the Hamburg Kunsthalle in 1959. Lardera exhibited fifteen prints in his one-man show at the Kaiser Wilhelm Museum in Krefeld in 1958. Two years later, the New York Knoedler Gallery presented a show of his graphic work. The date of Lardera's first intaglio prints is not known, but he exhibited two etchings on iron at the Knoedler Gallery, and an etching and aquatint in *La Gravure française contemporaine* at the Bibliothèque Albert Ier in Brussels in 1963. He made three etchings with Editions Lacourière in 1964, and it is likely that most of his intaglio prints were pulled in this workshop. The largest exhibition of Lardera's prints was in the 1966 one-man show at the Maison de la Culture in Le Havre, which included thirty-nine intaglio works and a single lithograph.

As a child, Lardera had been fascinated by the sight of the bare bones of the vessels under construction in the La Spezia shipyards, and by the blueprints spread out on the ground. These experiences undoubtedly influenced both the methods of construction and the shapes that he employed in both his sculptures and his prints. Lardera's use from 1948 of *découpage* parallels the practice of Matisse, whose *Jazz* was published in September 1947. He made no use of traditional printmaking tools for his works in intaglio. Instead like a metalworker, Lardera cut, hammered and shredded iron plates, before inking them and running them through the press. His lithographs were closely related to the many gouaches and collages that he made, as well as to his sculpture. The touches of colour correspond to the variations of oxidized metals that he used in his sculpture. The role of light is vital both in Lardera's sculpture and in his prints. The spaces cut out from the metal and the carefully judged placing of the elements in his lithographs and etchings created airy effects,

which contradicted the weight and mass of the materials. Also significant for him was contemporary music. Lardera particularly admired the work of Alban Berg, and parallels have been drawn with the music of his compatriots Bruno Maderna, Luciano Berio and Franco Donatini. It is likely that he drew inspiration from El Lissitzky and Moholy-Nagy. The striations in some of his lithographs can be compared with Constructivist works. Lardera was closest to Magnelli among Italians, and he may have been aware of the wartime collaborative album of lithographs made in Grasse by Magnelli, Sonia Delaunay, Jean and Sophie Taeuber-Arp, which was not published until 1950 in Paris.

BIBLIOGRAPHY
There is no publication specifically devoted to Lardera's prints. Some of them, however, are illustrated and discussed in the catalogues for two slightly different versions of the same exhibition, *Berto Lardera entre deux mondes*, Musée de Grenoble, 2002, and *Berto Lardera tra due mondi*, Museo Diocesano, La Spezia, 2002. Ionel Jianou's monograph *Lardera*, Paris, 1968, discusses his work as a sculptor.

105 (see colour page 72)

TRIPTYCH

1968
Three etchings, touched in gouache on Arches paper 768 × 565 signed in pencil, and numbered XI/XXV
2005-8-30-19 (1–3)
Presented anonymously, 2005

Printed by the artist at the Atelier Lacourière in Paris, these etchings were issued to coincide with the publication of Jianou's monograph in an edition of seventy-five, plus twenty-five *hors de commerce*, and presented in a turquoise-coloured cloth-covered portfolio. Lardera used three of the iron plates with which he was accustomed to assemble his sculptures, and gouged them with his tools. All three etchings were taken from the same matrices. For one of them, Lardera simply turned over the plates to print from the other side.

Emilio Vedova born 1919

Born in Venice, the son of an artisan, Vedova taught himself to become an artist by studying the paintings of Tintoretto and the interior architecture of Venetian churches, as is evident in his early drawings. In 1937 he visited Rome, where he drew and painted perspectival views and the classical ruins. Vedova attended Silvio Pucci's Scuola Libera di Pittura in Florence in 1939 and 1940, where he studied the life of the underprivileged, and came into contact with anti-Fascist groups. In 1942, he became involved with the Corrente group, meeting Birolli, the translator Elio Vittorini (1908–66), Guttuso and Morlotti, and the following year he joined the resistance to the German occupation in Rome. After the war, his drawings made as a partisan were exhibited all over Italy. With the help of Morlotti, Vedova wrote the manifesto *Oltre Guernica*, which was launched in Milan in 1946. The same year, he became a founder member of the Milan-based Nuova Secessione Artistica, later known as the Fronte Nuova delle Arti, and of its successor in 1952, the Gruppo Otto Pittori Italiani.

Up until this date, Vedova's work had been figurative in a feverish expressionist style, evoking memories of Baroque perspectival paintings. In 1946–7, however, his style became abstract, drawing on the work of the Futurists and of Picasso. Vedova's paintings were gestural and highly architectural, their spaces sometimes echoing Piranesi's famous etchings. This was not coincidental, for his work was highly politicized, as the titles of both his pictures and his prints have indicated throughout his career. Franco's Fascism and American imperialism have provided particular targets. Vedova was an active participant in the political demonstrations of 1968. Despite the dominant and heavy use of black, Vedova's prints often have an airiness which is explained by his study of Tiepolo. There is a dramatic quality in them akin to that found in the works of Goya, another printmaker, whom he much admires. In the early 1960s, Vedova began to make *Plurimi*, freestanding hinged and painted sculptures made of wood and metal. He was also deeply involved with avant-garde classical music designing moving light sets and costumes for the Venetian composer Luigi Nono's opera *Intolleranza '60*, in

1960. Vedova's growing interest in variations of light led to his exhibition at Montreal's Expo '67 of a light-collage, in which moving images were projected across a huge asymmetrical space by the means of glass plates. Since the late 1970s, he has experimented with mobile works on steel rails, double-sided circular panels and multifaceted manipulable painted objects.

Vedova began to make lithographs in 1958, and set up his own press in 1962. Up until 1964, he used stones for his lithographs. Vedova then changed to zinc plates. Almost all the lithographs were printed in his studio or under his direct supervision. Likewise, Vedova has been accustomed to print his etching plates in his Venice studio. His lithographs have been published by Edizioni Giulio Einaudi in Turin, Verlag DuMont Schauberg in Cologne, Edizioni Teodorani in Milan, Il Torcoliere in Rome and Edizioni Poligrafa in Barcelona, who have also published a suite of his etchings and aquatints. Since 1969, Vedova has issued some sets of lithographs himself. Among the other publishers whom he has worked with for his etchings are Edizioni d'Arte Fenati-Zanotti in Ravenna, Ruggero Aprile in Turin, Il Capello in Verona and P.O. in Milan. More recently, Vedova has made monotypes and large-scale engravings on glass.

Vedova became director of Kokoschka's Summer Academy in 1965 on its founder's retirement, and ran it successfully for five years. He was appointed Professor of Painting at the Accademia di Belle Arti in Venice in 1975.

BIBLIOGRAPHY
For his prints the best publication is *Vedova grafica 1958–90*, Istituto Italiano di Cultura Veneziana, Vienna, in collaboration with the Graphische Sammlung Albertina, Vienna, 1990. There have been many exhibitions of Vedova's paintings and sculpture, among them, *Emilio Vedova*, Museo di Arte Contemporanea, Castello di Rivoli, 1999, for which the catalogue was written by Ida Giannelli. This includes records of the prints that Vedova exhibited in one-man shows up to 1999.

106 (see colour page 73)

SPAGNA

1969
Lithograph touched and dated 500 × 400
2005-4-29-1
Presented anonymously, 2005

Vedova dedicated this artist's proof to A. Rainer, who may well be the Austrian painter and printmaker Arnulf Rainer (born 1929), who is known to have used other works by the Italian artist as the basis for his own work. The title of the print relates to Vedova's opposition to General Franco's Fascist regime in Spain, which was first expressed in his work in 1959. Vedova's first prints devoted to Spain were the ten lithographs in the portfolio *Spagna oggi*, published in 1961. His last were the three lithographs *Ancora Spagna (A Rafael Alberti)* of 1972–9. Vedova made at least four other lithographs with Spain in the title in 1969.

Enrico Baj 1924–2003

Born in Milan, Baj began painting at the age of fourteen. He fled to Switzerland in 1944 to avoid enrolment in Mussolini's army of the Republic of Salò, where he saw Post-Impressionist, Fauve and Cubist paintings, and recent work by Picasso. From 1945 to 1948 he studied at the Accademia di Brera in Milan, while simultaneously attending courses on law at the University there. Baj was initially interested in Matisse, but turned first to Post-Cubist abstraction, and then to Art Informel. In 1951, troubled by the uncertainties of the Cold War and the threat of the atomic bomb, he founded Arte Nucleare with Sergio Dangelo (born 1932). The movement attracted many Italian and foreign artists. Baj met the Danish artist Asger Jorn in 1953, and together they promoted the Mouvement pour un Bauhaus Imaginiste, in opposition to the new Bauhaus, recently founded by Max Bill. This friendship brought him close to the CoBrA group, whose members shared an interest in impasto and texture. For the rest of his career, Baj was an opponent of abstraction. In 1955 he founded the periodical *Il Gesto*, to which Fontana and Manzoni contributed. Baj made his first collages and assemblages that year, incorporating fabric and glass into his paintings. Later in the 1950s, he became close to the French Nouveaux Réalistes, and his work bears comparison with Niki de Saint Phalle and Arman. Baj was a signatory in 1957, alongside Arman, Yves Klein, Pierre Restany and the Pomodoro brothers, of the manifesto *Contro lo stile*, affirming the irrepeatability of art. Baj had two one-man shows in 1957 and 1958 in London at Gallery One, where he met E.L.T. Mesens. He became associated with Surrealists and Marcel Duchamp, whom he met in New York in 1961, when he was given a prominent space in the Museum of Modern Art's exhibition *The art of assemblage*. The following year, Baj became friends in Paris with André Breton, who wrote sympathetically of his art. Through these contacts he met leading French writers, many of whose works he illustrated. He began to add *objets trouvés*, particularly in his *Generals* series, in which he attacked bombastic militarism. In the early 1960s, Baj started to use wooden knobs and pieces of metal, plastic

and children's toys, and to make robotic Lego and Meccano sculptures.

From the late 1960s, he produced burlesque interpretations of Picasso. Ernst, Dubuffet, Victor Brauner and Seurat were also targeted for reinterpretation. Baj's work remained politically barbed. His 1972 *Funeral of the anarchist Pinelli*, an attack on the Italian police, was suppressed in Milan, but acclaimed when exhibited abroad. In the late 1970s and early 1980s he warned of impending Armageddon through his Apocalypse series. It was a natural progression for Baj to draw on the absurdist Alfred Jarry's *Ubu Roi*, for the staging of which he made designs for the Théâtre d'Arc en Terre in 1984, having the previous year organized an exhibition, *Jarry e la patafisica*, at the Palazzo Reale in Milan. Jarry had conceived the imaginary science of pataphysics, a philosophy beyond the world of metaphysics, in 1893. Baj, who may have been introduced to the Parisian Collège de Pataphysique de France by Raymond Queneau, was in 1963 with Arturo Schwarz, Man Ray and the Futurist poet Farfa, one of the founders of its Milan-based Italian offshoot, the Institutum Pataphysicum Mediolanense. Stage design was particularly important for him throughout the 1980s. In his later work he was open to inspiration from much younger artists, such as Francesco Clemente (born 1952).

Baj made his first prints, his etchings for Lucretius' *De rerum natura* from 1952 to 1954 (no. 107). He then turned to colour lithography, making twenty-four prints between 1955 and 1959. Baj's interest in printmaking quickened as he devoted more of his time to *livres d'artiste*, of which he has produced well over seventy. These often accompanied French poetry by writers, including Benjamin Péret, Jean Clarence Lambert, André Pieyre de Mandiargues and Raymond Queneau, with the last of whom he became particularly associated. In 1986, Baj illustrated translations of Lewis Carroll's *The hunting of the Snark* and of Milton's *Paradise lost*. The latter, accompanied by forty etchings published in Padua by Mastrogiacomo, was one of his most important books. Although his oeuvre consisted

mostly of etchings and lithographs, Baj also made aquatints and screenprints, and printed from pieces of Meccano. He worked with many publishers and printers in Paris and in Italy. His most long-lived partnerships were with Arturo Schwarz and Giorgio Upiglio's Grafica Uno. At the time of the publication of the catalogue of his prints in 1986 he had made 640 prints.

BIBLIOGRAPHY

Jean Petit, *Baj. Catalogo generale delle stampe*, Milan, 1986, brings together the material from two earlier catalogues by the same author. Baj's *livres d'artiste* have been catalogued by Massimo Mussini, Nani Tedeschi and Luciano Caprile, *I libri di Baj*, Palazzo Dugnani, Milan, 1991, and Luciano Caprile, *Baj. Libri d'artisti*, Bollate, 2000. The exhibition *Enrico Baj. Monstres figures histoires d'Ubu*, Musée d'Art Moderne et d'Art Contemporain, Nice, 1998, provided a recent survey of his work as a whole. Baj's writings include *Automitobiografia*, Milan, 1983, and *Cose, fatti, persone*, Milan, 1988.

107

SOLAR HEAD
FROM DE RERUM NATURA
(ON THE NATURE OF THINGS)

1952–4
Etchings 150 × 125
1988-7-23-16 (35)
Purchased, 1988

Baj was attracted by the theme of the origin
of the world expounded in the first-century
BC Roman writer Lucretius' six-book philo-
sophical poem to embark on his first series
of prints. The topics of the development of
things and of human beings from a world
of primeval chaos, and of cyclical rebirth,
appeared to have considerable relevance after
the horrors of the Second World War, and at
a time when further, even more destructive,
conflict threatened. The poetry of Lucretius
offered grounds for hope and optimism. Baj
made fifty-eight etchings, thirty-six of which
the Milan publisher and art dealer Arturo
Schwarz offered to publish, with an introduc-
tion by the poet and philologist Roberto
Sanesi, in an edition of fifty-one. The prints
were divided into three series of twelve,
devoted respectively to images of the sun,
to life in an Arcadian setting and to apocalyp-
tical violence and death. The etching on dis-
play is the fifth print devoted to the sun. Baj
had already used other prints in this series to
illustrate Beniamino Dal Fabbro's
Descrizione di Orfeo, published by EPI,
Milan, in 1954, and Osvaldo Patani's *Poi
ancora un giorno*, published by Stedar,
Milan, in 1956, and was to use others for an
edition of the first-century AD Roman poet
Martial's *Epigrammi*, published by the
Verona printers Alessandro Corbulo and Gino
Castiglioni in 1967.

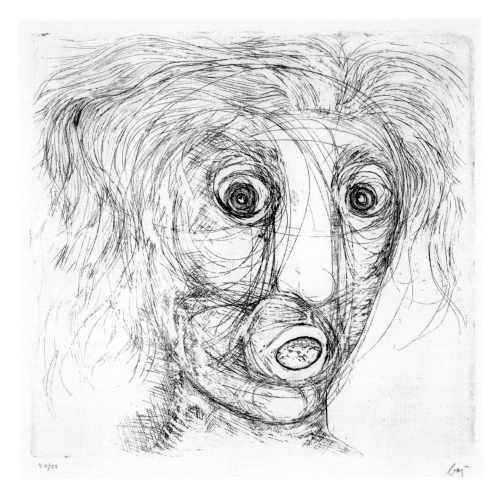

Giuseppe Capogrossi 1900–72

A descendant of an aristocratic family, the Capogrossi Guarna, Capogrossi was born in Rome. Initially he qualified as a lawyer, before, in 1922, deciding to take up painting and to attend the Scuola del Nudo, run by Felice Carena in Rome. Capogrossi became close friends with Armando Spadini, Oppo and, in particular, Emanuele Cavalli (1904–81), with whom he shared a studio. He travelled to Paris in 1929 and, on his return to Rome, became associated with a loose group of painters, including Corrado Cagli and Cavalli in the orbit of the critic Waldemar George, which was known as the Scuola Romana. The subject matter of Capogrossi's pale fresco-like paintings paralleled the Magic Realism of the poet and theorist Massimo Bontempelli (1878–1960). In 1933 with Roberto Melli he signed the *Manifesto del primordialismo plastico*.

In the late 1930s Capogrossi began to employ darker hues. He made his first prints in 1944, a set of eleven lithographs. These, the first significant lithographs to be printed by Roberto Bulla, were published jointly by Documento Editore and Galleria La Margherita in Rome. They were of female figures, some of which were indebted to Derain's *Metamorphoses* of the late 1920s. After the war, Capogrossi gradually turned to abstraction. His first fully abstract works date from 1949. Towards the end of that year, Capogrossi started to use a language of signs, which he was to employ in his paintings and prints for the rest of his career. He arranged these signs in comb-like compositions against backgrounds of a single colour. Although apparently structured, their arrangement was intuitive, and hence Capogrossi was closer to the sensibility of Art Informel than to Geometric Abstraction. He was one of the founders in 1951 with Burri, Ettore Colla and Mario Ballocco of the Gruppo Origine, all Rome-based artists who promoted abstract art as a counter to realism, arguing for a reductive simplicity. Capogrossi was also in touch with abstract artists in Milan, and exhibited in several group exhibitions devoted to Spazialismo.

He resumed printmaking in 1950, when he began to work with the Stamperia and Galleria del Cavallino in Venice, a partnership which was to last until 1966. These prints were mainly lithographs, but also included screenprints and a linocut. In 1960 Capogrossi made four woodcuts, which he printed in his own studio in Rome. He made his first etching with the Florentine workshop Il Bisonte in 1963–4, and began working with Valter Rossi's 2RC Studio in Rome in 1964, at first for etchings, but later principally for lithographs. The Galleria Marlborough in Rome joined 2RC to publish an album of five lithographs and a relief etching in 1968. Many of Capogrossi's 122 prints were published individually. His last portfolio was a set of ten lithographs, printed and published by Erker Presse in Sankt Gallen in 1971. Many of his relief etchings were printed by Edizioni d'Arte Fratelli Pozzi in Turin. Capogrossi also worked with the printers Mourlot and Leblanc in Paris, Brano Horvat of the Galleria del Deposito, Grafica Romero, Multirevol and the Swiss Atelier der Galerie Pro Arte Kasper in Morges among others.

BIBLIOGRAPHY
Capogrossi's prints have been catalogued by Ulrike von Hase-Schmundt, *Capogrossi: das graphische Werk*, Sankt Gallen, 1982. For a catalogue of Capogrossi's paintings, there is G.C. Argan and M. Fagiolo dell'Arco, *Capogrossi*, Rome, 1967.

108 (see colour page 74)

IN HOC SIGNO NR 3

1970
Colour lithograph 640 × 480 signed and numbered *53/75* in pencil
Von Hase-Schmundt 81
2003-6-30-30
Presented anonymously, 2003

Printed by Stamperia 2RC in Rome, this is one of a series of six prints published by the Société Internationale d'Art-XXe Siècle in Paris. The title refers to the vision of the Roman Emperor Constantine at the Battle of the Milvian Bridge, north of Rome, on 28 October 312 AD. He saw a cross against the sun in the sky. Taking it as a propitious sign, he exclaimed 'In hoc signo vinces' ('By this sign you will conquer'), and led his troops forward to victory over Maxentius, his rival for the role of Emperor.

109 (see colour page 75)

QUARZO NR 3

1970
Colour lithograph 760 × 530 signed and inscribed *pa* in pencil
Von Hase-Schmundt 88
2003-6-30-31
Presented anonymously, 2003

This lithograph is one of a set of six prints that were published at Sankt Gallen in Switzerland by Erker Presse in an edition of seventy-five together with fifteen artist's proofs.

Piero Dorazio 1927–2005

Born in Rome, Dorazio began drawing and painting while still at school. From 1945 he studied architecture at the Università degli Studi in Rome, while founding the Gruppo Arte Sociale with a group of young artists. His early realist paintings were influenced by Expressionism and Cubism, and he frequented the studio of Renato Guttuso. However, Dorazio soon converted to abstraction, and in 1947, with his school friend Achille Perilli, Pietro Consagra, Giulio Turcato, Carla Accardi, Mino Guerrini and others, he founded the Forma 1 group. He was in contact with the sculptor Henri-Georges Adam and the painters Pignon and Singier in Paris. In 1948, with Consagra and Prampolini, Dorazio organized a major show, *Arte astratta in Italia*, for the newly formed Art Club at the Galleria di Roma. Through Severini, he met many leading abstract painters and sculptors on a visit to Paris, of whom Sonia Delaunay and Magnelli were the most significant for his development. Before returning to Italy, Dorazio also visited Belgium and Holland, studying works by artists associated with De Stijl. Together with Perilli, he saw an important exhibition of Die Blaue Reiter in Munich. Dorazio was very interested in jazz, and organized the first large concert of the New Orleans Jazz Band in Rome. Musical rhythms, as well as those found in the paintings of Balla, whom he met in Rome in 1950, were to be important for his art for the rest of his career. In 1951, Dorazio wrote the foreword for a Kandinsky exhibition at the Galleria L'Obelisco in Rome. He also contributed to André Bloc's *L'Art d'Aujourd'hui*, and, jointly with Ettore Colla, edited *Arte visive*. The Galleria L'Age d'Or, which Dorazio founded with Guerrini and Perilli in Rome and Florence, promoted art of the international avant-garde. In 1952, with Burri, Capogrossi, Mario Ballocco and Colle, he founded the group Origine. Dorazio's *La fantasia dell'arte nella vita moderna*, written between 1952 and 1953, and published in 1954, was one of the first books in Italian on international post-war art.

Following his first New York exhibition at the Museum of Non-Objective Painting in 1950, Dorazio made frequent visits to America, where he later regularly taught at the University of Pennsylvania between 1960 and 1969, and with the painter, sculptor and poet Angelo Savelli (1911–95) in 1963 he founded the Institute of Contemporary Art in Philadelphia. Of all Italian artists, Dorazio had the closest relations with his American contemporaries. He frequented the 6th Street Artists Club, and he knew all the leading painters in the New York School, both the Abstract Expressionists and the hard-edged post-painterly abstractionists. However, Dorazio also had close links with European abstract art. In 1958, he joined Otto Piene, Heinz Macke and Gunther Uecker in the German group Zero, and in 1960 he was also a founder member with Armando, Henk Peeters and Jan Schoonhoven of the related Dutch group, Nul. Dorazio taught in Berlin for six months in 1968.

In the early 1950s, Dorazio experimented with reliefs, bronzes and transparent sculpture in perspex, but it was as a painter that he established his international reputation. His compositions were always tightly controlled. Dorazio painted a series of white canvases in 1951, and, throughout his career, produced works of great tonal refinement. In a period in Paris and at Cap d'Antibes in 1957, he produced pink and violet-blue canvases of notable delicacy. In the late 1950s, Dorazio used a divisionist technique akin to that used by Previati, Boccioni and Balla in the first decade of the century, and the surfaces of these works seem to vibrate. Densely packed parallel diagonal lines feature in his works of 1959 to 1963. The colours in Dorazio's paintings are notable for their translucence. Later in the 1960s, he adopted a crisper and flatter style, often using bands of harmonious colour. These bands gradually became more delicate and threadlike in the 1970s. For the rest of Dorazio's career, decoration and pattern became more important, but his paintings retained their strong affinity with music.

Dorazio made some monotypes and lithographs while he was on holiday in Nice in the summer of 1957. He then worked from 1959 to 1961 with the lithographic printer Roberto Bulla in Rome. Dorazio began to etch in 1960, having met the Rome printer and publisher Renzo Romero, who became his close friend. Romero was to be the principal printer of Dorazio's intaglio plates until 1985. These included drypoints and aquatints, in which technique he became particularly proficient. Dorazio made his first colour aquatints in 1964, the earliest bearing resemblance to antique tessellated pavements. From 1967, he began to employ broad layers of single colours akin to delicate washes, which in appearance have some similarity to the compositions of the American Kenneth Noland, of whom he had become a friend in 1965. From 1968, Dorazio began to work with the Stamperia 2RC and the Marlborough Gallery in Rome. 2RC printed for him up to 1979. In 1970, he met the Locarno artist and printer François Lafranca, whose handmade paper was notable for its irregular surface and rich texture, which proved particularly attractive for Dorazio to use for his aquatints. He also worked with a large number of printers in Rome, Florence, Venice, Udine, Milan, Pescara and Todi. A notable feature of Dorazio's intaglio work is that many works were commissioned as single plates by private individuals, reflecting the popularity of his art with the world of Italian business and industry. In the mid-1970s, Erker Presse in Sankt Gallen replaced Edizioni 2RC as the principal printers of his lithographs.

BIBLIOGRAPHY
Dorazio's 329 intaglio prints up to 1993 have been catalogued by Gabriele Simongini, *Piero Dorazio. Catalogo ragionato dell'opera incisa 1962–1993*, Florence, 1996. As yet, there is no publication on his lithographs and screenprints. Groups of lithographs are listed in the catalogues to the exhibitions *The work of Piero Dorazio*, Cleveland Museum of Art, 1965 (by Leona E. Prasse and Louise Richards), and *Piero Dorazio slike i grafike*, Muzej savremene umetnosti, Belgrade, 1970. The latest major publication on his paintings is the catalogue *Piero Dorazio*, IVAM Julio González, Valencià, 2003.

Tancredi 1927–64

110 (see colour page 76)

UNTITLED

1975

Colour lithograph 415 × 675 signed, dated and inscribed *42/150*

2005-8-30-17

Presented anonymously, 2005

This lithograph was printed by Erker Presse in Sankt Gallen, and published in an edition of 150 in Marie-Suzanne Feigel's Galerie d'Art Moderne Basel's portfolio *30 Jahre Galerie d'Art Moderne Kunst*, with an introductory text by Willi Rotzler. The other artists who contributed prints were Gottfried Honneger (born 1917), the Surrealist Meret Oppenheim (1913–85), Franz Fedier (born 1922), Betha Sarasin-Baumberger (born 1930), the French geometric abstractionist Marie-Thérèse Vacossin (born 1929), the sculptor Erwin Rehman (born 1921), and the Basel painter Max Kämpf (1912–81). Most of these were Swiss. The Galerie d'Art Moderne, which was founded in 1945, showed mainly Surrealist and abstract art. The only other Italian artist with whom the gallery had a close connection was Marino Marini. Feigel published her reminiscences, *Erinnerung an die Galerie d'Art Moderne, Basel 1945–1993*, Basel, 1993.

It is likely that Dorazio supplied the printers of Erker Presse with a watercolour from which to work, as was his practice on other occasions.

The British Museum also owns Dorazio's *livre d'artiste* Pablo Neruda's *La nave*, published by M'Arte Edizioni, Milan, in 1973, which is illustrated by three colour lithographs, and his portfolio of fifteen screenprints *Amici colori*, published by Galerie Aras, Ravensburg, in 2002, the latter of which was presented by the artist.

Born in Feltre, Tancredi Parmeggiani attended the free course run by Armando Pizzinato (born 1910) at the Accademia in Venice. There he met Vedova, Guido Cadorin and Virgilio Guidi (1891–1984). Initially, his work was influenced by Van Gogh, and his drawings had the elegance of Modigliani. A brief visit to Paris in 1947 introduced Tancredi to Cubism. Two years later, he found a copy of Kandinsky's *On the spiritual in art* in Vedova's library. At the same time, Tancredi's discovery of the work of Kupka and De Stijl was fundamental to his artistic development.

Tancredi spent a year in Rome in 1950, where he met Turcato, Dorazio and Perilli, and, partly inspired by memories of the paintings of Jackson Pollock, which he had seen at the 1948 Venice Biennale, he moved away from geometric abstraction to a freer, more informal style. When Peggy Guggenheim met him in the Galleria Nazionale d'Arte Moderna at the 1951 Art Club exhibition, *Arte astratta e concreta*, she offered him a studio back in Venice in the Palazzo Venier. She also promoted his work in the United States. Tancredi's paintings of this period have been compared with the 'white writing' of Mark Tobey. In 1952, he joined Burri, Fontana and others as a signatory to the *Manifesto del Movimento Spaziale per la Televisione*, and became a close friend of the dealer Carlo Cardazzo. In 1954, the Kunstmuseum Bern included Tancredi's work in a group exhibition alongside Pollock, Wols, Riopelle, Tobey, Mathieu and Bryen. The following year, a love affair with Peggy Guggenheim's daughter, Pegeen, brought to the end the patronage that he had enjoyed. This led him to go to Paris, where his work was included in Michel Tapié's *Art autre* exhibitions at the Galerie Fachetti and at the Galerie Stadler. Back in Venice, in the catalogue for his 1956 one-man show at the Galleria del Cavallino, *Grafia d'acqua pulsante d'intatta energia vitale*, Tancredi wrote that 'painting ought to be nature just as much as a leaf', suggesting that he did not see his work as abstract, but as 'full of humanity'.

In 1958, he achieved international acclaim through exhibitions at the Hanover Gallery in London, the Saidenberg Gallery in New York

and the Carnegie Institute in Pittsburgh. Tancredi's wife, the Norwegian painter Tove Dietrichson, encouraged him to study the paintings of CoBrA artists and North European Art Informel. Despite his critical success, the couple suffered from poverty. Together, they moved first to Milan, and then to Paris, where Tancredi joined Anti-Procès, a movement against abstract academicism, which was promoted by the writers Alain Jouffroy and J.J. Lebel. His paintings of this period approach the work of Robert Rauschenberg. In the early 1960s, Tancredi suffered from alcoholism and depression, the effect of which is visible in his art. His wife left him, and he spent time in clinics and hospitals, before drowning himself in the Tiber. Only five prints by Tancredi, all lithographs dating from 1955 to 1958, are known. His first of 1955 resembles a collage in that narrow rectangular shapes arranged slightly off vertical are laid over parts of the composition. Tancredi's three lithographs of 1957, which make skilful use of areas of blank paper as part of the composition, have echoes of El Lissitzky and Moholy-Nagy, as well as of the work of Kandinsky of the interwar period. He printed them on the press of the painter Mario De Non.

BIBLIOGRAPHY

Marisa Dalai Emiliani's two-volume *Tancredi: I dipinti e gli scritti*, Turin, 1996, records his lithographs in among his paintings.

111 (see colour page 77)

SPATIAL COMPOSITION

1958

Colour lithograph 492 × 655

Dalai Emiliani 7

2005-10-30-1

Purchased, 2005

This, the only Tancredi print to be published, was printed in May–June 1958 by Giuseppe Rosa in the Stamperia del Cavallino at San Silvestro, Venice, and issued by Edizioni del Cavallino, Venice, in an edition of thirty. The Galleria del Cavallino gave him four one-man shows, and its associate, Galleria del Naviglio, gave him an exhibition in 1953.

Eugenio Carmi born 1920

Born in Genoa, Carmi learnt to paint in the studio of the Genoese artist Angelo Barabino (1883–1950) between 1934 and 1935, and was also active as a photographer in his teenage years. In 1938 he moved to Zurich, where he studied chemistry. In the galleries in Bern and in Zurich Carmi discovered the paintings of Klee, Kandinsky and Mondrian. He also had the opportunity to see work by Max Bill and other Swiss abstract artists. After the war, Carmi studied first with the sculptor Guido Galletti (1893–1977) in Genoa, and then from 1947 to 1948 with Felice Casorati in Turin. His figurative paintings reflect this training and his interest in the blue period of Picasso. Carmi visited Paris in 1948, and became aware of Hartung, Soulages and Mathieu. He pursued a career as a designer and graphic artist, while continuing to paint. By the mid-1950s, Carmi's work was in Art Informel mode. His use of collage and typography had similarities with that of Schwitters.

A key moment in Carmi's career was his appointment as artistic consultant to the Cornigliano steelworks in Genoa, which led eventually to a position as art director to Italsider, the Italian state steel company. He created an effective series of simple geometric designs, alerting employees to the regular hazards that they should avoid in the dangerous business of steelmaking. Work for the company also led to a series of iron and steel sculptures and enamel paintings on steel. Carmi was the moving force behind the foundation in 1963 of the Gruppo Cooperativo di Boccadasse and the Galleria del Deposito just outside Genoa, which published a remarkable series of prints, multiples, scarves, jewels and other objects over a period of six years. He was also active in the field of avant-garde music, and of electronic and cybernetic art. Working with the singer Cathy Berberian, Carmi designed the plates for *Stripsody* in 1966 and, at the same time, began working with the philosopher Umberto Eco on children's books. In 1967 he showed electronic works at the *Superlund* exhibition in Bordeaux, organized by Pierre Restany, champion of Nouveau Réalisme. The following year, he presented the *Carm-O-Matic*, a device for producing random groups of colours and shapes on a screen through the use of a stroboscopic cell sensitive to external sounds, at the ICA in London. In these works, Carmi showed himself to be the heir of the Futurist Luigi Russolo, while his *Il nastro rotante*, a rotating band of colour strips, echoed the work of Sonia Delaunay. His interest in multiples led to a series of multiple paintings on canvas for Edizioni Schwarz in Milan. Carmi has also worked on experimental television films, designed ties, carpets and mirrors, and made multiples in glass.

Carmi made his first print in 1959, a screenprint, which was published by the Guilde Internationale de la Sérigraphie, Galerie Kaspar, in Lausanne. All his prints in the 1960s and early 1970s were abstract, with one important exception in 1971, *Chromo – Synclasma*, a portfolio of screenprints printed by Albin Uldry in Bern, and published by Edizioni del Deposito in Milan, with an introductory text by the film director Michelangelo Antonioni. For these, Carmi photographed some of his works and projected them on to a woman's body. Among his prints were a series of lithographed sheets of tin plate made in 1964 and 1965. In 1981 Biograph in Milan published four aquatints inspired by Carmi's own illustrations to Umberto Eco's children's book *La bomba e il generale*, 1988. These were printed by Giorgio Upiglio's Grafica Uno in Milan. Throughout the 1990s, Carmi made aquatints and etchings, working primarily with Giorgio Upiglio, and with two printers in Verona, Luigi Berardinelli and Anna Ziliotto.

BIBLIOGRAPHY
Little has been published on Carmi's prints. His various activities during the lifetime of Galleria Deposito, including printmaking, are discussed in the exhibition catalogue *La Galleria del Deposito: Un'esperienza d'avanguardia nella Genova degli anni Sessanta*, Museo d'Arte Contemporanea di Villa Croce, Genoa, 2003. Umberto Eco and Duncan Macmillan, *Carmi*, Milan, 1996, provides information on his career as a whole.

112 (see colour page 78)

A 3

1965

Screenprint 388 × 400 signed and numbered *42/55*, and priced *12 gns* in pencil

2004-7-31-29

Presented by Friends of Prints and Drawings, 2004

This was printed by Brano Horvat of Zagreb, and published in an edition of fifty-five by the Galleria del Deposito, Boccadasse, near Genoa. It was one of nine screenprints by Carmi to be advertised in the first catalogue of graphic works advertised by the gallery. The screenprints published by the Galleria del Deposito were among the first produced by artists in Italy in the 1960s. Carmi had set up Horvat, a specialist screenprinter, in a storehouse close to the gallery, where between 1964 and 1969 he printed lithographs and screenprints by such artists as Vasarely, Bill, Lohse and Soto, as well as by the Italians Capogrossi, Perilli, Arnoldo Pomodoro, Lucio del Pezzo (born 1933), Fontana, Dorazio, Baj and Munari. Carmi's use of lettering, which stemmed partly from his works as a designer for Italsider, and from his study of Futurist graphics, parallels the contemporary *lettriste* movement in Paris.

Born in Homs in Libya, Schifano moved to Rome with his family after the end of the Second World War. He worked with his father, a restorer and archaeologist at the Museo Etrusco in the early 1950s, while starting to paint in an Art Informel style using thick impasto. From 1959 to 1961, Schifano executed a series of paintings on wrapping paper glued to canvas using only one or two colours. His work paralleled French Nouveau Réalisme. Schifano was also indebted to Jasper Johns in his use of numbers and letters, while his handling approached that of Robert Rauschenberg. In 1962, he began to use motifs from advertising, including the logos of Coca-Cola and Esso. Schifano became interested in the Futurists' attempts to depict motion, and painted several pictures of a walking man with multiple torsos and legs. He spent much of 1962 and 1963 in the United States, where he came into direct contact with American Pop artists. Schifano was particularly impressed with the gestural painting of Jim Dine and Franz Kline. Images of mass communication, such as road signs and publicity hoardings, became sources for his work. Schifano's homage to the Futurists led to his 1966 painting *Futurismo rivisitato*, based on a famous 1912 photograph of the group's protagonists, presenting them like a contemporary rock band. Variations of this work recurred for some years, both in paintings and in screenprints.

In the second half of the 1960s, Schifano turned to the world of cinema, television and performance. With the guitarist Urbano Orlandi, he founded a band, Le Stelle, and in 1967 he designed a booklet illustrated by his screenprints to accompany their Warholian album, *Le ultime parole di Brandimante*, taken from Tasso's *Orlando Furioso*. The idea was that this should be listened to with the television on, but with the sound turned off. In 1968, Schifano made the film *Satellite*, in which a stream of images passed across the walls of his studio. For his paintings of the early 1970s, he sat in front of the television taking random photographs, which he attached to canvases. He then scribbled over them, stained them, and painted them in enamel paint and aniline, setting them within a black frame resembling a video screen. Their garish colours and the X-ray-like low

definition created the appearance of the television controls being out of register. Schifano encountered the frequent attention of the police for taking drugs. He was a heroin addict, and periodically he abandoned painting, particularly in the late 1970s. On one occasion, he went to India to live in a commune. In the 1980s, he painted a series of very large expressionist gardenscapes, landscapes and seascapes, in which the paint was often applied direct from the tube. The flow of images over television screens remained a key inspiration into the 1990s and at the end of his life he was engaged in experimenting with computer and internet art.

Schifano began making screenprints in the 1960s. Throughout his career, many of his prints were derived from the imagery of much earlier paintings. In the early 1970s, Schifano worked with Renato Volpini's specialist screenprinting workshop, Multirevol, at Cornaredo, just outside Milan. One of his most striking prints was *Il gusto*, commissioned for the journal *Bolaffi Arte* in 1974, an impression of which is in the British Museum. He also made a lithograph in the workshop of Roberto Bulla in 1977 for Ingegneria C. Lotti e Associati. From 1980, Schifano made a series of sets of screenprints, including *6 × art works*, which was printed by A. Ruffo's Stamperia d'Arte Grafiser, and published by Felice Ferdinando Silanos, editor of *La Grafica d'Arte*, and *8 × art works (Schifano)* of 1980–1. Another portfolio of three prints was published by Galleria G. Cesari di Argenta of Ferrara in 1980. A set of eight screenprints, each in a different colour, was published by Edizioni Tacconi in Rome for the 1984 Venice Biennale. From the late 1980s, he often worked with the Roman publisher Torcular of Trezzano del Naviglio, who issued a series of catalogues beginning with *Best seller: raccolta di 31 opere grafiche* of 1988–90. Schifano provided a screenprint for Ippolito Avalli's *Angeli musicanti*, published by L'Obliquo in Brescia in 1989. Among his last prints were an aquatint for *8 + 8 poesie da Esopo* in 1993, and an etching for Aesop's *Il leone e il toro* in 1995, both of which were printed by Luciano Trina in Rome, and published by Rizzardi in Milan.

BIBLIOGRAPHY
Very little has been published on the prints of Mario Schifano. A small group is recorded, but not discussed, in Federica Di Castro, ed., *Mario Schifano viaggiatore notturno*, Istituto Nazionale per la Grafica, Rome, 1980, p. 36. The compiler has not seen Thomas Appel and Riccardo De Mumbro Santos, *Mario Schifano*, Galleria Anna d'Ascanio, 2002, which also included prints. The most recent survey of his work is *Mario Schifano tutto*, Galleria Comunale d'Arte Moderna e Contemporanea, Spazi Esposivi ex Fabbrica Pieroni, Rome, 2002.

113 (see colour page 79)

MONOCROMI

1971
Screenprint 720 × 540
2005-8-30-18
Presented anonymously, 2005

This screenprint was printed by Renato Volpini (born 1934) of Multirevol in the Milan suburb of Cornaredo, and published in an edition of 120 by Nino Soldano in Milan. Other screenprints by Schifano, printed by Volpini and published by Soldano in 1971, included *Coca Cola, Esso, Compagni Compagni, Oasi, Televisione* and *Futurismo rivisitato*. The Galleria Nino Soldano gave Schifano a one-man show in 1974. Volpini is himself a talented painter and printmaker, who taught screenprinting at the Accademia di Brera. After a period painting in an Art Informel style, Volpini turned to Pop Art and worked in a vein akin to Enrico Baj.

Schifano had begun producing monochrome paintings in 1960, and exhibited some of them at the Galleria La Salita in Rome that year. It is probable that this screenprint is based on one of these paintings of the early 1960s. The overlapping rectangular forms in Schifano's print, some of which could be read as doors or windows, anticipate the work of Pierre Buraglio and of other artists associated with the French Supports Surfaces group.

Mario Merz 1925–2003

Born in Milan, the son of an engineer and inventor, Mario Merz became friends after the war with Mattia Moreni (1920–99), Fausto Melotti and Luigi Spazzapan (1889–1958). In 1949, some of his drawings were published in the Communist newspaper *L'Unità*. Throughout the 1950s, Merz painted abstract pictures in an Informel style, which were based on macroscopic analysis of natural phenomena, such as plant leaves. In his study, he discovered spirals and parabolas, which he incorporated in his work.

In the mid-1960s, Merz broke free from the confines of traditional painting through the inclusion in his pictures and in his sculptural installations of artefacts such as overcoats, bottles, umbrellas and neon tubes. He used neon, but very differently from the constructivist mode of a light artist like Dan Flavin. The light flowing down a tube gave his works a biomorphic reference. It has been compared to a capillary tube. From there, Merz progressed in 1968 to making hemispherical igloos built around a metal frame, which were covered with clay, wax, branches, fragments of slate and broken glass. Into this framework neon lettering with literary and political references were inserted. Both Merz and his wife, Marisa (born 1931), were leading figures in the Arte Povera movement. His ideas paralleled the 'global village' of the sociologist Marshall McLuhan, and he believed in the bringing together of elements from the nomadic primitive past and the scientific present.

From 1969, the formula of mathematical progression discovered by the fourteenth-century mathematician Fibonacci became central to his art. In this, each number is equal to the sum of the two preceding numerals (1, 1, 2, 3, 5, 8, 13 . . .). These proportions can be found in the natural growth of leaves, shells and reptiles' skins. Hence came the appearance of organic material, crocodiles, tiger skins and sequential neon numbers in Merz's work. In 1970, the complexity increased with his introduction of the table, another human creation basic to everyday sociable life like the igloo, which he used for a series of happenings, in which the participants followed Fibonacci rhythms. Merz's installations, in which artificial and natural objects were combined, were intended to convey the idea of constant interaction, and of the flux to be found in the contemporary world. He returned to painting in 1979, using unstretched and unprimed canvas. The paint sank into the support. In Merz's pictures and in his later sculptural installations he continued to assert the effect of natural processes, chance and human technological intervention. Tigers and crocodiles, and the plant world, remained central to his subject matter.

Merz only made occasional forays into printmaking. His first prints were lithographs made in 1970, which were devoted to the Fibonacci sequence. His first portfolio was published in 1974. Four years later, Bruno Corà's A.E.I.O.U. published six lithographs in the album *Sei case a Sydney* (*Six houses at Sydney*). A portfolio of six screenprints with the same title was published by Studio Nuvolo in Rome in 1982, accompanied by a text written by Corà. Merz executed and published a black and white lithograph of plants, *Untitled (Fibonacci)* of c.1980, in a small edition of forty, while, at much the same time, he issued an untitled photolithograph in an edition of 5,000. When Merz was selected as featured artist for the Zurich journal *Parkett* 15 in 1988, he was expected to make an edition for the periodical's subscribers, in this case a sugar-lift aquatint. This commission spurred him to produce a suite of three aquatints, *Untitled*, also of 1988, which were printed in Zurich by Peter Kneubühler, and published in Munich by Maximilian Sabine Verlag. The prints, which were of small, medium and large formats, show his favourite igloos as open diagrams, in which the interior and exterior spaces are in harmonious balance. An edition of eight aquatints, *Untitled*, was also printed by Kneubühler and published by Maximilian Sabine Verlag in 1993. Merz made fourteen lithographs and photolithographs for the portfolio *Da un erbario raccolto nel 1979 in Wogga-Wogga*, which were published in Turin by Marco Noire only in 1989. Some of his prints form part of mini-installations, as in the 1988 *Salamandra*, which consisted of an iron box with magnets, glass, putty and two colour lithographs on two hollowed punched tables placed one upon the other.

BIBLIOGRAPHY
Merz's work has been very widely exhibited, and there is an extensive literature on his art. Discussion of Merz's prints, however, has so far been limited to references to the publication of individual portfolios in various issues of *Print Collector's Newsletter*, and in Gilbert Perlein, *Arte Povera: les multiples: 1966–1980*, Régie Autonome des Musées de la Ville de Nice, 1996. A retrospective exhibition of his work was held at the Museu de Serralves, Porto, in 1999. The Fondazione Merz's opening in Turin in April 2005 (www.fondazionemerz.org) coincided with a show shared between the Fondazione, the Galleria Civica d'Arte Moderna in Turin, and the Museo d'Arte Moderna, Castello di Rivoli.

114 (see colour page 80)

THE NUMBER INCREASES (LIKE): THE FRUITS OF THE SUMMER AND THE ABUNDANT LEAVES 1, 1, 1, 2, 3, 5, 8, 13, 21, 34, 55 . . .

1974
Four lithographs, three of which are in
colour, 700 × 900; each print is numbered,
and signed on the back
2005-5-30-1 (1–4)
Presented anonymously, 2005

Merz's first portfolio was published by
Edition Pio Monti Arte Studio in Macerata in
an edition of 125. Tate Modern owns a paint-
ing, *Fibonacci tables* of 1974–6, which is
related in subject to these prints. Irregular
five-sided tables, this time each bearing a leaf,
are also the subject of a colour etching,
aquatint, soft-ground and drypoint, which
was published in 1991 by the Turin dealer
Franco Masoero. The idea of using tables
came to Merz when he was dining in a Turin
restaurant, and the concept was first present-
ed at the Ristorante della Spada in 1972. He
employed a photographer to take a picture
first of a single guest at a quadrangular table,
and gradually progressed in the Fibonacci
sequence up to 55. Merz's first installations
used 2 by 2 feet as the module, as being the
smallest to comfortably seat a single individ-
ual. Merz wrote, 'what interested me was the
physical side of the table, since the table is
connected in a deeply organic way with a
man. The table is a piece of earth that rises,
that appears as an elevated area. That is inter-
esting, for starting from the square table,
I came to the idea of a table which does not
exist in architecture.' Merz's progressions of
tables can be seen as evocative of evolution,
but also of conviviality and dialogue between
human beings.

Chronology

1796	Napoleon invades Italy.
1814	On Napoleon's defeat, Lombardy and the Veneto become part of the Austro-Hungarian Empire.
1845	Società Promotrice di Belle Arti in Turin starts to publish albums of lithographs.
1848–9	Piedmont unsuccessfully attempts to drive Austria out of northern Italy.
1855 and 1859	Degas visits Italy.
1858	Mariano Fortuny arrives in Rome.
Late 1850s	The Tuscan I Macchiaioli start painting landscapes in the open air.
1859	Piedmont with its ally, France, defeats Austria in the second war of independence. Tuscany and other duchies vote to unite with Piedmont.
1861	Vittorio Emanuele II of Savoy becomes the first King of Italy. First national exhibition of the United Italy held in Florence.
1862	Alfred Cadart founds the Société des Aquafortistes in Paris, and begins publishing albums of etchings. Publication of Carlo Righetti's novel *La scapigliatura*.
1865	First Italian etching to be included in one of Cadart's albums. The capital of Italy is transferred from Turin to Florence.
1866	Austria cedes the Veneto.
1867–8 and 1871	Ludovic Lepic in Naples.
1868	De Nittis settles in Paris, followed by Boldini in 1870.
1869	First issue of *L'Arte in Italia* published and first Italian etching society, L'Acquaforte, founded in Turin.
1870	Italian troops annex Rome and Lazio. The Papal temporal power is confined to the Vatican City.

	Rome becomes the capital of Italy.
1873–4	First *acqueforti monotipate*, made by Giuseppe Grandi.
1883	Giovanni Fattori commissioned to make an etching.
1885	Giovanni Costa founds In Arte Libertas in Rome.
1886	Vittore Grubicij takes up Divisionism.
1888–93	Max Klinger in Rome.
1894–1901	Arnold Böcklin in Fiesole.
1895	First Venice Biennale.
1897	Vittorio Pica starts publishing art criticism.
1902	Turin International Exhibition of Decorative Art.
1907–30	Nino Barbantini organizes exhibitions at the Ca' Pesaro, Venice.
1909	Marinetti publishes his *Futurist manifesto* in Paris.
1910	Rome International Exhibition of Fine Art. First Italian exhibition of Impressionist paintings held in Florence.
1910–26	Vittorio Pica general secretary of the Venice Biennale.
1910–11	Giorgio De Chirico paints the first pictures that are later to be called Pittura Metafisica.
1911	Ettore Cozzani launches the journal *L'Eroica*, promoting contemporary Italian woodcuts.
1915–18	Italy, an ally of France and Britain in the First World War, fights Austro-Hungary in the eastern Alps and Friuli.
1918–21	Mario Broglio publishes the journal *Valori Plastici*.
1922	Mussolini marches on Rome and takes over the government. A room of German Expressionist prints at the Venice Biennale.
1924–43	Mino Maccari's journal *Il Selvaggio*, together with Leo Longanesi's *L'Italiano*, leads the nationalist Strapaese movement.

1928	The Venice Biennale placed under state control.
1929	Black and white section of the Sindacato Fascista di Belle Arti set up.
1931	First Rome Quadriennale.
1932–6	Several Italian artists join the Parisian based Abstraction-Création.
1933–58	Carlo Alberto Petrucci Director of the Calcografia Nazionale.
1938	Anti-Fascist artists group around the journal *Il Corrente* in Milan.
1940	Mussolini joins Germany's side in the Second World War.
1941	Start of the golden decade for the Italian *livre d'artiste*.
1943	The allies invade Italy. Mussolini is dismissed, but the Germans set him up as ruler of the puppet Republic of Salò in northern Italy.
1945	Defeat of Germany and execution of Mussolini. Foundation of the Rome exhibiting society the Art Club.
1946	The journal *Forma* published in Rome. The *Manifesto blanco*, the first formulation of Spazialismo, published in Argentina.
1947	International exhibition of abstract art in Milan at the Palazzo ex Reale. Lucio Fontana returns to Italy from Argentina.
1948	Foundation of M.A.C. (Movimento Arte Concreta). Peggy Guggenheim organizes an exhibition of contemporary American painting at the Venice Biennale.
1950	Jackson Pollock exhibition at the Museo Correr, Venice.
1951	Enrico Baj and others launch Movimento Nucleare. Alberto Burri, Giuseppe Capogrossi and others launch Gruppo Origine.
1957	Cy Twombly settles in Rome.
1959	Valter and Eleonora Rossi found Stamperia 2RC in Rome, and soon establish a partnership with the Galleria Marlborough.
1960	Renzo Romero opens Grafica Romero in Rome.
1962	Giorgio Upiglio opens the workshop Grafica Uno in Milan.
1963	Eugenio Carmi founds the Galleria del Deposito in Boccadasse.
1967	First Arte Povera exhibition.
1968	Edizioni Multipli begins to publish in Turin.
1970	Exhibition of contemporary American prints at the Venice Biennale.

Appendix

Works donated by Italian artists to the British Museum 2000–2006

(in alphabetical order)

asterisks refer to work illustrated

GIACOMO BENEVELLI (b. 1925)

(Untitled abstract composition), etching. 1963
2003-1-31-48

(Untitled abstract composition), linocut. 1969
2003-1-31-49

(Untitled abstract composition), linocut. 1970
2003-1-31-50

(Untitled abstract composition), etching. 1972
2003-1-31-51

(Untitled abstract composition), etching. 1972
2003-1-31-52

(Untitled abstract composition), etching. 1973
2003-1-31-53

(Untitled abstract composition), colour linocut.
1982
2003-1-31-54

*(Untitled abstract composition), colour litho-
graph. 1990
2003-1-31-55

Come illegittima cometa (illustration to
Chlebnikov), etching. 1996
2003-1-31-56

LUDOVICO CALCHI NOVATI (b. 1931)

A un tratto (illustrations to Mario Luzi),
four colour etchings. 2003
2003-12-31-41

PIERO DORAZIO (1927–2005)

Amici colori, series of 15 colour screenprints.
2002
2002-9-29-160

ACHILLE PERILLI (b. 1927)

L'historiette, colour etching. 1973
2003-3-31-23

Lot, colour etching. 1973
2003-3-31-24

Pirale, colour etching. 1973
2003-3-31-25

La marimente, colour etching. 1974
2003-3-31-26

Venturiere, colour etching. 1991
2003-3-31-27

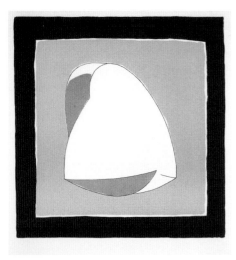

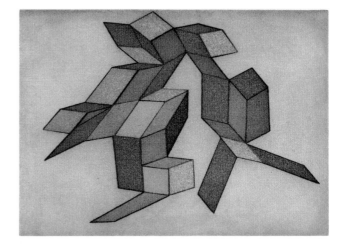

GIANCARLO POZZI (b. 1938)

Il canto del cigno, colour etching. 1972
2003-1-31-60

Realtà di un nuovo paesaggio, colour etching.
1972
2003-1-31-61

Andare via, colour etching. 1972
2003-1-31-62

Ode della città morta, colour etching. 1972
2003-1-31-63

Asino del soma, colour etching. 1975
2003-1-31-57

Il volo arrugginito, etching. 1975
2003-1-31-58

**I falsi armonicanti*, etching. 1977
2003-1-31-59

L'albero dei liberi, colour etching. 1978
2003-1-31-64

La montagna sacra, colour etching. 1979
2003-1-31-65

La porta del cielo, etching. 1990
2003-1-31-66

ANNA ROMANELLO (b. 1950)

Paysage dans l'eau, colour etching. 1991
2002-9-29-165

Dietro la finestra, colour etching. 1992
2002-9-29-166

Rosso sempre rosso, colour etching. 1994
2002-9-29-167

Fontana del Moro, colour etching. 2001
2002-9-29-168

**Fontana di Trevi*, colour etching. 2001
2002-9-29-169

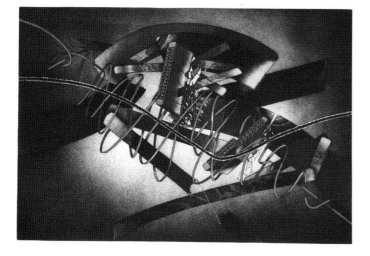

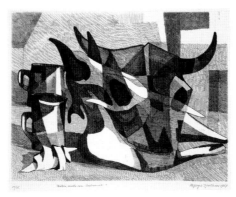

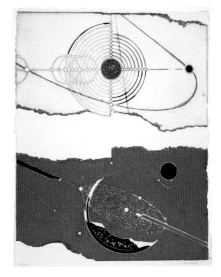

PASQUALE SANTORO (active from 1957)

Da in cieli piene, etching. 1978
2003-1-31-46

La preda e il cacciatore, colour etching. 1986
2003-1-31-47

(Untitled abstract composition), engraving. 2001
2003-1-31-45

PIERGIORGIO SPALLACCI (b. 1935)

Natura morta con bucranio, etching. 1957
2004-5-31-38

Strumenti musicali, etching. 1961
2004-5-31-39

In negativo, etching. 1973
2004-5-31-40

Il volo fra ferro e cemento, etching. 1975
2004-5-31-41

Viaggiatore, etching. 1978
2004-5-31-42

Orizzonte, colour etching. 1980
2004-5-31-43

WALTER VALENTINI (b. 1939)

To the moon, etching and embossing. 1990s
2002-9-29-162

*(Untitled composition with circles and ovals),
etching and embossing.
2002-9-29-163

(Untitled composition with triangles), etching
and embossing.
2002-9-29-164

EMILIO VEDOVA (b. 1919)

Aus dem Augenrund, series of five illustrations
to Joachim Sartorius, etchings. 2000
2002-9-29-161

OTHER GIFTS

Leonardo Castellani (1896–1984),
37 prints presented by Claudio Castellani,
the artist's son

Almina Dovato Fusi (1908–92),
22 prints presented by Umberto Fusi,
the artist's widower

Emilio Scanavino (1922–86),
7 prints presented by Galeazzo Tutino

Index